FROM LIGHT TO BYTE

D0731637

# FROM LIGHT TO BYTE

Toward an Ethics of Digital Cinema

**MARKOS HADJIOANNOU**

 *University of Minnesota Press*

*Minneapolis*

*London*

The University of Minnesota Press gratefully acknowledges financial assistance provided for the publication of this book from Trinity College of Arts and Sciences, Duke University.

Portions of the Introduction and chapter 2 were published as "*Waking Life:* The Destiny of Cinema's Dreamscape; or the Question of Old *and* New Mediations," *Excursions* 1, no. 1 (2010): 53–72. A portion of chapter 2 was previously published as "How Does the Digital Matter? Envisioning Corporeality through Christian Volckman's *Renaissance,*" *Studies in French Cinema* 8, no. 2 (2008): 123–36. A portion of chapter 4 was previously published as "Into Great Stillness, Again and Again: Gilles Deleuze's Time and the Constructions of Digital Cinema," *Rhizomes: Deleuze and Film* 16 (Summer 2008), http://www.rhizomes.net/issue16/hadji/index.html.

Published by the University of Minnesota Press
111 Third Avenue South, Suite 290
Minneapolis, MN 55401-2520
http://www.upress.umn.edu

Library of Congress Cataloging-in-Publication Data
Hadjioannou, Markos.
    From light to byte : toward an ethics of digital cinema / Markos Hadjioannou.
    Includes bibliographical references and index.
    ISBN 978-0-8166-7761-0 (hc : alk. paper)
    ISBN 978-0-8166-7762-7 (pb : alk. paper)
    1. Technology in motion pictures.   2. Motion pictures—Aesthetics.
3. Digital cinematography.   4. Cinematography—Technological
innovations.   I. Title.
    PN1995.9.T43H33      2012
    791.43'656—dc23                                    2012022918

Printed in the United States of America on acid-free paper

The University of Minnesota is an equal-opportunity educator and employer.

20   19   18   17   16   15   14   13   12        10   9   8   7   6   5   4   3   2   1

This book is dedicated to my mother and father, for getting me here; and to the memory of my beloved grandmothers, Elisavet and Ourania.

# CONTENTS

# PREFACE

CINEMA HAS BEEN UNDERGOING A TECHNOLOGICAL SHIFT in recent years, in which celluloid film is being replaced by digital media in the production, distribution, projection, and reception of moving images. While these changes have had a direct impact on the organizational and economic operations of movie industries across the globe, they have also led to new aesthetic forms in both mainstream and avant-garde movie-making, as well as novel possibilities for the ventures of independent and amateur moviemakers alike. Indeed, as the binary codification of the computer introduces different modes of recording and creating images, and expands the spectatorial experiences of movies quite significantly, we are faced once again with that primordial question: *what is cinema?* Concerned with the debate of digital cinema's ontology, and the inter-relationship between old and new media that is revealed in cinema cultures, *From Light to Byte* addresses the very idea of change as it is expressed in the current technological transition. In so doing, this book asks what is different in the way digital movies depict the world and engage with the individual, and how we may go about addressing the question of techno-logical change within media archaeologies.

Here I turn to the technical basis of the image as my first point of departure, but I propose that the question of cinema ontology needs to consider also the creative and perceptual activities of moviemakers and viewers. This is a matter of seeing how the digital configures its rela-tion to both reality and the individual while it simultaneously replays and destabilizes celluloid's own ontological structures. I observe that, where film's photographic foundation encourages an existential asso-ciation between subject and reality through the screened image, digital depictions are graphic renditions of mathematical codes whose causal

relations are more difficult to trace. Nevertheless, I argue that the digital does not obliterate celluloid's visual culture, but develops it within the presets of its own technological specificities whose delimitations are always affected by the variability of thought and creation. While each chapter individually looks at how the two technologies set themselves up with reference to reality, physicality, spatiality, and temporality, the final chapter suggests that the question concerning digital cinema is ultimately one of ethical implications—a question, that is, of the individual's ability to respond to the image of the world, in the sense of a creative involvement in life itself and its events.

# INTRODUCTION

*Going Digital: Cinema's New Age*

WHEN IN 1982 JEFF BRIDGES WAS BEAMED into a computer hard drive by the menacing Master Control Program of ENCOM Corporation and made to battle software in a life-threatening round of video games, the extent of digital technology's impact on the world of cinema could not have easily been foreseen. Steven Lisberger's extensive use of innovative computer-generated images (CGI) in *Tron* (1982) became a major fore-runner of digitization in mainstream industries, which would gradually replace the use of celluloid in whole stages of production, distribution, projection, and reception.[1] Ever since the movie's basic 3-D models, color filters, and glowing circuits, studios have achieved the creation of com-pletely fantastical worlds that do not simply push the boundaries of a celluloid culture, but redefine it within a digital setting.[2] Low-budget and amateur moviemaking have turned to digital video almost entirely, and nonlinear editing, location digital audio recording, and sound design have all become standard practices for the big studios. Moreover, digital pro-jection has made an increasing appearance in cinema theaters—espe-cially after the significant increase of 3-D productions in the first decade of the second millennium, culminating with the worldwide success of James Cameron's *Avatar* (2009). Further, image archivists are using the technology for restoring the sound and picture of their holdings; and, as pioneered by movies like *Toy Story* (John Lasseter, 1995) and the last two episodes of *Star Wars* (George Lucas, 2002, 2005), animation and science fiction genres have created works constructed entirely on hard drives with computer software that model, color, and move characters in envi-ronments dramatized with virtual cameras alone.[3] All this is to say that cinema has undergone a technological transition that is not an advance-ment of an existing format, as was the case with the change of substrates

and screens (between 8mm and 70mm formats, and from standard ratio to widescreen projection), the inclusion of analog sound on the filmstrip, or the addition of color chemicals on film stock. Rather, the recent transition has challenged the standard technological base of the moving image entirely—cinema's *old* medium—by introducing a novel computational environment—*new* media.

The use of light-sensitive halide-coated celluloid film for the creation of works has now become an option, or just one aspect of cinematic production in which digital technology has begun to play an imperative role. Within this setting, equipment, techniques, and aesthetics from both technologies are being combined in the creation of movies and television shows, advertisements, computer games, and art installations.[4] It is this relationship between celluloid modes and digital practices in the creation and perception of cinema's images that forms the subject of this book. My aim is to examine the impact this technological transition has for our relationship with the movie screen and with the models of recording, creating, and interacting with movies that have now become available. Although the consequences of the new technology range from changes in the economies of various industries to the politics of distribution and access, the aim of this study is to explore what is new about digital movies by examining their technical structures in relation to the functions of celluloid film. My intent is not to construct a definitive theory of either digital technology or media in general. Rather, my interest is in seeking the digital's newness by turning to its distinct modes of production, projection, and reception, as it reconfigures rather than replaces celluloid modes of creation and interaction. As such, I have chosen to focus on digital cinema in search of those forms of expression and perception that present us with a new ontology of the cinematic—that is, as they change the existential relations between the movie image and the world it presents and with which it interacts. To be clear, the idea of change within this context will be interpreted from the perspective of the technical and functional differences between celluloid and digital technologies, but always with a view toward the similarities of attitudes in movie production and spectatorship that create bridges of encounters between diverse forms. This will be a matter of exploring the different theoretical setting that the digital creates, but by understanding how the new technology restructures rather than replaces a celluloid culture.

Despite some fearful prophecies made by scholars working in the field of film studies, cinema has not died. At the same time, however, it has

not remained intact. Cinema continues to harbor new possibilities for creativity within the digital world; but digital cinema is not restricted to a further strengthening of verisimilitude in special effects, or cheaper production modes for amateur moviemaking. Indeed, the use of digital technology goes beyond computer effects, design, and editing, or even the substitution of analog devices with digital equipment for recording and projecting movies. On the contrary, the widespread proliferation of personal computers, with their multimedia extensions and their interfaces that function as interactive points of access to information, suggests an important difference at the end of distribution and consumption as well. If one adds to this the Internet, DVD and Blu-ray technologies, digital still and video cameras, and the recent addition of digital projection in cinema theaters, it becomes apparent that a significant transformation has taken place in screen culture in general. Discussing these changes in her essay "The End of Cinema," the media theorist Anne Friedberg asks the pertinent question of whether the computer screen signals not simply a different mode of delivering and viewing movies, but a complete end of cinema specificity in its traditional sense.[5] As she explains, with the addition of interactive computer screens and virtual reality headsets to technologies of projection, the notion of "screen" itself expresses a convergence that cannot be restricted to one type of medium.[6] In the same way, the meaning of "film" as a storage medium becomes a figure of speech referring not only to celluloid, but also to versions of video, digital disks, hard disks, or online databases. And the "spectator," in direct contact with the interfaces of diverse input devices from remote controls, keyboards, mice, and touchpads, to goggles, gloves, and body suits, expresses the much broader term of the "user." What becomes important to understand is that as the notions of "screen," "film," and "spectator" lose their terminological stability, film studies as a discipline is being asked to reinvent itself by addressing the form of its inquiries under the influence of this fluctuating audiovisual culture.

This concern takes on larger dimensions in the work of the film scholar D. N. Rodowick, who has been seminal in providing a vast array of philosophical avenues—most famously that of Deleuzian film theory—for studying the relationship between cinema and continental philosophy, the development of thought in film theory, and the history of film studies in general. His recent book *The Virtual Life of Film* is dedicated to exploring the status of the discipline in the current multimedia environment by turning to an ontological interpretation of celluloid and digital cinema.[7]

Here Rodowick astutely points to the need for film theory to return to the age-old question that has taunted film theorists since the early days of cinema's appearance: *what is cinema?*[8] This is to say that the emergence of digital technologies in cinema practices does not simply invite one to understand how computers function in creating their images, or what kind of images these are, but how this affects a broader awareness of, and approach to, cinema. To be sure, it is with an interest in the value of newness in media archaeologies that I question both the idea of a finite break with the past as well as the nostalgic immobilization of the present. This questioning is a matter of reconfiguring the current debate of new media's newness by deciphering not only what radically new functions the digital enables or what existent processes it repeats, but also what further implications arise from an exploration of technological developments in visual culture. This is precisely the matter to which the subtitle of this book refers, and which I will explore in the pages to come.

## Tracing the "New" in New Media

There is an ongoing debate to clarify the consequences for the way film theory understands its object of exploration, be it an aesthetic, cultural, economic, spectatorial, or other medium-related inquiry.[9] Film scholars have been discussing not only the aesthetic impact of the technological change, but also the extent of its effects—or whether it in fact is inducing something drastically new for film history. This debate is interested in clarifying whether the substitution of photographic equipment by digital alternatives within modes of production, postproduction, distribution, or exhibition drastically affects how cinema creates its works and meanings. As I will discuss, I am interested in emphasizing that digital technology does induce a new setting for creating and experiencing movies, albeit without excluding or eliminating the modes of expression and reception that lead from a celluloid culture. Digital cinema is something new that gives rise to change, but this change is not a cutoff point from *film* history.

This historical dimension of the digital debate was the driving force of one of the most influential studies in the field, presented by the new media scholar and artist Lev Manovich. Indeed, his book *The Language of New Media* is exemplary in identifying the extent of the newness that emerges with new media.[10] While seeking to examine digital technology's originality for an aesthetic appreciation of movies, Manovich challenges

the idea of a historical break in its entirety. By mapping the supposed specificities of new media onto Dziga Vertov's 1929 movie *Man with a Movie Camera*, Manovich maintains that digital technology merely extends the aesthetic proportions already set up by celluloid film, albeit by finally fulfilling the desire for a means of cultural communication in the form of a visual-computational Esperanto.[11] As he reiterates in his later essay "Old Media as New Media," he is intrigued by new media aesthetics, but only to the extent that this is linked to previously established modes of visual culture.[12] For Manovich, cinema's aesthetic language is being poured into a computer, so that in the digital one actually encounters a celluloid culture.

Laura Mulvey—whose scholarship has been formative in establishing and developing psychoanalysis and feminism as methodological modes of inquiry in film studies—turns to the same question of technological newness and reaches similar conclusions. In her book *Death 24x a Second* she explains how the new conveniences DVDs offer in accessing classical cinema and examining movies frame by frame foreground the relationship between motion and stillness inherently latent in film technology.[13] While this phenomenon draws Mulvey's attention to psychoanalytic processes of traumas and desires hidden beneath the surface of appearances, she does come closer to my own concerns by turning her attention to the effects new technology has on modes of spectatorial perception. Nevertheless, for her the technological shift is restricted to a fresh view toward cinematic time, through which one is reminded of the complexities of celluloid rather than digital structures.[14] Peculiarly, cinema is thus discovered in the digital as fundamentally celluloid—an approach that dovetails with Laura Marks's work as well.

Directly influenced by the existential phenomenology of Maurice Merleau-Ponty and Deleuzian philosophy, Marks introduces a novel reading of corporeal visuality in film studies. Extending these concerns to digital cinema and new media works, her essays "Video's Body, Analog and Digital" and "How Electrons Remember" (both published in her edited collection *Touch*) seek to redeem the digital from the purported curse of its virtual status that confines it to the realm of the immaterial. The problem, though, is that they do so by turning to how the digital can express a relation to time in accordance with *photographic* indexicality and entropy.[15] Undoubtedly, Marks is sympathetic toward the historical innovations of the digital, but it seems she constructs this change by

forcing digital structures into celluloid relations by turning to the micro-physics of computer chips. Indeed, Marks's notion of "haptic visuality," which emphasizes the sensorial interpretation of multitextured images and displaces the central position of the eye in cinema's Cartesian ocular culture, pays no attention to media distinctiveness.[16] Similarly, Mark Hansen's own phenomenological approach—founded on the premises of Henri Bergson's writings—repeats this strategy. Working in the broader field of new media and philosophy, Hansen proceeds to negate technological specificities based on the individual's embodied affectivity, through which the image is actually created as either celluloid or digital.[17] For these writers, digital technology does have effects on cinema, but these are positioned in a theoretical approach that ultimately undermines the differences between media through common features and unchanging perceptual experiences. The desire to acknowledge points of interaction between the two technological forms is unquestionably crucial, and a main focus of my study as well. Closer, though, to my own interpretative perspective is the possibility to account for the differences experienced by others working as either scholars or practitioners in the field of digital media.

In other words, for some, the technological transition discussed here is encountered as a forceful rift in visual culture. The experimental artist Malcolm Le Grice—whose work has been seminal in the development of British avant-garde cinema—explores the new possibilities offered by computers in very early stages of the technology's development. His 1974 article "Computer Film as Film Art" focuses on the variability and manipulability of the digital's mathematical encoding.[18] Rather than emphasizing the continuities between celluloid and digital production, Le Grice's experience leads him to speak of the new grounds for artistic exploration that in fact would not have been made possible without computers.[19] In a later article, he develops this argument further by considering the digital's operational functions that create a predetermination for artistic expression.[20] Here Le Grice reveals an important factor of my research into technological change, linking the understanding of newness to an interpretation of medium specificity. I will return to this idea in the following section, but for the time being it is important to see how a practical grasp of a new medium is actually experienced as something new. An experimental movie and installation artist herself, Babette Mangolte also verifies the difference between cinematic technologies as an experience

of the unfamiliar. A beautifully emotional discussion, Mangolte's essay "A Matter of Time" reflects on how a sense of experiential time made palpable in celluloid moviemaking is lost in a digital culture.[21] As opposed to Marks's meditation on the possibility of theorizing a sense of mortality for the digital image, Mangolte asserts that digital images prevent rather than continue the sense of rhythm and transformation in time's passing. Ultimately, she feels that the passion of difference and loss embedded in celluloid's entropic character becomes inconsequential in the digital's functions of reversibility and permanence. What becomes apparent here is that the encounter with the digital experienced in moviemaking cannot be simply equated with, or assimilated into, an analog awareness without some diminution of its own nuances.

In viewing the technological change as a new landscape for communicating with cinematic images, these meditations express a stance that is central to my concern in this book. Several scholars follow suit by turning to what emerges as identifiably distinct in technological difference. One of the most influential cinema and media theorists to promote the coalition of film theory and continental philosophy, Vivian Sobchack introduced the relevance and vast potential of Merleau-Ponty's existential phenomenology for the theorization of film spectatorship. This was the main aim of her book *The Address of the Eye*, in which she begins to explore the important role that technology plays in the ethical activities enabled by the moving image.[22] In her later essay "The Scene of the Screen," Sobchack focuses more specifically on the temporal experiences of photography, celluloid film, and electronic media, through which she outlines the differences between the visual cultures that surround each technology.[23] Change is distinguished in the meanings and values that arise from a mode of existential activity linked with vision's perceptual relation to the various types of images: photography's causality and stillness provide a nostalgic turn to the past; cinema's inclusion of motion produces a sense of constant constitution of being; and the electronic image's overall fragmentation and dispersion yields an absolute fixation in the present. Likewise, in the first systematic critique of digital image construction, William J. Mitchell's book *The Reconfigured Eye* examines the impact of new media techniques on the concept of indexical authenticity.[24] Mitchell explains that the factual guarantee of photography's chemical causality, on which practices of scientific probing and industrial commoditization were built, is irrevocably subverted by digital

images that create complex and varied means of creating and blurring the intentions of representational depictions.[25] In other words, the digital's newness in these approaches is generated on the basis of the technology's functions, but it is outlined in direct opposition to celluloid.[26]

Working in film and media theory, at the crossroads between film philosophy, cultural studies, and media historiography, Thomas Elsaesser attempts to think of new media's impact differently, without disregarding the continuities found in the visual culture that upholds and surrounds the perception of, and interaction with, moving images. For example, his essay "Cinema Futures" points out how technological specificity is challenged by digital audiovisual practices that can in fact continue the ontological and epistemological implications of photographic indexicality.[27] With this in mind, Elsaesser calls for a more cautious approach to cinema's digitization by thinking of media specificity as an archaeology of convergences and divergences that are not driven by technological factors, but by market strategies and demands. On this note, he continues in the essays "Digital Cinema" and "The New New Hollywood" to undermine the indexical consequences of the celluloid image, by turning to a framework of trust induced by the social and cultural conventions and institutional claims practiced during specific periods and in particular areas.[28] Indeed, the film scholar Mary Ann Doane's approach resonates with Elsaesser's reading, as she focuses on the indexical overlaps between photography, film, and the digital by way of institutional and social practices. In an exceedingly comprehensive study of the philosophy of time, the social structures of modernity, and the development of visual culture from still photography to the Internet, Doane's book *The Emergence of Cinematic Time* explores how the powers of indexicality are linked to the unique immediacy involved in "liveness" rather than in technical characteristics.[29] In other words, diverse technologies seem to be homogenized based on the cultural context of their use—an idea echoed in Philip Rosen's *Change Mummified* as well.[30] A leading scholar in the exploration of cinema, modernity, and historiography, Rosen proposes the concept of "digital mimicry" to describe the digital's drive to imitate modes of imagery relevant to celluloid's historical forms. In so doing, he places the image's potential for representation on sociocultural rather than technological specificity.[31]

In other words, this scholarship's sensitivity toward the complexities revealed by a stratigraphic archaeology of history comes close to the sense of media interpretation that interests me as well. Here the technological

base of a visual culture is positioned in a broad framework that undermines a strict classification, and so the newness of new media is unhinged from the predetermination of a technological language: neither excluding it nor simply inscribing it in its functions, the digital replays the functions of a celluloid culture. Yet the theoretical interest of these discussions leaves little room for understanding how the cultural context of a technology also involves an encounter with the technological itself. This is repeated by the film preservationist and media theorist Paolo Cherchi Usai, whose book *The Death of Cinema* focuses on the idea of cinematic mortality and the archival strategies born from the desire to evade it.[32] In a sense, by forging an unbreakable link between cinematic technologies based on the transient nature of cinema, his approach is not too far from that of Marks. For instance, speaking of the physical perishability of film stock, he writes, "As soon as it [the print] is deposited on a matrix, the digital image is subject to a similar destiny; its causes may be different, but the effects are the same."[33] Cinematic decay becomes a constant that repeats a disregard for the effects of technological change. Nevertheless, in its entirety Usai's book brings the concept of continuous change to the fore, showing how cinema has always been subject to entropy, be it physical, technological, or cultural. This observation shifts the terms of the debate significantly by refusing a stable character of origin or distinctness for an ontological grasp of cinema. Rodowick uses these thoughts as the basis for his own discussion of cinema and film studies in light of the emergence of new media.[34] As he explains, the digital is foregrounded as a stem of virtuality intrinsically related to a multiplicity of cinematic formats and theoretical evaluations. In a similar manner, Sean Cubitt—himself a scholar whose work on digital cinema has been extensively detailed and original—thinks through the digital in order to retrace the theoretical and historical elusiveness of the cinematic object.[35] In cinema's constant changeability, Cubitt maintains, the nature of the "cinema effect" is change itself as a special effect. Indeed, digital technology might still be able to create a sense of authenticity and factual discourse as Elsaesser stresses, but how it does so is an important query that triggers my own approach to media specificity. This will be a matter of dealing with the new as not new *or* old but new *and* old, as simultaneously distinct and interactively interrelated, so that each medium acquires a space of its own but where boundaries are in fact always shifting. In the first instance, though, I will examine what is meant by the term "medium," on the basis of which I will lay out the theoretical foundations of this study.

## Configuring the Message of the "Medium": McLuhan to Heidegger

Le Grice's understanding of a medium as a set of predetermined forms that direct the creative and expressive impulses of technological communication coincides with an ancestry of structuralist sociocultural criticism of media. To be sure, Marshall McLuhan's declaration in his book *Understanding Media* that "the medium is the message" is a foundational precursor of this tradition.[36] Although a historical overview of the growth and complex theoretical relations of critical studies is outside the aims of this book, McLuhan's discussion of medium specificity is certainly useful for an examination of technological innovation and its effects. Speaking of the powers of the electric light bulb, he explains that its message—that is, its essential effect that makes it a medium distinct from other media—has nothing to do with the content of its appearances. For instance, in the case of a lit advertisement, the message of the light bulb cannot be the textual content of the brand or the caption. Rather, the message of the light bulb as a technology is information in general, as it is this that the light bulb always makes available. As McLuhan explains, "The 'message' of any medium or technology is the change of scale or pace or pattern that it introduces into human affairs."[37] As such, the notion of the medium is not associated with the diversity of a technology's technical aspects or with the variability of its usage. Instead, a medium for McLuhan is defined as the sociocultural currency that emerges from a technological innovation.

Ultimately, McLuhan's definition means that it makes no difference if electricity brightens the streets of a city, projects film frames on a screen, amplifies the sound waves of a radio, or charges the cathode ray tube, because electricity's social import and cultural space is information. An examination of a medium, in this context, must be informed by the consequences of a homogeneous function of its technological base that uniformly drives the psychic and social conduct related to the medium's modes of communication. Nevertheless, to fuse all cultural impact of a technology in the general rubric of one medium's message need not be the case or the solution. What my focus on technological innovation in cinema intends to show is that an understanding of a medium's functions solely on grounds of its technical base remains insufficient for an evaluation of the broader consequences of mediation. On the contrary, in its mediating capacity a technology is a force of communication that

encounters and interacts with the individual—an understanding closer to Martin Heidegger's appreciation of the essence of technology.

Coming from another background and working in a different field, Heidegger's turn to technology a decade before McLuhan's *Understanding Media* extends not from the technological base of the medium but to the meanings that result from a phenomenological interpretation. In his essay "The Question Concerning Technology" Heidegger argues that what is revealed in a technology is not merely a material substance, a form, a function, or a causal practice.[38] Although these aspects undeniably remain active components of its forms, they do not refer to the essence of technology but to its immediate instrumental components, where "eidos" is interpreted as characteristic appearances. This is why, for Heidegger—as for Sobchack, too, as I will discuss in chapter 2—"the essence of technology is by no means anything technological."[39]

In questioning what a technology involves, Heidegger examines the modes of knowing and interacting with the world that its functions reveal—precisely that on which his phenomenological account is based. A technological medium, thus understood, is circumscribed as a means for defining the world that cannot be restricted to how the medium functions. As Heidegger maintains, the medium reveals a relation to the world as a mode of knowing. Indeed, his interest in the meanings produced in the active encounters of a technological culture turns swiftly from the basic operations of instrumentality to a worldview. Nonetheless, where McLuhan's stream of information is the only message made available by the medium, Heidegger's technology loses all sight of how the instrumentality of a technology takes part in informing an overarching meaningful mode of activity, either by supporting it or resisting it. For Heidegger's phenomenological account, the medium as a mode of knowing and interacting is thus restricted to one all-pervading encounter that is drawn not out of the technology but from the way of acting and thinking that is revealed as it is used in the world.

Rather than focusing on the technology or the pervading system of meaning that informs it, I argue that the potential of cinematic technology's mediating activities can be found somewhere between the instrument and the encounter with the world. In my view, digital cinema's emergence indeed causes a historical and theoretical rupture, but one that entails changing a celluloid culture while sustaining a relation of differentiation and repetition with the latter. This is not a matter of rewriting

the history of film through the computational pane of the digital. Such an approach seems to question or refuse the difference that remains part of media relationships, overlooking how variance and distance can become gestures themselves of change. Rather than merge the one form into the other, the ontological explication of a medium may take account of its specific technological base while simultaneously paying attention to previous technologies that reside in it, intact yet affected by the contextual possibilities of the new. Newness, thus understood, is a complex concurrency of differences and similarities that shift the borders of distinct forms in unexpected and, most importantly, continually renewable ways.

Whereas some critical discourse, as I have suggested, highlights the shortcomings of the digital's novelties, this book draws on the functions of celluloid technology as a medium that is involved in the meanings and effects of the digital. A visual medium is thus understood as "mediation" in the sense of a broad system that includes a conflict and intrusion of preceding formats inside a new technology, as well as the variable shapes that human activity can take in the creation of, and interaction with, movies. Indeed, the inclusion of celluloid structures in digital operations manifests the central role of media convergences that become points of departure and return with new and renewed consequences. For instance, authentic credibility is not associated with the numerical graphic renditions of the digital screen, but with a tradition of photographic causality. Nevertheless, it becomes part of new media's language and makes sense in the encounters that render it a form of mediation. A new medium is thus a portal in time to previous technologies as well as various formations of its own history, and the space of meaning that takes place in the subject's interactive exchange with it. It expresses a mediation as a spatiotemporal point of access to an involvement in creativity that links the individual both to the world and to her- or himself. A medium is thus simultaneously a language of its technical interiority and a passage of interactions where the old (in this case celluloid cinema) is brought in direct contact with the new (the digital) through the variability of a cultural and creative context (i.e., cinema as an institution consisting of the expressive input of moviemakers and viewers alike).

In sum, the ontological focus of this study is drawn from the technical operations of the technological, understood as an inseparable yet not determinate part of the encounters experienced in mediation, which combined set up modes of exchange with the world. This is a matter of implicating media specificity with the qualitative values of change that

arise from technological and human relations. Concerned with the possibilities that the interrelated differences between technologies induce, I turn to Gilles Deleuze's ethics of change, which places an emphasis on the constant variability that arises from the interactive encounter between distinct structures. At the same time, while I extend Deleuze's concerns to the potential of spectatorial involvement in cinema's structures as another point of change inclined toward the world, Deleuze's philosophy of cinema—developed in his two cinema books—becomes a platform from which other theoretical strands emerge or on which they abruptly meet.[40] Rather than apply Deleuzian readings throughout my exploration of celluloid and digital cinema, I aim to join the philosopher's voice with the theoretical and philosophical investigation of a number of scholars based on their common concern with the consequences and potential of mediation. Before moving into the main part of my discussion, however, it will be necessary first to outline the theoretical framework for understanding celluloid's ontological realism on the one hand and for the instrumental functions of digital technology on the other, which together form the initial source of investigation for this book.

## Film Talk: An Overview

### Benjamin's Accidental Photography

The significance of technology for a theoretical interpretation of the moving image is certainly not a new debate. The history of cinema's theorization reveals a variety of polemical studies that center on the question of what makes film *film*. In relation to celluloid's photographic basis, scholarship has sought to understand what association may be made between a photographically created image and the world itself. Walter Benjamin's 1931 essay "A Short History of Photography" is an early example of this tradition, where photography's use of technological equipment for the creation of images becomes a point of concern for art criticism.[41] Examining photographic images, Benjamin points to the accidental elements that convey a sense of reality to the viewer despite the artificiality related to the postures of the photographed people. The photographic camera, he explains, becomes an optical unconscious as it freezes real time and enlarges real space, making possible a view of the world's details previously unexplored.[42] Here, in the direct display of the actual world with technical means, Benjamin traces the destruction of painting's elitist grandeur as a liberation of the image from the distance that art's aura had upheld.

In its direct manifestation of reality, that is, photography achieves the dual role of showing the uniqueness of things in every situation, simultaneously making the world available in its visual reproduction. Indeed, the reproducibility of the photographic image becomes an important aspect of Benjamin's inquiry, as it creates a new perception whereby the exclusive and subsequent authority of the original is undermined by an unprecedented plurality of the work. This idea is developed further in his famous essay "The Work of Art in the Age of Mechanical Reproduction," where the sociopolitical import of his discussion becomes clearer: in its mass reproducibility photography expresses a historical transformation whereby all social groups gain equal access to art, thus making the universal equality of things apparent.[43] In other words, Benjamin's interpretation of photographic technology shows us how the technical functions of photography take on broader cultural implications, as the image gains a direct relation to reality and transforms the mode of accessibility to art.

## Bazin's Realism

Although Benjamin refers to photographic technology's authentic relation to the world, it was André Bazin's work that widely established a realist approach to cinema. In his book *The Major Film Theories*, Dudley Andrew presents two major strands of film theory that developed from the oppositional strategies of Georges Méliès's science fiction movies and the Lumière brothers' factual cinema.[44] Indeed, cinema's ontology was at the center of film criticism since the early writings of Hugo Münsterberg and Rudolf Arnheim, who aimed to distinguish film from the other arts—especially theatre—by disclosing certain features they found essential and specific to film itself. For Münsterberg (writing in the mid-1910s), this was a consequence of film's psychological effect on the mind of the viewer;[45] and for Arnheim (writing in the early 1930s), it was a matter of the difference between the viewer's habitual perception of reality and the creative portrayal of film's recorded and framed *image* of reality.[46] In a similar manner, Sergei Eisenstein's examination revolved around thought and the transformative powers of dialectical relations in montage;[47] and Béla Balázs's theory advanced from the cultural distortions of vision and the creativity generated by industrial civilization.[48] Rivaling the concerns of these theorists to ascribe great importance to cinema based on aesthetic qualities and the signifying powers of the moviemaker, realist theory turned instead to film's intimate relation to the world itself. A key figure

of the realist camp, Bazin laid out the basis of his approach in his seminal essay "The Ontology of the Photographic Image."[49] It is indeed important to note how he develops a metaphysical framework for a critical approach to cinema by turning to celluloid technology's mechanical and indexical rendition of reality. As the functions of photographic indexicality are central to my own study, I will focus on Bazin's ruminations in some detail with a view to establishing the grounds for understanding the existential implications of celluloid images and the position of the spectator within this framework.

Bazin begins to describe his concept of the "mummy complex" as a desire to save life from death by artificially preserving the body.[50] The ancient Egyptian rite of mummification, he explains, serves this purpose by chemically preserving an individual's body and enhances the procedure further by replicating the deceased through images and statuettes. From this, Bazin bases his description of a history of the arts on an obsession with embalming life through its iconic mimesis with the purpose of evading death. While time's irreversible progression inevitably leads to death, art becomes, in this view, a survival stratagem to intercept the flow of time through the substitution of the real body with a likeness. At this point, Bazin notes that the existential link between image and reality in contemporary practices of the plastic arts is in fact made through the psychological preservation of the depicted subject in the invoked memory. He writes, "No one believes any longer in the ontological identity of model and image, but all are agreed that the image helps us to remember the subject and to preserve him from a second spiritual death."[51] One sees, therefore, that the quality of the mummy complex, its ability to stimulate life, gains momentum in a phenomenological evaluation of the image: its existential guarantee is derived from the implication of a viewing subject who assigns meaning to it based on her or his living experiences.

This correlation between subject and the meaning ascribed to the image gains a new perspective with the advent of photography, which significantly alters the relation. As Bazin maintains, photography creates a dramatic shift in the history of the arts because it finally satisfies the desire for reproduction of life in an image not simply accurate but as real as life itself. Of course, in his interest in photography's authentic presentation of reality, Bazin overlooks the importance of painting in photography's history (e.g., photographic technology's relation with the camera obscura, as well as the associations of early photography with characteristics of painting like long exposure times and retouching).[52] In other

words, in the linear structure of his teleological history, Bazin loses sight of the limits he himself places on his vision. Nevertheless, his attention to the unique relation of the image to its source, based on its means of production, is undeniably significant for the establishment of a realist approach to cinema. As he explains, the originality of the photographic image lies in the fact that, unlike other forms of reproduction, it retains a photochemical link to the real that resembles the physical connection maintained between a finger and its manifestation in a fingerprint. The photographic image does not simply look like reality, it is perceived as a fact of life in itself. Not simply being drawn from the image's resemblance with its source, the photograph's factual impression is based on the automatic mechanization of photographic technology and the indexical quality of photochemical celluloid substrates. As Bazin writes, "For the first time, between the originating object and its reproduction there intervenes only the instrumentality of a nonliving agent. For the first time an image of the world is formed automatically, without the creative intervention of man."[53] In other words, due to its mechanical and chemical foundation, which essentially removes the subject from the procedures of representation, the photographic apparatus is endowed with the ability to create an *objective* image.

It is clear, for Bazin, that the mummy complex is satisfied in the photographic medium because, while minimizing the participation of a subjective intervention through technological automaticity, it acquires the ability to create images that are linked to reality through indexical causality. Bazin uses the notion of indexicality based on Charles Sanders Peirce's framework of semiotics. Although I will return to Peirce's understanding of indexicality in more detail in chapter 1, it is important to note at this point the causal function that characterizes the "index." Peirce's semiotics is based on three categories of signs of which the index bears proof of an event having happened because it is directly produced by it. In the creation of the index, that is, there is a physical bond between the sign and its cause of creation, so that the index testifies to the existence of its source. The photograph is such an example because its image is a direct chemical transcription of a source's luminous reflections. The photographic image is thus not perceived as a copy of space in a past moment, but is experienced as an imprint of that spatiotemporal segment through which a past instant of reality—a snapshot of time and space—reemerges at another time.[54]

Further, based on indexical causality, Bazin proceeds to discuss the photographic image in terms of an ontological transference. Not just

representing the model, Bazin sees the photograph as being that same model because it maintains the objective connection with it. As photography releases the subject from the limits of time and space that govern and determine it, the technology gains an authority of objectivity to which the other arts could not cater. Wrapped in its indicative nature and mechanical origin, the photographic image bestows for the perceiver that which has actually happened, what actually took place in a past moment. Further, as photography retraces a past moment as an imprint, its objective nature gains momentum as a sign of truthfulness—granted, of course, that there are no signs of interference (a matter, once again, to which I shall return in chapter 1).

Certainly the counterargument is that photographic images are also subject to the personal project of the photographer or moviemaker—indeed, this was acknowledged explicitly by the deliberate inclusion of the camera or moviemakers in the cinema verité practices of the 1960s. Bazin does not avoid this issue but insists that, even though the personality of the photographer may shape the image by selection and intention, it does not have the same effect as it did in the plastic arts.[55] The reason is indeed important for the understanding of reality's position in the debate on cinematic technologies: however much the subject remains present in the construction of the image, photographic causality is a testimony of reality's existence in time's past.

In all certainty, Bazin is not alone in the history of film theory in his understanding of the consequences of an indexical technology. For instance, in his book *Nature of Film,* Siegfried Kracauer describes the primary function of cinema as the recording and revealing of the physical world.[56] Nevertheless, contrary to these readings, Christian Metz focuses on the involvement of the viewer's imagination that is triggered by the absence expressed in the image as a fictive construction, as an unreal appearance of the world, and as a reflection that does not contain the viewer.[57] Jean-Louis Baudry similarly pays attention to the psychological effects of cinema, but instead links the cinematic apparatus with the dominant ideology to which the spectator, unaware, is subjected.[58] Further, as the image is always a perception, Baudry insists that it cannot reproduce reality because it is a subjective construction.[59] In contrast, while Jean-Louis Comolli also addresses the spectator as an ideological and social subject, he sees her or him to be of equal importance in the construction of the image as its analogical connection to reality.[60] To return to Bazin, it is not that he is unaware of the moviemaker and viewer's intervention in

the image; rather, the importance of his theoretical investigation is that it approaches a sense of reality precisely with a view toward the implication of the subject in its conception. It remains to be seen, though, how the authenticity of photographic images can be challenged on grounds other than subjective intervention and ideology—a matter that becomes the focus of chapter 1. For the moment, I will continue with Bazin's contemplations on ontological realism in celluloid film, in which the importance of the viewer's involvement is emphasized further.

Although photographic objectivity satisfies the mummy complex, Bazin stresses that it does so partially because the still photographic image embalms an instant and not the full force of time. Rather, it is the cinematograph that extends this objectivity in time's momentum by adding motion to the process—the basis on which Bazin coins the phrase "change mummified."[61] While linking the image with the world as it evolves, celluloid film is unique in its proximity to reality. Initially freed from the constant threat of disappearance by photography's instantaneous transcriptions, the moving image of reality now exists more solidly as a duration. In fact, in his essay "The Evolution of the Language of Cinema," Bazin conceives of an aesthetics of cinema that stays true to celluloid technology's direct association with the world.[62] In so doing, he recounts the history of cinema based on the strategies that add external motives to cinematic realism, or which remain faithful to it. On the one hand, there are those movies that emphasize the plastics of the image (i.e., the "mise-en-scène"), as well as those that create their fiction or meanings through editing techniques. On the other hand, however, there are the movies whose aesthetic construction allows reality to be presented intact. Ultimately, Bazin's judgment of cinematic realism links movie form with the existential ontologies of photographic and filmic operations: recording in long takes and deep focus reveals reality in its temporal and spatial continuity. In the first instance, the long take permits the unfolding of time in its natural state of passing, without being subject to the scissors of the editor. In so doing, it corresponds to the indexical nature of photographic media by respecting the real duration of events and thus conveying time objectively. Similarly, deep focus permits the materialization of space in its unimpeded depth without being deformed by the lens of the photographer. It, too, is a form of filming that corresponds to photography's integral realism by respecting the structure of the world and thus conveying space objectively.

It is important to stress, though, that Bazin's realist project is deeply concerned with reality not in the sense of a fixed precondition for life, but as an unpredictable evolution of existence. In both the long take and deep focus, reality is revealed because it has the time and space to appear casually in arbitrary occurrences. What is at stake in the subjective distortion of the filmic image through design, editing techniques, or camera settings is this connection of the spectator with the everyday unpredictability of living. Indeed, as I will show in the following section, digital technology makes this relation much more difficult as it substitutes indexicality with mathematical symbolization and exceptionally increases the means and effects of manipulation. The sense of reality in celluloid film, on the other hand, is based on a combination of the causality embedded in the technology, the perceptual involvement of the spectator, and an understanding of reality as essentially unfixed.[63] It is from this point of view that Bazin suggests in his essay "The Virtues and Limitations of Montage" that cinematic realism is a matter of believing in the reality of the image while simultaneously knowing it has been manipulated.[64] Similarly, in the essay "An Aesthetic of Reality," he turns to the style of the Italian postwar cinema, where he discovers the "image fact" as a direct point of access for the spectator into reality's arbitrariness.[65] Besides the newsreel style of these Italian movies, and their use of long takes and deep focus, Bazin discusses their use of elliptical editing to reduce a complex development of the action into a few fragments. In this editing style, each shot becomes a detail or a piece of information that exists independently, just as it does in life. In viewing their loose linkages, the viewer must turn to her- or himself in order to imagine and deduce meaning. As such, the fragment of concrete reality is thus multiplied in meaning and its ambivalence emphasized. Here reality is not controlled by the indexical function of light imprints, but is born from the relation these imprints share with the viewer.

Ultimately, Bazin sets up an interesting framework according to which the causal nature of photographic and celluloid technologies gain perspective based on reality's unregulated progression and the viewer's perceptual experience of the image. What the long take, depth of focus, and "image fact" allow is a direct sense of the spectator's involvement in the creation of meaning. It is not that the image is closer to reality just because it looks like reality. Resemblance is obviously not reason enough for Bazin. On the contrary, it is necessary for celluloid to reveal its causal link

to the real by reassuring its own impartiality as a mechanical and chemical construction and involving the spectator's mental activity through the unpredictable extension of the image. One sees, therefore, that the ontology of cinema in Bazin's interpretation takes on meaning in a perceptual involvement that makes the spectator aware of the entropic character of living. On this point Bazin is actually quite close to the affective phenomenology of Roland Barthes's work, which, while focusing strictly on the indexical potential of still rather than moving images, makes the entropy of reality the main point of the debate. Whereas Bazin led my discussion through the implications of reality and the spectator in the indexical functions of photographic and celluloid media, I will now turn to Barthes's work in order to gain further perspective on the spectatorial involvement in reality's contingency.

## The Barthesian Punctum as Testament

Like Bazin, Barthes's attention is drawn to the potential of photography's causal structure. In his book *Camera Lucida,* Barthes describes the photograph as a pointer to a reality that existed at one specific moment in time, making present what had taken place at another time—an image of "that-has-been."[66] It is evidence of a real existence to the point where the real and its image cannot be separated, so that when looking at a photograph, the viewer is not looking at a photograph of someone, but is looking straight at that someone. Barthes writes, "The Photograph belongs to that class of laminated objects whose two leaves cannot be separated without destroying them both."[67] It is, as he describes, a sort of stubbornness on behalf of the referent, a matter that ends up being the very core of his experience with photography. If a photograph is an image created by the chemical reaction of physical matter through the function of a mechanical apparatus, then what one sees in it is a reality stuck in time on paper—not the imprinted paper, but the imprint itself. As in Bazin's interpretation, therefore, the power of the photographic medium for Barthes is a matter of temporal extension: what took place then can be directly seen at another time. Nevertheless, instead of leading to a metaphysical revival, the uniqueness of reality that the index reveals is unrepeatable. In other words, the photograph represents an actual event that took place in the past as an assurance of that reality, but from the temporal distance of the viewer's perception. In his book *The World Viewed,*[68] Stanley Cavell follows the same understanding of cinema's ontological powers, whereby reality

is revealed as an actuality that is spatially concurrent within the settings of projection, but temporally at a distance.[69] Whereas for Cavell the consequences of this distance are somewhat appeased by the assurance of a reality existing despite the viewer's isolation from it, for Barthes the temporal singularity of the event leads him to the horrendous inevitability of time—that is, to death.

Although convincingly tied to the mechanical and causal function of photography, Barthes's insistence on mortality in the image in *Camera Lucida* is evidently affected by his emotional involvement with his mother's death at the time. In fact, death seems to surround his formulations regarding the photographed object or person, which he names "spectrum," inspired by the connotations of ghost and eidolon in the word "spectre."[70] For Barthes, this consequence has to do with the act itself of posing: as the person prepares to be photographed, she or he is affected by the objectivity of the photograph and so becomes transfixed accordingly. From here, Barthes continues to examine the emotion induced in the spectator by the photograph and concludes that what is felt is a time indeed existent, albeit lost forever. Nevertheless, while I am sympathetic toward Barthes's own emotional involvement in the events surrounding *Camera Lucida,* I am more interested in the means by which the temporal axis of indexical causality becomes for the spectator a direct point of access to the unfixed nature of reality itself.

Barthes's notions of the "studium" and the "punctum" present the complex relationship between teleological intention and the openness of unpredictability that photographic technology enables.[71] What is at stake in this duality is the potential of photography's causal nature to implicate the viewer. Barthes is clearly interested in this relation throughout the book, and it becomes evident early on when he claims that a study of photography cannot remain an impartial scientific examination, but can only be "a science of the subject."[72] The act of looking at a photograph is linked to a matter of personal taste—it involves liking and disliking, experiencing the image as desirable or detestable. Nevertheless, this evaluation does not explain why some photographs excite a personal response and others do not. Thus he goes on to distinguish between images that are aligned with the studium and those that are characterized by the punctum. On the one hand, the studium involves a body of information that is predestined in the image, unifying it into a self-contained whole. It is a product of a certain cultural training whereby the viewer effortlessly recognizes the ideological meaning inscribed in the image by its

creator. Here the force of the photographic index—its causal place in reality—is subordinated to the imposed social strategies of the studium; thus the "that-has-been" of the image is experienced with indifference. Conversely, the punctum is a point in the image that disturbs the ideological equilibrium of the studium altogether.

It is important to note that Barthes approaches the dual nature of the meaning of photographic media in essays written some time before *Camera Lucida.* In "The Photographic Message," he speaks of this photographic duality with reference to the "connoted" and the "denoted" message.[73] Like the studium, the connoted message is the supplementary meaning of the image, the cultural or social code that determines its perception. The denoted message, on the other hand, is the analogical relation it bears with reality, the representational link to the real that makes it a photographic transcription of physical proportions. The paradox is that the photographic message always contains both the connoted and the denoted. But the issue of its denotative quality becomes noticeable when it is traumatic, when the symbolic system of language is suspended by the affective potency of trauma.[74] Here, meaning as predetermination is arrested by a sign of meaninglessness—what Barthes calls the obtuse meaning of the photographic in his essay "The Third Meaning."[75]

Such is the power of the punctum: while disturbing the unity of the studium, it becomes a sensitive point, a wound that accentuates the element of contingency that the determinate patterns of the studium subordinated. The punctum is that simple object or event to which the camera necessarily bears witness, the chance occurrence that expresses the contingency of reality; and by suspending meaning, it draws the spectator into the photograph, making her or him part of the construction of meaning rather than its passive receiver. It is at this point that the viewer gains a strong existential connection with the perceived image. As language fails to offer a framework for perception, it is overtaken by the attentive reflection triggered by the punctum's disturbance, and the memories, desires, and fears that accompany it. The causal function of celluloid technology elicits a simultaneous involvement of the spectator in the piece of reality made visually present and, by extension, to the world to which she or he belongs as well.

The unique quality of indexicality for both Bazin and Barthes is not simply its ability to reveal the world, but also its ability to implicate the viewer in her or his perception of the photographed or filmed world. Indeed, reality is always part of celluloid film because the image bears

the physical traces of luminous reflections, or in the case of cameraless movies it is a direct trace of objects having been positioned onto or used to engrave the filmstrip. Celluloid film maintains this direct imprint of a past occurrence that took place, causing the image to materialize. Moreover, while it reveals this connection to the world, celluloid film is an "image fact" in Bazin's terms, or a "punctum" of "that-has-been" in Barthes's terms. Nevertheless, it is crucial to note in both discussions that this link to the real is sustained not only on the part of the image, but also through the involvement of the viewer. It is on the side of the individual's vision that the image can be felt as a reality. Ultimately, the objective fixity of indexicality's guarantee gains a new perspective linked to the necessary flexibility that accompanies the perceptual and emotional activity of the viewer. In the aesthetic choices of deep focus, long takes, and the fragmentary editing of the "image fact," the objective reality of the image is extended by the viewer's mental wandering or pursuit to make sense of irrationality. Similarly, in the indecipherable message of the "punctum" and the emotional grasp of the accidental occurrence, the image is carried into a personal wandering of memories and feelings. In both cases, the technological aspect of cinema becomes the platform onto which the image gains the dual role of revealing a passage to reality and of involving the spectator in this potential. What is necessary for this relation to take place is the presentation of reality as unpredictable, as untamed by reason, as the ambiguity of the chance occurrence. From Bazin's ontological realism and Barthes's accidental occurrences, I will now turn to Deleuze, whose philosophical investigation of cinema becomes a scrupulous study of movies and the ethical potentials of spectatorial awareness. My interest in the French philosopher's work lies in the importance he places on the irrationality that is generated from specific constructions of the image, which reintroduce the potential of cinema's self-movement to induce thought and reestablish a connection to the world.

## Connecting Images to Reality: Deleuze and Thought

Deleuze's study of cinema looks at the potential powers latent in falsifying phenomena through which he creates an image of thought founded on the unthought as a means of generating a creative awareness of life. He conceives of a history of cinema split into two large segments, each expressing a certain way of thinking. In the first case, he turns to the

earlier decades of cinema leading up to World War II and the few examples of a different approach to meaning by moviemakers like Orson Welles and Alfred Hitchcock. During this first period he speaks of cinema in terms of the "movement-image," where change is expressed in terms of motion, as bodily displacement and progressive narrative development. Change is achieved here as a result of exterior forces affecting a situation and a person who must react in order to achieve a solution to a problem that arises. As a result, the movement-image creates a self-contained narrative world within a teleological perspective. The turn to different modes of narration and construction after the war, Deleuze maintains, expresses quite a different attitude toward change: no longer predetermined in a set framework, change is now expressed as incalculable force. This is a cinema of the "time-image" where displacement is no longer situated in a physical or emotional advancement, but is made prominent as a matter of creation that directly implicates an awareness of personal thought, memory, and response.

In the time-image, the movie's world is depicted as a dislocation of meaning through a gap in the unity of the shot itself, in the shot's relation to the preceding and subsequent shots, and to the overall equilibrium of the entire movie. Deleuze speaks of this gap as an interval that first appears in the desolate images of Europe's ruined cities, where bodily movement becomes an inconsequential wandering of the characters. These empty spaces, what he terms "any-space-whatever," gain larger consequences when irrational cuts leave shots drifting unhinged from the plot, emphasizing their quality as purely optical or sonic images (what he calls "opsigns" and "sonsigns").[76] Thus disequilibrium becomes the basic effect of the movie.

In other words, cinematic meaning in Deleuze's study turns to forms of change and their potential for spectatorial involvement in each case. In the "movement-image" the significance of change is reduced to logical motion that comes to an end, a telos, in the movie's resolution. Quite differently, in the "time-image" change is problematized in the limitations applied to rational thought by the aberrancy expressed in the image. It is here that the spectator is brought into the depiction as a necessary component: the ambiguity that the time-image expresses induces a desire to find meaning in the image. But meaning cannot be found there. The necessity to think caused by the image reflects back on the spectator, who thus gains an awareness of the activity of thinking.

Thought as a process of creation induced by meaninglessness is the basis of Deleuze's project in his two books on cinema. Although the French philosopher does not emphasize a dependence on the technological aspects of movies, he explicitly turns to the instrumental novelty of film technology in the chapter "Thought and Cinema" in *Cinema 2*.[77] Here he locates the power of celluloid film in its ability to create images of automatic movement, making movement the direct reality of the image (an idea that resonates with Metz's own approach to the image's self-motion that triggers a reality effect).[78] In so doing, the moving image causes an immediate shock, of which the other arts could only abstractly or figuratively speak. He writes, "It is only when movement becomes automatic that the artistic essence of the image is realized: *producing a shock to thought, communicating vibrations to the cortex, touching the nervous and cerebral system directly.*"[79] As the moving image creates automatic movement, it brings forth a "spiritual automaton" in the viewer, an automatic response of subjective thinking aligned with the automaticity of the image. To think is an intrinsic potential of the subject, but it becomes an active power that arises from the shock of the moving image.[80] However, as Deleuze realizes, this potential does not necessarily materialize in all cases. On the contrary, the movement-image succumbs to a weakness to trigger an approach to thought as a conveyance of models of truth. Thought, in this case, is contained in a calculated manner leading to an overall unity—that is, to a sublime higher singularity. However, by fragmenting this ideal of a universal whole, the time-image turns thinking back to thought, commenting on what has not been thought of yet, on the impossibility of fixed universal truths, and on the potential power of bringing thought back into the relation between individual and world.

To be clear, it is Deleuze's emphasis on the potential for thought from the ambiguities of the time-image that interests me. While Deleuze does not turn to the causal structure of celluloid, his examination stresses the ability of movies to elicit an awareness of thinking through which the viewer gains a link back to the world. Reality is at the heart of the matter as a reconnection with the activity of thinking that has the potential for becoming involved in the world. Indeed, this potential of involvement through thought arises from the point of reality's unpredictability and indeterminacy. Thought in the movement-image is a process that derives from a predetermined, prearranged structure. It restricts reality within boundaries of order and aims—a calculated studium. In this structure, movies become

at times nothing more than entertainment and propaganda that appease thought by directing it toward resolutions and fixed values.

In contrast, the time-image, like the punctum, pierces this schema and reveals thought as a force of creative potential. In the elliptical structures of the any-space-whatever, and of opsigns and sonsigns, the successive flow of action is woven into diverse paths of time structures. The functionality of the movement-image surrenders to the incongruity of nonchronological temporalities. Here the past is found in its entirety contracted within the present as virtual sheets that the mind actualizes at another time through remembrance. Similarly, the present is virtualized as it is opened up to incorporate incompatible potentials that thought condenses into simultaneous differences: what could happen and what did happen in an event reflect on that event as it is happening.[81] Thus past, present, and future are placed in an interactive relation with one another. Nevertheless, reality cannot be separated in either past or present because its present development reflects on both what has passed and what it is directed toward. Temporalities are thus further implicated as concurrent forces of a desire toward change.[82]

Nevertheless, it becomes important to question this relationship between "movement-image" and "time-image" further when the technological base of movies is disrupted. Indeed, how can one imagine a setting for incalculability when the fixed predetermination of the binary system lies beneath each image? This question will guide my discussion throughout the book. Before moving further in the description of the basic functions and questions of the digital, it is necessary to establish an understanding of the spectator that does not involve only the ability to think but the ability to feel as well.

## Sensing Bodies: Sobchack

The sensual involvement of the viewer was already suggested in the traumatic sensation of Barthes's punctum. While Barthes kept his own work restricted to the powers of the still image, Sobchack's reformulation of Maurice Merleau-Ponty's existential phenomenology focuses on the corporeal participation of the viewer.[83] As she describes in her polemical book *The Address of the Eye*, her aim is to interpret the signifying and meaningful origins of vision based on the perceiving body. She does so by turning to the phenomenological notion of intentionality, where consciousness is structured as a dynamically intra- and interdependent set of relations.

The activity of vision is directly informed by all the bodily senses, through which a relation is established with the object of view. Distinct structures of subjectivity and objectivity are sustained as both elements express this interior self; but in reflecting on the world and its events, their own interiority is brought into the experienced relations. In other words, the independence of structures is entangled with the interaction that perceptual experience entails so that meaning is neither simply subjective nor simply objective.

Spectatorship, as Sobchack maintains, is thus an act of perception that incorporates the body of the viewer and the viewed "body" of the screen in their modes of perception and expression. This is why meaning in cinema is created by the interaction of the viewer with the image and by her or his understanding of what the screen expresses in interacting with the world it records. From this point of view, the spectator can be seen as a body that experiences the image not only through mental recollection and desire but also through sensual memory and emotion. My purpose of bringing the bodily aspect of the spectator into the debate here is to foreground the meaningful position of the viewer in reality: while the subject retains this interactive relationship with the world, its actions reflect directly on both itself and reality. Here is where Sobchack's own desire meets with Deleuze's: they both want to reconnect the viewer with the world on the basis of an awareness of her or his position within it, albeit with a different approach. For Deleuze, the reestablishment of the individual in the world can be achieved only by the complete dismissal of discrete stages or hierarchical structures implied in the enduring becoming of change. For Sobchack, though, the individual's existential union with the world takes place in the sensual involvement of her or his body's dynamic interaction with reality. Perception in this schema is not a pure means of experiencing the world through the body as if we were cut off from mind and culture. It is, on the contrary, already informed by the sensible intentionality of the living being that is setting itself within a dialectical and dialogical relation to the world. The address of the eye, for Sobchack, is the very place of the individual whose perception is directed intentionally toward the world of the movie. In the same way, the moving image is perceived as another body that intentionally addresses itself toward the "body" of the world.

To be sure, Sobchack is not initially attentive to the implications that may arise from the technological basis of cinema—that is, from the internal organs of the cinematic "body." As she writes, "A film is an act of

seeing that makes itself seen, an act of hearing that makes itself heard, an act of physical and reflective movement that makes itself reflexively felt and understood."[84] While emphasizing the interrelation between subject and object in their reflexive and expressive modes, she disallows an interaction with the technological materiality of movies, as if this were erased in projection, or as if it made no difference if what one was seeing was a projection of light through film or by a computer. The image, for Sobchack, is neither an indexical sign nor a symbolic number; it is simply a mode of seeing and expressing. Although there is much to be learned from her focus on the sensual involvement of the body, however, it should still be possible to interpret cinema's technological transition as a meaningful change as well. Rather than eliminate the difference between technologies in a way akin to Deleuze's or Sobchack's theories, I am more interested in examining how the instrumental base of the image makes itself a necessary part of perception and a necessary meaning of distinction. At the same time, though, this is a matter of seeing how perceptual involvement and creative functions can blend into modes of change understood, through Deleuze, as a quality. Neither eliminating differences nor keeping them fixed, I will explore the impact of technological specificity while simultaneously focusing on the exchanges that take place between technologies that blur but do not disable differences. On this note, I will now examine how digital technology shapes its images differently from celluloid film, to establish the questions that the following chapters will address.

### http://www.whatisthematrix.com/or=how-to-define-the%DIGITAL

In Andy and Larry Wachowski's 1999 blockbuster *The Matrix*, Keanu Reeves's character, Neo, is on a quest to discover what the matrix is. During this quest, he is approached by a group of people who explain that the matrix is a computational reality that has taken over human reality. Although the question posed by *The Matrix* was undeniably successful for the promotion of the movie, creating a sense of mystery and intensity, it might be more useful to paraphrase the question for the purposes of my current exploration of digital cinema. Instead of asking what the digital image is, one could initially ask: What does the digital do differently from celluloid cinema? With this in mind, this final section of the introduction will address the differences between celluloid and digital

operations in order to set the basis for an interpretation and evaluation of the technological change in the chapters to follow.

As I have been discussing, celluloid cinema is an indexical technology based on a semiotic interpretation of representation that sees the connection between source and image as causal. Celluloid photographic processes result in the formation of the image sign through chemical reactions caused directly by the rays of light that are reflected off a source at the past time of the filmstrip's exposure. This indexical relationship between source and image extends into an ontological interpretation and understanding of the medium. In his book *Moving Image Technology*, the film scholar Leo Enticknap offers a comprehensive overview of cinema's technical history, through which he describes how analog technologies work. He writes, "An easy way to imagine how analogue recording works is to think of it as an analogy: images and sounds are represented, or analogised, as continuously variable physical quantities which can be read and written by a machine which converts them to and from visible images and audible sounds."[85] A direct quantity of the original source is materially represented on the base and then reproduced in projection. In the case of celluloid film, the pattern of silver halides is continuously analogous to the pattern of light that existed at the time and space of exposure. Similarly, in the case of magnetic analog sound, the pattern of magnetized iron oxide on the tape is continuously analogous to the changes in air pressure at the time and space of the recording. Or with analog video, the changes in light values are stored as continuous changes in voltage values on the magnetic tape. In these cases, the intimate link between representation and its origin stems from the material intensities of the source and their direct impact on the recording material.

Yet digital equipment introduces different operations that change previous understandings of analog procedures: it operates with discontinuity and transformation rather than continuity and transcription. In other words, a computer hard drive attached with optical lenses does not inscribe a continuous process of change but converts this change into information represented abstractly in the form of binary numbers. The process is one of interrupting the flow of change and the causal proximity of an event to its representation by translating the latter into a set of symbolic codes that must also be converted back into an analog signal by a computer to be perceptible. Thus the image cannot be tied down to

a material base as it is a configuration of data, nor can it be tracked back to its cause without difficulty because the direct relation is not upheld in codification. Speaking, that is, from a clearly technical basis, celluloid cinema *is a photochemical means of recording and projecting images that are both analogous to the material relations of the original source and are transcribed directly as material traces onto the filmstrip.* Digital cinema, on the other hand, *is a means of registering images as binary relations and algorithmic calculations, which are rendered in graphically visual images by a computer to be humanly perceptible.* It is in this sense that one can term digital images more accurately "digitographic."

Numerical representation is indeed what changes the cinematic image when it becomes digital. As Manovich explains, digitization entails two steps.[86] The first step is "sampling," whereby continuous quantities are turned into discrete units of data according to a preformatted, regular grid of pixels. "Quantization" then follows, according to which each of these samples are assigned a numerical value drawn from a defined range based on the type of the image (e.g., if it is a grayscale or an RGB color image). As such, the continuities of both space and time are disrupted: space takes the form of separate, discrete, self-contained units (pixels), and time as causal relations in the past is replaced by computational correspondences that are configured in the present. In becoming a grid of elements stored as numerical values, the world's reflections take on the usefulness of any piece of information on a computer: they are easily stored and directly accessible and are continuously open to alterations with the help of computer software. Digitization thus entails an unprecedented fragmentation of the moving image due to this unique event introduced by numerical conversion.

Of course, one could argue—as Manovich does—that photographic and cinematographic processes also break up reality's continuity into discrete fragments. With photography, this discontinuity is measured by the stillness of the image, as well as the grains of the silver halides that become visible when the image is magnified. In the case of celluloid film, this fragmentation is applied further to the continuity of time because change in movement and duration is recorded and re-created as twenty-four frames per second. In both cases, though, the continuity–discontinuity dichotomy is more complex than Manovich presents it to be. Mitchell's approach is quite useful here. In describing the difference between analog and digital media, he uses two metaphors: continuously rolling down a ramp in the case of analog representations, and walking down steps in a sequence

of discrete movements in the case of digital representations.[87] What this means is that the number of digital steps can be counted, as opposed to the analog levels of a ramp. In the case of the photographic image, in other words, the grains might be identifiable as such, but they are glued together as a continuous material substance that reacts en masse and concurrently with the recorded source. Moreover, with celluloid, the rotation of the projecting apparatus repeats the rotation of the recording mechanism whose motion is concurrent with the physical movement of reality. Motion is thus physically present in the recording equipment and physically reenacted analogically in projection. The rhythmic rotations of the technology bear a direct relation to the physical events recorded, and the analogous motion of the projector manifests this relation through repetition. And if one thinks of the continuous physical degradation celluloid substances endure, time as continuous change never ceases in general.

In contrast, digital technology makes discontinuity a necessary process and also a favored function. Whereas the relation between continuity and discontinuity is intricately complicated in analog and indexical media, the digital favors absolute discreteness and complete transformation. As an image is digitized, it is codified entirely into numerical relations so that its original source becomes materially insignificant. This means that the only difference between a digital image of a landscape captured from reality (i.e., a raster image) and a digital image of a landscape generated on a computer (i.e., a vector image) rests in a difference in sets of numbers. The discontinuity can be further illustrated in the modular structure of a digital object. Manovich explains: "Media elements . . . are represented as collections of discrete samples (pixels, polygons, voxels, characters, scripts). These elements are assembled into larger-scale objects but continue to maintain their separate identities."[88] The benefit of this discreteness is that digital images are widely open to manipulation at a microscopic level. Every element remains independent from the whole structure and can be addressed individually without any direct consequence to its surroundings. Therefore, as digital constructions are constituted by isolated elements all the way down to the level of the text character, the image's relation to reality and its complex interdependent associations are displaced significantly.

As a result of this numerical representation and integral fragmentation, digital technology makes possible two functions that present an important difference in special effects and editing: digital compositing and CGI. In the case of compositing, the computer enables the formation

of an image by the seamless amalgamation of disparate layers or elements. In this process, an editor can combine anything from two separate landscapes to two people who have never really met face-to-face. Although resembling techniques of double exposures in film cameras or matte composites with optical or contact printers, the digital introduces an unprecedented precision in the application of its techniques. Essentially, this means that what is represented as an instance of reality might never be so, and the artificiality might not be decipherable. Here, worlds are created that do not necessarily correspond to any specific place.[89]

In fact, with CGI the consequences of this artifice for an existential guarantee of reality are further complicated: what is drawn on the computer never existed as anything else but numerical values in a hard drive. Indexicality is thus erased because there is not only a shift of a causal link to reality, but there is no reality to speak of besides what rests in the electronic configurations that translate binary codes into visible forms. Indeed, one can think of causality with reference to the electronic particles that take part in the electric pulses of the computer. Marks points to this matter in her essay "How Electrons Remember," in which she claims that the computer's electronic waves induce a sense of indexicality at a microscopic level.[90] Intriguing as her analysis may be, it does not take into account an important relation that indexicality covers: the direct link between temporalities expressed through a physical change. What changes in the digital is not a qualitative transformation in the sense of an organic metamorphosis, but a reversible and continually repeatable transfiguration. Moreover, what might change at the microcosm of electrons remains insignificant for the spectator because it cannot be perceived as such. Whatever potential for causality might be left to the confines of the hard drive, it is undoubtedly overshadowed by the defining intrusion of the creator who gains complete control and becomes the overtly empowered element of digitographic relations.

All this means that as the digital breaks the image's direct link to reality, it favors more and more the manipulative control of the subject, as both creator and spectator. Sobchack turns to the controlling powers of the subject and the idealism that leads from this in her essay "Scary Women."[91] Here she focuses on digital morphing whereby something or someone gradually transforms from one form to another uninterruptedly. In so doing, the material and sensual relations of bodies are replaced by a glamorous and spectacular mutation. Instead of maintaining a

position in the world, the body loses its boundaries and any connection to space and time; it floats in thin air as moving patterns of color and light. Sobchack points out that this perfect transformative power of the body's image speaks for an ideology of an essential excellence, where difference is deemed a fault that can be magically rectified. At the same time, the pain, cost, and labor of transformation—that is, the spiritual and physical effort of change at either a personal or a societal level—is not disclosed or given any significance in the morph. Thus the body, its position in the world, and the accomplishment of change do not matter: they lose both their materiality and their gravity. Under this extremely extroverted surface, time becomes invisible because any mutation can be rapid, reversible, and age defying. And existence is presented as immaterially effortless and painless. In other words, the variability, incalculability, and material causality of entropy are effaced under a compulsion for a pure spectacle, for an ideal image. This is where the digital functions as a means to control, and an activity directed by perfection where nothing really *matters*.

At the same time, though, the fragmentation and codification of numerical representation enables the operations of random access memory (RAM). It is here that an examination of digital images' immaterial status takes a new direction. No longer is it necessary to adhere to a specific sequence or hierarchy; elements can be stored, accessed, and organized in any imaginable way. Of course, this arbitrariness is founded on the fact that these elements are not physical objects. Nevertheless, in being accessed they engage with corporeal existences: the creator and the spectator who becomes now a potential user. Indeed, with the interactive functions of digital media, the distance of the image gains a new kind of proximity, albeit one that necessarily takes place via a human–computer interface. It remains necessary, nonetheless, to pay attention to the specific forms of interactivity, to decipher what this interaction entails, how it creates its meanings, and how dynamic it really is or can be.

Speaking of this need for vigilance, the media theorist Klaus Bruhn Jensen demonstrates how a singular understanding of interactivity is a problem because the operation appears in different guises and with different implications.[92] He outlines three types of interactivity, which each has a distinct role while retaining an interrelation with the other types. In the first case, Jensen refers to the medium–user relation of communication, where an exchange takes place between the user's actions and

the paths permitted by the system's predetermined configuration (e.g., the setup experienced when playing computer games). In the second instance, he speaks of the medium–society relation, according to which the medium becomes a means of distributing thoughts and information (as is the case of the Internet). As such, it becomes both a recollection of a society on itself but also an ideological institution that chooses and prioritizes the knowledge to be distributed. Finally, Jensen turns to the user–society relation, where the participation in social procedures necessitates and favors communication via a medium. Here he refers to cases where the Internet becomes a forum for political rallying or campaigns, as well as the means by which citizens take part in political events or procedures (e.g., in local or even national elections). In this case, while access and retrieval gain a perspective of political participation for society, new media also enable the reproduction and sustenance of ideological agendas.

Although Jensen's discussion is more concerned with a social critique as opposed to my own interest in the ontology of cinema during the transitional phase of its technologies, it nonetheless points to an important consequence that is useful for me, too: that interactivity is an exciting new phenomenon of the digital, but one that cannot be fixed to a single meaning or effect. Consider Sobchack's essay "The Scene of the Screen," where she maintains that the digital's independently transmitted information, which is scattered throughout a network of electronic chips, disks, screens, and the Internet, creates a sense of a coreless matrix of instantaneous, and thus immaterial, availability.[93] As the user clicks and picks from whatever is instantaneously available, she no longer feels the inevitability of mortality or the stream of life, but the dominating rush of a recursive present. In similar terms, Bent Fausing's essay "Sore Society" suggests that, while the irrevocable crisis in referentiality can be linked to the emergence of an aesthetics of heightened trauma and affect, it cannot overcome the fact that the ultimate referent is not reality but an *image* of reality.[94] What, then, of the physical movement that interactivity necessitates on behalf of the spectator? Indeed, the distinction of spaces in traditional screening structures is now being transformed into a navigable and manipulable space in which the viewer/user can actively participate. This activity is more vividly apparent in gaming technologies and virtual reality systems, but DVDs and the Internet as platforms for distribution and projection have created a dynamic interactivity for movies as well.[95]

## Cinema as Media Conglomerate

My discussion thus far has focused on understanding what is different between celluloid and digital cinema from the point of view of each technology's technical foundations. Based on numerical codification, the indexical and analogical configurations of celluloid representations are substantially displaced in digital technologies. Where celluloid's physical continuity between its images and their cause manifests a direct link between representation and reality, the digital's computational setting fragments this relation, making an index of the real seem impossible. From sampling and quantization to seamless compositing and CGI, reality has been cast under the spell of the digital, making the world a possible element of the technology's functions rather than an integral existence within the image. In the case of morphing, reality is not only reduced to a nonindexical quantity, but is also made an immaterial state where a body's reliance on spatial arrangements and temporal structures is annihilated in favor of an iconic spectacle. It is at this very relationship between digital technology and celluloid's associations with reality that my theoretical concerns are aimed. Nevertheless, it is necessary to be sensitive toward the potential complications that arise from an interpretation of media ontologies in general. For instance, based on the computer's ability to organize its immaterial data arbitrarily, interactivity becomes a significant potential for creativity between image and spectator. Thus the question concerning how digital technology operates needs to be restated once again, because a sole focus on technological functionality could lead to a teleological ontology that loses sight of the mutations the digital's creative impulse might take. Therefore, instead of simply asking how the digital works and what this means in itself, the following pages will ask what the new technology is, based on the relations it upholds or unsettles with regard to the appearance and transformation of reality in the movie image and the moviemaker and viewer's position in the world. This ontological interpretation of cinema is a matter of asking how celluloid's manifestations of reality are both affected by the digital and implicated in the latter's creations.

The point to be made is that in the transition from celluloid to digital cinema, relations are destabilized, replayed, or renewed as functions of, and matters that arise from, a technological change. But this does not mean that the existential powers of cinema are lost. The idea of *newness* is

precisely what is positioned at the center of the debate, which is expressed in my use of the idea of "mediation" to explain what a medium is: a constantly changing or potentially transformable—that is, virtual—space where old and new technologies become exchanges and interactions that form means of perceiving and expressing. Indeed, by moving beyond the conception of the medium as the technical result or cause of sociocultural changes in a specified historical development, this book becomes a philosophical exploration of the digital image, which moves through an array of scholars and thinkers to see the type of thinking that the digital reflects. In so doing, *From Light to Byte* examines the digital as an *image of thought*, which reconfigures understandings of the movie image on the basis of the ethical concerns raised with regard to the individual's existential positioning in the world.

Each chapter focuses on a separate issue concerning reality's status in cinema. Chapter 1 looks at indexicality to see how it might reveal a structure that could loosen the strict opposition between the two technologies. Here I argue that the complete exclusion of reality from digital structures becomes a problematic stance when the focus turns toward the implication of the subject in indexical relations. Chapter 2 proceeds to question the sense of immateriality connected with the digital's non-analogical relation to reality. With reference to a series of debates regarding the corporeal involvement of the subject in spectatorship, I focus on how physical reality and technical materiality are both experienced as a spectatorial awareness, thus bringing world, technology, and individual in close interaction. While the instrumental aspects of the two media are inseparable elements of their materiality, the same must be said of the corporeal responses of the subject as well. Once again, the individual is implicated in the ontological setting of movies. Cinematic technology is thus understood as a space of interactivity that is not confined to a digital operation—an issue that chapter 3 addresses in more detail. Technological space is outlined as an environment of interconnected and renewable structures. The convergence of the technology's materiality, the viewer's body, and reality's physicality are now drawn out from the contact between Cartesian, Euclidean, and Riemannian spaces. Simultaneously, the examination of reality, materiality, corporeality, and spatial associations conjures up a question of time that, owing to Deleuze's Bergsonism, sees an exchange between movement, repetition, and stillness in the temporal functions of filmstrips, computer calculations, and perceptual memory. Time is examined in chapter 4 in the modes of temporalities

that appear within both the functions of the technological mechanisms and the perceptual and sensual responses of the viewer's thought and memory. Finally, as ideas of duration and existential differentiation are foregrounded, chapter 5 centers on the ethical issues of cinema's technological change. Looking at the two media as fields of forces, this chapter examines the implications of the individual as creator and viewer of the image in the association between technology and world. Here I examine the potential for an active response to celluloid's indexical and analogical structures, in order to outline a basis on which the digital's structure of control—based on the image's extreme manipulability and accessibility—can be evaluated. Each chapter involves a specific set of questions through which I address the subject of this book by involving a sense of variability that change as unpredictable and interconnected metamorphosis induces. As such, my method of examination moves from the theoretical arguments to examples of various movies, amateur recordings, multimedia artworks, and hypermedia Web works. While I discuss concurrently examples that come from a range of historical periods, artistic movements, and national industries, my stance does not suggest an indifference to each work's specificities. On the contrary, each one is brought into the discussion to outline the richness and diversity that creativity can induce. Like all studies, this book involves turning back to what has passed in order to get a glimpse of a present situation or question. In so doing, both theory and practice are made to meet and offer a point of view on what technology in cinema means, and what it means to ask what digital cinema is within our contemporary visual culture.

# 1 THE REALITY OF THE INDEX, OR
## WHERE DOES THE TRUTH LIE?

I WOULD LIKE TO BEGIN WITH A PERSONAL NOTE regarding my first conscious experience of digital cinema: Steven Spielberg's dinosaur thriller *Jurassic Park* (1993). Spielberg's blockbuster was not the first digital work on which I laid eyes, but it was for me the first movie to signal cinema's reliance on computer power. A fourteen-year-old boy at the time, with a box full of popcorn and a heart ready to explode, I watched in awe as the striking images of dinosaurs moved across meadows and jungles, breathing, eating, fighting, and bringing characters and audience alike under their magic spell. As a devoted fan of movies in a time before the Internet, I rushed through the pages of *Empire* and *Premiere* magazines to learn all about Spielberg's amazing achievements: how he created the monstrous T. rexes with their seismic stomp; how he stirred audiences' fear with the skillful attacks of the menacing velociraptors; and how he brought Sam Neil to hand-feed the colossal Brachiosaurus some breakfast. Indeed, by combining robotics, CGI, and photographs of dinosaur skeletons and live footage of wild animals, Spielberg's production triumph brought creatures long extinct back to life. It was not simply that *Jurassic Park* was full of breathtaking suspense and gripping action, but that it featured moving images of beings that simply could never have existed in its time of production. This was the magic of computers for me then—and this continues to be the power of the digital for me today. Undoubtedly, digital cinema is an amazing technological achievement that has brought about a whirlwind of new imaginative approaches to creativity in cinematic production. At the same time, though, it has caused a substantial displacement of celluloid film's intimate relation to reality. Spielberg's dinosaurs do not simply stretch the boundaries between what is real and what is a fake, but trigger an uncertainty about what exists and

what does not. Following this uncanny relationship between the digital image and inexistence, this chapter will examine and begin to question the terms on which the digital is understood to rival celluloid's ability to convey reality.

As I discussed in the introduction, numerical codification retracts the indexical causality of photographic operations. In the case of celluloid's photographic foundation, the light reflected off bodies, objects, and landscapes causes chemical reactions on film's photochemical matter. With the intermediary assistance of automatic mechanisms, these reactions create a latent image that is made visible with further chemical processes, revealing the chemical imprints of light. The photographic image is thus a visualization of reality's own physical behaviors and patterns; it is evidence of nature. On the basis of these functions, Peirce thought of photography as an example of a certain type of sign: the index. Like a footprint in the snow, an index is a sign formed directly by its source and so functions as an evidentiary fact of an event having taken place. In the case of digital processing, however, the evidentiary quality of indexical signs is seriously disrupted. It is only through semblance and convention that the digital can continue to be used as if it were *photographic*. In actual fact, as digital technology samples and quantizes the images it captures, it follows the structures of another Peircean sign—the symbol—according to which abstract signs gain meaning through convention or habit. Moreover, by generating images straight onto the computer with CGI, or seamlessly compositing heterogeneous images to appear as one unified whole, the digital also follows the regime of Peirce's other type of sign—the icon—whose representation is based on semblance. Nevertheless, as either symbol or icon, the digital image is not indexical. What, then, of the factual power of the index's causal structure?

To be certain, this question is not as simple as it may first seem. For instance, when watching dinosaurs of the Jurassic era, one is not actually fooled into believing that the dinosaurs really exist. The intervention of artifice is clearly established in the portrayal of beings that, even though they are historical existences, do not belong to the temporal space of cinema history in any way, and only visually conform to an approximation of actual dinosaurs. Similarly, one wonders why celluloid's indexicality is necessarily linked to a quality of authenticity when its images contain elements that intervene in the directness of causality. Tom Gunning turns to this question in his essay "What's the Point of an Index? or, Faking Photographs," where he questions the opposition of the digital

to indexicality.[1] As he maintains, the debate concerned with the digital's impact on the truth claim of photography, which bases its argument on indexicality alone, neglects that celluloid film can also be transformed in ways that devalue causality: through retouching, choice of lenses and additions of filters, times of exposure or use of prepared chemicals in the developing stages, addition of other elements to the printing process, or simply through the selection of angles and framing. Gunning's point here is important because it emphasizes a degree of subjective manipulation that is associated with celluloid practices. It is from this point of view that the nature of indexicality's authentic status involves a potential for subjective artifice. How, then, can the digital be opposed to celluloid if indexical authenticity cannot offer a stable point of departure? To answer this question, I will continue by clarifying what is involved in Peirce's notion of the index, looking to decipher how exactly the digital might be understood to challenge the ontology of celluloid cinema.

## Peirce and the Index

In describing his semiotic categories, Peirce makes an important link between all three types of signs and reality. He explains that the purpose of every sign is to signify the presence of an object through a connection to reality, or else it would not function as a sign of something.[2] For instance, the direction of a weathercock—an indexical sign—signifies the direction of the wind that made it turn. In the case of a painted portrait—this time an iconic sign—the image represents the person it depicts by virtue of its likeness to the sitter. This resemblance, though, is the result of the impression of the sitter's appearance on the painter's mind. Thus, although there is still a link between reality and the iconic sign, this association is made indirectly as it passes through the hand of the painter. Similarly, a statement—which belongs to the symbolic regime of language—retains a link to a fact because it was caused or determined by it—that is, via the perceptual and expressive insertion of a subject. In other words, Peirce understands all three signs as representations that have to do with reality in one form or another. Nevertheless, where the connection with reality is made directly in the index, for the symbol and the icon this association is mediated via a subject.

Peirce insists on the relationship between signification and reality further to clarify an important factor that takes part in this structure. He explains that what is always present in signification is the *material* quality

of the idea of signification that appears in the subject. As a sign produces the mental perception that it is a sign of the thing it signifies, it gains a physical presence as the feeling of the thinking process that it triggers.[3] In other words, as indications, images, or marks signify, they necessarily involve a subject who makes sense of the sign's meaningful relations to objects or events. It is here that we begin to understand the difficulty of connecting an idea of representational authenticity with indexicality's seemingly objective nature. Peirce himself addresses this matter in his essay "[A Treatise on Metaphysics]." Here he writes, "There is no such thing as having immediate faith in the statements of others, be they men or angels or what. For whenever we believe statements, it is either *because* there is something in the fact itself which makes it credible or *because* we know something of the character of the witness. In either case there is a because whose major premiss is some principle concerning general characters of credibility. To believe without any such 'because' is mere credulity."[4] This excerpt illustrates Peirce's direct concern with the implication of a subject's thought in creating meaning. An idea or sign is not a pure fact as a kind of natural finality, but rather an element of the encounter between subjects and reality. This is to say that Peirce does not simply base his schema of signification on a scientific objectification of meaning; rather, his approach stems from an interest in how signs gain their powers from the relation they build concurrently with reality and subject. At the same time, he does not support an overall distrust of signs simply because they include a subject's intervention. Instead, he emphasizes the inescapable inclusion of the subject's involvement in making sense of signs.

## Image and Subject: Bazin

Peirce's emphasis on the subject's participation in the creation of meaning in signs invokes the activity of "intentionality" in phenomenology's subject–object encounters. The understanding of an object necessarily involves the mode of perception and expressive qualities of the subject who takes notice of the object. In fact, Philip Rosen insightfully points to the same phenomenological implications in Bazin's realist project as well. Rosen writes, "Bazin's theory of cinema contends that film has special capacities to convey something of reality, and it is certainly true that one must always read him with awareness of his emphasis on the pregivenness of the concrete, objective real. However, another fundamental

aspect of Bazin's theoretical work needs emphasis, and I would put it as strongly as possible: the processes by which human subjectivity approaches the objective constitute the basis of his position."[5]

The importance of the subject is certainly evident throughout Bazin's theorization of celluloid's existential guarantee. As I examined in the introduction, Bazin emphasizes two aesthetic forms that directly manifest celluloid film's unique ability to reveal the world: the long take and deep focus. For Bazin, by respecting the continuity of time and space these formal practices allow for the concreteness of the profilmic field to be unveiled: the long take refuses the temporal fragmentation of editing, and deep focus prohibits the spatial disunity of the close-up. Nevertheless, while pointing to indexical causality as a means for the objective revelation of the world, Bazin is concerned primarily with what this revelation means for the subject. For instance, in his essay "The Evolution of the Language of Cinema," when dealing with the advantages of the depth of field, he writes, "in addition to affecting the structure of film language, it also affects the relationships of the minds of the spectators to the image, and in consequence it influences the interpretation of the spectacle."[6] He continues by referring to the psychological qualities of deep focus, explaining that it allows the spectator to engage with the image in a way that resembles her or his relation to reality.[7] The configuration of reality in the image, in other words, is considered from the point of view of the subject's experience of reality itself. Moreover, as deep focus opens the image's breadth without disruptions, it enables a more active mental engagement on the part of the spectator, thus granting her or him a greater role in the progress of the action: instead of following the director's guide deterministically, the spectator can exercise at least a minimum of personal choice in the filmic world.

Bazin's approach is clearly concerned with the spectator's choice and involvement in the image, as both the duration of the long take and the space of deep focus allow the individual to face the ambiguities and irrationality of living. It is with this in mind that Bazin turns to the "image fact" in his essay "An Aesthetic of Reality," which makes elliptical editing a metaphysical structure that forces the spectator to make meaning of happenstance just as she or he would in the real world.[8] In fact, the importance of the subject's role in Bazin's realism is already evident from his concept of the "mummy complex." In this case, he speaks of humanity's need to evade death, which is expressed as a psychological desire satisfied in artistic practices.[9] What photographic and filmic indexicality

achieve is not a removal of the subject's role in art's metaphysical implication, but an establishment of the relation between subject and reality on objective grounds. If, therefore, the photographic index is a sign of that which was there—an authentic fact of reality taking place in space and time—it is so because a viewer perceives it as that spatiotemporal piece of the world. The sign of the index gains meaning and potential as it is brought back to life by the reality of its perception. Celluloid indexicality, in other words, is more than the chemical transcription of light onto physical matter: it is a form of representation that gains importance in light of the life for which it becomes a *living* imprint.

In sum, both Peirce's and Bazin's discussions of the index illustrate how the potential of indexical signs is not bereft of a subjective participation. On the contrary, the subject is intrinsically tied in with all types of signs, albeit in different ways. As for the icon and the symbol, the intervention of the subject is openly displayed because these signs are direct expressions of an individual's interpretation of the world or its concepts. But the index presents an interesting case because of its immediate connection with reality that in the first instance takes place independently of any intervention. It is for this reason that it gains the potential to seemingly present the world authentically and objectively. Nevertheless, as understood by both Peirce and Bazin, the veracity and certainty of reality in the index is expressed as an encounter with the perceiving subject who intends meaning toward the sign as an expression of its existential grounding. How, then, does celluloid film address this relation between objective fact and subjective intervention? With this question in mind, I turn to debates of documentary moviemaking because of the form's historical connection with celluloid's evidentiary abilities. In so doing, my discussion will further investigate the relationship between indexicality, reality, and subjectivity, in order to establish the foundation on which the digital's nonindexicality can be understood.

## What Does the Index Document? The Case of *The Thin Blue Line*

Documentary cinema is a remarkable area for exploring the role of indexical authenticity in moviemaking. In a sense, any analog movie (celluloid or analog video), being a depiction of the causal link between reality and image, is always an exploration of indexicality, albeit one that does not necessarily make itself apparent within the context of the movie's narrative. With regard to documentary movies, the specific attraction has

to do with their classical opposition to fiction, as seen in the distinction made between the observational movies of the Lumière brothers and the special-effects magic of Georges Méliès's work. This is not to say that documentary practices or debates necessarily frame the form as a revelation of the world's truth, but that they approach its material with a sentiment involving the observational potential of cinema. Indeed, the concern with the degree or type of authenticity and the intervening hand of the moviemaker is already evident when the British documentarian John Grierson, writing in the early 1930s, describes documentary as the *creative* treatment of actuality. He writes, "You photograph the natural life, but you also, by your juxtaposition of detail, create an interpretation of it."[10] Nevertheless, documentaries, for Grierson, continue to stem from the camera's ability to observe and select from life itself, even when the resulting image is creatively configured. Cinema verité and "direct cinema" practices of the 1960s similarly express a concern for the authenticity being revealed. In the case of the American direct cinema, the camera takes on a fly-on-the-wall, observational role by becoming as unnoticeable as possible. In contrast, the French cinema verité emphatically draws attention to the intervening hand of the moviemaker by openly displaying the creative process as a means of probing rather than disregarding the world.[11] In both cases, the power of the recording lies in the camera's immediate access to events as they unfold in the world. Of course, my interests do not lie in a historical overview or examination of the history of documentary. Rather, I am concerned with understanding the potential of the index to document events as objective images, and what complexities arise from the psychological evaluation of objectivity. This is a matter of defining what the referentiality of indexical cinema can reveal, but also what it ultimately cannot reveal.

A seminal work both researched and taught extensively by cinema scholars, Errol Morris's *The Thin Blue Line* (1988) is an amazing exploration of the complexities of objective truth by discussing the constructed nature of information both in the story it tells and the way it forms its images. The movie investigates the events of the 1976 murder of the Dallas police officer Robert Wood and the judicial proceedings that followed regarding the convict, Randall Adams, and his accuser, David Harris. But *The Thin Blue Line* does not simply narrate what took place descriptively; it turns to analyze the discrepancies that surrounded the case through a juxtaposition of the testimonies by the two men, the actions of their attorneys, and the confessions of various supporting witnesses. While the

viewer begins to fully understand the facts of the story, Morris then challenges the stability of the events' nature, thus taunting the viewer's own perception of the objectivity of the narrative.[12] In revealing the horrific side effects of capital punishment where an innocent man can be falsely sentenced to death, Morris composes his movie as a complex palimpsest of truth strata that form history as encounters of alternative developments—not as a unified teleological framework.

The movie explains how Adams was accused of murder by the sixteen-year-old Harris, for which the former was sentenced to life imprisonment (after escaping the death sentence on grounds of inconsistency in the proceedings of the initial trials). In the end, though, the movie reveals that Harris was the real murderer, who had simply tried to avoid incarceration and conveniently managed to frame Adams. Pressured by the desire to quickly resolve the investigation and achieve maximum penalty for the murder of a police officer, both the police and the courts in Dallas preferred convicting Adams, who could be sentenced with the death penalty (a sentence that Harris, being a minor, would not have received). In so doing, the official bodies of the government failed to pay attention to the overall facts of the case, proving the unreliability of both the facts and their own judgment.

*The Thin Blue Line* depicts these incidents with a concern toward the malpractices of the American judicial system, and the false condemnation of an innocent man. But besides the subject matter, the movie addresses the unstable character of representational objectivity with the reenacted dramatization of the perspectives of the various people related to the story. As Linda Williams discusses in "Mirrors without Memories," the movie questions the veracity of the image's authority, thus presenting the question of how truth can be unraveled.[13] Indeed, Williams is accurate in highlighting how the fictionalization of Morris's construction does not devalue any discussion of truth; rather, it positions truth in a different framework where reality is not a mirror of a single event, but a complicated and indirect refraction of life.[14] Consider, for instance, the movie's repeated revisions of the staged reenactments: at the time of the very first dramatization, the viewer sees the murder take place; that is, she or he sees not that which actually happened but a close approximation to how things could have taken place. Nevertheless, the objectivity of this depiction is overturned in the following dramatization that shows things a bit differently, up until all *facts* succumb to the interrogating vision of Morris's intervention. Both truth and visual objectivity are undermined

through the foregrounded presence of subjectivity: according to Adams, this happened; but according to Harris, something else happened. Of course, while testing the limits of truth, Morris offers his own truth and his own worldview: mistrial, misconduct, deception, the horrific possibilities of capital punishment, and the ultimate confession by Harris in the closing scene that presents the final version of the truth for which Morris is campaigning. Nevertheless, as the movie has already set up a critique of authenticity values, this confession is no more reliable than any other argument. To be sure, as the scene contains only a tape recorder from which the viewer hears Harris's voice, the confession is singled out from the rest of the movie by basing its manifestation on the vocal instead of the visual. Nevertheless, the magnetic recording is not necessarily more objective than any filmic depiction, as everything is filtered through the operations of the subjective (Adams, Harris, or Morris) that fictively constructs the depicted information. Indeed, Morris does not shy away from the expressive nature of moviemaking, be it a documentary or fiction movie. He says, "There is no reason why documentaries can't be as personal as fiction filmmaking and bear the imprint of those who made them. Truth isn't guaranteed by style of expression. It isn't guaranteed by anything."[15] How, then, can one avoid filtering reality through the milieu of personal judgment in the visual construction of a movie, even in the case of nonfiction? Where, in other words, can one place the indexically based objectivity that celluloid practices enable?

## Questioning Cinematic Objectivity

The problem with an understanding of indexicality as a matter of authentic objectivity is that it presents an unwillingness or refusal to recognize the importance of the constructedness involved in all types of representations.[16] This matter has been much discussed in theoretical writings on documentary moviemaking since Grierson's musings to which I referred earlier. More recently, the British documentary editor Dai Vaughan turns to the creative aspects of documentary moviemaking in his book *For Documentary*, where he addresses the difficulty of defining the relation between reality and moviemaking and the problem with simply disqualifying documentary practices in their entirety based on the fictitiousness of narration.[17] He begins the book with the account of a debate regarding the better way to further edit a rough cut of a scene that included a female circumcision.[18] Here he describes the three suggestions that were

made by other participants in the production: the first maintained that they should signal the unpleasantness of the event by adding a scream or two; the second, agreeing with the first, added that they in fact had recorded a scream during production and so it would be valid to include it in the movie; and the third, commenting on how the scream was actually an uncommon occurrence during the ritual, insisted that to include it in the final movie would be an invalid representation. Describing this anecdotal account, Vaughan indeed points to the general problem with which a movie editor is faced in similar circumstances: the fact that documentaries declare a specific claim on the world. In other words, the suggestion to add the scream charges reality with a symbolic connotation because the scream would signify pain figuratively. In the case of the second opinion regarding the validity of using the scream, the recording is understood to have an objective value through which it acquires the ability to represent reality authentically. And with the third suggestion not to use the scream on grounds of its infrequency, reality is interpreted on the basis of an overall generalization that filmic representation reflects. Either way, each filmic construct is bound by a double reflection: the first of reality onto the photochemical emulsion, and the second leading from the subject framing, recording, editing, and mixing the representation.

The particular bond between image and reality, and the problems that arise from this relation, are also discussed in Bill Nichols's book *Representing Reality*. Nichols—a leading figure in the study of documentary cinema—maintains that the trouble with factual movies and their relation to history is that they fail at their attempt to present the world objectively because they do not represent *the* historical world, but *a* world—that is, a fabulation, a certain type of view.[19] Just like a fiction moviemaker, the documentarian who desires to reveal reality in its true state will do so while at the same time unavoidably allowing objectivity to succumb to the whimsical arbitrariness of the subjective: initially by herself or himself, and later by the spectator. Reality is there, but it is imperative to keep in mind that reality's image is of *a* truth—that is, it is of a subjective point of view. Thus for Nichols the basic difference between fiction and nonfiction is that the former is organized to create a milieu in which characters are located in a unified time and space, whereas the latter is organized in such a way as to present an argument located in a specific logic. Indeed, his discussion points to an interesting shift in the opposition between fiction and nonfiction that is not based on any truth claims but derives from a certain difference in the form of the artifice.

In a similar manner, the cinema scholar Michael Renov points out in his introduction to the book *Theorizing Documentary* that the direct antithesis between fiction and nonfiction movies is in itself a misapprehension precisely because each form is enmeshed in the other as interrelated components of the general rubric of cinema. He writes, "In every case, elements of style, structure, and expositional strategy draw upon preexistent constructs, or schemas, to establish meanings and effects for audiences."[20] However much moviemakers try to exclude themselves from the process by just letting events unfold as they record (in the fly-on-the-wall technique of the American direct cinema), or conversely, however much they try to include themselves in order to make obvious their role in the unfolding of the events (in the French cinema verité manner), there will always remain a sense of artifice, at the least caused by framing. It is a matter of creating meaning out of pieces of reality—a fiction as the narrativization of the real.

From this perspective, analog nonfiction as well as fiction movies are always constructed through an amalgamation of reality and some form of subjective "truth." However, to recall Barthes's analysis of the photographic paradox in "The Photographic Message," there is always a connotative and denotative element to the photographic image that generates in the viewer the expectation of seeing something that is also grounded in the historical world.[21] Undeniably, reality has been filtered through layers of ideology and reasoning that convert it from an exclusive point of access to the world into what Nichols describes as "*a* view of *the* world."[22] Nevertheless, the connotative element of the image does not exclude the denotative potential of the index. In other words, what remains alive in every shade of light, in every grain of film, in every gesture of love and tear of pain, in whatever framing the camera has to offer, is the "this-has-been" of the real. The subjectification of the factual potency of celluloid cannot be simply appeased by denouncing the link to *the* world altogether. Indeed, this is precisely what Morris achieves when he creates a documentary constructed from staged reenactments, slow-motion cinematography, expressionistic angles and cutting, and Philip Glass's hypnotic rhythms. As *The Thin Blue Line* became the reason for the murder case to reopen, and led to the ultimate release of Adams on false charges, the movie adheres quite strongly to a sense of reality. The power of the index lies in this paradoxical arrangement between the real and its subjective recording through an indexically objective instrument. By representing reality through the selection, recording, and arrangement of

its segments, the moviemaker adds an internal dialogue to the objective nature of photographically produced images that affects their authentic status: as meaning and interpretation motivate the construction, the indexical trace is fused with the symbolic feature of argumentative language. Nevertheless, reality is not excluded; it is, quite differently, impregnated with expressivity.

## How Does the Index Mean? *Night and Fog*

My discussion thus far has focused on reality from the point of view of the authenticity that the filmic image gains from indexicality's causal function. The question of what the index documents must necessarily take into consideration both the direct link of the index with reality and the creator's creative act, the dramatization that assigns new meanings to the index. The indexical reality of the image can be understood as a combination of a subjective narrativization and the traces of the world that celluloid's image refracts. In fact, as Morris's movie explores, even though reality is transmitted as an expressive and imaginative vision, it is still the field of exploration when truth is on the line. This is to say that *The Thin Blue Line* points to the inherent constructedness of historical facts in their entirety. The difficulty of representing truth authentically only really becomes a problem when objectivity is taken as a fixed and closed category. Authentic objectivity and a subjective point of view do not exclude each other; they coexist. Similarly, the degree of the creator's fabulation needs to be extended to another subjective encounter with the index: the spectator. As in the creative configuration of the image, the viewing process is not a pure vision as if someone leaped out of nowhere to witness a movie for the first time. Instead, the spectator is already prejudiced or simply prepared, equipped with a set of historical, cultural, and personal elements that affect the way the image is perceived, and thus interpreted. Spectatorship does not merely entail apprehending that which the moviemaker aims at conveying; it also includes the viewer's participation—a further subjectification of the index.

Upholding a historical moment in documentary moviemaking, Alain Resnais's *Night and Fog* (1955) is an outstanding case that works with the ambiguous association between historical truth, representability, and memory. The movie is a staggering depiction of the effects caused by the Jewish Holocaust, which brings together black-and-white archival footage of newsreels, military recordings, and photographs, with color

images shot at the time of production by Resnais. In combination with the survivor Jean Cayrol's commentary, the work exposes the continuous traumas of the concentration, torment, and homicide of prisoners during the reign of the Third Reich in Germany. By juxtaposing incongruous pieces of archival footage and by blending two separate temporalities (past and present), *Night and Fog* questions the representability credited to indexical images, but does so in order to prompt a traumatic aide-mémoire in its current spectators, thus contaminating the present with the past.[23]

As the movie unfolds, the images of the German army marching, the camps being built, the internees being rounded up, the prisoners, and the dead bodies make a harsh impression on the spectator. Nevertheless, the movie does not leave these images to speak alone; instead, Resnais uses editing and voice-over commentary to vividly bridge the distinction between past and present. The old footage is brought up against contemporary images of a concentration camp as it lay deserted and peaceful ten years after the liberation of the prisoners and the end of the war. The camp becomes, in this context, a witness of a historical truth to which our own vision does not have immediate access. Covered in green grass and bright sunlight, the land still bears the scars of a people tormented by a malicious regime; we are told that these are the gates that imprisoned millions of people, these are the watchtowers from which their every move was watched, these are the beds in which they were stacked up at night for a few hours. The combination of the two distant temporalities through the mutual space of the camp forces the past events to become a vibrant part of a historical memory that goes beyond ascertainable evidence. The land becomes a contemporary database of the footage based on its two separate recordings: it is alive both there and here so that on it are traced the lives that were lost. The existing land is the image's force that brings the viewer face-to-face with the reality of her or his presence, face-to-face with the reality of what has been engraved in that world, the reality of the horrors and death.[24] Such is also the power of Cayrol's unsettling text, read by Michel Bouquet, which describes how a peaceful meadow with crows and grass, roads and cars, peasants and couples, and villages and fairs can still lead to a concentration camp.

What Resnais points to by juxtaposing old footage of the camps with images from his contemporary recordings is the fact that the viewer cannot hide from the past, because the past remains part of his world despite its temporal distance. It is not a matter of the movie presenting a truth

of the historical events, but of the past haunting the present through the causal powers of the index—that is, powers that extend beyond the rigid interpretation of a seeming objectivity. Indeed, the indexical quality of the past image functions as a kind of trauma by laying bare not the truth of the Holocaust, but the reality of its effects. Like ghosts, the movie explains, the prisoners would vanish into the night, into the fog, leaving no trace behind them while heading toward their disappearance. Their image, though, becomes a testimony of their existence, representing them (or resurrecting them, as Bazin would have it) to arouse our memory, to make present the horror that occurred in Europe during those years. At the same time, *Night and Fog* sets in motion the conflict between Barthes's "studium" and "punctum": while the movie strongly declares its opposition and revulsion at the violence and extremities of war—thus aligning itself with Barthes's concept of the studium—it does so problematically.

Indeed, the spectator is guided by the image's ideological construction, but at the same time she or he is left with a feeling of uneasiness that lingers beyond the movie's antiwar encoding. This sense of incompleteness is evoked by what is missing from the image. As Bouquet describes how everyone from the kapos to the commandants refused responsibility for the extermination, the movie starts to reveal a crack in its representational status. The definiteness of indexicality's "this-has-been" clashes with the lack of information and the desire to know how it became possible to commit such atrocities against an entire community. What is clearly printed onto the image is also what remains unresolved, so that the concreteness of the image's reality cannot show the full breadth of the events. As the survivors face the camera in the final part of the movie, I am relieved that some people managed to escape the burning flames of the crematoriums. But this sense of joy does not seem to be shared by the survivors themselves, whose frightened gazes reflects their absolute bewilderment at what had been taking place, as well as the knowledge that what has been lost can never be replaced. The survivors' eyes are filled with grief not only for their immediate past, but for their future as well.

It is at this point that the subjective resonances of Barthes's punctum become clear, because the power of the image becomes a personal journey into the spectator's own thoughts. As I stare at the survivors' bewildered faces, I cannot but wonder myself about their future, about how difficult life will be for them and how one can ever go on living after such an experience. It is this *eye/I* of the viewer that confronts the index and

encounters the creativity of the moviemaker. And as the viewing subject becomes part of the reality of the image, she or he extends the bridge between past and present even further into the future. For instance, the contemporary French viewers of *Night and Fog*'s 1955 distribution would have been affected by the French Indochina War that ended in 1954, as well as the rising conflict in Algeria that began the same year. As for contemporary viewers, they may make connections with the wars in Afghanistan and Iraq, the death toll, the photographs of American soldiers torturing detainees in the Abu Ghraib prisons, and the atrocities at the Guantanamo Bay detention camp.[25] However much these current events remain historically distant from the Auschwitz camp, as did France's colonial battles from Germany's war practices, it becomes an element that is immersed in the reality of the image like a shimmering light projected onto it from the position of the viewer's own mind.

From this point of view, the index cannot be understood as an authentic structure of objectivity as if the subject (creator or spectator) encountered it from a distance. Indexicality is inherently informed by its relationship with subjects, their desires and thoughts, and their personal and national histories. In fact, to describe photographic indexicality as an objective reality in the strictest sense would only diminish its potential. Instead of an intimate experience of self and other in a common world, the reified index of reality can only become a Cartesian field of a supposedly inconsequential observation that ultimately invokes control and manipulation. Indeed, it is precisely this relation between objectivity, subjectivity, and the effects of Cartesian detachment that becomes the theme of Harun Farocki's movie *Images of the World and the Inscription of War* (1988). Turning to Farocki's movie, I am interested in unraveling further the complexities of viewing associated with the indexical image.

## Imaging the World and Inscribing War: Farocki

*Images of the World* is a compelling exploration of the repercussions of the Enlightenment's structure of vision as a mastering reification of nature and its link to the camera's role in acts of both preservation and destruction.[26] Farocki's concern with looking is immediately set up in the opening shots of the movie, which present an enclosed stream of water swiftly moving back and forth in a research facility in Hanover. These mesmerizing images are accompanied by the words of Cynthia Beatt's voice-over: "When the sea surges against the land irregularly, not haphazardly, this

motion binds the gaze without fettering it and sets free the thoughts. The surge that sets the thoughts in motion is here being investigated scientifically in its own motion, in the large wave channel at Hanover. The motions of water are still less researched than those of light."

At this point it is unclear why Farocki is interested in research on the motion of water and why the voice-over refers to the binding and setting free of the gaze, but these issues are slowly put into perspective in the course of the movie. After the Hanover scene, *Images of the World* continues with two drawings by Albrecht Dürer that illustrate the subjection of visible objects to the scrutiny of the human eye. At the same time, Beatt recounts how Alfred Meydenbauer introduced the use of photography for the scale measurement of buildings, thus making possible the scientific description of the world from a distance. Indeed, the movie's concern with the Enlightenment's promotion of an objectifying knowledge by a demarcated subject is explored further in the following sequence: here, Farocki shows a series of photographs of Algerian women taken by the French authorities in 1960 to issue them with identity cards. These photographs—made for the civil registration of the Algerians, and by extension, for the verification of France's colonial possession—are taken despite their disrespect for the women, who are unveiled and subjected to the foreign gaze for the first time. It is at this point that the movie turns to the evidentiary power of the photographic index on which practices of policing and cataloging society are based. Nevertheless, Farocki recognizes a problem in the objective authenticity bestowed on the image: both viewer and viewed are dehumanized and denaturalized so that another element of the photographs' reality is marginalized. Indeed, the photographs of the Algerian women include the complexity and uneasiness of their first subjection to the camera's click and the social glance, but the function of cataloging and controlling is indifferent to the uniqueness of the women and their experience.

Having set up this concern with the devaluing effects of an objectifying view, *Images of the World* continues with the extreme consequences of severe rationalization in the name of progress: the Nazi concentration camps. The movie discusses the first aerial photograph of the Auschwitz camp taken by chance on April 4, 1944, by an American pilot flying from Foggia to Silesia so that officials could examine the activities of industrial complexes in the area. What is most compelling about this account is the fact that the camp was not recognized in the image until the CIA stumbled on it thirty-three years later. Even though the camp was certainly

depicted in the image, the initial analysts did not see it simply because they were not under orders to look for it, and so the photographic evidence of the insane barbarity of Nazi totalitarianism was not made visible. What this goes to show is that the indexical trace of the Auschwitz camp in the aerial photograph is as much present as it is not! The image's out-of-field is thus illustrated in the frame itself, as that which remains out of vision although depicted: the tower, the commandant's house, the registration building, the headquarters, the administration offices, the fence, the execution wall, block 11, the gas chamber, as well as a vehicle. In fact, even when the CIA analysts discovered what had been hidden in the image, they still could not decipher whether the photographed vehicle was actually a Red Cross ambulance used to transport the deadly Cyclone B crystals. At this point, *Images of the World* turns to what is inscribed differently in the photograph and can indeed be read there: the oral witnesses of two survivors who explained how the SS divided the new train deportees into two groups, the one on the right aimed for work and the one on the left led to death.

The aerial photograph is a blurred and grainy image that cannot be easily deciphered. Nevertheless, Farocki's note is compelling: although unavailable to vision, the photograph is engraved with the cries and pain of a people that are now missing or are still remembering, and the awe and horror of a people that searches to learn and understand. This unstable nature of the index is the irregularity to which the voice-over refers in the movie's opening, one that triggers the mind and leads to the motion of thought—as in the incongruity of Deleuze's "time-image." Conversely, the deterministic subjection of reality to the scientific scrutiny of knowledge restrains the mind by outlining the path that has to be followed, and how this path must be adhered to—as in Deleuze's "movement-image." *Images of the World* emphasizes that the denaturalization of vision in the scientific distance of objectification can lead from a laboratory for the examination of water to the most extreme "laboratory" of the Nazi regime. Indeed, both Farocki's movie and the consequences of an extreme ocular culture are beautifully examined in Kaja Silverman's discussion of the gaze in her book *The Threshold of the Visible World*.[27] Here the film theorist discusses models of vision with reference to the oppositional binary of subject and object, but always from the perspective of the mental involvement of the subject and the consequent variability generated by social structures. It is precisely Silverman's discussion of the psychical realm of vision that interests me further, in order to broaden the interaction between index

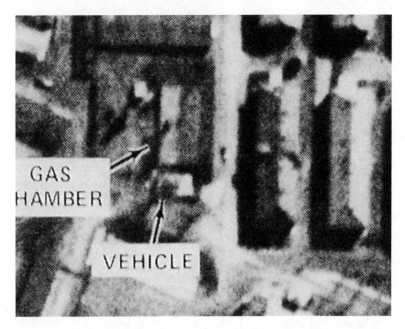

A gas chamber and a vehicle potentially carrying Cyclone B crystals, as recognized in the accidental aerial photograph of the Auschwitz camp thirty-three years after it was taken. Still image from *Images of the World and the Inscription of War* (Harun Farocki, 1988).

and spectator into the space of the subjective imaginary, thus examining the index as an inherently irregular structure.

### Indexical Irregularities of the "Fact"

Concerned with the ocular culture that the camera advocates, Silverman turns to Jonathan Crary's book *Techniques of the Observer*.[28] Here she scrutinizes Crary's strictly historical examination of optics, according to which modes of vision are based on the scientific and philosophical concerns of a given period. Crary relates these modes to the analogous apparatuses of the times, with the camera obscura being the dominant metaphor for the geometrical optics of the seventeenth and eighteenth centuries, and the stereoscope that of the physiological optics of the nineteenth century. The problem that Silverman detects in Crary's theory is that it ignores a factor that goes beyond the social and historical, persisting from one visual epoch to the other: the psychical. For this reason, she turns to Jacques Lacan's book *Four Fundamental Concepts*

of *Psycho-Analysis,* which defines the subject as both visual agent and object of vision by the external gaze of society—a structure symbolized by the camera.[29] Once again, though, Silverman recognizes that Lacan's theory falls short of the broader implications of vision by neglecting to take into account the historical dimensions to which Crary refers, thus creating a gaze that is completely eternal in a transcendental otherness. To resolve the inconsistencies of the two theories, Silverman proposes a unification of their approach so that Lacan's gaze can be historicized and the potential of Crary's historical views be taken into psychical realms.

At this point, Silverman turns to *Images of the World* to argue that the camera is simultaneously a locus of a representational logic and a complex and continually variable field of social and technological relations.[30] Although it is not necessary to recount Silverman's analysis of the movie in detail, her exploration of the viewing subject is particularly fruitful for my own investigation of the potentials of indexical structures. In the first instance, she explains how Farocki's movie gradually moves from Dürer's mastering model of vision to a blatantly specularized look where a woman's makeup is being applied on her eye. In the latter case, as the eye is being steadily weighed down by the makeup that is shaping it for view, it loses its own visual power, thus becoming an eye *to be seen.* From this initial observation, Silverman discusses the relationship between the two functions of the subject's visual perception: the agency of the seeing subject and the reification of the seen subject. It is from this point of view that the aerial photograph of Auschwitz becomes the locus of differentiation between what the subject cannot see and how her or his visual abilities are replaced by the mechanical eye of the camera. The camera, thus linked with the exteriority of the gaze, becomes a field of vision shaped by institutions of surveillance, observation, and inspection. It is this detached and objective feature of the camera that has tied it to the activities of modern military, industrial, and policing operations—a link theorized extensively by Paul Virilio in his seminal book *War and Cinema.*[31] At the same time, though, the objective gaze of the camera delimits the subject within its own formulating system. Focusing on shots from *Images of the World* where a composite sketch is made for the apprehension of a suspect, Silverman explains how reality is not lost by the camera but is conversely made to conform to its viewing functions. In other words, as the real is drawn into the representational form of the celluloid image, it is informed by the intrusive nature of the film camera that binds it with a purpose and sets it within the conditions of an objectifying vision.[32]

Indeed, the camera's gaze is itself an institutional practice that, as I have been discussing, is grounded in the mechanical, automatic, and indexical functions of the technology. Nevertheless, more than simply positioning the subject on either end of vision's spectrum—from master of vision to visual object—the camera is also brought up against the internal psychical structures that define how the viewer sees, both as the recipient of a foreign gaze and as the agent of a look. Here Silverman explains how the nature of a mediated representation is always erroneous: although the seeing subject is positioned within the frames of specular representation that direct her or him, the individual does not lack the capacity to see differently from the demands of the gaze. *Images of the World* underlines this potential of irregularity in a sequence that consists of art students sketching a nude model. In these shots, the camera's gaze and the subject's look are brought together in a single image that focuses on their inevitable estrangement: Farocki's camera records only one model—that is, a naked black woman explicitly defined by both her sex and her race—whereas the drawings record the personal perception of the students, whereby sex and race are essential but not defining features of vision. While each student sees something very different from the others, they blur the boundaries within which the subject is placed and accentuate the variable corporeality of the eye (the *address* of the eye to which Sobchack's work refers). As such, the look is intricately informed by the temporality, desire, and memory of the subject who is aligned with the indefiniteness of change. Both Silverman and Farocki justly place the factuality of the photographic trace under extreme pressure, to the point where truth stems not from the fixity of the index but the mutability and evasiveness of life. In *Images of the World,* it is not the index of the image that is authentic, but the oral testimonies and the hand drawings of the Holocaust survivors. In other words, as the index is cut from reality's space–time continuum and own internal logic, it becomes a structure that conforms to the internal logic of what the gazing camera as apparatus, institution, and society deems it to be. At the same time, though, the index gains renewable potential as it is communicated by the psychical constructs of a vision that belongs to a subjective look of a spectator, so that the *eye/I* ultimately sees more than what can be inscribed indexically.

It is this fictionalization of the subjectified index that similarly interests the film scholar Stella Bruzzi in her book *New Documentary.* Here Bruzzi outlines a theory of documentary moviemaking that embraces the alignment of nonfiction with reality without undoing the inherent

fictionalization that is part of this reality. Her focus is not on how the creator defines her or his work ideologically, but how the encounter with the work follows the fabrications of the imaginary. She writes, "The fundamental issue of documentary film is the way in which we are invited to access the 'document' or 'record' through representation or interpretation, to the extent that a piece of archive material becomes mutable rather than a fixed point of reference."[33] Bruzzi speaks here of the interplay between reality and its fabrication through representation, but stresses that this should not be considered a failure in documentary practices. Rather, she maintains, fabulation has always been at the heart of the document.

In support of her argument, Bruzzi uses very skillfully one of the most famous examples of accidental recordings: Abraham Zapruder's twenty-six-second amateur footage of John F. Kennedy's assassination.[34] What is remarkable about the recording is that it reveals a momentous event in modern U.S. history while simultaneously leaving it viciously concealed. There is no doubt that one can actually see the moment of Kennedy's murder, the horrific details of the effect to his body, the terror of Jackie Kennedy as she scrambles over the trunk of the car; but what one cannot see, which is the reason the footage was subjected to copious examinations and interpretations, is the person or people who pulled the trigger and the motives for the assassination. The recorded event has become a thin pane of glass through which the viewer can see reality as that which is visible but not penetrable. Instead, it is an indexical document, an authentic moment of reality that is always reimagined by the reflections, emotions, and thoughts of the subject's perception of it. In fact, the Zapruder footage displays how fragile the indexical document can be: at one stage of the shot-by-shot examination of the film's enlarged frames, it had been inconclusively alleged that figures were visible crouched behind a picket fence or standing at a window.[35] This is to say that the extreme objectification of the index's authenticity becomes itself an act of fiction, an imaginative fictionalization that can result in shattering the pane of the index's reality.

### Narrativization of "Truth": *Blow-Up*

The debate surrounding the index, its authenticity, and its relation to reality is by no means confined to the field of documentary movie-making. On the contrary, the index and the psychological proportions

it gains from the subjective experience of reality have been the focus of many fiction movies throughout the history of cinema. Consider Michelangelo Antonioni's movie *Blow-Up* (1966), which is a masterful exploration of the futility of a claim to indexical objectivity. Rather than clinging to the authentic potential of the index, the movie exposes reality as a milieu that cannot be contained within fixities. The main character, Thomas, played by David Hemmings, is a photographer who takes some photographs of a couple in a park without their approval. To his surprise, this act causes a strong reaction from the woman, who relentlessly demands the film spool from him. Intrigued by her unabashed persistence, Thomas develops the film and obsessively enlarges portions of the photographs until he discovers the possible evidence of a murder in their grainy details: hidden in a seemingly peaceful and innocent landscape is the worrying look of the woman, a gun in the bushes, and what seems to be a hidden male corpse. Yet, instead of empowering the camera with the capacity to solve the mystery and restore order, *Blow-Up* contends with its evidentiary ability. When asked by a friend who the man was, how the murder happened, and why the man was shot, Thomas answers, respectively: "Someone"; "I didn't see"; "I didn't ask." He himself does not question these matters; on the contrary, he is trapped in a manic obsession to reveal only what the photographs have recorded, not what his eyes can see. Thomas is a subject who has entrusted himself to photography's authenticity to the point where he has been enslaved by the technology and has lost touch with himself, his emotions, and his thoughts. He has been dehumanized in his blind belief in photographic objectivity so that he cannot see without looking through the viewfinder. He is not interested in the emotional impact of the event, its implications for both the dead man and the woman. Rather, he simply wants to photograph the body to prove that it exists.

Nevertheless, this denaturalization that Thomas undergoes is overturned at the end of the movie in an astonishing scene. As Thomas walks away from the park after discovering that the remains he had found have vanished, he sees a group of mimes that are playing tennis without rackets or a ball. This irrationality forces him to focus now on vision itself not as a gesture of documentation—an austere objectivity—but as a means of relating to the world as an individual being among other beings. Through the simple gesture of Thomas taking part in the mimes' game, Antonioni's exquisite finale conceives of both reality and subject as fields of possibilities that cannot be restricted to a fixed authentic status

of representation. Instead, it is the absurdity of the incident that finally brings Thomas, and by extension the viewer, back to seeing as a real subject—that is, as a subject creatively positioned in the world. Ultimately, the meaning of the dead body does not lie in the evidence of its indexical representation, but in the unpredictable bifurcations of life itself.

## Narrativization of "Truth": Ararat

The power of the index, in other words, cannot simply be its ability to convey reality objectively by completely removing the subject. Indeed, even when Bazin stresses the automatic instrumentality of the camera, his concern remains with the connection this objectivity enables between reality and subject. As the examination of the Auschwitz photograph and the Zapruder footage exemplifies, even the most authentic representations are never free of subjectivity. Bringing an image in the process of a communicational schema necessarily subjects it to the variability of the related components. Similarly, it is this qualitative aspect of the index's fictionalization that Atom Egoyan's movie *Ararat* (2002) portrays. The movie discusses the emotional and imaginative participation of the subject in an exploration of the truth behind the Armenian genocide of 1915–18. Acknowledging the scarcity of archival footage documenting the event, *Ararat* makes visual and oral reenactment the central means of encountering the impact of a community's suffering. It tells the story of a director making a Hollywood movie of the genocide, with an epic illustration of drama and action staged from the fictitious point of view of Arshile Gorky (a member of the American abstract expressionist movement of Armenian descent). At the same time, the personal histories of the people involved in the production are juxtaposed so that the discussion of the possibility to depict the trauma and breadth of a historical event becomes a meeting point for emotions, lies, denials, deceptions, and psychological quests that are not restricted by the history of the genocide. Truth in *Ararat* is not a fixed fact, but a force whose nature is malleable so that different possibilities can lead from a mutual origin. Like Deleuze's second chronosign—"de-actualized peaks of present"— Egoyan's approach to reality stems from the incompatible coexistence of opposing experiences of thought, where for one subject the genocide takes place, for another it does not take place, and for others the genocide is a national drama imported into family conflicts and personal traumas. As these worlds commonly compete with each other, they conjure up

a sense of falsehood inherent in the encounter with reality, thus bring-
ing the significance of thought in emotion and imagination to the fore.
Indeed, while Egoyan juxtaposes the Hollywood translation of the geno-
cide with video footage of Armenian shrines in Turkey, he does not allow
either of the representations to depict an objective truth. Rather, he
uses both recording processes as platforms for subjective involvement.

Herein lies the consequence of the object–subject relation: while both
object and subject may exist as separate entities in themselves, they
remain inseparable from the world they inhabit concurrently. The nar-
rativization of the objective on behalf of the subjective does not obliter-
ate it, but sets it in an intense interaction that marks it as a facet of the
same event—both objective and subjective, both denotative and con-
notative, both true and false. Photographic indexicality, in other words,
is a category that is not limited to the objective in the sense of a stable
fixity characterized by an ideal image of truth that remains unaffected by
change. On the contrary, the photographic index is in fact a sign of the
relation between real and subject, a worldly trace via the subjective. As
such, the index is not unencumbered by the attributes of either one of
Peirce's other two signs—the icon and the symbol—in which the subject
plays a founding role. The main difference is that in the latter two signs,
the constructive intrusion is openly evident because the sign is related
to meaning principally through subjective assignment. Nevertheless, the
determining role of the subject is present in all three forms.

Undeniably, Bazin's theory of photography and cinema stems from
the objective nature of the image that is derived from the indexical and
mechanical function of the apparatus. Bazinian reality is the preexistent,
concrete real. Nevertheless, in his emphasis on the powers of the long
take, deep focus, and "image fact"—forms of the image that replicate
the ambiguities of life and offer the chance for the viewer to become an
active participant in the construction of meaning—Bazin is obviously
concerned with the relations in which the subject is placed concurrently
with the objective. The indexicality that the photographic image pre-
serves is part of the events of a world that is mechanically represented as
it had been at a moment of, or during, time. At the same time, however, it
is part of the imaginative experience of the viewing subject who lives the
image as the life she or he is within. As the index is a sign of that which
was there, which actually existed in a time and space, the viewer is the
one who is here, actually existing in another segment of time and space,

for whom the fixity of the index becomes a spark for pleasure, fear, and meaning—that is, for life. Detached from life, the authentic objectivity of the indexical sign means nothing at all because it is denaturalized. The sign gains meaning and potential as it is brought back to life by the reality of its perception.

## Digital Lies: *The Blair Witch Project*

The aim of this chapter has been to think of a point of departure for an examination of digital technology based on its technical functions. For this purpose, I initially explored how the digital forms its images differently from celluloid practices. As opposed to the causal representations of celluloid's photographic basis, the digital uses a series of techniques that quantify the image and render it open to manipulation. Nevertheless, to regard digital images as distinctly subjective due to their symbolic and iconic nature is as problematic as it is to deem celluloid images objective because of their indexical nature. Indeed, both are creative illustrations of objective–subjective structures that are formed through expressive acts, to the extent that this constructedness is a genetic component of reality in general. The digital, as a result, does not lie just because it easily allows for nonexistent events to be portrayed; it is simply as "false" as the photographic, albeit by renewing the means of the image's construction and the structures upheld in perceptual and expressive acts. Consider, for instance, Daniel Myrick and Eduardo Sanchez's horror mockumentary *The Blair Witch Project* (1999), where the deceit originates from digital technology, although not from within the image. The movie purports to be 16mm and Hi8 analog video footage discovered in the woods of Burkittsville, Maryland, which shows the last few days of three student moviemakers who had gone missing. *Blair Witch* makes explicit use of the visual texture of low-budget direct moviemaking, like the news reportage, to create a sense of authenticity; but its success was achieved on the basis of a novelty employed in the promotional campaign before its release. Before the movie reached the cinemas, Myrick and Sanchez used the Internet, which at the time had only recently gained widespread popularity, to fabricate the direct transmission and update of news reports about the missing students.[36] They designed a Web site containing details of the "Blair Witch" legend and related stories, photos, interviews, and news, along with the story of the found footage,

thus crediting the movie with a sense of authenticity.[37] In other words, the trick effect of *The Blair Witch Project* has nothing to do with the tampering of the visual image, but with the manipulation of the Internet's own definitive quality: access to information.

Potentially, Myrick and Sanchez were able to trick their viewers because they were unknown moviemakers at the time, perhaps even because the Internet was a relatively new technology. But this does not fully grasp the consequences of new media. For instance, on October 30, 1938, Orson Welles's radio dramatization of H. G. Wells's *War of the Worlds* deceived its audience into believing that space creatures had invaded Grover's Mills, New Jersey. And in 1996 Costa Botes and Peter Jackson's mockumentary *Forgotten Silver* used supposedly old film footage to convince New Zealanders of the existence of a local cinema pioneer, Colin McKenzie.[38] Artifice, it seems, cannot be easily situated within medium specificity. Similarly, Mitchell's exploration of visual deceit refers to the example of Henri de Toulouse-Lautrec's 1890 photograph of himself in the position of both painter and sitter, as well as Woody Allen's photographic pose with Calvin Coolidge and Herbert Hoover in his 1983 movie *Zelig*.[39] How, then, can one obtain a view of medium differentiation between celluloid and digital technology? Or expressed differently, what is missing from the digital that celluloid upholds?

### Digital Lies: *Forrest Gump*

Not far from Toulouse-Lautrec's and Allen's simulated encounters is Tom Hanks's own brief meeting with John F. Kennedy in Robert Zemeckis's movie *Forrest Gump* (1994). The movie is an epic tale of twentieth-century American history told through the eyes of a developmentally disabled man, Forrest Gump. An extraordinary box-office hit, *Forrest Gump* gained fame for its elaborate use of digital techniques (digital-image processing and CGI) to create images of swiftly floating feathers, vanishing legs, and seamless interaction between old news footage and newly shot scenes in the studio. With digital-image processing, Zemeckis managed to remove visual elements like Gary Sinise's legs after his character is wounded in an attack in Vietnam. Further, using CGI the director created animated models (a speedy Ping-Pong ball), as well as composites of different visual layers, as in the case of Hanks shaking hands with Kennedy. Admittedly, both methods supersede the capabilities of celluloid effects due to

the scale and verisimilitude of the accomplishment: Hanks moves into Kennedy's frame and interacts with him as opposed to the static poses of Toulouse-Lautrec with himself, and Allen with Coolidge and Hoover; and Sinise swings his erased legs through physical (or seemingly physical) objects. Yet neither Sinise's digital amputation nor the Hanks–Kennedy simulated interaction has any grave effect on the status of reality, as viewers will recognize the artifice because of the people involved: Sinise is not really amputated, and Hanks cannot be physically interacting with Kennedy because the latter is long deceased.

Of course, as Sobchack points out insightfully in her essay "The Charge of the Real," audiences are hardly ever fooled into mistaking real footage for fiction, and vice versa.[40] Instead, she maintains that the viewer's existential knowledge of reality is not sealed off from cinematic fiction, but is temporarily bracketed so that the viewer can enter the fabricated field of the movie and play along. Nevertheless, the ability to enter into a documentary or fiction conversation with the movie is dependent on the viewer's awareness of the representation's status. From this point of view, the reality effect of the image shifts from the indexical to the perceptual that is grounded in the spectator. In his essay "True Lies," Stephen Prince similarly develops a theory of perceptual realism allowing for an interpretation of cinematic reality according to the visual form of the image: visual and social cues in the image are filtered through and interpreted on the basis of the viewer's experiential knowledge of reality.[41] As such, Prince insists that realism, being perceptual, need not be judged on the basis of the means of construction (indexical or symbolic), but on the structural verisimilitude of the result—that is, whether the image corresponds to the viewer's empirical relation to the three-dimensional world. Even though the Hanks–Kennedy meeting is referentially unreal, it is perceptually realistic and so constitutes a sufficient degree of real correspondences. In contrast, the photography theorists David Green and Joanna Lowry do not disqualify the perceptual importance of indexicality, but instead align the index with the creative gesture of the creator.[42] As indexicality is not expressive of causal reflections of light, but of the imaginative reflections of the artist on the world experienced in her or his creative work, the index for Green and Lowry is performative. Likewise, Marks assigns a sense of materiality to digital technology—and thus an association of the technology to reality—based on the image indicating a series of gestures on behalf of the creator, which resulted in the corresponding

544

Controlling digital reality through seamless compositing. Still images from *Forrest Gump* (Robert Zemeckis, 1994).

representation.[43] In other words, these debates conclude that it ultimately does not matter that the digital converts the referential premises of celluloid's ontology.

Indeed, these views are fascinating in their attempt to resolve the paradox that digital technology causes with regard to its relation to reality. Nevertheless, they all assume their standpoint from one aspect of the subject's implication, thus limiting the basis of the reality effect to either the viewer (in Sobchack's and Prince's case) or the creator (in Green and Lowry's and Marks's case). Moreover, the world as an active agent of real events and gestures that relate to its own inherent structures and multiple interactions loses its significance. Looking back at the ideas examined by Bazin, photographic reality evoked an element that remained part of the fixed nature of the index while allowing it space to breath—an issue that was translated in Barthes's punctum. The element I am referring to is the ambiguity of life expressed through the limitless and incalculable unfolding of events due to the complex structures that form its existence. Contingency, the chance occurrence, the incalculable, that which remains uncontrollable as a part of life that simply is—this is the

165

aspect of reality that seems to be suffering the most from the immense control and manipulability that digital techniques enable. The difficulty that the digital presents is not simply found in what is openly added or evidently erased, but in what is missing without a trace. Indeed, this matter becomes apparent in the extra features of the *Forrest Gump* DVD that include details on how the movie was made. Beyond the digital amputation of Sinise and the artificial interaction of Hanks and Kennedy, the extra features reveal that there are moments that hide more than can be detected. For example, during an ambush that the American troops suffer in the Vietnam War, Forrest Gump (Hanks) carries his injured friend and fellow soldier Bubba (Mykelti Williamson) away from the battlefield. But the viewer does not know that what seems to be one shot is actually three takes seamlessly integrated: during the first take a stuntman carries Williamson half the way; during the second take Hanks replaces the stuntman and continues the move; and during the third take bombs explode in the landscape without any of the actors. This example draws attention to the fact that every aspect of the digitized image is subjected to the scrutiny of the creators, who control what is and is not desirable in the depicted world. Digital reality thus seems to favor a controlled

environment determined to reveal whatever its creators specifically aim to convey. This is not to say that a digital movie can never be free of any manipulative intervention; but it does mean that the numerical, discrete, and immediately accessible structure of the digital affects the expressive creativity of the creator as well as the perceptual awareness of the spectator, as there is always the possibility of some intervention and an undetectable determination.

## Digital Lies: *No Maps for These Territories* and *Naqoyqatsi*

This matter can be illustrated further in a wonderful piece of independent moviemaking, Mark Neale's digital documentary *No Maps for These Territories* (2000), which distinctively allows its digital foundation to be manifested. The movie follows a series of discussions with William Gibson, author of the 1984 science-fiction novel *Neuromancer* that coined the notion of cyberspace as an extremely intricate network of a computational posthumanity.[44] Speaking to Neale's camera, Gibson explains how mediation is so firmly entrenched in contemporary society that it is impossible to return to any previous sense of unmediated reality. The world, for Gibson, is a constantly accelerating, unstable state of being, wherein computation and genetics have been combined to reach the point of immortality. He explains, "There would be . . . no reason to die, if you had sufficient nanotech to keep resetting the cellular clocks." Time in this view becomes irrelevant. The natural contingency of life, from the smallest unforeseen events to the irreversible condition of aging and death, is replaced by an absolute control that drains life of its creative potential. And so one is left with a reality where no existentially defined body lives anywhere, at any real time. Indeed, Neale's documentary stresses this issue in a number of ways. During the entire documentary, Gibson is seated in a car, where he answers questions and talks about his work and ideas. As he travels from south of Los Angeles to Toronto, Gibson seems to be in a constant state of displacement so that he is not situated anywhere. Moreover, there are times when the car windows become composites of two different exteriors, so that through one window the car seems to be going backward in time, and through another window it is someplace else, moving forward. The spatial and temporal continuity of the index's ontology is annihilated so that Gibson is literally disengaged from the world. In a more disconcerting scene, U2's lead singer, Bono, is seen from a billboard in Portland reading from *Neuromancer*. There is

nothing surprising about the scene in itself: compared with the images of the car's windows, the viewer assumes that Bono's projection had also been digitally added to the environment. It is only from the extra features of the DVD that it becomes apparent that what seems to be a composite space is actually real space: the billboard is a video billboard that directly projected Bono's image for an hour during shooting.

Similarly, in Godfrey Reggio's compelling documentary *Naqoyqatsi: Life as War* (2002), the convergence of physical and digital reality becomes the entire theme. *Naqoyqatsi* is the third part of the Qatsi trilogy that began with *Koyaanisqatsi: Life out of Balance* (1983), Reggio's debut movie that dealt with the effects of the industrialized market and its strategies of standardization and abundance. Making use of recording techniques to alter the visual result of the image (mainly slow-motion and fast-forward), *Koyaanisqatsi* creates an urban space that is not opposed to natural environments, but is made to converge with them. For *Koyaanisqatsi*, life is out of balance because of an accelerating drive toward technological and financial exchange and consumption: contemporary living is life *as* technological and market forces. *Naqoyqatsi* continues with the examination of the implications of technology for contemporary reality, but the technology now prominent is not the electric, but the electronic. Life as war in *Naqoyqatsi* is not a reference to organized or unorganized warfare, but to an absolute transition from physical reality to reality as computational technology. The word *naqoyqatsi*, the viewer is told, is from the Hopi language, meaning "each other–kill many–life," from which Reggio concludes—civilized violence. Indeed, the movie consists of realistic CGI compositions, actual footage that has been digitally filtered to take on a uniform tint and peculiar perspective, digital illustrations of mountains, morphing people, floating signs, and graphically rendered animals. And as the zero–one binary form of the digital's numerical structure fills the screen, it becomes clear that reality has become inseparable from the world of computers.

Both Neale and Reggio's movies create a sense that the index's absence from digital configurations annihilate the existential grounding of the celluloid's image altogether. The two movies have been blatantly processed inch by inch, as if the software sucked up any reality from their images. In this view, the digital appears like a black hole, violently clearing away any unwanted particles from the visual field in order to form a predetermined, finite arrangement. What, then, of the associative exchanges that celluloid's causality upheld between reality and subject? As the variability

The world as a computational reality. Still image from *Naqoyqatsi: Life as War* (Godfrey Reggio, 2002).

of real time vanishes from the digital's controlling techniques, one must ask whether reality can continue to maintain any relation with cinematic creation at all. Reality—as a complex exchange of interrelated components that function as distinct yet concretely enmeshed structures of life, where indeterminable ambiguities are uninterruptedly set in motion, this reality that the index so openly expresses—is what is missing from the prearranged grid of the digital's Cartesian codification. In other words, the symbolic foundation of the digital does not point to a loss of authenticity or objectivity. Rather, it induces an elimination of the existential awareness that the indexical image enabled, with its creative potential. Nevertheless, instead of charging the digital with an irretrievable loss, I argue that it is more fruitful to examine how celluloid's structures may in fact be reset in cinema's new media. In the chapters that follow, I will be guided by the conviction that reality can still be found in the digital and that the computational image is still a real platform where the subject can encounter the world and in which she or he may still find her- or himself. Rather than thinking of what is simply missing from the digital image irretrievably, it will be a matter of interpreting how the technology makes up for its losses.

# 2  PHYSICAL PRESENCES

*Reality, Materiality, Corporeality*

DIGITAL TECHNOLOGY'S NONINDEXICAL OPERATION prompts an uncertainty in the authenticity that celluloid film reflects. As the digital no longer bears a directly causal reflection of a real event or person, the moving image seems to lose its evidentiary ability to document the world. This shift stems from two main features that the new technology enables: the unprecedented seamlessness and detail in the manipulation of images it records; and the perceptually realistic appearance of the images it generates through computer software. As I discussed in the previous chapter, however, the problem with this argument is that photographic recordings (still or moving) gain a sense of authenticity as the viewer mistakes mechanical automatization and indexical causality with a dissociated epistemology and a belief in neutral truth values. On the contrary, it is for another reason that digital images cannot re-create celluloid's direct relation with reality. Unlike celluloid's chemical reactions, which are caused by the patterns of light in physical reality, the digital does not function by transcribing at all. Here the ontological underpinnings in which my study is interested converge with the material guarantee of celluloid made perceptible in the physical bond between reality and the technical elements of the technology. My interests lie precisely in the analogical convergence between reality and celluloid representation, and the corporeal impact this relation has on the viewer.

While digitizing entails locking proportions of color and intensity on a grid and then assigning a number to each point, the digital seems to emphasize the immaterial state of its representations. Digital images themselves are not tangible because they consist of a series of interrelated numbers stored on a computer hard drive and made visible through a screen. In this case, it is not reality as objectivity that is questioned, but

reality as physical substance and, by extension, corporeal involvement. Being nonanalogical, digital images do not bear the physical traces of their source and do not manifest a relation to that source in palpable form. On the contrary, they are symbolic encodings that are not tied to any specific substrate. The materiality of digital images is connected only to the media one needs in order to see them as perceptible visible depictions: the carrier of the information (DVD, hard drive, etc.), the player, and the screen. It is on these grounds that the media theorist Timothy Binkley makes his distinction between the analog and the digital in his essay "Refiguring Culture." Here he writes, "Analogue media store information through some kind of *transcription* which transfers the configuration of one physical material into an analogous arrangement in another."[1] As an example he turns to the *Mona Lisa*, and he initially asserts that its analogical status is founded on the fact that it mimics in paint the appearance of a person in flesh. He clarifies that it does not matter whether Mona Lisa exists as a historical figure, because the painting's representational status follows a paradigm of portraiture whereby an actual figure could look like her even when no one really does. Nevertheless, while emphasizing acts of transcription and mimicry as keywords for distinguishing analogical images from digital alternatives, at first Binkley confuses the two modes of creation, leaving out an important aspect of analogical processes. It is when he speaks of paintings that have no representational subject that he comes closer to the matter at hand. As he explains, "The medium still registers at least the artist's gestures transcriptively as they impart analogous forms to paint: a straight movement of the hand creates a straight line, while a curved movement produces an arc."[2] In other words, Binkley minimizes the importance of *visual semblance* only when he turns to abstract forms. The fact, though, is that the processes of analogical creation are not based on how a depiction looks but how it is created. The correspondence between reality and its analog image is a matter of an analogical physical transformation: light waves are not transcribed symbolically on celluloid film, but their intensity molds the physical substrate directly. The *Mona Lisa* is not analogical simply because the figured portrait bears a resemblance to a person, but because its painterly form is shaped from the movement and intensity of Leonardo da Vinci's hands, the textures of the brushes, and the density of the paint.

Indeed, analogical transcription is a material matter because the quantitative configurations of reality's substances correspond to isomorphic transformations of the recording material. What is more, the analog

image does not discontinue this transformation after the initial transcription. Usai's brilliant discussion in *The Death of Cinema* shows how the materiality of analog film is extended in time because of the actual degradation of film stock.[3] Besides accidents in the function of the apparatuses, or mishandlings or mistakes in any contact with the materials, there are also physical and chemical agents that uninterruptedly affect the stock. These alterations can take the form of scratches or tears to the print, curling of the film stock, color alterations, or general physical decay. In other words, the physicality of celluloid film is not dependent on it simply being tangible, but is a consequence of its organic materiality. In contrast, digital images, being configurations of stored numbers, are not physical objects, they do not bear transformations that correspond to changes in the world, and they do not organically change. This is why a digital element (be it a still or moving image, a document, or a complex software program) is not affected when copied from hard drive to hard drive: there is no object being transferred, only numerical correspondences. As such, the digital questions the material connection of the image to its physical source, but also to its encounter with the creator or spectator.[4] Based on celluloid film's material physicality, this chapter thus focuses on how digital immateriality affects the contact between movies and the individual. To do so, it will first be necessary to explore the extent to which the material forms of celluloid play a role in the affective responses made possible with the movie image.

### The Physical Reality of Kracauer's Film Theory

My primary concern in the following pages will be to see how digital images change the sense of materiality tied to analog cinema. Celluloid film does not simply depict reality but carries it in its photochemical cells. It is for this reason that Siegfried Kracauer sees cinema as the art of redeeming the material world from the shadow of ideological frameworks. In his book *Nature of Film* he explains that movies turn the viewer's attention toward the world, assisting her or him in discovering its material proportions and the psychophysical correspondences in which world and subject are related. In directly recording reality, celluloid film makes physical reality visible by revealing its spatial and temporal structures and substances. Based on this revelatory capacity, Kracauer defines film as a medium with the unique ability to promote the redemption of physical reality. He writes, "Its imagery permits us, for the first time, to take away

with us the objects and occurrences that comprise the flow of material life."[5] Nevertheless, film does so because the materiality of its representations corresponds to the physical world it depicts. Kracauer is thus critical of those movies whose structure artistically overwhelms reality instead of allowing it to be concretely displayed. In these cases, he maintains that, by imitating painterly styles and motifs that do not belong to cinema's aesthetics, the moviemaker nullifies film's inherent affinity toward nature.

Contrary to Kracauer's approach, reality is actually always manifested in film in some form or other precisely because it is directly transcribed there in physical form. René Clair's movie *Interval* (1924) is an exceptional example of the physical bond between reality and the image, even while it belongs to the tradition of French Dadaism that built its aesthetics on a radical break from social and class conventions through absurdity, sarcasm, and playfulness.[6] As such, *Interval* turns toward the absurdity of objects and life, and so favors the intrusion of the artistic gesture and imagination over celluloid's physical inclination to reality. The twenty-two-minute short movie is a bizarre mélange of events and images, which was initially screened as an intermission between the two acts of Francis Picabia's ballet *Relâche*. It begins with a self-moving canon that Erik Satie and Picabia fire as they leap back and forth in slow motion. The following scenes move arbitrarily from situation to situation: deflating and inflating balloon dummies; a twirling ballet dancer seen from below a glass pane (later revealed to be wearing a man's beard); a pair of boxing gloves throwing punches at thin air; Paris by day and by night; and the events surrounding the accidental or deliberate murder of a man and the comical funeral procession that follows his death. While the narrative continues with a desire to mock the French middle class and its elitist societal practices, it nonetheless manages to draw the viewer's attention to what she or he is seeing: a world of independent yet concurrent events that take place between objects and individuals equally alive, both expressions of agency.

To be sure, the ability of *Interval* to forge a close bond with physical reality takes place amid its ideological aims. For example, as the balloon dummies deflate, the drawn faces that decorate them lose their form and vanish; and as they inflate, the possibility of their total destruction (due to overinflation) marks their presence as potential transformation. In other words, the physical change of the balloons and the interdependence of their exterior and interior substances (their plastic surface deformed in

accordance to the pressure caused by the amount of air they contain) are themselves marks of physical reality. The continuous and contingently changing structure of these objects conjures up their material nature despite the artistic interference of Clair. This immediacy of physical reality in celluloid is made even more obvious in the funeral procession, during which the lined-up followers leap behind the moving carriage in slow motion: both the absurdity of the human bodily behavior (the act of leaping during a funeral) and the irregularity of the filmic material form (the slow motion) emphasize the physicality of both the real event and the technology. During yet another scene, as the funeral carriage suddenly breaks loose and starts rolling down and up the hill, the followers start running after it. It is at this point that the shots openly express the uniqueness of the subjects' corporeality as they feature a plethora of bodily figures, gestures, and expressions. Indeed, it is the very material uniqueness of the body that is an elemental part of celluloid film's representational structure—the fact that what the viewer sees is not just patterns of light projections but also material relics of a past light replayed in motion.

Kracauer's approach to physical reality stresses that it is not the distortion of the image by the camera or editing equipment that causes a deviation from film's nature, but its subjective ideological treatment by the moviemaker. Movie techniques, like framing from close-up to long shot, cutting, speeding up or slowing down, still establish physical existence because, in a sense, they dwell on the spatial or temporal aspects of reality—its patterns, magnitude, and movement. As movies explore the forms of physical existence, they reveal these forms to the viewer, making the world available to view. The film camera is, as Kracauer maintains, a recording and revealing device. It is this dual role of celluloid that interests me, too, because it sets up a relation between the image and reality that necessarily involves the spectator: in recording physical reality, filmic images are points of departure for a revelation of the world to an audience. Therefore, in asking how celluloid gains a sense of materiality I am not simply asking what its technology does in itself, but what it does in relation to the reality of a viewing subject's corporeality as well. The amalgamation of light and matter is not a revelation in itself, but a perspective through which the viewer gains an awareness of her or his own place in reality. If there is no subject for whom the real quality of the image can become an exploration of the world and of living, then the quest of the real in the image loses all substance.

In the same tradition of Dadaist movies, Man Ray's *Return to Reason* (1923) is not so concerned with mocking the bourgeoisie directly, but in critiquing an elitist understanding of art by introducing an artistic vision of everyday objects and events. Here Man Ray connects abstract patterns and shapes, particles, a pushpin, nails and other objects, shots from a merry-go-round, and a woman's torso, to create an assemblage of arbitrary images.[7] Except for the exterior shots and the shots of the woman, the images of objects are created with his famous rayograph technique, with which he makes prints of items as he places them directly onto photochemical film that he then exposes to light. Indeed, the connection between physical matter and its direct imprint on celluloid is most evident in this technique: the image is literally formed by the material contact with a substance. As such, to describe these images merely as iconic images (according to Peirce's definition of the icon as a sign based on resemblance) results in a crucial omission, because what is visible is directly that to which the film had been subjected at the time of its creation: nails, a pushpin, and so forth. As those elements existed then, so they are seen now.

Although filmed conventionally with a camera, the woman also continues the physical connection between reality and celluloid because the filmstrip was subjected to the luminosity of her presence. She is seen in the same way she existed when she was filmed eighty years ago. But there is something else that draws me closer to the image, a sense that does not refer simply to the physical reality of the image, but to the very encounter of this viewing. This is the presence of my own vision, an essential feature of the present encounter that is imbued with the space and time that surrounds it. When I see that woman, I do not see her purely as she was; I see her in the past as she is now for me. I look at her beauty, but I know that I can never seize her, for all she can be now is a play of light in my imagination. What is mine is my imagination, but she is never simply here for me. In other words, while knowing that she existed in the past, I am drawn to her, only to face the impossibility of an intimacy due to the barrier set up by the screen. What this means is that to think of the physical reality of film necessitates a consideration not only of what happened in the past, but also what takes place in the present—a present that is outlined in the encounter between image and spectator. It is necessary, therefore, to seek out how the materiality of film is extended to include the sensualization of the viewer's own physical body.

## Shaviro on the Cinematic Body

An immediate response to the question of spectatorial affectivity comes from the most basic functions of cinematic conventions: the persistence of vision. As celluloid projections rush by, one after the other, at the rapid speed of twenty-four frames every second, the spectator is forced to reconstruct the fluidity of the movement through the perceptual functions of vision, albeit unknowingly. Recent scholarship has suggested that the theory of the persistence of vision is somewhat flawed, as can be ascertained from television technologies where engineers had to interlace the scanning sequence through a cathode ray tube display to get rid of the visible darkness between images.[8] Nevertheless, it is necessary to keep in mind that the reconstruction of the image's motion still necessitates some biological function on the part of the spectator—whatever this function might ultimately entail.

Speaking of the spectator's corporeal participation in film's cinematicity, the cinema and media theorist Steven Shaviro writes in his book *The Cinematic Body* that, as the image acts violently on the spectator, the individual becomes involved in the movie through bodily reactions before she or he has the time to mentally reflect on anything. According to Shaviro, the images pass in front of the spectator and excite the retina at a speed suitable for the stimulation of the brain but too fast for the procedure to become conscious. He thus turns to movies where bodily sensations are more vividly portrayed (e.g., thrillers, horror movies, or Jerry Lewis's intensely physical slapstick comedies). While watching such movies, Shaviro maintains that it is impossible to be detached, to remain uninvolved from the immediacy of the sensations that rapidly arise.[9] As the body is confronted and assaulted by a flux of sensations, the viewer, Shaviro insists, cannot attach the experience to physical presences and she or he cannot turn toward a predefined symbolic order of reflection— that is, language. The moving image is not an invitation to a dislodged perception of meaning, but a forceful invitation to the senses.

The importance of Shaviro's discussion is that it is aimed at showing quite convincingly that the spectator is not a simple eye positioned against the image, but a sensual component of cinematic encounters. Movies cannot be reduced to simple illusions because the body is vividly involved in the actual making of their mobility. The viewer as an affective body is a corporeal plateau that is sensually triggered by the visual

splendors of the screen. Indeed, this physical implication of the viewer is apparent in cases where the image portrays an extremely violent explosion of death and frenzy. Consider, for instance, Sam Peckinpah's *The Wild Bunch* (1969), a movie that is used as a canonical example in cinema studies of the shift in American production in the 1960s. The movie is an epic modern Western set on the borders between Texas and Mexico before the outbreak of World War I in Europe. It depicts the story of a group of five outlaws as they cross paths with the savage ruthlessness of a local oppressor in Mexico, but find themselves in a battle with their own principles and their necessity to change along with the relentlessness of the new industrial world. Of course, the movie has gained fame for its final scene, whose explosive end—depicting a mass of people torn to pieces by a storm of gunshots—causes an immediate shock due to the violent bloodbath.[10] The intensely prolonged scene of the continuous shooting, with rapid editing, slow motions, and fast zooms, is so powerfully constructed and so uninhibitedly raw that it grabs hold of the viewer, making the depicted violence be experienced in the flesh. Nevertheless, contrary to Shaviro's views, this experience is not limited to the sole impact of the visual aspect of the movie on the viewer's body. Indeed, in the discomfort caused by the visual demolition of what seems like a whole civilization, *The Wild Bunch* was both criticized for reflecting contemporary U.S. history, from President John F. Kennedy's assassination to the Vietnam War.[11] There is a sense, in other words, that the impact of the movie is not restricted to the *visceral* response of the viewer, but is also related to a *mental* stimulation that can make associations outside the immediate experience of the screening. Conversely, Shaviro insists that the visceral involvement of the spectator is attributed to an exchange between the absence of any representational quality in the image and the presence of film's luminous impressions on the retina that linger even after the actual image has disappeared. In fact, the continual exchange between what is absent and what is present is the base for Shaviro's whole discussion of the spectator's corporeality. As I will explore, his approach is intriguing in its attempt to bridge a way back to the bodily involvement of the viewer, but in so doing it unnecessarily leaves the celluloid image itself without a body.

Shaviro opposes psychoanalytic models and phenomenological methodologies in theories of spectatorship in order to shed some light on ways through which the hierarchical structures of Cartesian dualism can be rethought in film theory.[12] In order to do so, Shaviro wraps the viewing

subject and viewed object tightly together. He explains that while the eye is forcefully engaged in the process of viewing, the image is presented as a disembodied view. It is nothing more than an image and necessarily not a representation. It cannot induce a link to an exterior or distant world because it would then be reduced to a probing mechanism of reality for the benefit of the viewer. In this case, the viewer would subject the representation to the scrutiny of her or his gaze, placing reality under the authoritative control of the perceiving eye. As such, Shaviro follows Deleuze to propose that the image is not grounded in any physical reality but is forced directly onto the surface of the viewer's own body. The reality of film's viewing processes is thus the immediate shock of a vision that is actively stimulated while any mental response lags behind. Subjective perception is made possible, but primarily through the ungraspable physical shock of nonperception. As the object–subject dichotomy becomes impossible, it collapses in favor of a viewing experience that redeems the viewer's body as a plane of corporeal involvement rather than a point of meaning. Explaining further, Shaviro writes, "The disengagement of a primordial or preoriginary level of perception violently excites, and thereby fascinates and obsesses, the film viewer. Perception is turned back upon the body of the perceiver, so that it affects and alters that body, instead of merely constituting a series of representations for the spectator to recognize."[13]

In other words, Shaviro sees the absence of meaning in the moving image as a means of reestablishing the spectator in the process of viewing as a sensual awareness of, and integration into, change. The spectator's body is in the same stream of force as the image; they encounter each other in the flesh without being able to be withdrawn from their collision by exterior references (a represented world or a predetermined contemplation). As the materiality of the image is brought to the surface of visual stimulation, it cannot retain the status of an object for any actual or ideal spectator; and the spectator is drawn into—that is, made part of—the image, physically afflicted and viscerally intensified by sensations rather than ideological beliefs of any sort. Here is where the body becomes a vivid component of viewing that film induces.

Without a doubt, Shaviro's theorization of spectatorship is valuable in its attempt to break down the opposing realm of a Cartesian ocular culture. Nevertheless, it does so by way of a complete annihilation of the two other material components I have been discussing: physical reality and technology. While the reduction of the filmic image to pure visual and

aural stimulation assists in regenerating the importance of the viewer's corporeality, it is a matter of great loss for the investigation of how the medium's materiality—its technological specificity—takes part in the changing experiences of movies. Indeed, the pureness of the image that Shaviro describes resonates with Deleuze's exploration of emptied and irrational spaces and sounds (opsigns and sonsigns, in the latter's terminology).[14] For the French philosopher, the distinctiveness of a subjective consciousness is also brought under the pressure of a nonperceivable— that is, arbitrary—stimulation (an issue I will explore further in chapter 5). Still, I am less certain than is Shaviro that the effacement of the reality with which the image is linked is either viable or useful. It is not the *emptiness* of the image that draws the spectator in touch with her- or himself as corporeally active and altered, but the image's own material force.

### Empire of the Senses: Film Bodies

Although not concerned with the technological aspects of spectatorship, Linda Williams's position on the bodily influences of spectatorship offers a certain path that is useful in seeing how the physical reality of the image might have consequences for the visual appreciation of movies as well. In her essay "Film Bodies," she explains that the gratuitousness of sex, violence, and emotion in pornography, horror movies, and melodramas, respectively, qualify for a concrete bodily reaction in the viewer.[15] The ecstatic excess of these genres, she explains, are brought into the body as an uncontrollable convulsion or spasm as it is gripped by sexual pleasure, fear, and sadness.[16] Not only are the actors' bodies exhibited in the movie as they are aroused, intensely threatened, or emotionally distressed, but so are the viewers' bodies that share these emotions as physical changes, too: sexual stimulation, heightened pulse, tears. But there is an interesting point to take note of here: the visceral alignment of the viewer with the image is made on the premise of an actual body being affected in the image. This is more obvious in the case of sexual explicitness, as the behavior of the actors' bodies cannot be artificial even when their emotional involvement might be.

Consider Nagisa Oshima's *Empire of the Senses* (1976), which uses strongly explicit images to achieve its aims. In its transgressive combination of sex and violence, the movie embraces the viewer, denying her or him a distanced viewing position. Set in Japan in 1936, *Empire of the Senses* explores the tension between oppressive domination and escape,

between moral and corporeal boundaries, between sex and violence.[17] Recounting the story of the intimate erotic experiments of a geisha and her master, the movie overturns the Japanese tradition of masculine superiority by giving power to the woman in the pair's sexual encounters. What is more, in explicitly portraying these encounters as an actual sexual involvement of the actors, the movie manages to lure the viewer into sharing the physical excitement. The intensity of the experience is projected as a qualitative response in the spectator based on her or his awareness of the physical reality of the image. *Empire of the Senses* thus depicts the benumbed physicality of the viewer as a problem that is not solved in the emptiness of the image (in Shaviro's understanding), but in its corporeal abundance. In similar fashion, Hideo Nakata's *The Ring* (1998) invades spectatorial space through the fear induced by the actor's body visually breaking the limits of the screen and disrupting the safety of spectatorial distance. The movie tells the story of a videocassette that releases the deadly powers of a dead girl's spirit, Sadako, who haunts each viewer who plays and watches the tape. In a sense, the videocassette—an item of spectatorial experience itself—unleashes Sadako's body, making it omnipresent: during one scene, for instance, the girl crawls out of a television screen to grab and kill her spectatorial victim. In other words, both *Empire of the Senses* and *The Ring* show that the direct expression of the image's physicality can become a means of reconstituting or heightening a corporeal involvement in the spectator. In both cases, the viewer is brought in touch with her- or himself because the neutrality of the viewing process cannot be retained: in *Empire of the Senses* subjective detachment is reversed on the basis of the actors' sexual stimulation, whereas in *The Ring* the image itself is manifested as materially tangible in the form of the videocassette and the pierced screen. The analog image is not simply an image as Shaviro maintains, but a point of physical exchange.

To be sure, I am interested in how the visceral impact of these movies is not necessarily supported by a disconnection from the image's physical reality but gains strength based on their link back to reality, in which the spectator is also found. Instead of becoming a vacuous cause of stimulation, the corporeal involvement of the viewer in the viewing process can be thought of in relation to the overt representation of physical reality and the technology's own material status. Indeed, the issue of the image's material plenitude becomes, in Laura Marks's approach, a matter of "haptic visuality." It is important to note that Marks, like Shaviro, is also interested in overthrowing the hierarchical structures of mastery

and enslavement that may derive from Cartesian dualism, but instead of emptying the image, she looks at how its plenitude can resolve the problem.

## Material Plenitude: Marks and Haptics

In her book *The Skin of the Film,* Marks examines how the values of Deleuze's "time-image" can be traced in intercultural movies that deal with immigration, diaspora, exile, and colonialism. In her analysis, she shows how these movies, through textual density and narrative incongruity, yield a sense of disjunction and ambivalence experienced by the moviemakers who have lost a sense of national anchoring. In so doing, she shifts the effects of the interval (discussed on the basis of the unhinging of the image from rational fixity) to the level of the image's texture. Marks turns to movies that graphically portray their materiality by creating images that are like textiles, explicitly embossed or textured with alternations of the focus, enhancement of grain and scratches, double exposures, under- or overexposures, variations of speed, manipulation, or just natural decay of the stock. These "haptic images" attach the viewer physically to the materiality of the image. As they cannot be interpreted rationally, they require a certain degree of puzzlement on the part of the viewer; but as the viewer cannot easily explain these distorted or complexly textured images, she or he must turn to a personal repertoire of memory—a virtual repository of images—in an attempt to make sense of them. Marks writes, "The inability to recognize an image encourages us to confront the limits of our knowledge, while the film's refusal to extend into action constitutes a refusal to 'explain' and neutralize the virtual image."[18] In other words, as the density of the image deprives the viewer of habitual perception, in a sense it forces her or him to move toward the screen and fumble around for meaning. This personal involvement in densely sensual images, Marks explains, constitutes a cinema of haptic visuality.

The idea behind haptic visuality is the sensual rather than mental stimulation of the viewer for interpreting the image. Indeed, "hapticity" is a way of looking at the effects of gaps that tend to eliminate the notion of determinism. However, unlike in Deleuze's analysis, the body is what is at the forefront of the perceptual process, thus prioritizing corporeal memory and knowledge. The haptic opsigns evoke recollections that correspond to bodily experiences as the viewer tries to identify with the multitextured images on the screen. As a result, the image becomes

a body that is fossilized and revealed through a unique contact with the viewer's corporeal sensualization. Marks calls this way of encountering the image "mimetic," because it involves a physical contact between the image and the viewer much like the physical contact of the indexical sign and its cause. Imitating is used here in the sense of a form of representation whereby what is represented is reenacted. Marks explains, "Mimesis, from the Greek *mimeisthai*, 'to imitate,' suggests that one represents a thing by acting like it."[19] Her understanding here is different from Bazin's idea of artistic mimesis, which seemed to satisfy illusively the desire to evade death through an iconic representation. For Marks, mimesis is in fact an indexical representation: as the viewer brings the image into her or his body to decipher it physically, she or he reenacts it, thus realizing it existentially at that very moment. This is a form of spectatorship that ultimately fosters a continuity or direct impact of the world and its representation in the actuality of the spectator, such that she or he is dynamically brought up against this contact in the flesh. As such, haptic visuality overturns the dispassionate distance of a purely optical perception. Instead of identifying objects—and the world—from afar, haptic visuality brings experience inside the details of the representation as a sensual closeness.[20] Haptic visuality is a matter of an intimate relation with the image that brings the viewer closer to it, into it, to the point of rubbing her or his body against it.

While achieving the important task of emphasizing the role the body can take in the experience of moving images, Marks restricts her analysis to what takes place on one side of the screen. Like Shaviro, she does not turn to the physical layers that lie behind the image. To recall my example of the woman in Man Ray's movie, it is not simply a nude female torso that fascinated me, but the voluptuousness of the model, her posture and archaic proportions, and the sensuality of her undulating body in the light and shadows. Her impact on my senses is not restricted to her luminous emanations as I remain in front of the screen, but extends to the matter of her presence in front of Man Ray's camera. It is not simply her visualization in the image that excites me, but her physical presence in a distant moment of the past. It is here that spectatorship gains the potential of becoming an experience that does not necessitate the effacement of reality, but is built on its insistence in the image.

To obliterate any materiality on the side of the image would mean that the technological instrumentality of the image did not matter at all. Instead, it should be possible to embrace the hapticity of the image as it

is structured not only in the present contact with the spectator but in the past contact that the image expresses with the world. It is precisely this relation between viewer and screen, and screen/camera and world, that allows Sobchack to think of the image as an existential subjectivity in her book *The Address of the Eye*. As I will now explore, Sobchack's approach to spectatorship is inspired by the perceptual alignment of spectator and film that lends each other a sense of corporeality and an existential place in the world. It is her emphasis on the corporeal perspectives of movies that are of utmost interest to my own study.

## Film Matters: Merleau-Ponty and Sobchack's Existential Phenomenology

Sobchack's work on existential phenomenology addresses the idea of vision as an embodied and meaningful existential activity. Through her reading of Merleau-Ponty's existential grounding of the body, she interprets the moving image as a representation that is not opposed to the subject as object, but is understood as a subjectified object and, by extension, an objectifying subject.[21] Sobchack explains that, as the embodied subject comes to grasp the world through perceptual organs, and expresses her or his own position in the world through a sensing body, the viewer is inspired to make meaning of the world in the modes with which she or he makes meaning—that is, through the body.[22] This mode of interaction is indeed a matter of phenomenology's "intentionality," as I explained in the introduction. Perception of the world becomes a perception *of* the world because it entails incorporating the body's internal operation in its external affiliations. In perceiving, therefore, the body is also expressing itself; and so the meaning the body makes of the world is infiltrated by the means by which it makes that meaning. In so doing, the image is also understood as a meaningful bodily act of perceiving and expressing: as it makes present an act of seeing the world and seeing in the world, the moving image is itself a presence of a seeing agency in the world.

It is important to note that Sobchack advances her argument on the basis of celluloid film's ability to create a moving rather than a static image. As film makes motion itself a perception, it expresses its presence as a becoming. Sobchack writes, "Film is always presenting as well as representing the coming into being of being and representation. It is a presence inserted in the world and our experience not as a series of discrete, transcendental, and atemporal moments, but as a temporal

*movement*—as a presenting felt as presence and its passing, as a presence that can then be said to have a past, a present, and a future."[23] What she terms film's "body" is a movement in time and space that actualizes life as a multiplicity of lines and planes and their interaction ad infinitum. Through the succession of the photographic stills that create its cinematicity, film actualizes—that is, it brings into vision and brings into being—its own agency as body of an intentionality and subjectivity. In other words, Sobchack supports an embodied existence of film on the basis of its activity as a momentum that keeps shifting the field of vision, and makes the screen an event of existence that resists the singularity of a still (read objective) meaning. As such, it manifests a body that not only is seen, but that is the expression of seeing: a representation that presents itself as an enworlded body of existence.

Her understanding of the existential activation of film is wonderfully portrayed in Dziga Vertov's *Man with a Movie Camera* (1929). The movie is an early example of experimental moviemaking in the tradition of city symphonies that addressed modern urbanization and industrialization.[24] In *Man with a Movie Camera,* Vertov makes visible an urban environment as a space of rapid changes, of busy streets and city dwellers, and of industrial and technological power. In his exploration of Soviet cities, life in the image is viewed as a space of multiple confluences between society and modernity. By bringing the camera, operators, editors, and screens into the displayed image, *Man with a Movie Camera* also makes its phenomenological intentionality explicitly apparent: its images are expressions of its own bodily perception of the world. But this body (that is, the equipment and the film base itself) is not just a means of perceiving and expressing; rather, it has its own meaning that affects the visual relation of the viewer to the image. It is at this point that my own project diverts from Sobchack's positions. While Sobchack makes way for an intimate connection between the image and corporeality, she does so by limiting bodily functions to the activity of a perceptual and expressive agency— the emphasis remaining on the activity involved, not on the materiality of the image's analogical relation to reality.

Indeed, in Sobchack's definition of film as "body," the technical materiality of celluloid remains outside the realm of any meaningful act. In contrast, I have been arguing that the instrumental specificity of celluloid is an element of meaning in the same way that an embodied and enworlded understanding of movies gives meaning to the image. Beyond the phenomenological implications of spectatorship, that is, celluloid film is a

fundamental element of the encounters that arise from the viewer's experience. Of course, film's materiality is not always flagged by the image, but it remains an implication of viewing, albeit unconscious most of the time. Both the persistence of vision (the incorporation of viewed movement in the spectator through mental stimulations) and the stimulating potential of celluloid (enabled by the image of real actors recorded in the past) are expressions of this material unconscious of spectatorship. In shaping the viewer's corporeal reaction to and imaginative stimulation of the image, celluloid's configurations take on a formative role in the ontology of the cinematic image. Here the medium of film is not understood as a passage through which ideas or visions of ideas are channeled uninterruptedly, but as a constant presence that informs the experience of viewing movies.

## Encountering the Physical Presence of Film Stock: A Brief History

Indeed, there are a number of ways that celluloid induces an experience of its materiality. In her essay "A Matter of Time," Babette Mangolte discusses her personal contact with celluloid film as a vividly physical matter. She describes her corporeal interaction with celluloid film in editing as she touches the substrate, feels the weight and size of the roll, and literally cuts the film in splicing. The cut of the filmstrip elicits a corporeal stimulation experienced as desire, anticipation, and fear because its consequences are tangible, transformative, and irreversible.[25] Moreover, the materiality of film for the viewer becomes apparent in the accidental flickers or jumps of the movie, but also in the grain that creates a constant shifting texture across the screen. In fact, in turning to the history of film technologies it becomes apparent how changes in instruments and formats make a vivid impact on both the creative impulse of the moviemakers and the spectatorial experiences of the viewers.

Leo Enticknap explores cinematic technologies with a view toward the influences of their changes in the industrial evolution of cinema. He describes how, in the early history of cinema, the chemical compound of the filmic substrate was not an issue one could easily forget. Cellulose nitrate was a simple, reliable, and strong base for film that could be manufactured at low cost. Nevertheless, its high volatility and inflammability created a significant health hazard that the industry needed to address. The combustion process of nitrate generates highly toxic fumes, and while also generating oxygen, it burns fiercely and cannot be extinguished. Consequently, fires would break out during screenings and result

in the death of hundreds of viewers. The elaborate health and safety precautions that were taken due to the inherent dangers of the material had a strong impact on virtually every aspect of film activity until the late 1940s. For instance, state laws were introduced for regulating the fire precautions in every space where film would be handled. While these regulations were meant to protect the viewers from the hazardous idiosyncrasy of nitrate, Enticknap notes how a footnote in the 1909 Cinematograph Act in the United Kingdom established the legal basis for movie censorship by local authorities (a matter that continues today despite the attempts at standardization by the British Board of Film Censors in 1912).[26] At the same time, it was certain that a better way to control nitrate fires was to develop a nonflammable base.

Acetate cellulose was the next development—although not without its own problems, as it was too fragile. Initially, it was used in cases where nitrate fire precautions were not available, and so started circulating the market of amateur moviemaking, where 16mm formats were being used. Soon after, acetate evolved into the much more robust cellulose triacetate that forms the base of film stocks used today. Besides the triacetate base, a polyester base stock was introduced, which is an inorganic base that does not suffer dimensional change, does not break, is inflammable, and is less prone to scratching than the other technologies. However, because of its high resistance to breaking, any pressure on the polyester stock is transferred to the mechanisms of the apparatuses that handle it, resulting in serious equipment damage. Moreover, being inorganic it cannot be spliced with cement (used to break down the organic solvents of nitrate and acetate), so it remains suitable mainly for cinema exhibition.

Indeed, Enticknap's discussion shows how the chemical structures of celluloid undoubtedly affected the cinema industry. The technical materiality of film affected the experience for the viewers as well as the moviemakers, who had to deal each time with the new problems that each format brought, as well as discover its new potential. The matter of creative potential and artistic novelties is most evident in the case of the sizes of substrates. For instance, due to the smaller sizes, lighter weights, and lower costs of 16mm, standard 8mm, Super 8mm, and later Super 16mm formats, these technologies found a prosperous position primarily in the home movie markets. As for 16mm film, its use was soon expanded to include educational movies for schools, promotional and training movies for governments and industries, reduction copies of 35mm for film societies, propaganda movies, and news reportages during World

War II. Most notably, though, the development of 16mm cameras from the 1950s onward grew from the emerging market of television and was also embraced by a new generation of moviemakers who created the French cinema verité, the British school of "free cinema," and the American "direct cinema." In other words, the portability of the new 16mm cameras, as well as the faster film stock and magnetic tape sound recording, enabled a creative potential that could not have been achieved with 35mm cameras alone. If one adds to this the impact of color, sound, and large film formats, it becomes evident how imperative technical materiality is for cinema's history and aesthetics, and its spectatorial appreciation.

## Film as Cyborg: A Return to Haraway

In directly affecting the experience of moviemaking and screening, celluloid film's own materiality shares an important role in the image. This is not to say that the technology's physical substance needs to be visually signified in the image. Rather, celluloid's materiality is incorporated in the experience of viewing as a conscious or unconscious awareness. As such, film's materiality is not distinctly separated into the physical reality of its image's indexical and analogical structures, the subject's body that creatively shapes it or sensually addresses it, and the technologies that constitute its tangibility. On the contrary, it expresses a convergence of all forms of physical reality, technological materiality, and corporeality. It is on these premises that one can think of the moving image as a cyborg similar—but not identical—to Donna Haraway's explication of the notion. The viewer is thus not positioned against the image as if it was an object for exploration, and the medium is not left inert as a dissociated tool. Rather, each element is activated in the meanings that celluloid film elicits.

Haraway bases her notion of the cyborg on the idea of transgressing boundaries that are opposed to binary opposites. As she explains in her influential essay "A Cyborg Manifesto," the cyborg is a metaphor for a state of transgression and combination of dualities, through which oppositional terms can be allowed to embed themselves within each other.[27] This is to say that the limits of each term are not simply reset, but completely dissolved by an elimination of distinctions. Haraway's argument looks at the mastering control that oppositional terms had produced in the preceding centuries. As she explains, positioned as the center for

viewing and examining the world from a distance (a global eye of sur-
veillance), the white male of Cartesianism hierarchically ranks nature
and culture for the sake of knowledge. In so doing, every other individual
as well as the natural world are objectified into an *other* whose essence
must be scientifically revealed.[28] In contrast, Haraway's cyborg elimi-
nates the disparity of Cartesian dualisms and expresses a coexistence of
forms. Thus the cyborg is the cybernetic organism that is constructed as
simultaneously man and woman, physical and nonphysical, technologi-
cal and organic. It is a construction of social reality and fiction, of human
bodies and technology that breathe and click simultaneously.

Haraway discusses the background of her work chiefly on two
grounds: the problematic establishment of control patterns in the politics
of sciences, and the biological link between living bodies.[29] As such, she
approaches the idea of the cyborg not as a shift of terms, but as an anni-
hilating force. Differences are not maintained in any way, but are made to
fuse in an absolute sameness. As such, Haraway does not speak of a body
that is partly one and partly the other, or that is a composite of several ele-
ments that coexist. Instead, she describes a body that fuses the one into
the other (the subject into the object) as an irreducible value of its essence.
The cyborg she describes is an entity that equally incorporates the animal
and the machine and exists in a world both real and constructed. It is a
diagrammatic metaphor for literary and social narratives, for medicine
and biology, for work and war alike at the end of the twentieth century—
an image of the machine–organic hybrid of the contemporary body.
Therefore the cyborg is not a creature of an internal symbiosis of forms
(a conglomeration of units), but an independent species unleashed from
the ties of unities, origins, and differences that hierarchize social exis-
tence so that nothing can remain the object of appropriation or manip-
ulation.[30] Indeed, Haraway's attack on Cartesian thought is undeniably
important and rigorous. But the undifferentiating element of the cyborg
leaves a problematic consequence: in disparaging binary oppositions in
favor of fusion, it depreciates the qualitative contribution that difference
can sustain. As I have been discussing, the material forces of the celluloid
image are all involved in the meanings that movies elicit while they retain
their own history and individuality. As such, they enrich the experiences
of the moving image with a constantly renewable potential. It is here that
my project meets with Deleuze's appreciation of change as a becoming
that affects bodies without forcing them into cohabitation. Celluloid film

as cyborg, therefore, is a conglomeration, rather than a fusion, of a number of different elements that form the image, but not at the expense of their own distinctness. It is from this point of view that the technological change to the digital does make a difference. In its immaterial status and nonindexical, nonanalogical relation to the physical world, digital technology causes a new shift in the corporeal relations of cinema that makes weight, position, and transformation of physical and organic matter difficult to sense. On this note, the final part of the chapter will examine how the physical relations of celluloid can be renewed by digital technology, thus asking how the digital *matters*.

### The Incredible Digital: CGI Animation and Morphing

The question of how the digital makes itself felt in the experience of movies is an important one, although not always that simple to address. Scholars and students alike often ask me whether there is any significant difference for the habitual viewer watching a movie if it is made with celluloid or digital technologies. Indeed, what difference can there be when a movie does not display its digitization at all? The clear distinction between celluloid and digital forms of movies becomes blurred when the image is recorded analogically and digitized for editing without any CGI special effects. For the time being I will leave this matter unanswered and instead make my way toward it through examples where the effects of the digital are more vividly expressed.

Digital animation is an obvious area where the incorporation of the digital is highlighted as it graphically represents moving bodies, objects, and worlds that do not exist or move in reality. Of course, cell animation, too, creates worlds that do not exist physically, bodies and objects that can resist gravity, and which may transform rapidly and unpredictably. As Rodowick points out, however, there is an important difference between the two modes of animating.[31] Cell animation consists of sequential hand drawings photographed and then projected at a constant rate of movement to create an illusion of motion. In other words, the products of cell animation continue to be celluloid films with all the qualitative properties I have been discussing: they can be traced back to the physical activities of the creators, they sustain an indexical continuity with the past, and they involve the body of the viewer in projection. Conversely, digital animation does not actually animate, but rather displays a computational synthesis of movement—that is, it is computer-generated movement.

Rather than making some kind of material transformation—profilmic or photographic—perceptible through the cinematic image, digital animation in fact makes visible the processing speeds of hard drives, and the technical developments of CGI software. Brad Bird's *The Incredibles* (2004) is an interesting case because of its emphasis on the studio's achievement in portraying the movement of the human body realistically.[32] The movie is about a family of superheroes who have to keep their identities undercover after government legislation prohibits heroic acts due to the contingent damages caused. Nevertheless, the family members start using their powers again when a life-threatening conspiracy puts them in danger. Each person is thus configured as a digital body that gains physical proportions of weight and movement while simultaneously using that body in incredible ways: the father has colossal strength, the mother can stretch and bend like an elastic band, the daughter disappears at will, and the son runs with lightning speed. *The Incredibles* does not turn to the depiction of moving objects, fictional monsters, or talking animals, all of which would grant justification to the peculiar moving patterns that computer synthesis produces.[33] Instead, Bird and his team at the Pixar Animation Studios turn to re-create living human beings. Nevertheless, the incredibility of the naturalness they achieve is ultimately equated with the incredibility of the superpowers the figures display. That is to say, the only thing incredible about *The Incredibles* is how far the technical abilities of computers have come since the first fully digital movie, *Toy Story,* released almost a decade earlier.

What digital animation shows is that numerically based computer images tend to refer to their own sensational display. As they lack a direct association with the physical world, they gain properties built from the intangibility and rapidity of code transformations—instant, repeatable, and retrievable switches. In fact, the technique of digital morphing exemplifies the technology's immateriality as it turns the referential power of celluloid images into an iconic splendor of dazzling colors and mercurial transitions. As I explained in the introduction, morphing depicts a continuous and swift synthetic transformation of a digital body. Nevertheless, as the body mutates from one person or thing to another, it also causes a sense of loss that has to do with the existential relation of material substances to space and time. Nothing holds the morph down and nothing keeps it from turning back.[34]

James Cameron's *Terminator 2: Judgment Day* (1991) is a remarkable example of the morphing body, because it situates this newly introduced

corporeality against an older version of techno-physical robotics. The movie imagines a future where cyborgs rule the world until a man, John Connor, brings all people under his leadership in a battle against the cyborg domination. To destroy this revolution at its source, the cyborgs send an agent (the latest T-1000 model) to the past to kill Connor as a youngster before he gains his power. Of course, the rebels send their own agent as well (an older cyborg version called the Terminator, famously played by Arnold Schwarzenegger) to keep the boy unharmed, thus saving the future. Two versions of cyborgs thus collide, expressing a battle between the physical special effects of animatronics and the immaterial visualizations of CGI. On the one hand, the Terminator is a combination of organic and inorganic matter, "living tissue over metal endoskeleton" as he himself explains. Although he is not depicted as being human, he retains clear characteristics of a corporeal being: he is really present in the diegetic field, he is bound by his specified bodily potentials, and he adheres to the immediate natural laws of his environment (with the exception of his initial time travel). The physical guarantee of the Terminator figure is also heightened by the fact that he is played by a Hollywood star, especially one like Schwarzenegger, who is famous for his strong, muscular build. In contrast, the T-1000, played by Robert Patrick—an unknown actor at the time with a characteristically slim and cold, almost plastic appearance—is a new breed of cyborgs made of a liquid metal that can morph into anything he "samples" by physical contact. As such, he can independently form the shape of any living being or thing: from cyborg, he morphs into the floor of a police station, and then transforms into the police officer he kills. During another scene, his frozen, shattered pieces reunite once they start melting. Similarly, gunshots merely puncture him momentarily without any real consequence.

What the comparison of the two cyborgs shows is not a shift in the believability of science-fiction movies, but a shift in the sensual intuition of movies' physicality. During the moments when the T-1000 activates its morphing operations, the spectator does not see a physical body of any kind (artificial or natural). Rather, the image becomes purely "digitographic"; it displays the rendition of a series of computations as graphic elements. Unrestrained by any physical specificity, the morphing cyborg creates a sense of transformative corporeality that reduces material substance to nothingness. The body of the morph disregards not only where it comes from, but also where it is going: it is atemporal. This is the difference that digital images cause: they do not relate to a physical past or

a material presence directly. The digital morph thus expresses the appropriation of physical reality, its individuality, and its reliance on space and time. The morph is a site of visual splendor that suspends life by taking its breath away—a metaphor depicted visually as the suspension of action in the plot during the T-1000's morphing transformation. It is an enchanting display of colors that evades a beginning and an end, a spatial orientation, and a temporal development: a vacant vessel for pixel glamour. Nevertheless, it still remains important to consider whether the digital creates other techniques for granting a sense of physical space and material substance to the image.

### Making "Sense" of the Image: Digital Rotoscoping and Motion Capture

At the beginning of the previous section I asked whether the spectator could sense the immateriality of the digital's numerical basis. Stated differently, the question asks if the digital makes a difference in the existential bonds of celluloid's physicality. Indeed, the matter is more obvious in the case of computer-generated effects, because the computational intrusions make themselves directly visible onscreen. Yet the transformative powers that numerical codification enables are not simply restricted to visual effects. Rather, the potential of the digital's intervention on the displayed image forces itself onto the spectator's awareness. Just as the indexical and analogical structures of celluloid created an unconscious awareness of the image's material connotations, the numerical structures of the digital similarly reflect on the perceptual instincts of the viewer. This is not to say that the image is robbed of any physical existence. On the contrary, my aim is to show that, while movies continue to exist in digital form, they stimulate a different set of interactive exchanges between physical reality, technology, and viewer. Indeed, the choice of Schwarzenegger for the Terminator is an indication of how a famous personality can lend a sense of reality to the image. In similar manner, motion capture and digital rotoscoping are both techniques that create their images by turning to reality to gain a sense of corporeality based on physical motion. It is interesting to see, though, how in both techniques the physical import of reality is deeply weakened by the digitographic prostheses.

Digital rotoscoping is an animating technique created and originally used by Bob Sabiston in 1999.[35] As Sabiston describes, the process entails creating a graphic cartoonlike visual style by filtering video footage

through software that interpolates frames between key drawings. The technique generates a seductive image of floating and fluid animation jammed together with the raw footage. And the animated characters obtain a sense of physicality because they are outlined on the basis of actual actors. Richard Linklater's realist interests led him to collaborate with Sabiston on *Waking Life* (2001), the first feature-length animation of its kind. The subject of the movie is a gripping series of monologues and conversations on topics ranging from existentialism to technology, from God to the biological structures of memory. These encounters take place in Austin, Texas, between a number of people and a young man (Wiley Wiggins) who wanders around in a psychological state somewhere between reality and dreaming. As the man tries to discover whether he is awake, sleeping, or actually dead, the movie simultaneously comments on its own visual style: while watching the dreamy colors and mercurial sways of motion, the viewer, too, wonders whether reality can be found in the image at all.

Motion capture induces a similar question, but it does so through a different process. With motion capture, the movements of digital characters are created by digitizing the movement of a number of marks positioned on real actors. Once again, the result achieves a more naturalistic effect than animation generated directly on the computer, because the gestures and activities of the characters are taken from physical bodies. These realistic tones attracted the French director Christian Volckman for his own animated project. Volckman's digital movie *Renaissance* (2006) uses motion capture extensively to address the problem of creating a sense of physical movement with computer synthesis. The plot itself deals with the ethics of the body and science's control over life. Set in Paris in the year 2054, it depicts the corrupt practices of a pharmaceutical company called Avalon as it tries to achieve the ultimate product: beauty and immortality. In wanting to create a graphic, film-noir visual style for *Renaissance*, with realistic characters that could arouse affection in the audience, Volckman chose to use motion capture that generates such naturalistic effects. Like digital rotoscoping, motion capture attempts to bring a sense of real corporeality and materiality within its images by encoding a causal link between the representation and reality: characters gain a bodily substance based on physical motion that is lifelike because it follows the anatomy and behavior of the world. Nonetheless, the characters continue to seem too light, too fluid, too clean, too weightless: in other words, bodiless. The reason for this inadequacy has to do with the numerical discontinuity that the digital inevitably

Wiley Wiggins as a rotoscoped character. Still image from *Waking Life* (Richard Linklater, 2001).

introduces in its image's encodings. Ultimately, the fact that the base of the image comes from reality cannot reduce the effect that digitization introduces. As bodies become digitographic, they lose their material connection to the world because they function according to the symbolic regime of numbers and codes. They can render a sense of reality, but as pure images they cannot materially denote it.

### The Digital's Materiality: Entropy

Nonetheless, it is important to note that the technical materiality of the moving image is not lost with the digital. On the contrary, novelties and alterations in digital equipment have a strong impact on the viewing experience, as did the developments in celluloid technologies. In "Video's Body, Analog and Digital," Marks points to this aspect, explaining that the digital's materiality can be seen in older or obsolete versions of hardware and software. As digital technologies become obsolete, digital images suffer their own death, too. In fact, versions of computers and software do not make old formats simply difficult to display but rather make them completely redundant. Enticknap describes, for instance, how in 1987 the British Broadcasting Corporation (BBC) worked on creating a computer-based multimedia database of life in the United Kingdom that would consist of texts, photographs, and video.[36] At the time, the BBC

The digitographicity of motion capture. Still image from *Renaissance* (Christian Volckman, 2006).

chose to use twelve-inch laser disc, which was a semiprofessional video format used between the 1970s and early 1990s. To do so the BBC had to develop a hardware interface and software designed to work on a nonstandard type of computer. The only problem was that soon after this initiative both hardware and software became obsolete. For the material to remain accessible, therefore, it had to be transferred onto a new medium supported by current technologies. It is obvious, in other words, how the rapid obsolescence of digital formats becomes a significant mode of technological mortality that even surpasses the speed of physical degradation to which celluloid is subjected. Indeed, it is the stability of the latter technology that has allowed celluloid to remain the primary medium of moving images for the time being.

From another point of view, Marks points to how the sense of the digital's corporeal entropy can make itself apparent in the distortion of the image due to accidental or unavoidable data loss (in the case of either file corruption or conversion from one file type to another).[37] She describes this lessening of the image's resolution as "bit rot." The only problem is that this mortality is experienced not as decay itself, but as a mistake of the functionality of a computer that can be corrected by updates to the computer system and future developments in the industry. The image itself does not suffer because it is not directly—that is,

physically—susceptible to entropic change. This is why the characters in both *Waking Life* and *Renaissance* are ageless. The digital figures do not have physical bodies themselves, but signify the transformation of living bodies into digitographic elements. Even though the actors form the basis for the creation of the characters, they seem completely absent from the movies. Their cinematic counterfeits are mesmerizing creatures, plastic entities whose physical weight (their relation to space) and signs of age (their relation to time) are erased. All that remains is the image of lines and smooth exteriors fluidly moving along the screen. The physical body in the digital is thus replaced by an ageless surface that can connect to real bodies only through pictorial and aural semblance, not analogical transformation. This is not to say, though, that the digital cannot connect to materiality at all. Indeed, the notion of the cyborg allowed me to think of the filmic image as a conglomeration of material elements whose encounter evolves through exchanges between their interconnected structures. It is possible for the fractured link between the image and physical reality to be redefined through the involvement of the viewer. Indeed, computer interactivity is a principal illustration of how the technology engages directly with the viewer: with interactivity the digital becomes a physical point of access to the image through touchpads, keyboards, mice, and other optical and sonic devices. But this still does not answer the question of materiality entirely, because interactivity is not always possible, and its effects can also be very limited according to the predefined choices and paths of the software design. Where, then, can materiality be found when interactivity is not available?

### Barthes, Barney, and Mullins: The Reality "Effect"

Matthew Barney's DVD of his movie *The Order* (2002) is an interesting case because, while it directly points to the potential of interactivity, it also opens a path toward another understanding of digital materiality. The video is an excerpt from the third series of Barney's epic *The Cremaster Cycle* that he made between 1994 and 2002. *The Order,* the last part of the movie, depicts the Apprentice, played by Barney, seeking Masonic redemption through a death-defying climb to the top of the Guggenheim Museum in New York. To succeed, he must face the legendary sculptor Richard Serra before the molten Vaseline that the artist is tossing down the museum's ramps reaches ground level. Four levels, each one of which

encompasses a test to be completed, separate the Apprentice and Serra. Here the DVD makes use of interactive functions by allowing the spectator to choose either to watch *The Order* in its theatrical release form, or to watch it by freely skipping from one level of the Guggenheim to the other irrespective of the Apprentice's adventure. At the same time, though, *The Order* assumes another material aspect through a personality that figures as one of the Apprentice's contesters: the famous amputee track star, actress, model, and activist Aimee Mullins. Of course, as I have argued, the digital image cannot become a physical corporeality itself because its nature is based on a symbolic order. As I will explain, however, something about Mullins grants the image a corporeal sensation. It is the matter of a reality *effect* that can be connected to the digital's numerical basis. Before continuing with *The Order*, though, I need to establish the idea of a digital materiality through the connection made between reality and another symbolic system: language.

In Barthes's essay "The Reality Effect," the French theorist turns to realism in literature to make sense of certain details of narrative that he calls "notations."[38] He describes notations as certain descriptive details that do not fit into the articulations of the story's development and so stand out as superfluous and functionless. As an example, he discusses how the description of a barometer in Gustave Flaubert's book *Un Coeur simple,* the duration of Charlotte Corday's portrait sitting, and the size and location of a prison door in Jules Michelet's historical work *Histoire de France* do not play any role besides adding clearly descriptive information.[39] As Barthes explains, these details are scandalous for the structure because they seem to convey a kind of narrative luxury whereby unnecessary details increase the cost of narrative information. Ultimately, notations evade the purposes of the narrative by not conforming to any clear objective and by not taking part in the predictive structures of the system. As such, Barthes explores what meaning can be assigned to these seemingly insignificant details and proposes that they signify *reality.*[40] As he explains, these seemingly superfluous elements partake in the creation of events by situating them in a space of reality; they do not need to abide by any laws of narrative development because they refer to things that were simply there in reality—which is reason enough for their appearance. It is a matter of gaining a sense of reality on the basis of the functionlessness of its details (a matter that resonates with Barthes's concept of the "punctum" as the accidental detail that directly signifies the reality of the image).

Indeed, in Barthes's earlier essay "Rhetoric of the Image," the linguistic message in a photographic advertisement appeared as a technique of anchoring the image in a specific meaning or to direct the events of a narrative toward a specific aim.[41] In contrast, in the irrelevance that notations conjure up, the linguistic elements cause an impression of the real because they act on the reader's preparedness for reason and cause. If these notations do not adhere to the development of the narrative, then they are simply there and do not need any further reasoning. As such, they are constituted through the exclusion of the signified from the sign and the subsequent collision of the signifier with the referent. By hindering the habitual development of meaning in the narrative, that is, the representational construction of notations allow for a feeling of the real to find its way in the reader's encounter with the literary text. Nevertheless, the direct relation of the unnecessary detail with its referent is, as Barthes explains, a referential illusion. It is not that the real is directly denoted, but only implicitly connoted. He writes, "Flaubert's barometer, Michelet's little door, say, in the last analysis, only this: *we are the real.* It is the category of the 'real,' and not its various contents, which is being signified; in other words, the very absence of the signified, to the advantage of the referent, standing alone, becomes the true signifier of realism."[42] By escaping the site of the signified as signs that belong to, and that represent, the narrative, these disturbances become *signs* of reality; that is, instead of denoting reality directly, they are signifying it. Reality, in this sense, is represented not as a denotative category, but as the effect that is brought into action by the collapse of the signified. This is the "reality effect."

To return to *The Order,* it is obvious that it contains a number of elements that situate the image in physical space, with the Guggenheim's status as a New York landmark being the most prominent example. However, as the interactive choices of the DVD allow the viewer to focus on a specific level for the whole duration of the adventure, the reality effect is mapped onto the physical corporeality of the body—that is, on Mullins's amputated body. As Mullins walks around on her prosthetic legs waiting for Barney to arrive, her body exhibits the strain it endures. Her prosthetic legs, designed as the hind legs of a cheetah, are physical evidence themselves as they reference the legs Mullins used to break the Paralympic records in the one hundred– and two hundred–meter races. As the prosthetic legs gain referential substance, the impatience of Mullins's figurative character turns back to Mullins herself as the physical strain she endures while waiting. Even though she takes flight at the end of the video—a testament

to the immaterial foundation of the digital image—Mullins maintains her physical anchor in the details her body elicits. Indeed, these details of the body are found in the "gest" to which Deleuze refers in *Cinema 2* with reference to irrelevant elements in the filmic depiction. He writes, "The gest is the development of attitudes themselves, and, as such, carries out a direct theatricalization of bodies, often very discreet, because it takes place independently of any role."[43] Here the body is understood as a process of constant becoming that is caught up in the interval between everydayness and performance. Neither role nor habitual meaning, the gest is an activity of corporeality as the procedure of a body becoming a role—or a digital image—without losing the rudimentary elements of physicality that connect that body with a certain space and time. It is here that the spectator gains access to a glimpse of a body as a living entity, despite any digital makeup, transformation, or extreme disregard for natural laws. However much Mullins is digitally made to fly around the Guggenheim, the conflict that her body endures from walking on prosthetic legs and the strain that comes from the duration of this event elicit an effect of physical reality.

In the previous chapter, I turned to Godfrey Reggio's *Naqoyqatsi* as an example of a cinematic exploration of the effects of digital technology on contemporary reality. More than that, the visual construction of *Naqoyqatsi* is directly concerned with the immateriality attached to numerical representations. For instance, the first time the viewer sees bodies depicted, they appear as black and white shades shimmering across the screen like a blurred x-ray of people. As the figures fade away, they gradually become a parade of zeros and ones, flashes of scientific and mathematical symbols, graphs and diagrams, and technological equipment. Indeed, *Naqoyqatsi* anchors the numerical form of these images by filling the screen with the zero-one form of the binary system. Reggio's approach emphasizes the lack of corporeal substance in the digital that renders the image a computational field of a graphic character. The image in the digital remains, in other words, without substance, and becomes a visual display of stored data. Nevertheless, by examining how materiality is formed in celluloid film, this chapter has illustrated how imperative it is to think of the moving image as a structure of the experiences and encounters that it makes possible. To persist on the side of the numerical configuration of the digital risks missing the ways the digital itself replays, albeit differently, notions of celluloid's reality. Instead, by looking at the potential of its own symbolic system, one can imagine different sets of relations whereby materiality is revealed as part of the image in quite different

The corporeality of Aimee Mullins's body, as a digital gest. Still image from *The Order* (Matthew Barney, 2002).

ways. Technological obsolescence and interactive engagement allow corporeality to appear, albeit by tying the sense of physicality to the apparatus and not the image itself. At the same time, however, through the connotational effects of digital notations—the image's meaningless features—the digital image regains a form of access to the real even while encoding it. In other words, by piercing its own deterministic mathematical regime with irrelevant elements, the digital creates an image of superfluousness as a sign of that which simply took place—a digital punctum. Nevertheless, it is important to keep in mind that this "materiality effect" is not woven into the image as a direct consequence of the technology's technical operation, but is extracted from the encounter that takes place between the image and the viewer. In other words, it is in the experiential space between image and subject that the digital maintains a connection to physical reality. As such, the following chapter will examine how this space is configured in order to make meaning of this encounter and move further into understanding the implications of digital cinema.

# 3  SPATIAL COORDINATES

*In between Celluloid Strips and Codified Pixels*

## From "Kong" to "Kong"

CONCEALED IN THE FEAR Fay Wray expresses in her version of King Kong's beloved Ann is the fact that she never really faces the fictitious gigantic ape, despite their visual congruity in the 1933 movie *King Kong* (Merian C. Cooper and Ernest B. Schoedsack). Similarly, in Peter Jackson's 2005 remake of the classic thriller, Naomi Watts's Ann cries in terror as the incredible animal looks as if it were approaching her—even though it never really is. In both cases, what is created as spatial continuity in the narrative is in fact a visual effect used to cover the gaps of a fragmented architecture. Nevertheless, something does remain different in the two versions of fragmentation: from the electric puppet and the stop-motion animation of the first Kong, to the CGI and motion capture animation of the recent Kong, the blind spot of the image has hugely deepened. While Wray is not really threatened by the mechanical ape, she can still touch it physically, and indeed the moviemakers had to have moved it frame by frame to create the illusion of its self-motion. On the contrary, Watts has nothing to touch in material terms besides the screen on which Andy Serkis's rendered movements are portrayed digitographically as a moving ape. Indeed, as I discussed in the previous chapter, the numerical basis of the digital problematizes the physical relations of celluloid. At the same time, though, the difference in the two Kongs expresses a change in spatial structures as well: by quantifying its image, the digital positions the encounter between image and viewer in the physical interaction between the screen and the viewer who now becomes a potential user. It is this spatial framework between the numerical and interactive screen and the spectator/user that this chapter will now examine. Before

From the spatial incongruity of celluloid's early special effects, to the seamless cohabitations of digitized spaces. Still images from *King Kong* (Merian C. Cooper and Ernest B. Schoedsack, 1933) and *King Kong* (Peter Jackson, 2005).

focusing on digital spatiality, though, it will be necessary to turn once again to the technical operations of the two technologies to examine the sense of space, or the spatial regime, that they conjure up.

Looking at the scene during which the tied-up Wray coexists with her acting partner—the Kong puppet—it is obvious that the two figures are not concurrently together. The image of Ann is laid over the shots of Kong so that they do not in fact belong to a common space besides the fictitious field generated by the montage. Where the viewer sees one jungle on Skull Island in which a terrified Ann tries desperately to break away from her ropes to escape the menacing Kong who progresses toward her, she or he is actually seeing a multiply interrupted construction: a composite of Ann's space (the stone altar to which she is tied), Kong's space (the jungle through which he walks), and the creators' space (the studio in which they are recording and which is signified in the jerky gestures of the puppet's stop-motion animation). In fact, it is celluloid film that serves as the unifying carrier of these detached spaces, albeit simultaneously signifying the fragmentary status of the image in its own

frame-by-frame construction. How then is this unified fragmentation different from the fragmentation that the digital upholds?

Turning to the same scene in the 2005 *King Kong*, Ann's space is once again a stone altar, but Kong's space is something else, something unrecognizable as such. The ape is seen coming out of what seems to be the depths of an abyss, like an apparition gradually materializing from thin air. But there is no distinction between him and his surroundings, nor a distance between him and Ann: as opposed to the obvious difference in sharpness between Ann's and Kong's space in 1933, Jackson has brought the two together seamlessly in 2005, deliberately flaunting this ability with prolonged contact between actress and digital character. That said, one wonders not only where Kong is, but where Watts is as well. Are they in actual physical space, are they in front of a blue screen in a studio, or are they floating in thin air?

In fact, both Kong and Watts are in some way present in all three types of environments, yet it is impossible to differentiate which space is which because the layers of the image have been intricately melded together. Jackson's world has been masterfully constructed to seem like a unified world of extravagant scenery and plush color. As such, the "thin air" of the image's numerical basis takes over to give the image in its entirety a hue of inexistence—including Watts's personal space. Speaking of numerical representation, Manovich considers it the main principle of new media, a form that leads to a different mode of storing and accessing material than celluloid film.[1] As he explains, a digital image is

composed of symbolic codes that are linked to the separate elements that make up the image; what actually looks like a seamless image is actually a grid of quantified color pixels. This means the data of the image file are configured into visible form as a spreadsheet of color intensities. Moreover, through the human–computer interface and according to the operations of the computer hardware and the "tools" of its software, these pixels can now become points of access both for the creative manipulation of the image and for the interactive access to menus or functions. In opposition to the sequential and material storage of, and access to, celluloid's images, the digital introduces the arbitrary system of RAM, where the image's space becomes a flattened hypertext.[2] As such, the viewer gains the potential ability to roam around the image as if it were navigable. Contrary to the unification of disparate spaces that celluloid film achieves, the digital organizes its information continually as a functional and consistently defined geometric fragmentation. It is with an interest in the forms and meanings of this fragmentation that I will examine the spatial configuration of the digital image, first by turning to celluloid constructions to examine where the difference between the two technologies may lie.

### Forming Space: Celluloid and *Blinkity Blank*

The primary question I wish to address is how the two technologies form the spatial arrangement of their images—or expressed differently, how their images are shaped. In the case of celluloid, the film stock itself reveals a space made up of fine particles, the silver halides, which are arbitrarily spread out onto the plastic film. These photochemical salts become clusters of patterns as a result of their contact with light reflected off a source, and they are visible during projection as the soft hue or gentle flickering that covers the image—that is, in the grain of the filmic image.[3] Indeed, the visible grain of the image manifests palpably the physiochemical processes of the image by depicting the aleatory formation of the substances that bear the image. What is more, the arbitrary haze that covers the screen emphasizes the material and entropic character of celluloid's materiality. In these flickers one can also see another aspect of the filmic plane of construction: the continuous and consistent jump from one frame to the next that takes place as the image is recorded and projected at a rate of twenty-four frames per second, with the inevitable rapid exchange of light and darkness. There is a sense of disjuncture

in the formations portrayed, a kind of space where infinitesimal empty blocks, or intervals, become part of the filmic event.

The celluloid image, in other words, consists of a space where incalculable physical elements are engraved by light or by hand and then made to move by interacting with the empty space between the frames, as well as with the patterns of each subsequent frame. Indeed, Norman McLaren's wonderful experiments aptly exhibit these structural relations: for instance, his short movie *Blinkity Blank* (1955), which he created without a camera, instead directly engraving the film stock with a penknife, sewing needle, and razor blade, and later coloring the engravings with transparent dyes and a sable-hair brush. The movie is a marvelous example of the constant tension between the indeterminable form of the image's patterns (the clusters of chemical particles) and the prearranged settings of projection (the twenty-four frame per second rotation). The movie begins with flickering lines bouncing off the black background, which burst like fireworks until they start forming more identifiable shapes. Among these shapes, the viewer can see a feather, an umbrella, stars, and other abstract figures. Lines explode, the feather dances around, a star reaches out to grab two feathers, geometric designs flash about and unwind, and so on. Later on, a bird starts grabbing at a worm, and the worm reacts with bursts of colors and shapes until finally being transformed into a bird that incorporates the first bird to form a hatching egg. Overall, the movie is a celebration of shapes, colors, and the potential of experimenting with forms of film animation. What is most interesting is the revelation that no visual element remains stable or fixed. On the contrary, everything flickers and bounces, constantly shifting around, moving and transforming from one body to the other, thus indicating both the shifts of texture and the transition from the one frame to the other—a disjuncture, that is, made palpable in the sudden jerks and transformations of the dancing elements. Explaining the technical aims of his project, McLaren writes that animating directly on opaque black film posed the problem of how to position and register accurately the engraved image from one frame to the next.[4] *Blinkity Blank,* therefore, sets out intentionally to investigate the possibilities of intermittent animation and spasmodic imagery, taking into account the relation of the effects of the afterimage of a projection and the stimulations of the persistence of vision.[5] As such, the black background of the image is not just a backdrop but also a part of the animated bodies, the place not on but within which they flicker and flee. Both the space within the image and the space between frames are thus brought into the animating

activity, making meaning out of the structures of celluloid film itself. The animating effect that *Blinkity Blank* achieves is in fact not characteristic of cameraless or cell animation, but of celluloid film in general: animation as the image's *self-motion* consists of engraved frames, constant and erratic movement of physical particles, intervals between the frames, and the perceptual organs of the viewer on which the light projected plays and comes together, as it were.

## Forming Space: Digitography and *Star Wars*

While these spatial structures are tied in with the techniques of celluloid technology, the digital presents a completely different setting. To explore the spatial architectures of the computerized image, I turn to one of the most celebrated digital movies in which space as structured pixels is vividly brought to the fore: George Lucas's *Star Wars Episode III: Revenge of the Sith*. The movie is nothing less than a monumental feat for the Hollywood enterprise, and especially Lucas's special effects company, Industrial Light and Magic. This third episode is actually the last of six to be produced, which links the beginning of the story with the final three that were produced between 1977 and 1983. Here the story turns to the origins of a lethal warrior, Darth Vader, where it is revealed that he is the creation of the personal psychological battle Anakin Skywalker (played by Hayden Christensen) has endured: Skywalker is a Jedi—that is, a knight responsible for the maintenance of peace in the Galactic Republic—whose fervent desire to save his beloved from death drives him to join the dark forces of the Sith—that is, the evil rivals of peace and democracy. Indeed, as the *Star Wars* saga portrays the intergalactic rivalries between diverse species and futuristic technologies, it is set on different planets and spacecraft, making spatial design a prominent aspect of its images. Episode 3 is particularly interesting for my discussion because it was captured in its entirety on high-definition digital cameras and constructed with CGI effects and animation, and digital editing. As it was the most advanced technologically, it illustrates further the latest research and cutting-edge achievements of Lucas's effects studio at the time of its production. Moreover, *Revenge of the Sith* is the episode with the most vital moment for the story's progression: the battle between the newly crowned Darth Vader and his old mentor and loyal friend Obi-Wan Kenobi (played by Ewan McGregor)—a battle that essentially signifies Anakin's complete integration into the Sith and their evil nature. It is no

surprise, therefore, that Lucas wanted the battle sequence to be extravagantly momentous in form, and so positioned it on the flaming environment of a lava planet called Mustafar.

The digital construction of Mustafar is an astonishing case. The desire to make a complex movie sequence on a lava-drenched landscape led to the creation of the planet from an extensive and laborious series of processes involving a few shooting days combined with months of work in postproduction.[6] The actors were initially recorded fighting in front of a green wall mapped with $x$, $y$, and $z$ targets that were used as reference points for sophisticated software to register the relations between the camera, the actors, and the background in every shot. With this procedure, the problem of the actors' displacement from physical spatial coordinates was solved digitally with the help of a grid that numerically referenced actual space. In combination with various measurements, photographs, camera reports, and lens data, the creators built the digital environment that replicated with extreme precision every movement of the camera in relation to both the actors and the surrounding field. In accordance with this constructed environment, matte paintings were drawn that also incorporated real footage like the eruption of Mount Etna in Italy, creating the final 25,000-pixel-wide landscape. Then the image was brought to life with the addition of digital lights, shadows, reflections, CGI models for buildings, textures, and animated bodies, as well as footage from miniature models. And with the help of the rotoscope and the compositing departments, everything was melded to form one seamlessly unified image. As a result of this undertaking, the image presents the two men fighting the battle of good and evil on the fantastical planet of Mustafar—in effect, a product of Lucas's imagination.

In fact, the lava planet exists as data archived in a number of computer hard drives. This ferocious planet of sweltering vapors and blazing rivers is the result of months of numerical configurations and processes. Unlike celluloid's construction, the Mustafar sequence does not include any material interruption between frames, although the whole image is unavoidably fragmented into constant pixels that are formed on the basis of a geometric grid. Space in *Star Wars* does not, in fact, contain stars; instead, as a geometric arrangement of computations and algorithmic configurations, it consists of nothing but computational numbers—even with McGregor and Christensen, even with Mount Etna. As opposed to the fluttering grain of celluloid images, the digital image refers to the Cartesian coordinates whose $x$, $y$, and $z$ relations represent mathematically

Ewan McGregor and Hayden Christensen fighting the battle of good and evil in Lucas's CGI-drenched world. Still image from *Star Wars Episode III: Revenge of the Sith* (George Lucas, 2005).

the breadth, height, and depth of the quantified pixels. Of course, the perceptual physiology of the viewer does not actually allow for an immediate translation of binary code into recognizable impressions. The code is not an immediate perception, but a symbolic expression of what is understood as a perception. Nevertheless, while the code itself is readable only by computers, the points, lines, and shapes that make up the image's graphic renditions are certainly perceivable by the viewer. The computer background of the image is an algorithmic setting where algebraic functions are associated with geometric relations, and the perceptual ground of the image expresses space as a defined environment of spatial geometry comprising equidistant blocks of a consistent and fixed size, positioned on a horizontal and vertical axis. The structure of digital space, in other words, is constructed as a depiction of the world as shapes: the arbitrary display of grains is substituted by the digitographic elements of block pixels; and the animation created by substituting frames with intermittent darkness is replaced by the immediate change of color in each pixel with every new scanning. It is for this reason that it is possible to link the digital to the meanings and consequences of a spatial regime that is not simply based on the Cartesian geometry that its algorithmic association expresses, but on a Euclidean regime where space is determined by fixed shapes and their predestined coordination. Before outlining its

consequences for the digital image, I want to examine briefly the context of Euclidean geometry in mathematics in order to understand what meanings are potentially ascribed to it.

## Geometric Coordinations: From Euclid to Riemann

A pioneer in the field of geometry, the ancient Greek mathematician Euclid established the grounds for the study of space as relations between shapes. As Jeremy Gray explains in his book *Ideas of Space,* Euclid based his approach to shapes on a set of ground rules necessary for anyone addressing spatial calculations.[7] He combined five common notions that are rational assumptions deniable only through absurdity (e.g., things that are equal to the same thing are also equal to one another), together with five postulates that permit the construction of geometric figures. Of the postulates, the most famous—and also the most problematic, for reasons I will discuss below—is the fifth or "parallel postulate," which defines the principles necessary for two lines to be considered parallel. It is important to keep in mind that at the time, Euclid was trying to set the ground rules for developing geometry and positioning it as a mathematic discipline of equal value as arithmetic—but at the heart of the principles that Euclid constructs lies a significant problem for an understanding of space.

Euclidean geometry expresses space as a mathematic relation of bodies whose motion is set on the path of very rigid lines: figures are studied in terms of distance and angles on flat planes; and the integral interdependence of body, motion, and space as continuities of change is replaced by transcendental fixities. It is here that the geometrical arrangement of space becomes controversial because it imposes functions that force figures to abide by a set of abstract and determining rules. For instance, according to Euclid's postulates, space is assumed to be infinite and continuous where the shape of figures is not altered by a change in their position. Moreover, the controversial parallel postulate assumes as self-evidently true that the infinite is merely the extension of the finite, and therefore that space is continuous and homogeneous. As Gray writes, the postulate is described as follows: "If a straight line falling on two straight lines makes the interior angles on the same side less than two right angles, the two straight lines, if produced indefinitely, meet on that side on which are the angles less than the two right angles."[8] In other

words, two straight lines are not parallel to each other if an intersecting line creates two interior angles whose sum is less than 180°. Proclus Diadochus and John Playfair reformulated this postulate thus: "Through a given point can be drawn only one parallel to a given line."[9] The proof of this claim has troubled mathematicians for centuries because what seemed to be a mere theorem deduced from the previous four postulates was an essential element for the general status of geometry. For example, the parallel postulate leads to a number of functions: the "transitive" property of parallelism, according to which if one line $a$ is parallel to another $b$, and $b$ is parallel to $c$, then $a$ is parallel to $c$; the study of equal angles and their relation; and by extension, the study of the angles of triangles. But the problem with the parallel postulate is that it simply takes for granted without explaining that parallels exist, that nonparallel lines definitely meet each other in some far indefinite distance, and that not more than one line through a given point can be parallel to one other universally.

What is remarkable about the discussion surrounding Euclidean geometry, and specifically the parallel postulate, is that what seems practically true for a sense of space is in fact not necessarily so. This potential of falsity is exemplified in the work of a series of mathematicians at the beginning of the nineteenth century. Nikolai Ivanovich Lobachevsky and Janos Bolyai, for instance, proposed a geometric space where Euclid's fifth postulate could not be sustained at all. In the case of saddle-shaped planes and prisms, the strict rationale of Euclid's configurations are overthrown by the possibility of more than one line being parallel to another through a given point. Moreover, Eugenio Beltrami's pseudosphere exemplified other potentials of lines as well: in a vaselike surface of constant negative curvature (meaning that the curve is drawn inward rather than outward), lines can approach each other without necessarily intersecting, despite their length. Spatial arrangement in such examples is one form of curvature that adds a degree of independence from the strict equations to which the Greek mathematician subjected the world, adding new degrees of variety for an understanding of space. Moreover, space becomes a structural framework that introduces incompatible truths as an essential element of coordination.[10] For instance, in Euclidean geometry the total sum of the angles of a triangle is always 180°, whereas in a pseudosphere the sum of these angles is always smaller than 180°. Georg Friedrich Bernhard Riemann took this realization even further by turning

to the positive curvature of spheres. In this case, space remains paradoxically unbound although finite, as lines can revolve continually without breaking away from the sphere itself. As such, the eternal guarantee of *infinity* is challenged, as is the parallel postulate in its entirety, because lines constantly intersect at the poles. Moreover, Riemann proposed an erratic space based on irregular curvature where the configuration of space is complicated based on manifolds. Indeed, it is in manifolds that I find a link back to the design of photochemical celluloid images and a peculiarity in the grid-like form of the digital.

The problem that arises in relation to irregular curvature is not restricted to the relation of figures with space; rather, it is extended to the relation of figures with their own interiority and the concurrent interdependency between their own interiority and exterior space. As opposed to the flatness of Euclidean space, the constant irregularity of Riemannian space suggests that as a figure moves, its own shape and properties change accordingly. Moreover, space for Riemann is intricately complicated, as it is understood as a multiply extended curved magnitude made up of interlinked yet distinct sections. These sections are small, disjointed topological segments that remain locally defined as Euclidean while being connected to an adjacent neighborhood that belongs to a possibly more complicated global structure. To this Riemann adds an inner product—that is, a metric variable of potentially infinite values—that changes smoothly from point to point on the tangent space. In other words, he introduces the manifold as a set of all the possible values of a variable with certain constraints. From this, he constructs a continuous stack of dimensional manifolds, thus liberating space from a one-, two-, or three-dimensional configuration. As such, each point of this $n$-manifold space is always more than the combination of three $x$, $y$, and $z$ coordinate axes. Instead, it is a unique instance in the field of relations that the specific spatial magnitude upholds.

The suggestion that space can be irregularly curved opposes the flatness of the geometry that Euclid proposes, suggesting important new possibilities that essentially invalidate linearity, conformity, and unchangeable fixities. By denying Euclid's axioms as a priori, Riemann conceives of the constant potentiality of alternative states that are concurrently linked back to the local and the global. With the possibility of irregular curvature, Riemannian space is a plane of constant variation that affects and is affected by its structural elements, which constantly vary according

to their internal and external values as well. Although the entire consequences of Riemann's work for mathematics and physics are outside the scope of my current discussion, it is important to note that he proposes an understanding of space as something more in tune with human experience. Discussing the relation between Riemann's geometry and experiential space in her book *The Fourth Dimension and Non-Euclidean Geometry*, Linda Henderson describes Hermann Ludwig Ferdinand von Helmholtz's example of an imaginary world of two-dimensional beings living on a spherical surface.[11] According to this world, parallel lines could not be experienced because lines would always intersect when extended sufficiently. That said, to claim that space, as that within which individual people exist, is Euclidean a priori is opposed to the mere possibility of conceiving of a non-Euclidean space. On the contrary, in Riemann's space one can actually think of milieus where a straight line is not necessarily the shortest way to reach a point, or where there are multiple "shortest" routes, or where movements of bodies manifest a change in qualities rather than relations of coordinates. Austere rationality is thus overturned by variability and unexpected inconsistencies.

In sum, Euclidean space is formed as a set of axioms that designate validity to interpretations in accordance with one set of rules that defy empirical affirmation. Here space is not considered a platform for living relations that are molded in time from what comes before and leads thereafter—space, that is, that mutates as a field of understanding according to the activities of its constantly shifting permutations. Euclid's space, and by extension digital space even when understood in its Cartesian aspect, is homogeneous, universal, regular, definite, and thus calculable objectively. It provides a paradigm of scientific objectivity as an a priori establishment to which everything must abide. In contrast, Riemann's addition of dimensionality into his conceptions of space allows for an empirical understanding of the world. In such a world, infinitely small neighborhoods are configured geometrically according to a wide array of physical forces or fields through which their context is produced. In this *n*-dimensional space, space and body are tightly interrelated through sets of measurements or coordinates, from which the two elements are defined in constant fluctuation according to every new set of relations— that is, in every new position in space. Instead of the predetermination and fixity of Euclidean geometry, therefore, Riemann offers a space of minuscule planes whose interactions take place in infinite and unpredictable ways.

## The Subject as Constant Variable

The variability expressed in Riemannian manifolds is precisely what I want to link back to the powers of celluloid film. This variability is not restricted to the incalculable formation and interaction of the photochemical substance alone. Rather, the link between frames, their rapid succession, and the viewer whose perceptual stimulation generates the animating effect of the moving image, illustrates that the spectator is her- or himself an integral component of change. Indeed, the invigoration of space's meanings by the viewer is what von Helmholtz's aforementioned example expresses with reference to the two-dimensional subjects living on a spherical surface. Moreover, this intrinsic relation between subject and space is a matter of concern in Elizabeth Grosz's book *Space, Time, and Perversion* as well.[12] Influential for her work in feminist theory and corporeality, Grosz addresses the issue of subjective spatiality in a fascinating reexamination of mimicry in insects. Here she explains that the insect's behavior of mimicking patterns and colors in its environment is not based, as commonly believed, on survival strategies but on tendencies similar to human psychoses where the subject is depersonalized.[13] Following the French sociologist Roger Caillois, Grosz describes that both the mimicking insect and the psychotic subject renounce their perspectival point—the look that defines where they are positioned in space and how space is organized—and instead assimilate themselves with their immediate surroundings. From this point of view, space becomes the defining focal point that shapes the individual whose perspective is overthrown by all exteriority.

What interests me in Grosz's examination is, indeed, her emphasis on the direct relation between subjectivity and spatial meaning, which she links to the early mechanisms of childhood. During the early period of life, Grosz explains, the child must not only identify with a virtual representation of the self (its mirror reflection), but also disassociate itself from that representation in order to locate its subject in its body.[14] It is a stage largely discussed in psychoanalytic terms precisely because of this paradigm's interest in the subject's psychological and physical sexuality as the grounds on which, or passage through which, it is positioned in social structures. Originally, Sigmund Freud speaks of these relations with reference to the cortical homunculus as an image of the ego, derived from bodily sensations with which the subject interacts for the formation of its psychical constructions and bodily satisfactions.[15] As Grosz explains further, it is in Lacan's reinterpretation and extension of these

ideas into the "mirror stage" that corporeality and spatiality are inter-connected with the formation of the subject's identity.[16] Lacan sees the perpetual alienation of the ego as the result of the opposition between tactile and kinesthetic senses—which yield a fragmented image of the body—and visual perception—which creates an idealized illusion of a unified self based on the infantile identification with the subject's own image in a mirror.[17] The subject is brought into the realm of the social through the internalization of the specular image that constructs its own relation to its body. Through this external image, the outside is brought inside the psychical realm to affect its own structuring, albeit problem-atically and without resolution according to Lacan. And it is on this inter-play between the imaginary self/space (the distanced mirror image) and the real self/space (the perceiving body) that the ego is acquired and the subject located in space.

What is important to note in these accounts is the interplay between virtual and real in the construction of both the spatial unity/disunity of the body, and its relation to the world it inhabits. The subject's identity is a psychologically inflected physiology and a physiologically inflected psychology that is a variation of relations. Implied in this understanding is that the perception of self as a surface in touch with a world of surfaces is not a one-way stream of consciousness, but a variant of the dynamic layers of the physio-psychical *and* the social (the *and* here signifying a concurrent application rather than a hierarchical succession). Indeed, Grosz points to this evolving variation of the subject in Merleau-Ponty's existential phenomenology as well.[18] The French philosopher refers to the gradual reconfiguration of image/space and body/space relations through perception and intellectual development: location and dimen-sion are perceived while the body orientates and directs itself in space; and they gain further layers of significance as experience changes and new relations develop. Space is thus understood subjectively, from the side of the subject's own perceiving and expressing body. Conversely, the rigidity of a mathematically configured space distances the subject and replaces its integral involvement with a scientific objectification.

## Constructing "Any-Space-Whatever": *The River*

To clarify, my main concern with Riemannian and celluloid space is that the subject gains an irreplaceable position in the creation of meaning. As opposed to the rational structures of a scientific order—upheld in the

mathematical structures of Euclidean and Cartesian geometries—space in celluloid becomes expansive because it is the place where living as a Deleuzian becoming is established. In fact, the prominence of arbitrary links, which Riemann's variable manifold upholds, is what Deleuze bases his discussion on when examining post–World War II movie production. As I discussed in the introduction, Deleuze focuses on the appearance of disconnected, disparate, or emptied fields in the image, what he calls the "any-space-whatever" of purely optical or sonic situations. The capricious interval of their connection arrests any teleological value in the mind of the viewer, instead building up new connections that bring her or him in relation to a space of infinite possibilities created by evolving relations and change. This is a movie space of infinite encounters— space as encountering and not as specified and closed.

Consider, for instance, Tsai Ming-liang's movie *The River* (1997), which is a beautiful example of the volatility of the any-space-whatever as described by Deleuze. *The River* tells the story of a young boy's torment from some infectious pain in his neck after playing a floating corpse in a dirty city river for a movie shoot. Once infected, the boy and his family try to find a therapy with the help of doctors and spiritual healers alike. At the same time, though, the movie is actually about something other than the tale of a character's problem and his endeavors to solve it, as in a classical Hollywood structure. On the contrary, *The River* is a study of the fragmented relations between the three members of a Taiwanese family and the alienation that they endure in an environment of contemporary urbanism. This isolation of the three characters is outlined in the first half hour of the movie, during which it is hardly made clear that they are at all related. In fact, the movie begins by introducing the characters in a jump from the one to the other's story; and with the editing's amazing choreography of their activities in their house, the viewer is left with the impression that they all move in disconnected strata stuck together arbitrarily.

But the spatial isolation achieved by the movie's editing suddenly collapses into the common field of the home. It is as if the construction of *The River* swiftly unravels to illustrate that the three separate spaces are in fact layers of one elaborate piece of felt or patchwork.[19] Nevertheless, as they are unable to communicate their personal suffering to each other, both parents and the son remain restricted to their own emotional fragment. At the same time, though, each stratum they express starts shifting around and interacts with the others, forging exchanges between the characters. Indeed, it is through physical contact that the characters'

relationships are reformulated. Space, that is, becomes a bodily issue in line with Grosz's corporeal associations of the subject. This subjective spatiality is emphasized by the son's inability to balance and coordinate his movement in space on his motorcycle, due to the accelerating pain in his neck. For the father, the invasion of his private space by water seeping in from the ceiling of his bedroom causes him distress, anxiety, and physical unrest from sleeplessness. And for the mother, the loneliness and psychological estrangement of her social surroundings has left her desperately seeking sexual affection and arousal in a relationship with a lover who seems to continue the pattern of emotional indifference. In fact, it is all three of them who seek to replace their solitude with sex, a common secret that finally leads father and son, unknowingly, to a sexual encounter with each other in a gay sauna. In the sauna, the individual spaces of the two men collide violently in an intense eroticism that creates an emotional climax for the movie; but as soon as they recognize each other, the father slaps the boy, who immediately leaves the room, and no mention is ever made of the occurrence. For a brief moment, that is, the two characters share a highly charged physical exchange, only to be left drifting apart once more as space unfolds in one big wave and pushes them to new milieus.

Tsai's movie presents a beautiful examination of the direct relation between subject and space as both intricately involved in the momentum of change. What is intriguing with *The River* is the central role that water plays in the reshuffling of each character's isolated space. It is what combines the detached family in one common stratum of existence: the son's illness is triggered by his contact with the polluted river; the father's bedroom is disturbed by a leakage in the ceiling; and the mother is forced to attend to the flooding of the entire flat when the father's temporary construction fails to hold the water out. Wrapped in the water that envelops them, it becomes clearer how volatile their life is, how easy it is for forces external to their fixed agendas to disrupt their everydayness, and by extension, their personal spaces. At the same time, in their different encounters with the water, they express their own subjectivity in the meanings that spatial relations elicit. It is this volatile quality of water that makes it the most extreme example of what Deleuze and Félix Guattari call "smooth" space in their chapter "1440: The Smooth and the Striated" in *A Thousand Plateaus*.[20] Keeping in mind the complications that the spatial configurations of digital and celluloid technologies produce, I would like to follow up on their discussion of space in some detail.

## "Smooth" Space: *Taste of Cherry*

Deleuze and Guattari discuss "smooth" space as a structure of continuous variation in which figures and their environment are intricately involved.[21] The first example they use to describe this sort of spatiality is the material felt, as its production is based on fibers of wool or other textiles rolled and pressed with the help of moisture or heat, so that everything is matted together in a solid, smooth surface. As felt is an entangled mesh of fibers, its smoothness expresses the inseparability of its threads. Much like the grains of halides on celluloid, the fibers of felt are arbitrarily attached on a microscopic scale. In other words, smooth space is this combination of elements as spatial components placed together in tight compactness to the point where they are both formed by space and forming space. Moreover, in accordance with the multidimensionality and variability that Riemann's manifold expresses, Deleuze and Guattari's smooth space is an arrangement that is not defined by values of determined direction: just like felt, it can expand toward any direction, infinitely open and in constant variation.

Smooth space is thus understood as a field of occurrences that, although they remain dependent on the structural arrangement present at each moment, they are determined neither by a transcendental rationale nor by a fixed internal aim. Indeed, it is this sense of spatiality that celluloid film expresses in the erratic motion of the grain in the predefined succession of frames in projection. Change in smooth space is not without aim, but instead constantly shifts from specified purposes to the arbitrary events of living. This framework is portrayed in the work of Abbas Kiarostami, whose movies seek to delve deeply into the psychology of the people living within the complexities of Iran's social constructs. For instance, his 1997 movie *Taste of Cherry* illustrates with compelling humanity how the openness of Deleuze and Guattari's smooth space functions even when determinations—social or other—are present. *Taste of Cherry* follows a middle-aged man, Mr. Badii, who wanders around an Iranian city and its surrounding desert in search of someone to grant him a favor: to bury his body after he has committed suicide. Driving his car from one urban street to the next, from one neighborhood to the next, from one barren hill to the next, and from one fork in the road to the next, his movement becomes a nomadic drift that creates an image of a labyrinthine structure without end. Of course, the man has a very specific purpose in mind: to find someone who will help him end his life. We

do not know what has brought him to this decision, but his overall isolation seems to be one indication. Either way, each encounter becomes an obstacle in his way, a blockage that causes a diversion in the completion of his aim. Despite the fact that he offers a large sum of money to the people he meets, his offer is turned down repeatedly; and so he must take new turns in his path and address new twists in the winding road.

To be sure, the path that Mr. Badii follows has no sense of direction— there is no sign or map to guide the tormented man. In so doing, the movie expresses how there cannot be any specific route in the space of life, because existence unravels extensively and unexpectedly with every encounter or convergence: Mr. Badii comes across other people in their own course of actions, duties, or desires at diverse intersections or junctions that remain part of the infinitely unfolding space that is his journey. In fact, even when he finds a man who accepts his offer, it remains unclear whether he actually commits suicide in the end. All the viewer sees is a distant view of Mr. Badii as he gets ready before leaving home, and then as he lies down in a hole in the ground and shuts his eyes. In other words, the purpose of his journey—or the end to the story—is cut out of the image to allow the continued variation of the constructed space to engulf the exterior presence of the viewer. Infinite variation is at the heart of *Taste of Cherry*.

### Striated Space: *Russian Ark*

In contrast to the variation and constant unraveling of smooth space illustrated here—where subject and space are brought within an inseparable relationship—Deleuze and Guattari also describe space of a different nature. This is a "striated" space where fragmentation predetermines the paths and the possible movement of figures, and thus places body and space as separate entities. Deleuze and Guattari use the metaphor of fabric to describe their notion of the striated, which resonates with the pixelated grid of the digitographic image. The striated is constituted by horizontal and vertical elements that are intertwined perpendicularly, with one element fixed and the other moving above and beneath it to create a plane of a defined and unchanging width. In such a space, motion is a directional change of coordinates from top to bottom, or beginning to end, in order to reach one telos through rigidly outlined routes based on straight lines and 90° angles. Its construction is finite, scientific, operational, and controlling. Indeed, it is from this point of view that the uniformity of the

Euclidean grid meets with the functionality of the algorithmic structures of Cartesian geometry hidden, as it were, in the computer hard drive. Striated spaces and the geometric space of the digital create fixed relations that coordinate roles and appearances. For instance, Alexandr Sokurov's digital movie *Russian Ark* (2002) manifests these characteristics as a conflict between the creator's desires and the powers of the technology itself. Recorded in one take, it depicts space as a unified stream of historical time with causal relations weakened by the arbitrary turn from one epoch to an incongruent other. Quite revealingly, though, it remains unable to escape the binary system that supports the image's cinematic construction. It is interesting to see how the determining control on which geometric and striated spaces are built is brought up in Sokurov's undertaking despite his creative aspirations.

*Russian Ark* was recorded famously as one unique take that runs the full span of its ninety-six-minute duration. The innovative ability to shoot for such a long period was made possible with the use of the Sony HDW-F900 high-definition digital camera, which was mounted on the cinematographer Tilman Büttner and connected directly to a hard disk, thus allowing the immediate storage of an uncompressed high-definition signal.[22] The reason for these technical specifications was that Büttner was to move uninterruptedly around thirty-three rooms of the State Hermitage Museum in St. Petersburg. For the duration of shooting, Büttner's camera would follow the Marquis de Custine, a French intellectual who wanders around the museum commenting on the art and people he comes across and conversing with a voice behind the camera. Indeed, as the Marquis leads the viewer on a guided tour of Russian history, art, and culture from the eighteenth century to the present day, Sokurov attempts to force chronological time to collapse in favor of an ever-evolving and constantly present history, which sees Russia as both an individual nation as well as an international figure implicated in the other European empires and events. From corridor to corridor and from one hall to the next, the viewer is introduced to Peter the Great, Catherine II, Aleksandr Sergeevich Pushkin, as well as twenty-first century visitors. Sokurov attempts, in other words, to illustrate time as the constant motion through a common plane of perpetual interactions between epochs and peoples, where space is this common field on which contacts and exchanges are positioned concurrently—just like the Hermitage that engulfs Russian culture in its walls to represent the force of the nation's illustrious and opulent entity.

At the same time, though, *Russian Ark* tries to achieve what its technological basis resists instinctively. Although Sokurov's single shot seems to re-create the Hermitage's representational achievement as a cultural force that combines Russia's history and position, the fragmentary nature of the technology elicits a different act: what seems to be a single continuous shot enclosed in the Hermitage is actually a number of steps, of sampling, quantizing, and archiving. The shot cannot be a direct and unified recording because it is a conversion of space and duration into fragmented numerical relations that are assigned a single position on a geometrical grid. What is more, this numerical archive is a uniquely convenient setting for direct access and manipulation of every minute unit of the image. Rodowick turns to this very point, commenting on how the functional specifications of the digital constitute a necessary "montage" of the image. He writes, "As constituted through digital capture or synthesis, the image is always 'montage,' in the sense of a singular combination of discrete elements."[23] It is this montage effect that makes the spatial terrain of the image available for reorganization and redesign. In fact, Sokurov took full advantage of these abilities by fixing—or in other words, editing—the movie in postproduction with the use of image corrections, filters, and enhancements, thus adding and removing elements, changing tones of color and light gradations, as well as the perspective of spaces. In an example described by Rodowick, a room that depicts Leningrad's siege during World War II by the Nazis took new shape in postproduction: the bright, neutral room was transformed into a gloomy, eerie, shadow-ridden space with a slanted, shifting, and shallow perspective. The space of the image, that is, was defined on the basis of selection and correction.

### The Smooth and the Striated

To be sure, it is the idea of controlling and defining space central to Deleuze and Guattari's notion of the striated that is so fitting for the operations of the digital. In the technology, the integral unity of space as the common arena for variability and interactive exchanges is subverted by an environment of calculations and predetermined designs. Space in the digital becomes a perceptual impression of applications and operations specific to mathematical values. Spatial unity—and as I discuss in the following chapter, temporal unity as well—is not upheld in the digital

because every element in the image is a discrete block or position for alteration or elimination. Incalculable variability is overturned by controlled transformations. Indeed, other elements of *Russian Ark* also point to the programmability of the movie's form. For instance, the final take on which the released feature was based is the fourth in a series of failed trials. More evidently, though, the nomadic drift that the Marquis purports to enact is confined to a very precise space: thirty-three rooms in the Winter Palace of the Hermitage. These rooms in which the various encounters take place seem to fragment the Marquis's wandering into discrete events or scenes that take place between the arrival of a group of people at the museum for a ball at the beginning, and the ball itself, with which the movie ends. As opposed to the constant and incalculable spatial shifts of Mr. Badii's movement in Kiarostami's smooth space, the Marquis's drift seems to be positioned in a narrative construction enclosed in space rather than evolving with space. As such, the radical technological novelty that *Russian Ark* purports to utilize—the ability to render a continuous and long stretch of spatiotemporal unity—is overturned by the technology's other specificity: its geometric arrangement that the narrative content fails to overcome.

The digital's construction of space leads from a uniform grid of stable and equally shaped color pixels, to the algebraic configurations of Cartesian geometry that convert space into the form of algebraic functions. The problem is that space thus understood cannot sustain its relation to the world lived because it is transformed into a fragmentation and abstraction where the intellect is distinguished from the material world, reality is constructed as a set of magnitudes, and meaning is a metaphysics of analytic reason that corresponds to abstract thought.[24] It is here that the model of thought in the digital image becomes a problem, because its geometric and algebraic grounding makes distinctiveness and distance between the subject and the world a central framework. Space in the digital's structures is thus understood as a representational deduction and not as a force where environment and individual are concurrently and inextricably involved. Indeed, it is the contrast between a controlled determinism of thought and a creative oscillation between multiple structures that lies at the heart of Deleuze and Guattari's discussion in *A Thousand Plateaus*. As Brian Massumi describes in the foreword to the book, the two writers build their discussion on the relation between the "arborescent model" of representational thinking, and "nomad thought"

that surpasses artificial divisions of binaries based on a boundless inter-activity. Massumi's description is exemplary of the distinction between the two models with reference to the production of concepts. Massumi explains:

> The concept has no subject or object other than itself. It is an act. Nomad thought replaces the closed equation of representation, $x = x =$ not $y$ (I = I = not you) with an open equation: . . . $+ y + z + a + \ldots (\ldots + \text{arm} + \text{brick} + \text{window} + \ldots)$. Rather than analyzing the world into discrete components, reducing their manyness to the One of identity, and ordering them by rank, it sums up a set of disparate circumstances in a shattering blow. It synthesizes a multiplicity of elements without effacing their heterogeneity or hindering their potential for future rearranging (to the contrary).[25]

In other words, space as a model of thought is an act of force that takes place irregularly and unlimitedly. It cannot be confined to mathematical reasoning simply because such an understanding arrests possibilities of change and confines thought to fixed universalities. By confining thought/space to determined structures, the mathematization of arborescent thought fragments the world into sets of truths whose connection is unidirectional. Breaking up the elements into calculable sets is effectively an act of judgment as to what is useful and what is not, what is worthwhile and what is redundant—a way of thinking that separates thought from its own self and the possibilities inherent in living. As such, living in space and space as living becomes an objective category that remains transcendentally constant, where change is reduced to pre-determined transitions from one step to the other.

While opposing the distinction of Cartesian duality, however, Deleuze and Guattari are careful to express the relation between smooth and striated space as nonantithetical. In fact, it is the encounter between the two spatial models that is of utmost importance to my discussion because it opens up a way of unhinging technological specificity from a rigid and secluded plane of structures and operations. From the outset of their account of the smooth and the striated, Deleuze and Guattari allude to the fallacy of a strict adherence to a bipolar system, and continue to break down the barriers between the distinction by looking at *smooth-nesses* of "striated" spaces, and *striations* of "smooth" spaces. In this case, the sea clearly points out the problem of opposing the two terms as dialectically antithetical: even though it is a smooth space par excellence, it was the first to endure acts of striation due to maritime navigation.[26]

Nevertheless, the sea returns from striation to smoothness by the deterritorializing consequences of the submarine's nomadic wandering, even though this war machine's intentions are driven by the desires of control and imperialism. In other words, the natures of the smooth and the striated are not confined to stable presets, but alternate in the oscillation of their exchanges and the consequent variations that appear in diverse circumstances. As such, the binary opposition between Euclidean and non-Euclidean systems, as well as between abstract thought and objective worlds in Cartesian geometry, is not sustainable. Similarly, a strict classification of digital spatiality in opposition to celluloid structures needs to be rethought.

### Between Smoothness and Striation: The Morph

With the alternating nature of Deleuze and Guattari's spatial structures in mind, it is possible to think of digital space beyond its mathematical foundation. Although without any concern for cinematic technologies, Richard Hornsey's paper on London's "*A* to *Z*" street map (presented at the *Real Things* conference organized in 2007 by the University of York) illustrates how a geometric arrangement of space can be involved in exchanges of human relations and physical experience.[27] Hornsey is right to react against the idea that the reduction of a city into a map of coordinates and lists of names becomes a degradation of its diversity. Rather than considering the map a manifestation of an environment's objectification and the subject's dissociation from the world, Hornsey thinks of the map as a sign of movement that connects emotions, desires, and events—a set of configurations as an invitation for traveling from $a$ to $z$ in any way via $b$, $c$, or $v$ to $j$, $x$, $o$, and back again. In other words, the diagrammatic and functional quality of the map's spatial representation is not limited simply to what lies inscribed on paper; rather, it is extended to the hands of the map's users and their interaction both with it and the city to which it is their ticket. In a similar manner, it is not only possible but also necessary to think of the spatial specifications of digital technology in view of the implication of the viewer in the creation and diversity of meaning in cinema.

A fascinating digital structure that complicates the rigidity of the technology's geometric foundation is morphing—that is, the seamless and continuous transformation of a person, object, or place into some other form. As it does not hide its artificiality in any way, the morph makes the

abstraction of its mathematic foundation an expressive act.[28] This distinctive power is manifested quite impressively in the emotional and imaginative creativity of morphing spaces in Peter Jackson's movie *Heavenly Creatures* (1994). Set in New Zealand in the mid-1950s, the movie tells the story of the close friendship between two teenage girls, Pauline Parker and Juliet Hulme. Once the close intimacy of their relationship becomes apparent to their mothers, the girls' friendship is deemed unhealthy for their Christian upbringing and they are separated. Wanting to be reunited, the two girls brutally murder Pauline's mother, whom they believe to be the primary instigator for their separation. Before reaching this brutal act, though, the movie describes how the girls' affection leads to the narrativization of reality in the form of an epic myth of a fictitious royal family and their romantic liaisons. Pauline and Juliet's deep immersion in this fantasy world comes to the point where their reality is at times intertwined with the fictional setting of the fabulous characters. For instance, as Juliet suffers emotional stress by her parents' decision not to take her with them on their trip to England, she frantically cries and runs away into the meadows with Pauline by her side to comfort her. At that moment, the dull, dry land morphs into a lush, green landscape filled with thick trees, flowers, and a pond with smooth running water, white doves fluttering, unicorns bathed in golden sunlight, and gigantic colorful butterflies flying away. As Pauline explains, this fantastic reality is the "fourth world" for which they have always held the keys in an extra part of their brains. In other words, in this image of the morph, space becomes animated as a digital transformation that uses the technology's mathematical configuration to express emotional associations. The foundation of the image does remain a Cartesian abstraction, while its digitographic rendition alludes to a disassociation from physical space; but as space morphs from one form to another, it makes possible a sense of variability that brings Euclidean space closer to a Riemannian geometry.

The morph is certainly a remarkable example of digital technology's novel techniques. As opposed to celluloid's stuttering or cut-away transformations, digital morphing generates a mercurially fluid and seamless transition from one form to another. In his essay "Animation and Animorphs," Norman Klein examines this operation in relation to cell animation.[29] As he describes, the animating effect is precisely the event of transformation that takes place between two concrete forms. Of course, animating transformations are not specific to either celluloid

or digital technologies. Indeed, as I have already described through McLaren's *Blinkity Blank*, the transforming act of animation is born from still elements appearing and vanishing frame by frame so that the implied motion of the image is actually activated in the shift from one still to the next. In essence, the transformation takes place in the gap between the still frames. This transformative animation—or to use Klein's terminology, the "ani-morph" (shortened from "animated metamorphosis")—is a site of hesitation wherein the two shapes of a body or space are neither here nor there, neither one nor the other, becoming a gesture of an activity much like Deleuze's "gest." In a sense, the digital morph foregrounds visually and extends temporally what happens in a split second in celluloid animation. Nevertheless, there is a significant difference between digital and celluloid metamorphoses: digital transformations are aesthetic effects, whereas celluloid transformations are fundamental to the function of moving images in general.

In the case of celluloid constructions, the interval between frames is not a background for motion, but the spatial plane within which motion is brought to life. Dissolving forms to create new ones, the celluloid ani-morph is a concrete absence that is the essence of the image's constant becoming. The spectator's corporeal involvement is induced by a continuous exchange between presence and absence. As such, the perceptual and affective participation of the spectator is a fundamental cog of cinematicity in general. The impression of real motion is created in the recurring jump from the visible to the invisible and back again. This is to say that change as a process of development, of a becoming present as what was and what will be, is found in the gap between the frames as if that gap was a gaping hole or wound that flooded the image with life. As these intervals or ani-morphs dominate the image as a hesitation and temporary disappearance of the narrative, they lead to a journey into some unknown land (or as Klein states, into an underworld).[30] It is this state of being nowhere—that is, of not being fixed somewhere specific— that is remarkable with this form. It is a rupture in the visual structure, much like the effects of Barthes's "notations" in literary narration, or his "punctum" with regard to the content of photographic images. It manifests a collision of events as if movement was not simply a geographical displacement, but an encounter of Thanatos and Eros. The space of the ani-morph is not a fixed state of solidity and permanence, but a constant dissolve as a vanishing point that persists.

This animating power of celluloid's moving frames is presented with various results in Oskar Fischinger's abstract work. With a career that extended from the 1920s to his death in 1967, Fischinger was an important figure in Germany's—and later America's—experimentation with abstract art, animation, and avant-garde cinema. As such, his work is characteristic of the tension between form, representability, and abstraction, and the antagonistic relationship that can be induced between music, rhythm, and image. In a late version of his short movie *Allegretto* (1941), his colorful geometric patterns animate a constantly shifting spatial plane that forms a meshed interaction of preceding and succeeding elements. Like all cell animation, Fischinger's various shapes come and go, carving diverse paths as a motion from image to image through the interval of the frames' exchange. The movie is a fascinating case because it consists of shapes that belong to a Euclidean regime while its base is celluloid film. Nonetheless, in its spiral world, the movie's spatial design alludes to change with its diverse formations, speeds, directions, and effects. The moving patterns of the movie form a Riemannian plane of interactions or conjunctures between layers that move around one another, triggering and triggered by one another. Yet, while *Allegretto* tries to form space as a variable framework of transforming contacts, the music that accompanies the piece seems to tie the animation down, shutting it off from any externality. Choreographed to a strict rhythm, the shapes become graphic visualizations of the music rather than a depiction of change itself. Similarly, the abstract flow of the music is forced down onto the visual as if the music signaled nothing but the move of a blue curve down or a red triangle up. This is to say that the transformative potential of the movie's spatial arrangement is heightened on the side of technological function, but appeased on the side of content where visual and aural conformity position the viewer's imagination strictly within the frame: from sparks to set configurations, from striated to smooth and back again.

Conversely, Fischinger's *Radio Dynamics* (1942) makes good on the possibilities of his earlier work through one simple gesture: the replacement of the music with silence. In this movie, the spatial plane becomes in its entirety a transformative gesture that moves with rhythmic variations in every dimension of the frame—that is, between the interacting layers both laterally and in depth, between the individual frames and their ani-morphic interlays, and between the inside of the cinematic image and the outside of its virtual perception. The image is not enclosed

Although Fischinger repeats his concerns with abstract geometric constructions from *Allegretto* (pages 129 and 130) to *Radio Dynamics* (page 131), the absence of music in the latter allows for the transformative complexities of animation to be revealed. Still images from *Allegretto* (Oskar Fischinger, 1941) and *Radio Dynamics* (Oskar Fischinger, 1942).

in the screen by a determining aural structure, and it is not fixed by its own shaped formation. While the many elements come and go in quick flickers, the eye is forced to drift in the shifting shapes and colors, unable to designate a determinate meaning to the experience. In the melding plane of color instances and outlines that create and change just as they appear and vanish all at once, the only meaning perceptible is experience as an event in motion.

What is noteworthy about *Radio Dynamics* is that it depicts a potential for generating an image of space in terms of Deleuze and Guattari's smoothness despite its geometric formulation. In fact, it is this hybrid connection between smooth and striated space that the ani-morph actually expresses. As I have been discussing with regard to celluloid film, transformative change takes place in every shift from a visually concrete image—at this point, a determinate striation—to the virtual variability of the interval between frames that radically opens space up into a

smoothness. In a similar manner, the digital image is striated in its technical foundation because it is based finitely on numbers and fixed blocks. But morphing's radical transformation of the entire visual plane into a pictorial abstraction manifests the digital's ability to express the sensual and imaginative involvement of the characters it depicts. Further, while digital technology's mathematical fragmentation submits the image to a strict determination, it also makes it available for immediate access, archiving, and manipulation—all with the help of the nonhierarchical structure of RAM. Every detail is an element in a constantly alterable connection of configurations that remains loose enough to the point of a crucial weakening of the fixity of the regime. The result is a space of no set configuration—space, that is, as functional change. Where the interval in the filmic is the gap as the emptied and unconnected space that connects diverse forms to animate the image, in the digital it is the incommensurable correlation that the random positioning of elements causes. Moreover, as the transformative space of the morph visually expresses the space between one and the other, it forms a plane not of a transition, but of a transitioning—that is, a constantly unstable terrain of an extreme displacement.

## Between Smoothness and Striation: Compositing

Instead of taking place between the frames, as it does in the case of celluloid film, the interval of the digital opens up to a world of chance and undetermined agency in the cracks that appear in the image. While splitting the image up into discrete values and combining disparate layers of information, the digital creates the potential for arbitrary connections—delinkages—not only in the cut between frames, but across the whole spatial field of every image. As such, the interval prevails as a fissure or crack that hinders the continuous flow of deterministic structures, thus creating a visualization of the potential latent in the inextricable and the irrational—a deterritorialization of the digital's striated structure. Such is a cinematic construction that follows the lines of Deleuze's "time-image," according to which purely optical and sonic images of the irrational cut and the any-space-whatever lead to the aberrancy and incalculability of determined thought, and to the awareness of the creative potentials of thinking as activity.

Working quite decidedly with digital cinema, the British moviemaker Peter Greenaway has shown the breadth of experimentation and novelties

made possible with new media. For instance, his astonishing multimedia project *The Tulse Luper Suitcases* (2003–4) tells the fictitious story of Henry Purcell Tulse Luper through the ninety-two suitcases of his collections, his writings, his personal geological and moviemaking projects, and his imprisonments and travels.[31] Greenaway constructs a historical narrativization of the twentieth century with a focus on the communities of the West, the wars and their effects, and technological and scientific inventions, with uranium (ninety-two, like the suitcases, being its atomic number) at the center of it all. The project in its entirety is quite vast, as it involves some three years of constant development and additions that create an ongoing network of referencing and referenced information, as if it were a cybernetic construction devoted entirely to Luper's story: three consecutive feature-length movies, CD-ROMs, exhibitions, a Web site, an online game, an opera, and a book. The project, as Heidi Peeters notes in her article "The Tulse Luper Suitcases," becomes a labyrinth of events where fictional and historical characters meet, and fantastical and actual occurrences are creatively conjoined.[32]

The multilayered vastness of *The Tulse Luper Suitcases* creates a complexity of strands all leading toward the same figures—Tulse Luper and his suitcases—while being pulled simultaneously somewhere else: the historical grounds of the development and use of uranium and the position of culture and mediation in understanding this history. Indeed, Greenaway is particularly interested in pointing out the direct relation between history and happenstance, culture and creativity. The first episode of the movies, *The Moab Story* (2003), is created as an elaborate visual plane where diverse media and their cultural histories are interwoven as historiographic layers. Old film footage becomes the background for digital recordings, with numbers, lines, drawings, and texts all appearing and disappearing at different points of each image on the screen. The painterly, baroque design of scenes as well as the theatrical acting, positioning, and auditioning of the actors add further to the convergence of artistic practices. And while history is enmeshed with myth, the movie emphasizes the exchanges and intermingling of falsities and truths in history and its mediation: different locales are brought together in the same frame either with clearly defined floating windows or a simulated blurring; sounds and actions are repeated momentarily while filling the screen in separate blocks; visual elements or narrative sidetracks add references to other moments in the story of the historical background; and objects become points of departure for a

Greenaway's spatial construction explores the digital image as a plane of historio-graphic layers. Still image from *The Tulse Luper Suitcases: The Moab Story* (Peter Greenaway, 2003).

narrative to evolve or end. To be sure, the movie takes full advantage of the arbitrary interconnections that the numerical basis of digital technology allows, creating an archive of the radical flights of thought as it meets the volatile, transformative structures of numbers and pixels.

Of course, the volatility and creative force that lies at the basis of the any-space-whatever is slightly transformed in the functions of composit-ing and morphing. By merging two dissonant spaces, the digital morph creates an irrational unity as well as an inexistent continuity. Instead of cutting abruptly from one place to some other disconnected locale—as in the case of a celluloid "time-image"—the digital forces space together, eliminating the possibility of a jump from here to there precisely because the here and there are at once *(t)here*. Nevertheless, space thus becomes a visualization of variation: it is not an irrational leap but an impossible fusion that results in the epitome of the any-space-whatever, as if the inter-val were persisting by not simply existing in the plane of the image but tak-ing it over for some time. This is the essential feature of digital space: the any-space-whatever of the digital is not an emptied or dislocated space; rather, it is a visualization of the interval as process of transformation, an extreme externalization of the ani-morph. And so, behind the inexistent jungle of Skull Island or the flaming planet of Mustafar, lies the idea that digital space is potentially any space as a visualized becoming.

At the same time, though, the digital continues to sustain the tension between striation and smoothness, albeit in different terms. Lars von Trier's movie *Dogville* (2003) is truly exemplary in this respect. Here von Trier chooses to eliminate the spatial setting as if to depict the digital basis of the image and elicit a terrain as constant invitation for the creative involvement of the spectator. Leaving only a dark stage with nothing but some furniture and a couple of doors positioned among drawn lines to define the streets and houses of this poverty-stricken American town, *Dogville* seems to transfer the possibility of spatial configuration to the spectator. It is as if the entire setting were expressing the transformative potential of the interval. Speaking of the movie in her article "Lars von Trier, *Dogville,* and the Hodological Space of Cinema," Tarja Laine describes its spatial structure as hodological.[33] Hodological space, she explains, leaves the architectural construction without defining walls and determining coordinates, thus allowing for the interrelations of spatial properties to become prominent on both the side of the screen and that of the viewer. Her reference here to hodological space is based on its definition by the gestalt psychologist Kurt Lewin as the complex energy field of the social sphere that consists of the positive and negative tensions of interactions and interrelations.[34] As Laine maintains, hodological space thus defined can illustrate the immediacy of the cinematic experience and the interdependence between individuals in the creation of meaning. Indeed, it is the Greek root *hodos*—meaning path—that alludes to a construction of space as evolving passages of interaction. It is in this sense that elements, like variables in Riemann's manifold, become forces that trace trajectories in the act of moving positively toward, or negatively away from, another entity. As such, movement in space is defined not as physical displacement but as the combination of forces (or valences) and directions (or vectors). By eliminating determinate structures, *Dogville* creates space out of virtual paths understood as potentials for the creation of meaning. The lack of a definite setting in the movie causes the image to become a plane of the interactions between the characters: without barriers to hide or diminish them, their motion and behavior outlines a milieu of forces interacting on the basis of ideas and ideals and in the direction of shifting aims and desires. For instance, after the initial suspiciousness of the town's residents for a stranger, Grace, they finally accept her plea for shelter from her persecutors. As the threat of the persecutors draws nearer, though, the community's eagerness to help Grace turns into a sly desire to benefit from the situation; and so, with the

The indeterminate construction of *Dogville*'s spatial terrain. Still image from *Dogville* (Lars von Trier, 2003).

excuse of protecting themselves from the exterior danger, the generous townsfolk of Dogville decide to enslave Grace, thus becoming manipulative villains just like the gangsters that are after the woman. Space, in other words, becomes the setting of individuals, their thoughts and wills, and the architectural and social structures that loosely coordinate their actions. In the same way, this environment is directed toward the spectator, who is also a member of this community of forces. As there is no arranged visual construction, her or his own position as viewer must be implicated as a certain locale that elicits a further layer of spatial meaning. The spectator's space is thus included in the screen's space to the point where the movie's construction is necessarily a function of the interplay of tensions between viewer and viewed. As such, the force of the functional associations depicted among the characters is extended to include the viewer as element of the hodological agglomeration of the constant becoming of space.

Yet it is interesting to see how the hodological space of *Dogville* is weakened by the visual and aural accompaniment of the end credits. Whereas space was an empty field of combining elements, it becomes a clearly defined stable character of a series of 1930s photographs from the slums of American towns. What was any space is now the documented land of photographic images that depict real people in their space of social hardships and financial oppression, a field populated by "young Americans"

as David Bowie's accompanying song declares. The space of the movie becomes now a reportage, a Barthesian "studium" that restricts the cinematic experience to the visually specific, unavoidably shutting the spectatorial condition out and eliminating the diversity of the any-space-whatever. Obviously, the indexical authority of the photographs directs the attention to the very specific space of a world past. Indeed, what is striking about the two types of images set side by side—the digital and the celluloid one after the other—is the different relation they uphold with time. Before moving on to explore these temporal structures further, I am interested in examining one final—and fundamental—configuration of digital cinema's space: interactivity.

### Between Smoothness and Striation: Interactivity

Digital interactivity is an exciting potential precisely because it illustrates the mental stimulation possible in movies by making it a physical act. The interaction between viewer and the screen's spatial field is not implied but is experienced necessarily in the body as she or he makes choices from one point of access to another. These potential permutations were already exemplified in the earliest example of a hypermedia Web work, David Blair's *Waxweb*.[35] Made available online in 1993 and hosted since 1994 by the Institute of Advanced Technology in the Humanities, University of Virginia, *Waxweb* is the interactive version of the movie *Wax, or The Discovery of Television among the Bees* (1992).

A peculiar science-fiction story about bees and their involvement in the televisual transference of the dead, *Wax* revolves around Jacob Maker, a bomb-simulation programmer for an American military program who is also an amateur beekeeper. After he is transferred to a new department at work, he starts to experience a spiritual wandering whenever he is among his bees, which leads him to start doubting both the morality of his job and his existential connection to the world. He then discovers his connection with the world of the dead, and more specifically with the Garden of Eden—the name given to his grandfather's estate where Jacob was born. He finally manages to travel there when the bees pierce the side of his head and insert a mirrored crystal, a portal that he uses to access the past (i.e., a television). Jacob Maker's interest in bees, we are told, derives from his grandfather James Hive Maker, an English beekeeper who in the early twentieth century wanted to record evidence of life after death using photography. At the same time, Hive Maker's sister, Ella Spiralum, was an

electrical inventor who dreamed of transmitting moving pictures through the telephone. Having lost her job after the modernization of the telegraph company, she started working as a photographic medium, taking photos of ghosts among the living. Not only documenting but also talking to the ghosts, she was contacted by the dead wife of a Hungarian Egyptian gentleman, Zoltan Abbassid, a bee scientist who attended Spiralum's séances. Abbassid was also the beekeeper that provided Hive Maker with Mesopotamian bees to replace his dying English bees, later also becoming Ella Spiralum's husband. While the English bees were completely annihilated, the Mesopotamian bees thrived to such an extent that Hive Maker believed they were the dead of the future. As such, he wanted to be the sole owner of the Mesopotamian bees and so began a feud with Abbassid. Finally, Abbassid was stung to death by Hive Maker's bees, which— as spirits of the dead—needed his body to return to life. Dead as he was, Abbassid also needed a new body to return to life, and was thus born Jacob Maker, Hive Maker's grandchild.

Undeniably, the complexity of the story and its constant references to visual technologies and natural sciences of the twentieth century is similar to the scope of *The Tulse Luper Suitcases*. As *Wax* develops by layering partial information of an event onto another while moving back and forth in time, it constructs a historical narrative equivalent to a hyperlink, where one detail in the image becomes a potential path to another image or text, simultaneously bringing fact and fiction together. Nevertheless, it maintains a clear narrative progression with a defined beginning and end; but Blair seeks to destroy this fixed exactitude—in fact, to the point of making it completely redundant—through the possibilities of different access points to the movie's hypermedia version in *Waxweb*. Here he splits the movie in one- to two-minute segments that the viewer/ user accesses and through which she or he progresses in linear fashion by clicking a button on the media player. At the same time, a scroll bar beneath the player's window allows the viewer to jump to any moment of the segment, accelerating the forward progression or reversing the order at will. At the far end of this scroll bar, a numbered list allows access to different chapters of the story categorized by their assigned numbers. Moreover, by clicking on the player's screen, a new, smaller window appears beneath, consisting of three consecutive stills and one larger still of the precise moment of the playing sequence that had been clicked. These two links open the movie up into a much larger array of information, both textual and visual, offering an encyclopedic background to

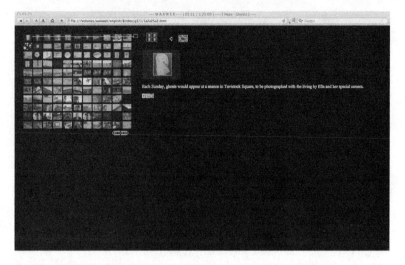

*Waxweb* as an interactive textual and audiovisual encyclopedia. Still images from *Waxweb* (David Blair, 1993). Referring to the image directly above it, the text in the above image reads, "Each Sunday, ghosts would appear at a séance in Tavistock Square, to be photographed with the living by Ella and her special camera." Referring to the image on the right, the text in the image on page 139 reads, "Prologue—WAX or the discovery of television among the bees—. Everything starts with the title sequence, filled with many mysterious images which in *[sic]* establish a few of the many portals and places that Jacob Maker, partial hero of this long story, will travel through during the clicking moments that follow . . ." Referring to the image directly below it, the text in the image on page 140 reads, "With a few carefully chosen words, and an orchestra of scent from the candles and dried flowers placed on the table by the emotional medium, a friendly ghost opens up the caul that protects her after birth in the new world of blankness that she sees, for the moment (a moment that lasts forever, but not in every religion) as a nice and somewhat dim vacation spot. She opens it to reveal her face, letting us recognize her not as a relative but as someone who once lent us a pen in school . . ."

*Waxweb.* Here the movie can be accessed as a grid of stills that resembles both the pixel structure of its digital base and the honeycomb-like construction of its narrative. Elsewhere, the movie is fragmented into one still image accompanied by an access point for the related sound file, as well as its textual information. Another subset leads to a grouping of the entire movie based on common words or common visual elements. Textual hyperlinks lead to other texts that are not included in the movie, but consist of descriptive extratextual information of events and visuals. And finally, visual hyperlinks flip still frames around and reveal a hidden three-dimensional arrangement of CGI shapes and frames that are connected arbitrarily.

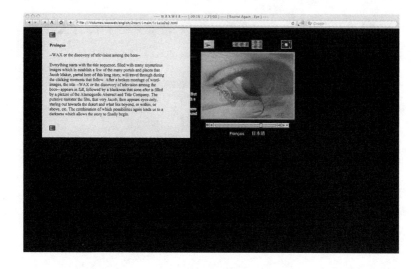

It becomes apparent how Blair insists on engaging with the viewer in the creation of the spectatorial experience by complicating the image with infinitely perplexing paths.[36] It is here that digital interactivity becomes a hodological space of open paths and incalculable forces. Of course, all these connections are made on the basis of presets designed by Blair, as well as the creators of the World Wide Web and the Multiuser Object Oriented–based Virtual Reality Modeling Language that Blair employs, so that one could speak of a highly controlled environment with the mere facade of a liberating interactivity.[37] Nevertheless, Blair constructs such a complex structure of relations that each interaction evolves into a new viewing. Not only across time, but in spatial depth as well, the viewer is positioned not as independent maker of the visual, but as intricate participant in its meanings. From the striation of its Cartesian and Euclidean spatiality, the complexity of the infinitesimal relations of the interactive potentials allow *Waxweb* to unravel as a multidimensional manifold where every new viewer becomes an agent of an active variability.

By drawing the spectator into its construction, the space of the image is intertwined with the personal space of the viewer/user, making cinematic construction an intimate layer of viewing. It is here that one can see a potential of digital structures that is in tune with the entropic materiality of the grain and the spectatorial involvement of celluloid's frame-by-frame projection. From striation to smoothness, the technical

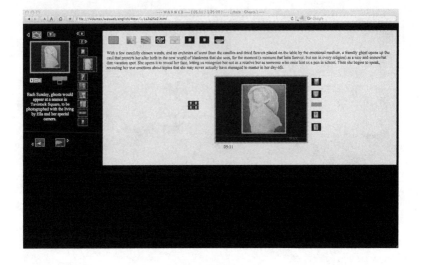

With a few carefully chosen words, and an orchestra of scent from the candles and dried flowers placed on the table by the emotional medium, a friendly ghost opens up the canal that protects her birth in the new world of blankness that she sees, for the moment (a moment that lasts forever, but not in every religion) as a nice and somewhat dim vacation spot. She opens it to reveal her face, letting us recognize her not as a relative but as someone who once lent us a pen in school. Then she begins to speak, revealing her true emotions about topics that she may never actually have managed to master in her day-life.

Each Sunday, ghosts would appear at a seance in Tavistock Square, to be photographed with the living by Ella and her special camera.

05:11

foundation of the digital does not vanish but becomes part of the various dimensions and variable potentials of its spatial construction. In the persistence of the interval in morphing, the impossible simultaneity of disparate spaces through compositing, and the extreme variation possible with interactivity, one is led to the imaginative immensity of the virtual that is actualized in the mental or physical choices of the viewer/ user. This procedure resonates with the immensity that Gaston Bachelard describes in his book *The Poetics of Space* when speaking of imagination.[38] As he explains, by beginning abruptly without the subject realizing it, imagination as daydreaming flees quickly from one object to somewhere else to create a structure of grandeur as immensity. Immensity is this agency of consciousness through which one is led to an open world of grandeur through one's imagination. He writes, "This being the case, in this meditation, we are not 'cast into the world,' since we open the world, as it were, by transcending the world seen as it is, or as it was, before we started dreaming."[39] Immensity, in other words, is the enlarging expansion of thinking and imagining as they come in touch with the exterior world, incorporating it into the subject's creative interiority. In such an understanding, immense space is the very intimate place of the subject who becomes an unlimited expression of an unlimited place. The subject is thus a poet in the Greek sense of *poiesis* that links the act of creative interaction with an evolving genesis. Poetic space is expansive

precisely because it is expressive. It comes out of movement as a creative impulse that activates the converging and dispersing interplay of forces. And clearly this space exists in the durational constancy of imagination, thought, and memory. Space, in other words, is already an immense field that is inextricably tied in with temporal functions and durational values. From space, therefore, to its duration, this will be the focus of the following chapter.

# 4  REDISCOVERING CINEMATIC TIME

THE SIGNIFICANCE OF TIME for the understanding of the technological change in cinema is triggered by the difference in the way the two media create their images. Where the indexical and analogical celluloid image sustains a direct link to a *past reality* as physical trace, digital media form their images without any necessary existential adherence to time. Rather, the "digitographic" image makes *graphically present* the algorithmic associations and instantly renewed calculations that take place in each related file on a hard drive. Nevertheless, as my focus on both spectatorial corporeality and spatiality attests, the reality of the image cannot be confined to one side of the image—that is, to how the image was created. Instead, the image is itself a renewable component of the structures it makes possible, as it becomes a point of contact with a perceiving and sensing, and thinking and expressing, viewer. The change from celluloid to digital cinema, as such, cannot be defined as a loss of reality, because reality remains an integral part of the moving image. What does change is how the association with reality is conjured up and what meanings the digital's structures appear to withhold.

To be sure, the mathematical foundation of the digital's configuration does not vanish from the image, but it does not define it either. As I discussed in the previous chapter, digital space remains a setting that unfolds into multiple dimensions as it is brought in touch with formats of the past—borrowing celluloid constructions—and desires for new means of contact—creating novelties. Morphing, compositing, and interacting can break away from the absoluteness of the digital code by enabling designs of diverse and alternating practices and reflective and involving receptions. Nevertheless, time as the continuous duration of change is more difficult to trace in a system that so readily favors distinctive

fragmentation. This matter becomes the point of focus in Rodowick's discussion on the digital, where he asks, quoting Mangolte, why it is difficult for the digital image to communicate duration.[1] His concerns lie with celluloid film's ability to create a sense of duration where all layers of temporality are involved simultaneously in the creation of meaning and the existential grounding of the individual. With this in mind, while the digital encodes the world functionally for spatial manipulation and operates with repetitive processes, one wonders whether it can elicit a sense of time as an existential experience for the creator and viewer of the image.

As Mangolte discusses in "A Matter of Time," time is indeed at the heart of celluloid film because it is radically located in the direct contact that analog media perform in their operations; because the rhythmic succession of the light and darkness between the repetitive exchange of the frames creates a temporal beat; and because the grain of photochemical celluloid performs a visible display of arbitrary haze and scratches that continue the entropy of the recorded world that is presented. As Mangolte asserts, though, regarding the digital, "The unpredictability of time passing and time past, the slippage between one and the other, and the pathos of their essentially ineluctable difference are lost."[2] Indeed, the entropic character of the celluloid cannot be found in the digital bitmap, because every pixel does precisely what it is ordered to do by a programmer and the operations of a computer. In a considerably early discussion of digital operations, Binkley similarly compares analogical and digital formats based on time. He explains that the information held by a photographic image is a quick and directly isomorphic response of the photochemical substrate to illuminations through which an image is recorded. In contrast, a computer stores information that is a fragmentary array of discrete numbers into which an event is translated. Binkley writes, "The end product is a photograph, but it visually 'depicts' the numerical contents of a frame buffer, and not necessarily the state of any real place at any particular time."[3] This is to say that the displacement of time is in fact an integral function of the technology, an issue that cannot be bypassed despite the historical and theoretical overlaps between technologies—or, as Rosen describes, "digital mimicry" that maps preexistent structures like indexicality onto the new technology.[4] Without a doubt, the break that takes place between the image's origin and its representation is significant because it adds a series of transmutations: a physical event at one point is read as a regular mosaic structure whose bits are assigned a binary numerical relation according to color, brightness, and intensity.

It is this structure that leads Manovich to discuss digital editing as spatial montage where the intervention takes place across the whole spatial field of the image bit by bit, as opposed to the temporal editing of celluloid film where cuts are made linearly between frames.[5] At the same time, though, Manovich points to an intriguing direction for the examination of digital temporality by turning to possibilities that stem from a particular operation of the computer: the loop. As he explains, "Programming involves altering the linear flow of data through control structures, such as 'if/then' and 'repeat/while'; the loop is the most elementary of these control structures."[6] This is to say that, instead of reconfiguring the data from the beginning at each instance, computers repeat a number of steps that are controlled by the software's main loop, and they only refresh functions and pixels whose associations have shifted. As such, time can be found in the digital image as a repetitive looping effect that instantaneously refreshes and repeats. From this, one is led to question whether the prominence of looping processes means that the time of the digital is nothing but an insistence of the present, as if change got caught in a stutter, unable to extend forward or backward. Focusing on this concern, this chapter will examine whether the fragmentary and repetitive operations of the digital can create a sense of duration as a continuous force of change. In other words, my suggestion is that instead of considering what eliminates duration from digital configurations, it is worth asking if there are potential relations that can bridge the way back to a cinematic image of time. It is a matter of seeing the ways that time can be felt in the image, thus binding the gaze of the viewer with a sense of duration. For this reason, Deleuze's "time-image" will play a prominent role, especially in its reformulation of Henri Bergson's work from which Deleuze derives the notion of duration as *durée*.

### Sensing the Duration of Time: Deleuze, Ozu, and Bergson

Deleuze's examination of movies in his two cinema books is based on the relation between structures that tie the existential change of duration with *movement* on the one hand and *time* on the other. Deleuze does not address the technological specificities of the moving image directly, as it is not what makes the image move that interests him but the fact that it is self-moving. Nevertheless, his understanding of change as that which endures across time and with multiple temporal directions is apposite for an exploration of technological change where time as duration is indeed

at stake. As my own study is also interested in this sense of duration, in this section I will follow Deleuze's thoughts on the matter.

Having gone through the deterministic progression of narrative in the "movement-image," Deleuze turns to the movies of the "time-image" where the progression from stimulus to action is problematized by the prominent independence of a purely qualitative interval. As an example, he addresses Yasujiro Ozu's movies, where teleological action is replaced by static images that depict everydayness in its habitual banality as experienced in the Japanese home and family. Deleuze writes, "Camera movements take place less and less frequently: tracking shots are slow, low 'blocs of movement'; the always low camera is usually fixed, frontal or at an unchanging angle: dissolves are abandoned in favor of the simple *cut*. What might appear to be a return to 'primitive cinema' is just as much the elaboration of an astonishingly temperate modern style: the montage-cut, which will dominate modern cinema, is a purely optical passage or punctuation between images, working directly, sacrificing all synthetic effects."[7] What interests Deleuze here is Ozu's slow camera movements, unchanging frontal camera angles, and preference for the simple cut in editing. Instead of foregrounding the plot, Deleuze sees Ozu's work as increasingly producing idle periods that take over the supremacy of action in the movement-image, favoring the purely visual and aural attributes of the image. It is precisely the insistent ordinariness and seeming vacuity of these images that Deleuze uses to link movies to the continuous duration of reality.

Speaking of perception, Deleuze explains that the individual becomes aware of events occurring and intersecting in a disrupted manner.[8] As such, time is understood from the perspective of the separate points of exceptional moments that split it into chronological order. Nevertheless, what Ozu's work shows is that everything is indeed of the ordinary; everything belongs to the same domain of existence that is life as it unravels undisturbed and uncomplicated, unchanged and regular. Ozu achieves this type of moviemaking, according to Deleuze, by creating "any-space-whatevers" with clear cuts that fragment teleological progression, and vacuous landscapes that draw events to a halt in favor of pure contemplation. Deleuze turns to Ozu's *Late Spring* (1949), a movie that depicts the emotional impact of the attentive relationship between a woman and her widowed father, and the social pressure for her to marry and leave her family home. Having proclaimed that he, too, will marry, the father convinces his daughter to accept a marriage proposal against her desire

to continue living with him and taking care of him. During their last vacation together before the wedding and just as they are dosing off to sleep, the daughter begins to reveal her thoughts and feelings to her father about his decision to remarry. At this point, Ozu's still camera focuses on the daughter's smiling face as she notices her father has fallen asleep and then cuts to a vase sitting on a table before returning back to the daughter, who is now beginning to cry. It is here that Deleuze identifies the still image of the vase as a consistent form onto which the flow of change is strung. As it sits fixed and continuous between the emotional change that the daughter experiences, the vase is a visual passage of a becoming from one state to another. This is, Deleuze explains, time itself in its pure state, "a direct time-image, which gives what changes the unchanging form in which the change is produced."[9] There is a direct relation, that is, between what changes and what resists change, between what passes and what comes to contain the passing in its structure. In its duration, the still image endures while its surroundings change, and in so doing makes evident a sense of time as the constant state of duration within which changing states—in this case an emotional passage from smile to tears—seem to succeed each another.

Time is obviously at the heart of Deleuze's analysis of cinema, and it is Bergson who is at the basis of Deleuze's conception of time as durée— that is, time as the constant duration of change. Indeed, fragmentary distinctness where time is understood as a chronological order of events is addressed by Bergson's work as a significant problem. In his book *Time and Free Will*, Bergson describes how human perception recognizes material objects as distinct spatial arrangements, and language similarly assigns distinct concepts to meaning.[10] As such, both the senses and thought are spatialized in the sense that they are assigned distinct and clearly defined and recognizable values. Nevertheless, this spatialization is the result of the homogeneity of space, where every object is uniformly confined to its particular figure. States of consciousness, though, are continually in contact with one another, informing one another as the person changes. As such, they cannot belong to the same order as space, but become elements of time as duration. Bergson writes, "Moreover, we can understand that material objects, being exterior to one another and to ourselves, derive both exteriorities from the homogeneity of a medium which inserts intervals between them and sets off their outlines: but states of consciousness, even when successive, permeate one another, and in the simplest of them the whole soul can be reflected. We may

therefore surmise that time, conceived under the form of a homogeneous medium, is some spurious concept, due to the trespassing of the idea of space upon the field of pure consciousness."[11]

Spatialization, in other words, leads to a symbolic representation of states of consciousness that forms extensive magnitudes out of sensations. Conversely, concrete time (what Bergson calls durée) cannot be related to space because it is of a qualitatively different regime. The externality of things in space, their magnitude that distinguishes them from one another as they occupy homogeneous space, cannot be applied to time as long as time is not subordinate to space—that is, as long as it is not considered a homogeneous category, too. Time is a heterogeneous regime precisely because it is in time that change as a constant event takes place. Time, in other words, is duration as the constant passage of a becoming—the very state of change. As such, Bergson maintains, what changes is always changing, and so life in its natural evolution cannot be separated into discrete instances of any kind.[12] Existing in time, therefore, means living without separating one's present state from all preceding forms. By tracing back to a previous state as one that has passed, consciousness loses its ability to endure—that is, to be in time as duration. Instead of situating one state of existence alongside another, life in duration situates the body as a stream of consciousness that flows constantly without losing contact with its past existence so that past and present are combined in an organic transformation.

To illustrate his understanding of durée, Bergson turns to music where the notes of a tune melt into one another to form one musical event. To split the tune up into separate segments does not simply disrupt the length of its duration but changes it qualitatively.[13] Of course, each note succeeds the other in linear fashion, but this is not a fragmented separation from one step to the next. Rather, it is of a sort of mutual penetration, or interconnection, that does not allow for any spatial distinction.[14] Indeed, to return to the example of Ozu's vase, there is no simple jump from happiness to sadness as if each emotion was a fragment of the woman's sensibility. Instead, in between the two instances lies the transition from one to the other, the formulation of feelings that led from the smile to the tear. The tear does not simply appear but emerges; it comes out of the preceding state of affairs and emotions so that in it hides a smile and its elimination. Time as Bergsonian duration is the qualitative event of emotional and mental changes that is inextricably linked to the appearance of a new quality. And it is this sense of duration's constantly

evolving continuity that Deleuze sees in the everyday banality and irrational incongruities of the time-image. In the time-image, film's internal relation to the changing force of time is foregrounded, thus bringing thought in direct contact with change itself. It is imperative to see, however, to what extent the different technological setting of the digital might disrupt or change the flow of duration, by making fragmentation and discontinuity prominent features of its products. To address this concern, I turn to a digital documentary where the passage of time becomes the main focus.

## The Duration of *Into Great Silence*

Philip Gröning's documentary *Into Great Silence* (2005) achieves a sense of duration that not only tests Bergson's ponderings on time, but also extends Deleuze's examination of movies to the field of cinematic technologies. The movie is a remarkable and unique documentation of the religious and austere life led by the monks of the Carthusian Order, in the Monastery of the Grande Chartreuse in Grenoble, France. In its duration, *Into Great Silence* follows the everyday lives of the monks for four months using almost exclusively a high-definition digital camera. The choice of camera was indeed the result of the conditions imposed by the Grande Chartreuse (among which no artificial lighting and no additional team besides Gröning were to be used), as well as of the moviemaker's creative desires: to create a spectatorial experience of the absolute and continuous ordinariness of time's passage as lived by the monks, whose lives have been completely devoted to a spiritual quest. For 162 minutes, *Into Great Silence* repeats scenes of the monks praying, reading, walking, and performing other odd jobs, creating a structure that mimics the repetitive pattern of life in the monastery. Unaccompanied, as it is, by any narrative besides the repeated quotidian rituals, there really is no way of avoiding the movie's lulling rhythms that manifest the everyday monotony of the monks' strict lives. It is as if Gröning invites the viewer to be taken by the meaning of time as expressed in the solitude of the monks' existence. *Into Great Silence* does not seem to question the purpose of the monks' decision, nor does it try to proselytize new friars. On the contrary, it is simply interested in creating an intensified experience of duration. Nevertheless, it is important to see how it achieves this sense of time while focusing on repetitive structures at the level of both content and technological form, thus creating a thought-provoking conflict

between a stillness that is drawn from digital structures and an activity that lies beneath it. It is this relation between duration and stillness that I would like to unravel further, in order to understand how the digital reconfigures rather than eliminates structures of time.

*Into Great Silence* begins with the slight clicking sounds of logs burning, heard over a black image that slowly fades in to reveal a close up of a monk praying. This shot soon fades out into an image of a clear sky that progressively darkens to reveal a fire burning in the darkness. This image is then interrupted by an intertitle containing an excerpt from the Bible. In much the same way, the movie is filled with a sense of slow tranquility that haunts its images and sounds as if its architecture were producing the monks' experiences as they live ad infinitum in the monastery. Time becomes a time of constant repetition, an incessant reverberation of the same acts led by the same vows that in turn are led by the same script: both the activities of the monks and the texts of the intertitles are constantly repeated throughout. The monks' lives are tightly contained in this recurrent act of duty toward their beliefs and their choices, so much so that every day seems to be any one instant that has gone by and will return: the same bell tolls at the same hour, the same rites are performed with the same precision, and the same gestures are followed with the same piety. Indeed, Gröning is very successful at creating a movie that echoes this very same sense of living experienced by the monks. Almost three hours long, the movie demands that the spectator insert her- or himself in the routine of the monks seen on screen. The slow transitions from one ordinary day to the next, with hardly any moments of departure from the solemnness of the order, create an engrossing and rich atmosphere that draws in the spectator. In a sense, the spectator becomes a monk in her or his own solitude and ponderings; but the question of what is implied in the monks' and, by extension, the spectators' choice to enter a great silence is significant and must be addressed further.

The silence to which the movie's title refers is a state into which the monks are drawn as they live in their remote monastery up in the French Alps, where their days are made up of silent prayers, readings, and writings. To be sure, the movie is not interested in giving the history of the monastery; rather, its concerns lie with the monks. To return to the title, there is a sense of activity, a movement of a body, which is inscribed in the preposition "into": *Into Great Silence* depicts a decisive will on the part of a group of men, one that leads the monks "into" a life of immense silence where vocal communication is indeed restricted to specific and

limited times throughout their days. This preposition is also a first indication that there is something other than an exact repetition of an austere meditation in the Grande Chartreuse. Coming back again and again to the movie, I find that there is something uncanny about it, something mysterious that is difficult to describe. Perhaps the very act of describing it is unsettling. For instance, during a scene, a monk is depicted eating his lunch while sitting on a doorstep. In itself, this description does not say much, especially in a movie that does not favor one event over another: the scene is not an event in the progression of the narrative, but a moment among many other moments. This is not the first time one sees the monks eat, nor is it the first time an isolated monk performs an everyday task. There is no more or no less significance placed on this event than the initiation ritual, for instance, of a new monk in the order. Why then does Gröning dedicate time to it, and how does the movie in general manage to draw me into its cinematic world even when I do not share the beliefs of the devoted men? Obviously there is something more to the movie's construction, a matter that can be answered by paying further attention to what might be hidden in the monk's luncheon.

Examining closely the details of the scene's formal structure, one can describe how at the eighty-sixth minute of the movie an establishing shot shows a monk (whom the viewer has seen before) as he kneels at an entrance of one of the monastery's chambers and prays as the bell tolls. A new shot frames his face from behind and diagonally in extreme close-up, so that the focus is on the side of his face as the monk brings a bowl of food toward his mouth. A further cut returns to a long shot of the monk from a different angle—this time from inside the building— where he is shown sitting in the entrance, leaning against the open door, gazing outside as he eats in the warmth of the sun and amid the ambient sounds of the landscape. A further cut closes in on his face from the front this time, so that his draped upper torso and head are visible as he eats a spoonful of food. All at once, though, the next cut reveals a six-second image of the clear blue sky across which an airplane is flying. The next shot frames the monk in a tighter close-up as he bites his bread, followed by a high-angle shot of him, and another extreme close-up of the side of his face. Then, once again, the viewer loses track of the monk and instead sees a shot of a rough and heavy exterior wall, covered partly in dirt and partly by moss, completely still with the exception of a few stems of plants softly swaying at its base. This shot is succeeded by an extreme close-up of a flower pod shot against the unfocused background of its

mother plant, which is replaced by a grainy—that is, celluloid—shot of foliage that the camera records as it pans and tilts across the ground. Finally, the monk is shown again, as the camera frames him in a medium long shot, succeeded by an exterior long shot as he momentarily kneels down in front of the chambers before slowly walking along the stone path that surrounds the small garden.[15]

It becomes apparent, therefore, that something more takes place in this scene than the straightforward statement of "a monk eating lunch" initially proclaims. On the one hand, the multiperspectival footage of the luncheon emphasizes, in its repetitive view, the individual and his present activity. At the same time, though, it expresses a correlation between what remains continuous in this repetition and what changes. To repeat Bergson's thoughts, the perception of existence is clouded by the idea that one passes from one state to the next as if each was an independent point from the other, comparable in size or hierarchy to the previous.[16] This would be like saying that at the beginning of the scene the monk is hungry, and when he starts eating he is less hungry, and when he nears finishing he is almost full, and when he starts his stroll he is actually full. Obviously, there is a sense of change embedded in this progression from hunger to fullness: at this moment he is hungry, at this he is not. Nevertheless, this is not a satisfactory understanding of change because it positions existence as if it were a leap from one state of being to another so that each is a point in space rather than in time, thus expressing a difference in quantity rather than quality: less hungry, more full. Ultimately, this would necessitate a fragmentation of existence into separate segments constantly multiplied to fill in every moment that goes by. At this point we would not have the monk who is hungry and later the monk who is full, but we would have one monk who is hungry and later another monk who is full. There has to be a continuity, therefore, from one state to the other, and this is precisely what Bergson expresses with regard to duration as a constant flux of existence evolving without stopping; time, that is, as variation that undergoes change at every moment so that there would be no moment that actually could be isolated from the next. Is this not what Gröning achieves by repeating the state of eating with the same attentiveness and the same rhythm in each shot? There is no privileging from the one moment of eating to the next and therefore no sense of some quantifiable fulfillment from the one shot to the next. The state of eating, as Gröning imagines it, is in the flow of simply being framed in the image. The monk does not proceed from the state of hunger to achieve

the state of fullness, but becomes full while eating. He is not simply there, immobile and unchanging, but constantly caught in the "into" of the title. He is not just there, positioned in great silence, but he is in a process of becoming as an act of constant change.

This sense of change is what the four arbitrary shots in the scene stress as well: the flying airplane, the wall, the bud, and the foliage. These shots cannot be point-of-view shots because they do not match up with the monk's eyeline or with any of his actions. Like the rest of the movie, these shots do not conform to a progression of a plot that abides by an event causing another (in the form of a classical narrative structure). Instead, they create a direct break from the event of the luncheon that does not relate to a necessary out-of-field or to a rational development of an activity. They express, in this sense, the interval of Deleuze's time-image in much the same way that Ozu's shot of the vase induces a sense of durée. Their fragmentary relation to the surrounding structure suggests something quite different: as any-space-whatever they seem to express a mental point of view as if thought found a place in the image. At the same time, though, they emphasize directly the discontinuous nature that the cinematic cut expresses in general. Indeed, beyond being celluloid or digital, the image is always a fragmentary form of change, a matter that points back to a paradox in its potential to create the existential continuity of durée. Before continuing with my exploration of the digital's creation of time, it is necessary to see, therefore, how both Bergson and Deleuze address this technical discontinuity. What is important to note is how the fragmentation of motion into a specific frame rate remains an essential problem for Bergson in *Creative Evolution*, whereas for Deleuze it is overcome by the potential for depicting duration's continuity in the constant and unpredictable emergence of the instant.

### Celluloid Fragments of Time: Bergson's Durée

The question that celluloid time induces is how it can depict durée when what it creates is technically a sequence of static moments, each one vanishing just as it is replaced by a following point. Bergson poses this question in *Creative Evolution*, although for him duration remains a problem when situated within a celluloid visual culture. In speaking of film technology, he writes, "we take snapshots, as it were, of the passing reality, and, as these are characteristic of the reality, we have only to string them on a becoming, abstract, uniform and invisible, situated at the back of the

apparatus of knowledge, in order to imitate what there is that is characteristic in this becoming itself."[17] Celluloid film creates motion by combining separate immobile photographs and reanimating them through the movement of the projecting apparatus. As such, though, the apparatus posits an impersonal and abstract sense of movement as an overall quality of movement itself. And so, what is depicted on the screen is not motion with all its peculiarities, differences, and multiplicities, but one unifying general principle measured by twenty-four subsets per second.

Time here is imitated through a withdrawal from its inherent continuity, which elicits a neutralized subject who dissects time without interfering in the production of meaning or being affected by the dissection itself. The problem that arises is that such an attitude poses an existential problem by creating a perception of life according to a mechanism of generalization that does not flow with the stream of time. As existence takes place in time's duration, though, it cannot be separated into fragmented segments that are cut off from one another, because time is a passage that pushes forward without losing its past. There cannot be distinct moments, as Bergson maintains, because this would eliminate change as flux in favor of change as classified instants: time as moments of states that take the form of clearly delineated objects positioned in space. Therefore it seems logical to assume that a cinematographic framework that breaks the continuum of time into static, quantifiable moments would be unable to produce a sense of the duration in which Bergson is interested.

While for Bergson the cinematograph expresses a scientific objectification of time that dehumanizes the image of the world, Bazin reaches very different conclusions when he sees time revealed in the complexities projected by the duration of the long shot and the irrational incongruities of the "image fact." Similarly, Barthes experiences the qualitative expansion of the still frame or the photograph through the "punctum," which incorporates an instant of the past on the basis of which the image's history is placed in immediate contact with the personal history of the viewer. Moreover, in his rereading of Bergson, Deleuze finds a way of including time into cinematic depictions through the potential of the time-image — that is, through the disruptive nature of specific structures of the moving image. What is quite intriguing in Deleuze's work is that the sense of Bergson's durée is achieved with the displacement of linear movement or its hindrance. Not only does Deleuze speak of a moving image that is

fragmented into twenty-four still instants per second, but he also bases his notion of time on the empty blocks of "opsigns" and "sonsigns," and the predominance of "any-instant-whatevers" through aberrant cuts and irrational editing. As such, the time-image creates intervals or mental blocks that jar the linear progression of habitual recognition for the sake of an awareness and involvement in the qualitative gap between stimulation and active response—where thought as creative process is held. The power of the emptied and isolated image of the time-image is precisely its ability to suggest the insistence of time that is filled by change and to confront the spectator with the limitations of a teleological approach to thought. Indeed, what is intriguing in the theories of Bazin, Barthes, and Deleuze is that the focus is on what disrupts the unity of the image so that a sense of time is actually drawn out of its discontinuity.

### Stillness and Motion: Stewart's Freeze-Frame

What becomes evident here is the correlation between stillness and motion that is at the heart of celluloid film's moving image. Although not openly addressed by the aforementioned theorists, the freeze-frame presents an interesting example of film's operations because it emphasizes the static and fragmentary technical nature of every celluloid movie. This becomes the subject of Garret Stewart's book *Between Film and Screen,* where he addresses the relation between the fragmentation of the film-strip into static frames, the freeze-frame's emphasis on stillness, and the inevitability of death.[18] Opposing what he calls the "phenomenological given" that sees the moving image as a continuous expression of time changing, he turns to what is always hidden behind the image: immobility. By hiding the separateness of each photogram that comprises its material base, by mapping the one split-second image onto the next so that the ruptures are overlooked, film screened becomes seamless motion uninterruptedly evolving. However, as if to creep up and halt the natural flow of things like the deferred effect of an unconscious trauma, Stewart describes how the still image appears from time to time in different guises. With this in mind, he turns to examine these instants whereby the singular unit of celluloid, the photogram, is more or less implicitly alluded to with a movie's depiction of still photographs—or as Stewart names them, "photopans"—and the insistent multiplication of one image in the form of the freeze-frame.[19]

With reference to the photopan, Stewart examines Ridley Scott's movie *Blade Runner* (1982), a futuristic portrayal of dystopian postmodern cities and robotic slavery. Scott's grim tale revolves around the loss of personal identity exemplified in the near impossibility of differentiating between organic and robotic entities and in the idea of creating a sense of individuality for the androids through the fabrication of personal memory. Harrison Ford's character, Rick Deckard, investigates a group of replicants—highly advanced androids who have escaped to Earth from their outer planet, enslaving labor in order to find their creator and force him to override a configuration that limits their life span. In one of the most famous scenes of the movie, Deckard examines a computer rendition of a photograph in which he moves freely around the image, turning to hidden spaces of the visual field. Speaking of this scene, Stewart writes, "The photo is, in short, cinematized—edited, cut, motorized, even lent the illusion of three-dimensionality resulting from shifts of perspective as the camera roams the already fixed image plane."[20] This ability is made possible through the digitization of the photograph, but what is openly foregrounded nonetheless is the tension between stillness and motion. While the photograph is in itself still, it is put in motion by the computer in the same way that the projector induces the illusion of movement with the rapid succession of the still photograms of the filmstrip.

Whereas the photopan simply summons a world that lies behind that of the screened world without really eliminating the latter, Stewart insists that the freeze-frame openly cancels the passage of the screened world, arresting its progression in a stuttering petrification that reveals a horrific truth about film's nature. Although he limits his approach to the implication of stillness in the moving image rather than the potential of change in the still image, it is crucial that he points to the inherent dangers of an overgeneralization of the matter. By equating film and spectator as existential acts, Stewart sees phenomenology as a disregard for the specificity of the image's medium. Such, he maintains, is the case with Sobchack's approach, which forces a complete distancing between the still and the moving and locates the past conclusively in the photographic, the future in the filmic, and, as I will return to later, the present in the digital.[21] Indeed, the freeze-frame of the filmic apparatus problematizes this tendency because it presents a view of the world that cannot be rationalized solely through the existential positioning of the viewer. As I discussed in chapter 2 with regard to film's corporeality, Sobchack's theoretical framework in *The Address of the Eye* endows cinema with a

perceiving and expressing body according to the existential experiences of the viewer. For Sobchack, the cinematic event cannot be reduced to one constitutive part—namely, the still frame filing past the spectator at a purposefully imperceptible speed—because such a reduction would fundamentally alter an understanding of the existential status of film. As the embodied experience of the world does not disassemble movement through the interruption of blinking, the existential activity presented by film similarly overrides the fragmentary nature of its serial discontinuity. Sobchack writes, "They [the discrete frames] are no longer 'moments,' set beside each other as a digital series of discrete points. Rather, they radically resolve themselves into the analog fluidity of intentional action, initiating and completing its tasks and constituting significance against the double horizon of a world and a lived-body."[22] For Sobchack, therefore, the movement on screen is not an illusion of movement, not even an allusion to movement, but is movement itself, thus understood because it is perceived and experienced as such from the viewer's point of view. Nevertheless, Stewart astutely points to an important shortcoming of Sobchack's argument reflected in her lack of consideration of the implications caused by the example of the freeze-frame.

To be sure, the fragmentary nature of the filmstrip does not usually take part in the spectator's experience of watching a movie—but usually is not always, and this is what Stewart's analysis focuses on as he examines the effects of the freeze-frame. According to his reading, the freeze-frame does not simply interrupt motion, but eliminates it completely. It visually displays film's latent stasis through a parade of the motionlessness that necessitates an irreconcilable distancing of the screen's view from the spectator's own natural experience.[23] Where for Sobchack the movement on screen cannot be tied down to its technological base but is perceived as real movement by the viewing subject, for Stewart the stillness of the freeze-frame keeps the apparent motion stuck onto a singular photochemical cell.[24] The reality on screen is not reality itself, but, as Stewart says following Cavell's approach in *The World Viewed*, a series of screened visions put on display that present a distance between a past world viewed and the viewer her- or himself.[25] Rather than bind the two viewing acts together through a phenomenological assimilation, the image actually presents their distance. As such, Stewart's reading of the freeze-frame opens a gap between, on the one hand, the visualized sequence of stills on screen and, on the other, a vision that is now projected on the screen from the viewer. The world of the viewer is not

directly the world viewed, although the latter is viewed as if it were the actual world. And if only with the intertextual allusion of the photopan or the revelatory manifestation of the freeze-frame, screen motion acknowledges its own reliance on the still frame. The frozen image reveals, in other words, what remains constantly hidden behind the image of movement as the primary celluloid origin: the movement of stasis.

Although Stewart insists on the idea of celluloid immobility, he does not eliminate time from the image. As it depicts an obsessive fixity that discards any sense of change, the image frozen recovers time from within this static interval. According to Stewart, this is a time that seems to be missing from Deleuze's categories in his time-image precisely because it is of a duration, but not of a change; a temporality that expresses, as Stewart writes, "the irruption of the pure durative, bred of repetition, amputated from all change."[26] Duration here is experienced in the act of contemplation on behalf of the viewer. It is the time of contemplation that the freeze-frame establishes by foregrounding its material base for some length of time. Thus understood, Stewart speaks of the freeze-frame as *frieze* frame: "The stuck (reiterated) photogram, rephotographed in multiples, becomes less a freezing of the imaged action than a lingering, numb cinematization of a photographic *frieze*, with the residual narrative (as well as pictorial) apparatus often powerless to get things going again."[27]

Paradoxically, though, Stewart eliminates a sense of subjectivity from the image construction on the basis of there being a lack of identification with any one character (thus excluding theories of suture), but also on the basis of the irrelevance of any personal lapse into past sheets of memory (which arise in Deleuze's reading of movies).[28] The subject is excluded from both the content and form of the freeze-frame: on the one hand, as there is no narrative to grasp and, on the other hand, as there is no aberrant link on which to dwell. The freeze-frame is the scene of the material base that becomes in itself, and without any necessary involvement of the viewer, both specularization and act of observation seen as time. It is for this reason that Stewart speaks of the photogram's persistence as a "forced presentness of imprint: then/now as the now."[29] As he describes, the return of the cinematic to its photogrammatical unconscious is actually a restoration of Barthes's punctum—the "that was here now" of Barthes's own contemplation of photography integrated in Stewart's own "then/now as the now." Nevertheless, stuck as it is in the arrestment of change as an inflated instant, the freeze-frame cannot impose any nostalgia for the past—as the photograph does for Barthes

in *Camera Lucida*—and it cannot drift into the future of becoming—as Deleuze's time-image does. Neither a lapse into the past nor a folding into the future, Stewart concludes that it presents the spectator with a nostalgia for the present.

Stewart finds this constant presence to be the ontological underpinning of the freeze-frame. As it resists moving on, the freeze-frame reveals what is constantly present in the image although covered up by the illusion of movement: the stillness of death to which change inevitably leads. By emphasizing the spectacle itself, these stilled images allow for the suppressed still frame of the filmstrip to be revealed as a return from the dead—or more likely, as the dead. Stewart is clear on this: "Death marks the spot."[30] Yet, while he builds a strong case for reading death and stillness in the freeze-frame, he loses focus of one imperative technical element of this aesthetic mode: the fact that it mechanically loops a single frame. In other words, while the freeze-frame points to the illusory nature of celluloid motion, it also points to its own illusory stillness because it remains still while in fact the filmstrip continues to move. It is this constant tension between time and stillness that I find to be imperative in the associations that film elicits. With this as my cue, I will go on to explore the still image of celluloid constructions further in order to see what film reveals about the complex nature of the static image and change.

### The "Still Moving" of Celluloid Cinema: (nostalgia)

The fragmentary nature of the filmstrip retains a degree of interaction with the moving flow of the screened image. By presenting itself as a self-moving development, the filmic image is experienced as a manifestation of time passing, albeit one where movement and stillness are in close contact with each other. As such, it elicits an interrogation of celluloid's relationship with movement and time. For Bergson the fragmentation of the filmstrip remains a problem because it spatializes change sequentially and thus limits durée within the confines of a different, homogeneous regime. Nevertheless, for Bazin and Deleuze—albeit differently for each of them—time as duration can become part of filmic structures based on an aesthetic form that disrupts the teleological determination of spatial movement. In contrast, as Stewart argues, the freeze-frame does not disrupt movement through emptied spaces or irrational jumps, but seems to eliminate change completely, thus returning the moving

image to its static substrate. Rather than examine the freeze-frame as a complete annihilation of change, it is more valuable to see how it configures change differently. In other words, I would like to examine whether the static image could function as a peculiar reassertion of the continuity of time, a reminder of the constancy of durée in the unfolding of existence. Indeed, my insistence on the static celluloid frame has to do with my interest in the matter of stillness that becomes a matter of concern in the case of the digital's moving image. Before turning to the new technology, though, I will continue to unravel the effects of the photopan and the freeze-frame as they function in Hollis Frampton's movie *(nostalgia)* (1971) and Chris Marker's *The Pier* (1962), respectively.

Frampton's *(nostalgia)* is an astonishing short movie despite its overall simplicity in content. It is made up of fourteen 16mm still shots that present different photographs one by one as they lie on a hot plate that burns them gradually, while Michael Snow's voice-over narrates the moviemaker's experiences as an art photographer in New York in relation to the photographs depicted. Despite its minimalist bareness, the movie discloses the dialectic relation that is established between still image and motion, as well as the rich bifurcations of time in which the spectator is involved as she or he is entrenched in the very passage of duration.

Beginning with black leader and a short discussion between two men regarding the sound quality of the recording, the image then presents a still photograph of a darkroom. Some seconds later, the narrator says, "This is the first photograph I made with the direct intention of making art." Notice the "this is" combined with the past tense of "made," which follows Barthes's and Stewart's understandings concerning the ramifications of the frozen image. Nevertheless, Frampton seems to complicate the persistence of the past with what follows. The narration describes how the photographer bought himself a camera in 1958, took photos of Carl Andre's drawings some days later, and having a shot left, took a portrait photo of Andre looking out from a small picture frame. The narrator also refers to a metronome positioned somewhere in the picture. In the mean time, the photograph starts to burn and by the time Snow tells of the reappearance of the picture frame in a photograph taken four years later, the image is nothing but a black, burning mass. Snow's voice continues to speak of the metronome, explaining how Frampton got rid of it, of Andre's current state and the deterioration of Frampton's relationship with him, and of the fact that the latter sees more of some people for whom he cares less. Finally, Snow's voice-over explains that even though

Frampton despised the depicted photograph, he could never bring himself to destroy it. Of course, by this time the photograph has been completely destroyed by the flames, leaving nothing but ashes slightly moving as they twitch on the hot plate, creating balletic formations of black dust for just over a minute after Snow has stopped speaking.

To be sure, the strong spectatorial impact that *(nostalgia)* achieves surpasses a simple alignment of image and narration; for, while trying to see in the picture what the words describe, something starts to feel unsettling or misrepresented. Either the viewer does not notice quickly enough the depicted elements described by the narration—the image vanishing too soon for her or him to read into it what was said to be there—or the narration is asynchronous to the image. Indeed, the next photograph reveals elements contained in the previous description: the small frame, the metronome, and the portrait of a man. By the third image it becomes clear that the narrated description refers to the photograph that follows the one presently depicted, the latter's description having been given during the immediately previous shot—a play, that is, from future, present, and past. As a result, the spectator becomes immensely involved in the act of viewing, so that watching *(nostalgia)* becomes an activity or performance of memory and the awareness of the viewer's mental stimulation. There, in every shot, is a double motion: on the one hand, to the past of what was said and, on the other hand, to the future of what will be shown, both directions contracted in the fleeting moment of the rapidly disintegrating form of the still photograph and the vanishing words. The result is a spectator who struggles between viewing, hearing, remembering, and anticipating so that, just like the burning still photographs themselves, she or he is animated.

The brilliance of Frampton's achievement with *(nostalgia)* is that the movie expresses what the cinematic apparatus does technically from camera to projector. Framing the still photographs for almost three minutes, *(nostalgia)* displays them initially unaltered, thus revoking the series of static photograms that form the filmstrip. Then it gradually animates the photographs by burning them, which results in each one vanishing as it disintegrates into flames and ash—a motion that ultimately destroys. This is to say that the still images reveal their mortality quite paradoxically as they are animated, not as they are frozen (to recall Stewart's reading). Initially persistent formations on screen, the photographs are gently nudged by the heat of the coil, and then completely penetrated and dispersed into black and gray cinders. Instead of supporting an ideal

As the still photograph is animated in its destruction, we hear a voice-over that belongs to the following image. Still images from *(nostalgia)* (Hollis Frampton, 1971).

of mortality, though, the movie actually expresses something quite different: the constant activity of change even when action seems not to change at all. Even when the photographs are static, in other words, they are actually moving, even if this motion is reduced to a molecular hastening for some time. Moreover, from a direct memento mori, *(nostalgia)* becomes a direct time-image as a becoming by complicating the move from one still image to the next on the basis of the disjuncture between image and sound in each shot, and the constant interaction of meaning between the shots. The nostalgia to which the movie refers is based on the Greek word that expresses an obsessive desire to return home, experienced as a self-devouring anguish. Of course, the sense of nostalgia in the movie is not one that causes such pain to the spectator, but the act of destruction is present, in fact threefold: loss of image and sound with the continuous flight of the filmstrip, destruction of photographs by fire, and inevitable distortion by the viewer's memory of both the visual and aural information. The fixed status of the photographs' unchanging stillness, in other words, has no place in *(nostalgia)*. All at once, the motion of the

filmstrip, the motion of the flaming still photographs, and the motion of spectatorship—considered here a consciousness as an expressive perception—makes the whole movie a seesawing shift from then to here and afterward in every instant.

Writing in her book dedicated to examining Frampton's *(nostalgia)*, Rachel Moore describes the movie's inherent destructive impulses. She writes, "Each burning releases the image from its fixed place in history to metamorphose and fit a new temporal register, as well as a different signifying function."[31] As each photograph combusts in every segment while described with delay, the movie registers a visual and aural displacement that unhinges the image from any fixed position (a displacement that resonates with the displacement of a nostalgic individual). As Moore astutely points out, *(nostalgia)* opposes an understanding of historical past as a series of static occurrences in favor of a "plastic" interaction with the past according to Friedrich Nietzsche's reading. Here plasticity is understood as a relationship with history that is not fixed as a predetermination, but gains a transformative, albeit historically informed, potential of recreation.[32] This plastic malleability of time is a component of the activity enforced by Frampton and played out by the

spectator: the burning still photograph, the delayed voice, the friction of time passed, time passing, and time coming—this whole construction is the malleability that reactivates the image's forms, re-creating them as an activity in which the movie is positioned in the flood of creating. While it complicates the interactive convergence of stillness and motion, *(nostalgia)* presents the inability to fix the two structures irreversibly. A hybrid of static frames and rotating mechanisms, of stops and speeds, of instants and durations, celluloid film perpetually devours both stillness *and* motion continually.

In her book *The Emergence of Cinematic Time,* Mary Ann Doane speaks of motion, stillness, and duration by turning to early actuality movies of the fin de siècle.[33] She explains how this cinematographic and philosophical period expressed time with movement, movement being a guarantee of time progressing and existence changing. Time here was measured by movement so that motion itself was necessary for any temporal component to be evoked. In the case of Bergson, continuous movement was considered a quality expressing the passage of time, and so even the rapid succession of spatial points or fragmented instants could not reproduce time.[34] Here lay his dispute, for example, with Zeno's paradox, according

to which the flight of an arrow is understood as the sum of all the static instants that it takes in space, thus analyzing motion as a series of poses.[35] Nevertheless, neither Zeno nor Bergson tried to question the forced coalition to which they subjected time. As Doane explains, the problem arises from instantaneous photography on which film technology is based, as opposed to the preceding daguerreotype that necessitated long exposure durations.[36] From the hierarchical poses of the eventual actualization of ideal forms that ancient philosophies supported, modernity hailed a mechanical rendering of time, wherein instants were serial, equidistant, and nonhierarchical—like the cinematograph. Indeed, as I have examined, these approaches err for Bergson because they insist on the fragmentation—and inevitable spatialization—of duration. In contrast, Deleuze sees a significant potential in modern thought's disavowal of privileging stases, which takes the form of his notion of the any-instant-whatevers that resonate with the twenty-four frames per second filmstrip of the cinematograph. According to Deleuze's approach, the new is produced in any moment whatsoever so that meaning becomes a process of emergence and surprise.[37] In other words, the emergence of meaning, its renewal as an act of a constant move into the new, the unforeseen,

the "not-here-yet," is extracted from the arbitrariness that is rendered into the image through its technological base despite the strict calculations of the moviemaker. Any instant is rapidly fed into the camera's hasty rotation, creating a potential glitch that is present in the arbitrary formation of halides at any one twenty-fourth of a second. Meaning is not presupposed; it does not exist somewhere in order to be attained, but is withdrawn from the contingency of existence. This is what resides in the instant: a potential of becoming, or duration.

It is interesting to note that the approach to cinematic time deals with a conflict between visibility and invisibility. This is the constant play of the filmstrip itself as it makes visible the passage of time while leaving the gap between frames imperceptible. At the same time, though, duration is actually energized by this invisibility, by limiting vision as it leaves elements of the image concealed. The interval between frames is a reminder of something more than the habitual progression of motion. The blind spot is not a simple break, but the qualitative activation of time passing—a Bergsonian transition as duration. What happens, though, when all motion is arrested and the spectator is left with the abundant insistence of the freeze-frame? It may appear that durational time is put to the test, but only seemingly so. Instead, what the freeze-frame actually achieves on a technological basis is a multiplication of a distinct image.

In its excessive spatial display and incessant temporal replay, the freeze-frame emphasizes what the film projector does by reversing the order: in pausing, it stresses the seeming effacement of the interval between shots where continual change can be found. As such, the spectator is drawn to what seems to be missing from the image but is there nonetheless: the fragmentation on which celluloid technology is actually based. Moreover, it rearticulates the visibility of duration on premises other than mobility. The freeze-frame declares: look, time is passing because duration is here in my body—felt through the vibrating intonations of the grain—and your body—perceived as a presence drawn to speculate on the lingering image. There is an interactive exchange at stake, where what is unseen in the image becomes perceived and what is forgotten outside the image is brought back to vision. As the static image revisits its own self, the spectator does so, too. And from one to the other, the *still* moving image—*still* in the sense of being both *static* and *nonetheless moving*—is enhanced by the involvement of the spectator and the potential of her or his thought. As such, the image is nothing but an activity made potently felt in its arrest of spatial progression, bringing

spectator and display as twofold elements of the same performance: that of time. What persists in stillness is not only the *static*, but a *nonetheless* as an instance of change embedded in the image's constant and consistent repetition.

## An Ontology of the Static: *The Pier*

Despite Stewart's insistence on aligning the stillness of the freeze-frame with the inevitable end of existence, it is indeed possible to see an existential renewal embedded in the ontology of static images. For Barthes, still photography—or stilled cinematography in the case of his examination in "The Third Meaning" of still frames from Eisenstein's work—is a negation of life in its temporal unfolding.[38] In *Camera Lucida*, his mother's pose as a young girl in the Winter Garden photograph, her instantaneous stasis in the image, is read as her inevitable death that will halt her life forever. Nevertheless, there is something other than a pause in the pose that is revealed precisely when the image is of a young child. The child does not naturally pause for the image to be taken; in fact, this attitude is gradually forced on the child's behavior as a social skill that teaches it the pretense of seeming enchanted ("strike a pose!") while inevitably leading it to its own self-hypnotization (the eventual striking of the pose). Initially, though, before the instantaneous still is deprived of that to which it bears witness further, the child is led to the lens out of curiosity, or amusement, because the camera seems like a bizarre piece of equipment that the photographer (daddy and mommy among others) places in front of her or his face. Either way, there is a focus of attention, and this is that on which the photograph focuses. In fact, this attention is what the photographer seeks out as the child plays irrespective of her or his desire, constantly wandering off and constantly shifting attention elsewhere. The pose is not only a static pause of motion, it is not even simply a point of trauma as Barthes's punctum expresses, but a point of departure between gazes: a moment sought after and a moment of wonder that wanders off as the photographed subject approaches with her or his gaze attentively and the photographer leans in to grasp the event encountered. Static, nonetheless of a movement not only beyond its confinement (outside the image as a world of unfolding possibilities in the likeness of Barthes's contemplation on the technology) but also in its own frame, the photographic image is quite revealing of this tension between stillness and durée.

It is precisely this potential of duration expressed in stillness that Chris Marker's *The Pier* (1962) displays beautifully as it situates the tension between static instant and change on the cohesion of mind and body, and memory and movement. Like *(nostalgia)*, Marker's *photo-roman* is revelatory in its narrative simplicity. Almost every shot is made up of still images and a voice-over narration that tells the story of the nuclear destruction of Paris caused by a Third World War. To stay alive, the survivors live underground, where the victors of the war keep prisoners on whom they perform experiments in the hope of reaching another time of peace, past or future, from where they might receive help. The scientists decide to focus on one particular man who is obsessed with a strong image of his past and so might be more successful in time traveling. In this past memory, the man is a young boy standing on the observation jetty at Orly Airport, where he sees a woman's face and then a man being murdered. Paradoxically, though, the man who dies is his own self who has traveled there from the future. Indeed, having successfully achieved time travel, the scientists no longer need the man and decide to kill him. As the man is helped by a group of people from the future, he returns to his past to rejoin the woman he loves—only to be finally murdered on the pier by a scientist who has sought him out.

In this collapse between past, present, and future, Marker creates a tension between existence and memory, revealing the complex relationship between stillness and time. There is actually no insinuation of a corporeal transportation of the man in the experiments; rather, the scientists seem to transmit his consciousness into the past and future, not his body. Nevertheless he dies, because his corporeal existence is glued to his mental activity. Herein lies the temporal encoding of the movie: the man is in fact lying still as a body, but leaping through time as a mind; and in the mental leaps, time is felt as bodily sensations, desires, and sufferings of memories and their renewal. The man, that is, moves as a body as he engages with the woman in the past, and as a mental state as he is affected by his sensations. With regard to the woman, the narrator says, "For him, he never knows whether he moves towards her, whether he is driven, whether he has made it up, or whether he is only dreaming." To be sure, it is all this at once: both voluntary and involuntary motion of the body inscribed in the seeming stillness accompanied by mental figurations of conscious imagination and unconscious wanderings. For Peter Wollen, this relation between stillness and duration is understood

as the ability of the static image to narrate a story that involves the spectator in its fictitious development.[39] And it is due to this animating effect of the still images that Philippe Dubois chooses to term the stills "cinematograms."[40] Moreover, as Catherine Lupton's beautiful discussion reveals, the static shots bear a cinematic presence from which they gain the constant potential of transformation.[41] Such is the very wink of the eye manifested in the only moving shot of the movie, where the woman is sleeping and then awakens to look straight at the viewer and blink. Although initially static as a still image of a sleeping body, by waking up and blinking the woman reminds the viewer that she is in fact a living existence in time's weavings, as is the viewer whose gaze meets hers— and whose gaze actually necessitates her own motion at this moment.

In sum, stillness here is not an annihilation of, nor even a resistance to, duration. On the contrary, it is another expression of duration's changing force as another experience of time—albeit one quite unsettling due to its contradiction of the common alignment of change with movement. The persistence of static images—be they photopans or freeze-frames— creates a sense of an existential lingering or stutter even though breathing continues. In stillness, the past seems to persist in the present, making whatever has passed the essential feature of the experience. At the same time, though, the unfaltering surface of stillness bears witness to a duration: in it lies its own past, brought forward to a future where it meets the present gaze of a witness who endures in the encounter between her or him and the stilled image. Time, that is, is experienced in the still as motion bracketed while change is ongoing nonetheless. The static image is like a sea pebble, a motionless element frozen and distinct, cut off from the passage of the world as it is contained homogeneously in its separate space. Nonetheless, this same surface bears witness to its own duration: smooth as it is, it has been sculpted out of the friction with fragments of land and lashes of waters through a journey from any place to here and now. And in this here and now of the encounter, it gains new momentum: remaining in one's possession it becomes a memoir of a day, an event, a sensation or emotion, or simply an artifact of nature's engravings; returned to the sea, it continues a journey of qualitative variations in its form all the way to its possible metamorphosis into sand, at the same time retaining the potential for any other encounter. This is a frozen or stilled regime as another type of a Deleuzian time-image where what is *still*, is still moving.

## "Now" of the Digital: *The War Tapes*

The reason for my insistence on studying celluloid film's photopan and freeze-frame, and their inherent change despite their stillness, has been to recognize a potential for durée in structures other than continuous motion. I have done so precisely because the operation of digital technology rests on the interaction between pixels that are in fact momentarily stilled in their projection and, as long as they retain the same relative position and configuration, are mathematically unchanged and thus repeated when the image is refreshed by the hardware. Stasis and repetition, in other words, are principal features of the digital's form of change. Indeed, Rodowick points out that the continuous rescanning and refreshing of the digital makes the image in its totality a fragmented mosaic of constant instantaneous shifts.[42] The paradox with digital images, he explains, is that their fundamental form is symbolic, a numerical structure that does not necessitate any link or relation to a spatial plane or temporal passage. Moreover, even in its projection, the image is never wholly there because it is discontinuously and constantly being reconstituted by a process of scanning and refreshing that leaves it wavering at every instant. As he describes, "Even a 'photograph' displayed on an electronic screen is not a still image. It may appear so, but its ontological structure is of a constantly shifting or self-refreshing display."[43] Therefore, where photographic media create visually present traces of a time past or time passing (thus involving the collapse of time into a present in constant contact with past and future), digital constructions are sets of encodings for the purpose of graphically tracing out an image of time as if it were present. Indeed, these graphical displays are in fact temporally unbound by both a past as well as a future toward which the image has no time to move. How, then, can the *instantaneously* renewed or identically repeated static numerical pixels of the digital express Bergson's life-affirming duration as a sign and agent of heterogeneous creative change?

Instantaneity—both in the sense of the immediate availability of recording devices, as well as of the immediate results of acts of recording and image manipulation—has become the hallmark of the promotion and widespread reception of new media. These expressions of instantaneity have been the focus of a number of recent movies, including Deborah Scranton's compelling documentary *The War Tapes* (2006). Indeed, the movie presents the possibilities of digital capturing and the immediate

access the technology offers for archiving images of the world. It consists of a selection from the eight hundred hours of footage captured with MiniDV video cameras by ten soldiers of the New Hampshire National Guard serving between 2003 and 2004 in Fallujah, Iraq, as well as some two hundred hours of tape documenting the lives of the soldiers' families back in the United States. Of the ten soldiers, the movie focuses on Sergeant Steve Pink, Sergeant Zack Bazzi, and Specialist Mike Moriarty, who captured the ongoing incidents they encountered in the war zone as they took place while keeping constant contact with Scranton via e-mail and instant messaging. The result is a riveting testimony of the personal thoughts of the three men, their ruminations on the causes of the war, the everyday banality as well as sudden attack and bloodshed in the battlefields, and the constant psychological impact and change of the experience.

Scranton's desire with *The War Tapes* was to gain a horrifying directness to the war in Iraq by utilizing the ease with which digital cameras can record events just as they occur. Due to the light weight, small size, and immediate and large storage capacity of digital camcorders, events are captured with hardly any need for preparation and with such rapidity that even the most unpredictable occurrence can be documented.[44] Of course, this potential is not something radically new. Photojournalists like Robert Capa reportedly recorded, among other events, the very moment of a Spanish loyalist militiaman's death in his photograph "Death of a Loyalist Soldier" (1936); and Tony Vaccaro, serving in the U.S. Army during World War II, documented Nazi and postwar Germany through his photographs. Nevertheless, there is an immense revitalization or utter domination of the instantaneity effect generated by the digital. Indeed, *The War Tapes* forces a return to the question of Bazin's indexical ontology, which boasted an assurance of the image through a link between present and past on the basis of light and an automatic chemical reaction to celluloid's substrate. To recapitulate briefly, Bazin understood that the past was saved from its actual mortality by being brought forward as a photochemical transcription. The sign of the photographic image is a moment of real time lived, taken an important step further with the help of the cinematic apparatus that gives motion to this reality, thus rendering time's flow. The index, in short, functions as a time portal, a gateway to reality that really happened (in the past) and is really happening again (in the present). What, then, of the nonindexical function of the digital? How can the digital make present what was once in the past and reconnect with time itself?

I turned to this question in chapter 1, examining the different relations that digital images set up to reenergize a value of reality that is lost from their technological function. At that point, I explained that superfluous elements of narrative create a link to reality by alluding to reality as an effect. But there is a specific sense of temporality inscribed in the index that is based on instantaneity. What the index actually transcribes instantaneously is a guarantee of an event's witnessing. Doane describes the relation that image technologies—be they analogical or digital—set up with the spectator by granting a promise for immediate access to reality. The index is a moment or momentum of eventful or extraordinary change. Doane writes, "Although the televisual and digital representations of explosions are not photographically based, their indexicality is a function of the strength of their exhortation to 'Look here!,' 'See this,' acting as the pointing finger of Peirce's empty indexical sign. The 'liveness' of the televisual image ensures its adhesion to the referent just as the index adheres to its object, and the website makes that 'liveness' relivable at the touch of a finger."[45] From this point of view, visual media's ability to make historical events available immediately endows their images with an evidentiary quality. Similarly, the powerful impact of *The War Tapes* is its ability to depict moments of combat where survival is at stake. It grasps onto the unimaginable immediacy of the index by placing the digital right in the middle of a war where death, quite perversely, is a sort of reality treat or shock treatment. From this point of view, the importance of the index is structured not on the specificity of the technology but on the relation with the spectator, whose role is that of witnessing.

The immediacy of the indexical instant is a unique imprint, a chance trace of change wherein time is contingent and irreversible. This is the promise of the index, and the fascination with it. It makes the spectator a witness of the recording of what happened in any one instant of time's passage. The instant thus understood is an event that reaffirms rather than contradicts the becoming of duration in its revelation of the unexpected, the irrational, or the uncanny. For instance, Doane refers to the fragmented analysis of bodily motion in Étienne-Jules Marey's images.[46] The photographer's images depict the body frozen in a series of poses that seem clumsy or unnatural because they do not confirm the habitual experience of motion. Of course, in film the cinematized filmstrip serializes the point, making its instantaneity (and singularity, and contingency) vanish in the fluid stride of motion; but film's dependence on

the photogram's instantaneity makes itself felt in the abruptness of the movie's cut, or the stillness of the photopan and the freeze-frame. There is a sense of violence in the abrupt break of the cut, a slip from continuous movement to its visible abolishment (a recurrence of the stillness of the photogram and the interval that surrounds it), a point that traumatizes the habitual recognition upheld by the ordinary in favor of the unexpected that traces the powers of contingency: a direct time-image. Instantaneity becomes here an immediate given and powerful structure of meaning for the temporality of movies as it grasps the viewer while making present an image of a past. Such is the force that is reaffirmed in the five horrific freeze-frames of the dead Iraqis with which *The War Tapes* ends the sequences in Iraq and continues with the aftereffects of the American soldiers' return home. To be sure, the friction between past and present, the idea that what took place then is here now, is not based on an indexical ontology of the digital, but on its ability to go places where the spectator cannot go and on its ability to be immediately available to archive any-instant-whatevers for the attestation of the spectator.

### Refractions of the Immediate Present: The Return of *Into Great Silence*

While celluloid film bears witness to the instant as an event of forceful change, it captures it as a moment of the past. The present instant of the indexical image is implicated in the historicity of the past that it makes present. Time in celluloid technology is an instant where past is brought in continual contact with a future present. Similarly, this varying refraction of temporalities can be found in the structures of the digital image that creates the tension between past and present through a combination of the instantaneously renewed and the *stillness* of repetition. Going back to *Into Great Silence*, it seems this tension between what changes while resisting change is precisely what the arbitrary shots of the luncheon scene had been pointing to all along. Here the stillness of the repeated pixels brings what has passed into immediate contact with what is instantaneously renewed, so that past and present are in fact contracted at one moment of the image. In one of the shots, for example, an airplane flies across a blue sky, as is captured by the still camera. Even though the image is refreshed, the parts of the sky that are unaffected by the airplane's course are numerically repeated intact—and so what was,

is again. On the contrary, the sky pixels that reveal the airplane's flight are instantly translated into new configurations that create a completely different set of coordinates positioned against the ones repeated.

In the convergence between a repetition and a renewal lies the tendency to archive while bringing forward: past and present instantly simultaneous in the fragmented image. While it loops the past, the digital creates an image of an archival strategy where time passed becomes constantly accessible for the future. Indeed, the confrontation between past and future can be seen in the obsessive gathering of information connected with the unprecedented proliferation of capturing devices and storing technologies: from the omnipresence of satellite cameras and CCTV systems, to the constant availability of mobile telecameras, DVDs, and the Internet, reality's duration seems to have become a continuous stream of information potentially open for another time. Speaking of the desire to archive, Doane writes, "The aim of this historiographic/archival impulse is to retrieve everything possible, driven by a temporal imperative (before it is 'too late') and the anticipation of a future interpretation (in this sense, the archival process is a wager that stacks the deck: this object, because it is preserved, *will* be interpreted)."[47] The point here is that as digital media obsessively archive events, they instantaneously historicize reality, thus making it available for future access. As such, the digital creates a sense of a will that draws the future into its construct as well.

Indeed, there is a strong drive toward a future in the information-packed qualities of the digital. For Barbara Filser, the overabundance of archived information has the potential of producing a future cinema where thought arises from a process of constantly interacting anew with the labyrinth of data.[48] Such is the potential that Peter Weibel sees by looking at developments of quantum technology that could allow for an excessive augmentation of interactive potentials, thus making each access point a new time-image.[49] In fact, Siegfried Zielinski notes that interactive experimentation of a temporal order lies at the very core of digital devices, because they create a portal between the fantasy and desires of the files' creators and the imaginative choice of their future users.[50] Indeed, interactivity and its potential permutations in appearance and experience are of the utmost importance in the digital's temporality. It is as if there is a lingering desire for the future embedded in the open accessibility of the technology's structures that invites the spectator's own fantasy and desires as a reactivating encounter—as a will.

The temporal role of interactivity is certainly fascinating. At the same time open to change and open for an exchange between self and other, it is also predetermined and thus closed. From a point of view, the exchange between the image's construction and the user/viewer is not one of a pure qualitative order—in line with a Bergsonian durée—but of a quantitative order where qualitative perceptions and expressions are reflected. The temporal continuity of the event, its affective effects, is encoded in calculable, reversible, and repeatable instructions. In itself, therefore, the image cannot sustain time. Time is not to be found, in other words, in the image, but in the event of the encounter; that is, in the immediate presence of the user's action in relation to the image—the interaction. Interactivity as function is numerical—and thus not temporal. Interactivity as an action, on the other hand, is temporal as long as this temporality is fixed to the present nature of the event. What, then, of interactivity as prospect? Is there not a sense of a future embedded in the promise of manipulability that lies at the basis of interactivity? Designed as always open for reformulation, does the digital not express itself as a constant potential for change—an imaginary state configured in the reality of the structure? Indeed, in the repeated shift from determination to potentiality of change, one is led to the genetic relation between the actual and virtual in Deleuze's crystalline regime. According to this temporal structure, what is actualized for perception in predetermined form is put in contact with the virtual of subjective memory. But in this contact the actual exchanges itself for the virtual as the latter covers its determination. At the same time, though, the virtual appears as an actual recollection and so exchanges its virtuality for a defined actuality. As such, the relation between actual and virtual is not obliterated, but the difference between each form remains indiscernible as the image presents them simultaneously. For the same reason, the numerical configuration of digital interactivity presents a predetermined form of functions and actions. Either way, this setting becomes an expression of change, as it remains continually open for access by every new user/viewer who reconfigures it as an actual path taken. From actual to virtual and back again, it is this constant tension between the digital's numerical specificity and the creative potential of subjective encounters that allow for a sense of durée to be found in the digital image.

In sum, in the immediate encounter with the digital, time is stuck in the present as a continual and instantaneous renewal of the image in real

time, an image that is itself disconnected from a time past and a time that is passing. But in its potential for engagement, the digital can become a constant and instantaneous invitation for transformation and a metamorphosing activity. Accessed in the present, its potential for reformulation is the constant promise that flings the encounter into the open vastness of a future where access is a structure of change itself. It is important to note, though, that this relation is based firmly on the grounds of the agency of the viewer/user because it is activity from the outside that endures, not the mathematical configurations themselves. Time is placed on the experience of the event and its potentialities—between technology and world—rather than in the technology's own operations. Here is where time can be imagined in the image—where a sense of time can be felt. It remains to be seen, however, what this means for the existential relation between subject and the reality of mediating technologies. The final chapter will thus explore how the nonindexical structure of numerical calculations affects the existential guarantee of the celluloid image, and how this becomes an ethical concern.

# 5  TRACING AN ETHICS OF THE MOVIE IMAGE

THE QUESTION THIS BOOK HAS BEEN EXAMINING regards the new-
ness of digital technology from the point of view of the different setting it
establishes for the relation between the movie image, the world, and the
viewing subject. Unable to corroborate a causal connection to the world
due to its mathematical conversion or generation, the existential asser-
tion of the digital is certainly difficult to trace. Celluloid film's indexical
and analogical functions create an image of the world, which function as
an assurance of real events and existences in the past. As I will discuss,
celluloid cinema thus enables a realization on the part of the spectator of
her or his existential position within the world and so qualifies an ethical
implication in the image as the potential for responding to, and acting in,
the world. It is from this point of view that celluloid's luminous transcrip-
tions bring reality and viewer in touch with ethics. Conversely, while a
reconfiguration of the material, spatial, and temporal structures of reality
is possible in the structures of digital images, the technology's relation to
the world is founded on the viewer/user's creative intervention or spec-
tatorial activity. This is to say that, in itself, the digital seems unable to
conjure up an image of the world as an existential guarantee. It is with
a concern for the meaning of this different relation between world and
viewer in the digital's images that this final chapter will turn to the ethical
positioning of movies. This will be a matter of asking what responses the
digital elicits in comparison with the power structures of celluloid film.

Consequently, the current chapter returns to the question of reality
with which this book began, but now my focus is to examine how the
spectator can sense her or his connection with the world even though the
digital screen only structurally alludes to the real. Indeed, as I discussed
in chapter 1, the viewer's involvement in the causal powers of indexical

signification is of vital importance. What this relationship between causality and subjectivity reveals is the existential position of the subject in the spatial unraveling and temporal duration of the world. Space here becomes a multitude of intricately combined strata that constantly interact with one another, shifting and forming new relations—space, that is, as Riemannian. And time becomes the continuous form of change as the force of life's unpredictable evolution—time, that is, as *durée*. As such, the spectator is affected by the visual image not only as an iconic display that causes an expressive emotion, but also as an extension of her or his existential belonging to the world that surrounds the framed screen. Celluloid film links the viewer with the continuous powers of change that take place simultaneously across corporeal, spatial, and temporal fields within reality. How, then, can the digital conjure up such an implicating relation to reality as constant force of change when its own formal bond to reality is missing, or at least strongly deemphasized? How can the digital recreate the existential experience of film, thus emphasizing the subject's ability to respond to reality as an ethical implication?

To answer this question, it will first be necessary to discuss the ethical response to screened reality with reference to celluloid film. This will be a matter of examining what problem arises from the distance that the screen sets up between world and viewer and the extent to which this complication can be overcome. For this reason, I will turn initially to Cavell's phenomenological reflections on cinema, which focus on the existential isolation expressed by mediated reality. From there, I will continue to explore how celluloid can elicit a belief in the world despite the distance the screen presents between subject and reality and then proceed to examine via Deleuze's ethics what is involved in this belief.

## Celluloid's Distancing Effect: Cavell on the Viewed World

In his book *The World Viewed*, Stanley Cavell focuses on the experience of watching celluloid film in relation to the causal link that the indexical image expresses with regard to reality. Unlike Bazin, for whom film's luminous imprints achieve a "*re*-presentation" in the sense of a metaphysical evasion of death,[1] Cavell's approach emphasizes that film's photographic technology makes reality visible through projection, albeit without the image itself becoming reality. The important question he then asks is, "What happens to reality when it is projected and screened?"[2] As Cavell

explains, film's projections make visually present a world that is not existentially present but past. The screen, that is, *presents* views of the world as it existed in the past. Celluloid film's spectatorial experience is thus grounded in the ocular perception of life at a temporal distance, and so the screen seems to shield the viewer from the world in replacement of an existentially isolated view of it.

Nevertheless, the difference between the world projected and the world of the viewer is not one of kind—as if there were two separate worlds—but one of time: the image of the past and the viewing of the present both belong to reality, but they are temporally distant. It is from this point of view that the disjuncture between viewing and being that film expresses, resonates with the metaphysical isolation caused by the opposition between subject and object—a phenomenon that can be traced back to the sixteenth century. Speaking of this philosophical point in Cavell's discussion, Rodowick explains that both the rediscovery of classical skepticism during the Renaissance, as well as the decline of theological dogmatism that came with the Reformation and Enlightenment, led to a detachment of the modern subject from God in favor of a scientific empiricism. Rodowick explains further: "Confined to itself or within itself, the individual subject then bore responsibility for the epistemological and moral consequences of this isolation. And since God was no longer in the world to give it meaning, whatever meaning nature could give to the individual had to be found in its isolated perceptions."[3] Without God to make meaning of life, the subject was drawn to her- or himself for understanding the world and a relation to it. As such, meaning would be found in the subject's perceptions of the world from the existential isolation of subjective thought. And the bond between the individual and her or his position in the world was persistently replaced by skepticism that found its way into every inquiry: world and body were displaced by a dominant and self-doubting mind that was forced to give meaning to nature while being in isolation, detached from the very world it sought to understand. In so doing, world and subject were othered as phenomena for scientific investigation and categorization.

Nevertheless, besides responding to this separation between subject and world, film also expressed a desire to overcome the existential isolation in order to rediscover the connection between subject and world. It is this powerful potential of film that Cavell's work illustrates.[4] He explains that the power of the photographically rendered image of the

world is that it becomes a means of reassuring the viewer's connection to reality, even while her or his displacement is maintained. This is the paradox that the celluloid image presents: as it mechanically records and projects a view of the world, it brings existence to light even though the viewing subject is removed from the process of creation. Reality is present in the image despite the subject not being temporally present within that reality. In other words, skepticism itself is not miraculously annihilated, but rather theatricalized by becoming the object of exploration in a format that, although built on the distance of that world there, confirms that the world is there all the same. Indeed, this is the constant "punctum" of the celluloid image: even though the narrativization of movies may determine a specific mode of understanding or responding to their forms, celluloid's analogical nature creates an image that functions as a testimony to the physical world's existence.

Nevertheless, Cavell goes on to emphasize that the world projected seems to leave the subject at a safe distance from it. The spectator, in other words, gains the potential of viewing the world by remaining unseen, ethically shielded from having to respond to the world viewed. There is another matter involved in the operations of spectatorship that has to do with a willingness or preparedness of the individual to take part in her or his enworlded position. While directing her or his gaze from a secure distance, the viewer seems to gain the power to become powerless and thus escape the burden of power itself.[5] The distant view of reality becomes, from the point of view of a skeptical attitude, a natural condition that justifies the subject's powerlessness to actively inhabit the world. What complicates matters, though, is the position of time within this schema: if one understands time from the point of view of continuous duration as is expressed in Bergson's durée, time ultimately bridges the existential gap that the screen creates. While the viewer may be able to view the world with the advantage of remaining powerless, she or he is also reminded of the fact that the world exists in time. As such, the viewer is necessarily involved in a view of the world because she or he is the future of that past being viewed. In other words, spectatorship, as far as celluloid film goes, expresses the continual flow of change where what passes flees to the past, just as the present's passing constantly renews itself in the anticipation of the future. Although the viewer is initially shielded from what took place in the past, film positions her or him as a temporally distant witness through whom the past event is redistributed in, and for, the future.

What this means is that the potential of celluloid film for connecting the viewer to the world is based precisely on its temporal ontology. In a sense, the act of viewing is in itself an act of repeating the framing of the camera: the viewer replaces the role of the camera at a later time, and so restores that viewed world for a different time. Indeed, it is the common presence of the camera with the reality it records that Rodowick understands as the reason for which causation almost always upstages intention in the case of photographic technologies. He writes, "Photographic causation implies not only the camera's presence at the events it relates, but also its implication in the duration of those events—that the photographic act registers the duration of the events it conveys and indeed conveys duration as much as anything else. It presents the common duration wherein camera and event were commonly held."[6] This is to say that where the viewer could never have been, the camera is. Similarly, where the camera cannot be, the viewer is—that is, as long as the *where* is understood as a reference to time. As the camera is the means through which the world is witnessed, the viewer is the one who is continuing this testimony through a displaced vision. For this reason, the primary part taken up by the viewer is one of witnessing, an act of testifying to the causal act generated on the filmstrip by the camera. Both the camera's and the spectator's views, therefore, implicate vision with an existential connection to reality because there can be found a common ground through which the events are linked: that of time. If the camera is an act in the past for the present view, the subject of that present is similarly an act in the present for a future.

Here is where one can see the ethical potential of celluloid film: while the spectator's vision seems shielded from reality through a distance in chronological time, it remains a personal involvement as an existential testimony where the separate layers of time are contracted into one continuous force of interactions. This is an ethics understood as an ability to respond to the world, to be existentially involved in the world. Indeed, it is an ethics founded on the impossibility of distinctly separating between the past reality on the screen and the present reality of the spectator's viewing. The past events of the world and the choices made by the moviemakers speak directly to the viewer, connecting her or him to them based on the common ground of reality. In so doing, the vision of celluloid's image hurls the past world into the future, so to speak, making the chronological separation between past and present powerless. Celluloid's views of the world are, in this respect, acts of responding to reality that are carried across

time to implicate every viewer. From here, the viewer cannot hide from reality's past because time forcefully engulfs her or him in its continuous becoming. This impossibility of sustaining an existential distance from the reality of the celluloid image is indeed expressed with riveting force in Claude Lanzmann's remarkable documentary on the Jewish Holocaust, *Shoah* (1985). I turn now to Lanzmann's movie to unravel the ethical implications that celluloid's temporal ontology elicits. It is in the strong mental and sensual responses generated by the existential poignancy of the movie that one finds a direct involvement between past and present that makes the reconnection with the world's events a responsibility for the future.

## Celluloid's Implicating Powers: The Power of *Shoah*

Lanzmann's *Shoah*, which took twelve years to create and runs for a total of 550 minutes, covers a series of interviews that the moviemaker carried out with people affected by, involved in, or related to the Jewish Holocaust by the Third Reich during World War II. The theme of the Nazi death camps is the same that Resnais and Farocki address in *Night and Fog* and *Images of the World*, which I discussed in chapter 1, but Lanzmann explores the traumatic events differently: by not representing them with the minimal and insufficient visual traces of their consequences. Lanzmann seems to want to find a way around the persistent distance of the past of which Cavell speaks and instead forces the past world to be revealed as one that is still, and thus always, passing. For the spectator of *Shoah*, the Holocaust is not simply there to be viewed as a Barthesian "that-has-been," but is brought forward as a state of being that grips hold of her or him in its agonizing unveiling. What the movie ultimately makes clear is that, however distant the past seems, it remains existent in the state of living in the present; and so, as past and present interact, being in the present is also a latent interaction with the future as an ethical responsibility— that is, a response-ability. It is certainly valuable to examine at length how *Shoah* creates this sense of involvement between times.

*Shoah* begins with scrolling text that describes the Polish village of Chelmno, where four hundred thousand Jewish people were taken and subsequently murdered in gas vans, leaving only two survivors. Of the two, Simon Srebnik—a thirteen-year-old boy when he was first taken to the camp—survived because he could jump higher or outrun his compatriots in the races through which the SS had put them; because he had a

beautiful voice and sang for the SS while on a routine task that took him through the village on a boat down the Ner River; and because a bullet to the head miraculously missed his vital areas when the Nazis decided to kill all remaining Jews by shooting them (instead of gassing them) under the imminent threat of the Soviet Army's arrival. Indeed, these horrific events were not recorded, and even if they were, the footage was destroyed, lost, or hidden, so that the images of this past are unattainable and ultimately invisible. Such is the utter prooflessness of the events to which Shoshana Felman points: the Holocaust took place unwitnessed as sufferers, perpetrators, and bystanders alike chose or were led to turn a blind eye to what was happening.[7] The question, therefore, that the Holocaust brings forth is how these horrific events can be represented directly when documentation is missing—that is, when ocular perception is functionless. To address this matter, Lanzmann turns to what is indeed available to view: the survivors themselves, whose spoken testimonies dig into the soil of the past to reveal its existence in the body of their own presence.

Lanzmann convinces Srebnik to return to Chelmno for the first time since his escape and sail down the same Polish river while singing the same songs that kept him alive years ago. From the beginning of the movie, that is, Lanzmann asks the viewer to pay attention to the voices of the survivors because it is there that the past is hidden as well as ultimately revealed as being present. As Srebnik revisits his past, he makes the events of his torture implicitly available in the common grounds of the land and the river on which the same man's voice is once again carried. To be certain, the simple act of representing the past through imitation does not return the past to view, nor does it bridge the gap between the view of the world and the state of being in the world in the present. Instead, Lanzmann's camera seeks to reach beyond the shield of the screen to involve the viewer in a realization of her or his temporal relation to the past—both depicted and invisible. Lanzmann achieves this by theatricalizing the temporal distance of vision through the disjunction of the interviewees' descriptions and the lack of visual representation of the events described. Unwilling and hesitant to verbally repeat and mentally revisit their past, the survivors overcome the shortcomings of sight by becoming a temporal bridge through their memory. What their voices express is a reality of events that seem to be simultaneously positioned and missing from, on the one hand, the land, and on the other hand, the survivors' own bodies.

In the case of the visible land, reality's past is conjured up by descriptions that move mentally beyond the contemporary environment of filming while simultaneously returning to that land. The events described are not actually visible but remain virtually present in their correspondence to the visibility of space. There is a disjunctive relation, that is, between the space seen and what is vocally linked to it that causes a powerful exchange between vision, sound, and memory: while memory refers to a past that cannot be seen even though it corresponds to what can be seen, it covers the visible with the reality of the voice hidden from vision. Speaking of this disjunctive relation in the movie, Rodowick refers to the image in terms of a Deleuzian "speech-act" where two distinct yet congruous layers create a "stratigraphic" space.[8] Here, events are all contained in the landscape even though their traces are not visually perceivable. Similarly, in her discussion of the movie in relation to Levinas's ethics of the "visage" as other, Libby Saxton contends that the priority that the verbal testimonies gain over the visual representation of the events creates a disjunctive relationship between voice and image.[9] As such, the past is conjured up as expression rather than perception. Indeed, the impact of the conflicting nature between voice, vision, and memory is openly expressed when one bystander to Srebnik's reenacted singing says that her heart beat faster when she heard him again and that she really relived the murder that had happened. And this is what is revealed when the now forty-seven-year-old survivor walks around Chelmno, frowning, nodding, sighing, coughing, to finally say while looking ahead, "It's hard to recognize, but it was here. They burned people here."

The camera, in other words, can bear witness only to what is revealed to it in its presence: on the one hand, the Polish land as it is now, covered by trees and wild vegetation, and on the other hand, Srebnik in his forties, no longer a prisoner, no longer in chains. The question is how the past can speak through what is available in the present, how Srebnik's memory can unbury the past from within the land to reveal a connection between distinct chronological segments, and thus implicate the viewer existentially with that reality—that is, make her or him able to respond to the world in Cavell's ethical interpretation. To be sure, Lanzmann's accomplishment is not that he *actualizes* either the past of the space or the memory of the voice, but that he relates the one to the other disproportionately. The voice is situated on the land by rubbing up against it, not unblocking the path to make visible what is missing, but revealing

something is there even though it cannot be seen. The past is accessed, in other words, on the basis of the interaction between the physical reality of the space and the memories woven into it by the voice of remembrance. Ultimately, *Shoah* exemplifies how an existential isolation from the past is impossible when each layer of time continually interacts with the others. The movie shows how the testimonies are acts of witnessing the past that implicate the past in the present in the same way that viewing the past is a response to this implication as its continuation. This becomes more vividly felt in the corporeal reaction of the survivors as Lanzmann forces them to revisit their past through remembering and expressing it. Lanzmann's desire is not to archive the past as information, but to make its expression a means of activating the future by inviting both the sufferers and the viewers to respond to it. As he urges the interviewees to relive the events through remembrance, he forges a response of their present body to their unyielding memory.

In fact, Lanzmann's stance in the movie is, in this respect, ethically conflicting: while the moviemaker encourages a revelation of an immense history of violence and suffering for future generations, he does so by recharging that history in its sufferers—that is, by setting them up to relive the events in the traces of their bodies' emotional histories. Writing on this matter, Dominick LaCapra maintains that Lanzmann's refusal to represent the historical events through footage allows for an activation of the past through the testimonies and in the process, leads to the consequent retraumatization of the survivors.[10]

Consider, for instance, the scene during which Abraham Bomba— a survivor of the Treblinka camp—describes how, as a barber, he was chosen to cut the victims' hair before their murder in the gas chamber. Recorded while cutting a man's hair in a barbershop in Israel, Bomba describes how the naked women and children were led into the gas chamber, where they would find a group of about sixteen compatriots who they thought would be giving them a professional haircut. Lanzmann asks Bomba persistently to give more and more details, and so the viewer is told that the women were seated on benches, that there were no mirrors, that the hair was cut using scissors and not clippers, and that they had about two minutes for every woman's haircut. Lanzmann then asks him to imitate the action of the hasty haircut. At that point, Bomba performs the gesture on the man whose hair he had been cutting throughout the discussion. Soon after, he speaks of a transport that arrived at Treblinka

from his hometown, and that he knew some of the women very well—as did another barber, whose wife and sister were brought in for a haircut. It is at this point that Bomba breaks down and remains silent.

The return of the past is witnessed, in this example, as a clash that is too unbearable to describe, too horrible to put into words because it is relived existentially in the body through memory's imagination. This is precisely what interests Gertrud Koch with regard to the aesthetic qualities of the movie: the existential weight of the movie is not based on any factual signification, but, quite paradoxically, on the nonvisible imagination generated by the interviewees' performative reenactments.[11] In other words, the past is not represented as such, but is brought forward as a bodily response to the intensity of imagination's affections that cannot be contained, or controlled, or rationalized.

The inability to speak is this inevitable impossibility to shut the past off from the present, to shield oneself from another point in life's progression. Bomba strives to hold his tears back, but his memory is too strong for him to regain control. Despite his torment, though, the camera remains fixed on him, and Lanzmann insists, "Go on then. You must go on. You have to." It is in these words that Lanzmann triggers a response that is now verbalized as Bomba says, "I can't do it; it's too horrible." Indeed, the corporeal agony that Bomba suffers is shared by the viewer, who cringes at the sight of the physical pain forced onto the man by the memory of the past and Lanzmann's insistence. As such, the viewer comes in touch with her or his connection to both the past of the survivor and the past of the movie as an intense emotional reaction—another performative reenactment.[12] In the sensual impact felt through the detached views of "that-world-there," the viewer experiences the past in the body; she or he feels the injustices of the past not from a distance, but from an imaginative stance in her or his own presence. As Lanzmann asks the survivors to remember and reenact their traumatic past, he also asks the viewers to take part in the testimonies, to experience them as links to events that remain temporally distant but engraved in the world. The viewers now sense the screened views of reality's past as a temporal layer that interacts with their present. As such, the screen cannot shield them from the past; rather, it connects them to the world to which they belong, and to which they are now involved.

The intense impact that *Shoah* elicits is the result of both the choices Lanzmann makes as well as celluloid film's own ontology. Like the viewers, the survivors seem distanced from the reality of their horrific past;

but the force of memory overcomes the survivors' temporal isolation as it penetrates both space and body despite the distance from the events invoked. In this weakening of the temporal and existential separation of the survivors from the past world, the spectators, too, lose the ability to remain isolated; and as they find themselves positioned existentially in reality's continuous duration, they are reminded of their ability to respond to the world and be involved in its unraveling across time.

It is precisely in the irreconcilable relation of the camera's present to the people's past that the world being viewed is spread out onto the common ground of reality as durée. Witnessing the uncompromising detachment between the visual and aural, and sensing the corporeal response to events long gone, the viewer—the camera's future—must now find her or his place in the same field as response-ability to the world's past despite its distance. As the invisible world of the past suffering is revived in the indexical image of film through the present tracings of the sufferers' memory, the invisible world of the future viewings is brought up against the image as another distant yet linked layer of time. In such an understanding, the position of the viewer toward the photographic images of the world is in fact an ethical act: although the past remains physically unattainable, it remains implicated ontologically in the viewer's present reality. As such, the skeptical and scientific attitude of remaining isolated from the world—and thus "naturally" unable to take part in its events— is lost. Celluloid film, that is, actually creates the potential of *losing* the ability to remain powerless and instead believing in the world. Indeed, it is the belief in the world to which Deleuze's film philosophy turns with great attention. In order to explore the ethical gesture implied in this belief, I will now turn to Deleuze's discussion of the matter in his book *Cinema 2*.

### The Potential of Believing: Deleuze and the Unthought of Thought

Deleuze sets up the relationship between ethics and movies in the recognition of the limitations of thought. Conjured up by the autonomous and unpredictable force of the "time-image," film does not make thought visible, but elicits it as a potential with repeated and renewed limits. In fact, it is film's continuous and rapid unraveling that reveals the inability of thought to follow without falling short of itself. As the image gives itself up to change continually, thought is brought up against its own powerlessness to fix the image with a stable meaning. Deleuze writes,

"If it is true that thought depends on a shock which gives birth to it (the nerve, the brain matter), it can only think one thing, *the fact that we are not yet thinking,* the powerlessness to think the whole and to think oneself, thought which is always fossilized, dislocated, collapsed."[13] In other words, the existential reconnection of the skeptical subject to the world presented on screen is not magically achieved but is made possible through the realization of the impossibility to think the image as undifferentiated, as constant stillness. This is a matter of giving up the mental isolation of a scientific empiricism and embracing life's force as a continuous becoming where thought is not a succession of definitions, but a creative invention that is constantly rejuvenated.

Indeed, the spectator's ethical response to the world is generated on the plane of thought, but at the point where thought has yet to be actualized. It is a matter of recognizing the powers of thinking where the subject becomes a creative element of reality rather than its designator of knowledge. What remains hidden in the image—impossible to be made into an ocular perception—is the matter that the image does not present facts about the world, but elicits reality as the persistence of change, of a relation between what has passed and what is coming in every actual moment of presence. Here is where the perceptual given of the image opens up into a world beyond the confines of the screen. The filmic image is the plane where actual and virtual constantly meet as layers interacting and reshaping their encounter. As I discussed with regard to *Shoah,* the image is a meeting point where an actualized image of the past (the indexical image of the world) confronts the virtual refractions of time through the creative motion of memory and imagination. Nevertheless, the relation that actuality shares with virtuality cannot be determinably fixed and defined because it is constantly being constituted by an outside that is created anew in each encounter; and in this out-of-field lies the image's relationship with the viewer and her or his own creative impulse.

To be sure, the viewer remains missing from the image on screen—that is, the subjective view of the world leaves the subject detached from reality. Nevertheless, there is a way back into the world. For Cavell, the link between subject and world is conjured up by the fact that, despite the subject's mental isolation from the world, the world continues to exist. In other words, even though the image expresses the relation between world and subject as an absence of the latter, it reaffirms that the world does exist despite this absence. For Deleuze, this absence is continued

as the subject is still missing from the image in the sense of a mental intolerance: the image is not fully available to the viewer's thought, it does not allow her or him to gain control over it, to define it from the detached position of an ocular knowledge. At the same time, though, in this absence or intolerance Deleuze sees the ability to return to reality in the form of a belief in the world. He writes:

Man *is not himself* a world other than the one in which he experiences the intolerable and feels himself trapped. The spiritual automaton is in the psychic situation of the seer, who sees better and further than he can react, that is, think. Which, then, is the subtle way out? To believe, not in a different world, but in a link between man and the world, in love or life, to believe in this as in the impossible, the unthinkable, which none the less *[sic]* cannot but be thought: "something possible, otherwise I will suffocate." It is this belief that makes the unthought the specific power of thought, through the absurd, by virtue of the absurd.[14]

In other words, the impossibility of a dislocated knowledge expressed in the "unthought of thought"—"the fact that we are not yet thinking"— enables the replacement of a transcendental knowledge with believing in the world as it is. While it is not situated in the image for view, thought is found in celluloid film as a potential that necessarily breaks down the division between world and viewer expressed by the screen. The screen, that is, cannot function as a buffer between the viewer and the world because it merely separates the two chronologically. But to realize the impossibility of the mental isolation that thought as transcendental knowledge expresses is to be taken by the potential for creativity where the force of time as durée is met with the force of thinking as reinvention. This is where the "unthought of thought" becomes an existential response to the image. And this is the ethical involvement of the subject in reality that the celluloid image makes possible: a belief in the world as the affirming stance of an active creativity where subject and reality are linked.

To be sure, I am interested in the connection Deleuze makes between world and subject based on the virtual potential of change expressed in the irrational interval of the image and the "unthought of thought." This is a matter of responding to what is missing in the image—a virtual beyond of the actual image—from the point of view of what is missing in thought—a conceptual beyond that thought cannot restrict. In realizing the mental limits of a subjective isolation, the viewer is brought back to thought as a potential for creativity; and creating becomes a belief in the

world as an active involvement in its differentiating existence. To return to my specific concern with celluloid technologies, the existential bond between image, reality, and viewer is indeed mapped onto the indexical formation of the image. Nevertheless, this indexical function cannot be understood as an authoritative fact immediately and wholly available for an ocular envisioning, because the image insistently expresses an absence from that world there: the absence of the subject from the reality on screen. The image, that is, returns the viewer to reality by pointing to her or his absence from it. This absence, though, is confined to seeing—not to existing. Vision is trumped by the existential assurance of causality that the image expresses; and knowledge is trumped by the ontological inference of a constantly renewable outer limit to thought where the subject is not eliminated but found as creative force. This is a belief in the world as a creative stance of redefining one's connection to it in the constantly renewable force of change.

The conflict expressed in the unthought of thought takes place between a defining knowledge of the world and a process of thought as a continuous becoming. Through its automatic views of the world, celluloid film finds a way of returning the viewer to the intolerable break between her or him and the world, and the unthinkable in thought by expressing a belief in the world. This is not a belief in a heavenly state or ideal model, but a belief in the world in which life unfolds. It is a matter of believing in the body as a voice and act of a force that takes place before exterior restrictions, before it is forced to think without power—that is, to be powerless. Believing cannot be equated with a desire for another world that one dreams of joining or understanding, because in both cases the body is left behind. Indeed, Deleuze's Spinozism becomes apparent in the expressive return of the self to reality implied in the creative act of believing in the world.[15] Thought is not a defined structure, but a compositional structuring where the subject encounters and is encountered by the force of change. Thought is an interaction with the world that leaves the subject and reality in a constant and codependent transformation— a relation that affects and changes both parties. As such, thinking is not a process of drawing out information from things, and does not consist in informing things either. On the contrary, it is an expressive experience of the subject who changes and is changed by her or his encounter with the self, the other, the world, and with the constant differentiation of thought itself. Here one is drawn to the ethical implications of film as a power: a potential to be affected and to respond actively to the limits the image

presents, the absence that returns oneself to the world as constant creation. What, then, happens to the creative interaction that film's ontology expresses when everything in the image becomes data—that is, when the power for thinking is visualized as a constant presence of information? How, in other words, can the viewer find a link to the world when the digital does not sustain celluloid's absence as creative limit, but instead aligns vision with the constant numerical control of digitographic renditions?

## The Digital's Byte: Codified Determinism and the Digital Superhero

The digital seems to favor a continuation of a disabling response to the existential anxieties activated by the isolation and loneliness of a determining approach to thought. By adding a transcendental order of control and manipulation—where what lies behind the image is not the world's duration but zeros and ones—the digital weakens the relation to the world and to the self. Instead of a link to reality, the image is viewed as a result of the activity of one or a number of creators or viewers/users in the present, albeit in an encounter that is overshadowed by discrete and unlinked effects to which the creating and viewing subject must react. The image of the world is no longer a view of a passing world, but one that is viewed as an effect that can be mathematically caused from the outside. The digital world viewed is ultimately an activity of a subject who seems cut off from the world and so must turn to herself or himself for comfort in her or his creative impulse. Bizarrely, though, this creative impulse is based on a control/controlled schema: the subject controls the image through the abilities of interactivity and manipulability, while she or he is also controlled by determined sets on the basis of which computer hardware and software function. Nevertheless, the question remains whether the diminishment of the capacity for being affected by a photographically rendered image of the world results necessarily in the absolute loss of the potential for a creative response to reality as an ethical potential of cinema.

The difficulty of finding a way back into the world, as a subject touched by, and in touch with, reality has become the locus of a series of movies that dramatize the digital impact through action-packed digital effects. From *Starship Troopers* (Paul Verhoeven, 1997) to *Transformers* (Michael Bay, 2007), the problem becomes an attack of the digital on human civilization in the form of gigantic mutant insects in the first case and of extraterrestrial megarobots in the latter. In both cases, the spectacular

sensationalization of CGI seems to imply that the battle is lost in favor of an already digitized world (an idea emphasized by the near annihilation of all humanity in the first movie and a vital coalition with the Autobots for survival in the second). Perversely, death is also the mark of the digital in Zack Snyder's movie *300* (2007), although in celebration of the heroic act of a death-defying patriotic devotion. In the case of *300*, a small Spartan army is eliminated by hordes of digital "barbarians." But their death is appeased through two means: on the basis of content, by invoking spiritual strength for their compatriots through their heroic sacrifice, and on the basis of form, by being incorporated in an entirely digital world with the use of blue-screen technology that renders their death a mere computer effect amid other effects. In fact, the digitized environment of *300* seems to conceal the actual pain and labor of the training the actors had to endure for their physical preparation; and so their muscular volume is equated with digital prosthetics similar to those of the barbarian monsters.

Nevertheless, this is not the only way the technology's immersion in cinema's creations is dramatized. Indeed, in the previous cases a battle takes place, although one where the real body is set against the digital body. In this case, the digital is understood as a visual set of configurations completely accessible to the manipulative abilities of the creators' imagination that threatens the existential reality of the viewer. But in the case of the illustrated superhero upsurge—the *X-Men* trilogy (Bryan Singer, 2000 and 2003; Brett Ratner, 2006), the *Spider-Man* trilogy (Sam Raimi, 2002, 2004, 2007), *Hulk* (Ang Lee, 2003), the *Fantastic 4* movies (Tim Story, 2005 and 2007), *Batman Begins* and *The Dark Knight* (Christopher Nolan, 2005 and 2008), *Superman Returns* (Bryan Singer, 2006), the *Iron Man* franchise (John Favreau, 2008 and 2010), and so on—the issue is taken a step further by forcing a complete transformation of the heroic act into an ethical potential of digitization: the superheroes' powers are digital enhancements, and so the conflict between reality and symbolic transformation is internalized in a cyborg subject. The problem of the power to act as part of the world is thus resolved through the digitization of the hero. As a result, the relation between the heroic subject and the world is expressed as a simple transformation of self into a digital event, as if the issue of the capacity to be in the world as ethical potential for active response is appeased in a glorification of an unattainable talent: to conjure up a storm, to weave webs, to become magnificently strong in

seconds, or to employ an all-encompassing array of super suits, gadgets, and cars (in the case of the *Batman* or *Iron Man* movies). In the heroic act of the digitized self, activity is expressed as a digital transformation that makes possible a means of belonging and responding to the world as a naturally unattainable superpower.

The problem remains, however, what the digital transformation of the superhero might imply. Although heroically active, the superhero can act only according to forces that affect her or him from the outside. The externality of the superpower's source is expressed in the specific gift that is inherited to, accidentally forced on, or otherwise implanted in the hero. This gift determines the abilities of her or his activity—echoing, that is, the programming capacities of the studio's staff and equipment. For example, Superman can protect Metropolis, but he can do so according to his inherited powers that grant him immense strength, near indestructibility, and the ability to fly. At the same time, though, he is cursed with a life-threatening weakness to the radiance of Kryptonite. Either way, all his endeavors and encounters are determined by both his strengths and weaknesses, so that his actions do not come in the form of an internal desire that activates an exterior field of forces, but as a reaction that is contained within the limitations set up for him.

Indeed, the relationship the viewer has with the reality of the image follows this same structure. Although the image becomes immediately open to the viewer's choices—through the available menus of the DVD or even the manipulative functions of software—this availability comes at a cost: the image does not sustain an existential assurance of the world because it is a graphic rendition of predefined numerical associations. This mathematical fixity of the image replaces celluloid's structures of absence— of the subject from an image of the past and of thought as a predefined knowledge—with a constant presence open to the actions of the subject, albeit where the existential relation to reality is questionable. Indeed, the dislocation between subject and world that the digital's numerical basis maintains is dramatized in the ostracism of the superhero from a community because of her or his superpowers. Spiderman, for instance, must protect both himself and his loved ones not only through active force, but also by hiding his identity as Peter Parker. As such, the relations between forces as acts of power retain a form of struggle, but one in which the hero is separated both from her- or himself and from the world: responding to, and acting in, the world is a matter of becoming completely fantastical.

Nevertheless, my concern in this chapter—and more generally throughout this book—is to examine the potential for an existentially creative response to reality in digital cinema. The form that the world takes in the digital image need not erase the ability to change, to create change, and to be in reality as continual change. Rather, it would be valuable to see whether the digital may still elicit a way of being in the world as a force interacting with forces. To return to Deleuze's understanding of belief in the world, the spectator gains access to reality by losing her or his ability to respond to the image from the isolated position of an all-defining vision, instead encountering existence in the creative powers of thinking. The Nietzschean thrust of Deleuze's ethics is based precisely on the premises of the "eternal return"—on the ability, that is, for a constancy of change expressed in the return of a new limit of differentiation (the unthought of thought). As Deleuze explains in his book *Nietzsche and Philosophy*, the important distinction made is between active and reactive forces, each of which implies a different structure of relations. He writes, "Obeying is a quality of force as such and relates to power just as much as commanding does."[16] In other words, it is not that a reactive (or obedient) force ceases to be a force, but that it expresses a relation with power that leads to control rather than change. The "will to power" expressed in active forces is the differential element that is manifested as a capacity to be affected by the other forces encountered.[17] Here is where power becomes an affirmation of life because it upholds and continues change eternally as a process of creation—as a becoming rather than a being. Conversely, reactive or inferior forces are not less forceful than active ones, but they exercise their force by confining power within a regime of a logical progression assimilated to mechanical and utilitarian regulations.[18] In so doing, the expressions of change are taken as effects that are stripped of their spontaneity and creative aggressiveness (where life is affirmed), and are confined to abide by sets of rules that are applied from a given distance, from an exterior consciousness (thus denying life its organic function).

Indeed, it is in my concern with the transcendentalism and determination of the digital's numerical basis that my interests meet with Deleuze's understanding of powers and thought. As the digital confines change to the rapid calculations of bytes and algorithms, the image loses the ability to make available the astonishing new bursts of change and the boundless potential that comes with every different encounter in the

world. It is from this point of view that the technological transition in cinema from an apparatus of causal links and chance occurrences to one of predeterminations and control is precisely an ethical question. Rather than assume, though, that the digital prevents the expression of an active involvement in the world, it should still be possible to connect an ethical response to the image on grounds specific to the technology's own structures. This is a matter of seeing how reactive forces can become active and how new media may enable this process.

## A Will of Action: *The Matrix*

The question of how to evaluate the ethical potential of the digital can be understood as the question of its ability to express a force of action rather than reaction—that is, to elicit a link between subject and world not based on causality but on the common ground of a continually renewed creativity. How, though, can one sense the force of reality's creative activity when every squared particle in the image is streamlined to operate according to a distinct set of rules in a mathematically defined environment? To be sure, the image's mathematic foundation is directed toward a structure of control where the viewer's ability to respond ethically to the image is reduced to the retrieval of information from a pool of data. The digital seems to warrant a dismissal of creativity by aligning it with the quantifiable and calculable changes of the image and the reactive involvement of interactivity and manipulability. Nevertheless, it is essential to see how the uniformity of the image's numerical quantification may be overturned by the diverse and arbitrary powers of a differentiating change—how, that is, the digital can involve an active "will to power" as a creative act of the subject.

To be able to address this question, it is useful to see the relation between controlling and creative powers implicated in Deleuze's distinction between knowledge and thinking. As Deleuze explains with regard to Nietzsche's philosophy of power, the main difference between forces is that active ones extend themselves far into the limits of their consequences, whereas reactive forces are confined to an environment that cuts them off from their surroundings and their creative potential.[19] At the same time, Deleuze refers to Nietzsche's example of illness, according to which the sick person can achieve new potential by learning the limits that affect her or him.[20] While physical weakness, in this case, forces the

person to adapt to a diminished environment, it separates her or him from certain capabilities. This weakness, though, reveals simultaneously a new will that goes to the limits of illness by tending toward healthier concepts and values. In other words, the body, although restricted, comes in touch with new feelings and is taught new ways of being affected by the desire to reach its limits and imagine what can go beyond them. There is a new power implicated in the reactive as a seed of potential for reversing the order of things into a creative will. Of course, it is not sufficient for the reactive force to simply go to the limits of its consequences, because this in itself could imply going to the absolute extreme of a will to nothingness—that is, a domination of nihilism. On the contrary, for the reactive force to become active it has to be transformed to lead to creativity where life is affirmed by the constant potential for change. On these premises, the question of the potential for the digital's determinate structures to express active forces of creative change is a matter of examining the extent to which the power of control can be overcome.

*The Matrix* is certainly a fascinating case in this respect. The movie expresses the concern for digital technology's imposition on everyday life in the form of a nightmarish cul-de-sac of the future, albeit depicted as a greatly stylized digital extravaganza. For *The Matrix*, the future is a realistic rendition of a digital construction that creates the illusion of living for the people who are kept in an eternal sleep. Bound in their pods, the dreaming individuals are being used as an energy source for highly developed intelligent machines—the sentient machines—whose agents safeguard this state of affairs. As such, the only reality of the matrix is a visual configuration of digits—an abstraction, that is, of an idea of reality. To be sure, the Wachowskis create a bleak history for the world that expresses the anxiety of finding a connection to reality while having to do so from the detached position of digits, interfaces, and predetermined paths of navigation. Keanu Reeves's character, Neo, dramatizes this tension in his personal quest to discover what the matrix is by turning to his only portal to the world: the computer. Nevertheless, *The Matrix* imagines a possibility of breaking away from the nightmarish sleep as a potential of redefining the bond between subject and reality: Neo is the chosen one who heroically brings the forces of resistance together and leads humanity in its battle against the life-controlling machines. *The Matrix* describes, in other words, a return to reality in the form of a fight against the forces of control that, like extreme reactive forces, have kept life constrained to nothingness. Before Neo can fulfill his calling, though, he must first choose

between continuing to survive in the world of the matrix (where he is nothing but a configuration of digits following the operations of a computational system) or being initiated in the truth of reality with all subsequent repercussions. In the specific scene of the apocalyptic dilemma, Morpheus (the leader of the resistance group that has broken away from the androids' systems) offers Neo two pills, by which he is given the choice between a reality of an eternal mental prison ("a prison that you cannot smell or taste or touch" as Morpheus describes) and the truth of the real world. Neo picks the latter option and so makes the conscious choice to leave the digital world by taking an action that leads him to an awareness of the world and his position in his body.

What is most intriguing in this scene is that the ethical gesture of returning to the real world is achieved through an *active* abandonment of a world made up of illusory mental stimulations. This is a matter of transgressing the limits of a belief in an ocular perception of the world to eliminate the burden of an exterior power of control. In the case of the digitization of the world and body in *Starship Troopers, 300,* or the aforementioned superhero movies, the digital is expressed as a fate that the subject must passively accept. Here the body is left in a constant state of reacting to external forces, unable to move beyond the bounds inflicted on it and become part of reality's "eternal return" of change. Conversely, *The Matrix* offers a way back into reality not through the demands of a computational direction but through a choice to act and an act of choice beyond the predetermined format inflicted by a culture of digital simulation.

On the level of content, therefore, the ethics of *The Matrix* elicits an ethics of an active force as a means of acquiring both an awareness of, and a place back in, the world. But the problem remains that the movie expresses the potential of an active involvement in the world in what seems like the total abandonment of any reality whatsoever in favor of an absolute digital control (a matter that is not overturned by the following two sequels, *The Matrix Reloaded* and *The Matrix Revolutions,* both released in 2003). Ironically, Neo must learn to fight against the matrix through software fed straight into his brain. Further, he is taught that, while in the matrix's system, rules like gravity can be bent or broken. As Neo learns that anything is possible (hovering in midair or dodging bullets in slow motion), Reeves's body itself becomes a digital display that merely alludes to a real body.

In this digital transformation, the present is not a force of becoming in change, but a subordinate element to the strengths of a future

manipulation/reconfiguration: the past recording of the actor is overlaid with so much digital work in postproduction that the temporal connection of the spectator to the world viewed is flung straight into an unknown future of no time whatsoever. As Morpheus says, "I can't tell you what year it is because we honestly don't know." The diegetic option to act in the world of the matrix is thus made not as a decisive choice to transform the limitations of the present into a force, but as the compliance to another state of order unconditionally inflicted on the individual from the future. In this potential of the future, however, the chance of change is subordinate to the specific alterations that the technology allows. This is a digital force as a return to powerlessness by abandoning the illusions of a subjective consciousness in favor of the temporal indifference to any past or present, preferring a future that is itself predestined by a series of commands: the timelessness of a controlling transcendentalism, an image of control.

The disregard for the body's weight, texture, and limitations is precisely what Sobchack sees as a characteristic of the current technomania, where the subject loses her or his capacity to be charged existentially. In her essay "Beating the Meat/Surviving the Text," she writes, "One of the consequences of our high-tech millenarianism is that the responsive and responsible material and ethical significance of the lived body have been elided or disavowed."[21] In its virtual nothingness, the digitized subject is set to look somewhere else, or in the sometime else of the digital's timelessness, where the significance of physical mortality is made weightless, unimportant. This is to say that the discourse manifested by *The Matrix* purports an approach to digital worldlessness as a fatal consequence on the subject, both destined by fate (people being connected to their pods at birth) and fatal (no longer in time at all). As such, the body, which does not want to connect to the world (how could it?) but to escape from it altogether, is not lived but objectified as a sign not simply for representation (an actor's representation on screen) but of representation (a representation of an actor acting).

### The Illusion of Action

Both creator and viewer/user of this digitized world are caught up in a desensitizing alienation from reality: the first, due to the ability to record raw footage without the pressures of the event because anything can be

retouched, or because the whole diegetic world is actually going to be rendered in a computer at a later stage, and the latter, due to the inability to respond to the ontology of the digital's visual renderings as she or he is left untouched by the intricately multiplied and incalculable forces of life's unraveling. It is not a matter of believing that, like the actor on screen, the subject, too, can run and jump horizontally from wall to wall. Rather, it is a matter of a deepening of the gap between subject and world on the premise of the determining structures of the technology's image of control. Here the ethical implication of the image cannot be evoked, like celluloid film, in a distant yet real trace of the world's continual powers of change, because change is expressed as a function, not a force. Perversely, the immortality expressed by the digitized body becomes a promise of death as it opens the way toward nihilism. There is a sort of alienation where the subject is considered from the outside not from the point of a distanced exploration, which would imply a continuation of the epistemological remoteness of skepticism, but as a consequence to put up with an exterior fate and remain eternally reactive within its defining limits.

It is not simply that the digitization of the body on screen creates an image of effortlessness where the reflective and reflexive struggles of existence become insignificant.[22] Rather, the creative impulses of the digital (both for creator and viewer) elicit a sense of acting in the world without necessarily becoming active—that is, remaining reactive within a determined path. Of course, the digital image is always open in the sense of the ability of the user to transform it, thanks to the proliferation of available resources and equipment, and the ability of the computational image to be transformed endlessly because it is never bound by the specificity of one form of output.[23] At the same time, though, the potential of manipulability is led by a drive that forces a certain way of access following a number of menus, an assortment of filters, and a list of functions. The image, therefore, seems open within a closed regime because the ability to be active takes place as the power to react toward determined presets. In fact, one can see a perverse desire cultivated in this structure: a desire to lose the ability to respond altogether while feeling the satisfaction of being active. The subject has more means—that is, in the sense of media outlets—of expressing a relation to the world, but must do so by giving into the controlling patterns of digital technology. Change in the digital's manipulability takes the form of a transformative ability that

demands for this ability to be predetermined—that is, manipulability as self-manipulation. The screen is no longer a shield from reality's past, but a shield from reality's presence altogether, because it is understood as a force of the fixed configurations of presets.

At the same time, while the ability to respond to, and be involved in, an image of reality's past is eliminated, existence is projected to the future. For instance, at times postproduction does not simply take part in the procedure of moviemaking, but defines the form of preproduction, recording, and acting entirely. Movies like the last two episodes of *Star Wars* (both captured entirely with the use of high-definition cameras and constructed in the laborious work of the postproduction) as well as techniques like digital rotoscoping and motion capture are indeed exemplary of this situation. The future, in other words, is summoned as a means of blissfully preparing everyone for its arrival, but in so doing, it overshadows any willingness to be concerned with the present.[24] Indeed, following in the line of modern capitalist economies, the constant innovation of digital applications and equipment seems to display the present as an imperfect situation that the future purports to better. Consider the competitive conflict between editing software (primarily Adobe Premier, Avid, and Final Cut Pro) or multimedia frameworks (like Windows Media and QuickTime) that each fight to replace the predominance of the other based on an ideal image of functionality and effects. This desire to overshadow the present for a promise of a better future is even apparent in the software's incessant updating that appears to fix glitches or loopholes of the system, thus treating the present as if it were a constant threat appeased by the future. Similarly, the whole selling point of high-definition digital disk formats and television sets guarantees to make the possibilities of visual entertainment *finally possible*. For Panasonic's Viera series, this means allowing the viewer to "get closer to the action," whereas Sony's Bravia offers "color like no other." What remains hidden, though, is that this promise of the all-so-better future is not necessarily a blessing, but a further extension of exterior forces that are imposed on the subject–world link, fragmenting the continual becoming of the present and configuring it to seem incomplete and undesirable. In this view, the present is not a form of creative becoming in living, but an incomplete representation of the future that, needless to say, is not here yet and will always not be here yet. How, then, can the subject be ethically involved in reality now, if all one desires is to be replaced by the power to be referred somewhere—that is, sometime—else?

## Archiving the World as a Response-Ability

The mathematical determination of the digital's numerical configuration and the image of control that it consequently conjures up are not easy to overcome. While the nonindexical foundation of the digital image leaves it cut off from reality, the predetermined structures that define any creative or interactive encounter with it make the subject's ability to respond to its mediated image of reality *reactive*. Where, then, can one find a point of access in the digital that involves a response between world and subject as a Deleuzian ethics of creativity—as a potential to believe in this world here?

The answer can be found in the tendency built into digital technology to archive and access information with such immediacy that equipment and interfaces actually become tools for a direct interaction between the subject and world. This is, of course, quite a simple answer to the matter at hand, but one that seems deemphasized by current digital cultures. The immediacy interwoven in the activities of archiving and accessing is of utmost importance here, because it creates the potential for the redefinition of control. The camera becomes a tool for exploring the world and the relation of the creator to it as it is unfolding. Similarly, the screen functions not simply as the surface of presentation but as an interface and instrument panel that empowers the viewer/user anew by allowing her or him to become part of a multiplicity of functions. Indeed, digital equipment has been built on this ability of storing information efficiently for the purpose of immediate and direct access to, and interaction with, it. What is stored on a hard drive are data that can be retrieved via a number of points or routes as made possible by the RAM. Similarly, the stored information can be expressed in multiple ways due to its numerical form, thus gaining a phenomenological sense of the variable nature of change. In fact, as I discussed in chapter 4 with reference to the airplane shot in *Into Great Silence*, the digital display repeats the displaced character of data as its image constantly shifts due to its repetitive rescanning and refreshing, as well as by jarring the habitual linear progression of time by incorporating previous and new pixel configurations simultaneously in every instant. What this essentially means is that the digital makes possible a relation to the world as a form of time that is possessed by the vastness of a dense archiving strategy, whose potential is brought up in the immediacy and multiplicity of both its present capturing and the future interactive contact with its stored information. In the vastness and multiplicity of the

archiving and interacting ability, therefore, the confined order of the digital is surpassed not by reaching the limits of nihilism, but by bringing the subject in a necessary coalition with the potency of variability. It is here that the transcendental image of control can be appeased by the active powers of creativity—a Nietzschean image of power.

## The Act of Gleaning Images: Varda

This potential of digital cinema is beautifully illustrated in Agnès Varda's *The Gleaners and I* (2000), a digital documentary that, among other things, expresses the relation between the variability of the archived information and the immediacy that the subject's relation to the world gains as moviemaker. Varda chooses to use a handheld digital camcorder to document two events: on the one hand, the phenomenon of waste in contemporary France and the marginal practice of gleaning, and on the other hand, her own position in the practice of documenting events and commenting on them. Indeed, her interest lies in the social importance of gleaning, whereby agricultural products that are thrown away because their shape or size does not conform to what is marketable are gathered from the rural wastelands or urban streets and consumed. What is most intriguing, though, is the parallel Varda draws between this social exchange that redefines the relationship between the value and use of products for everyday survival, and moviemaking as another act of gleaning—albeit one where images of the world are collected as a personal encounter between subject and reality.

During one of the scenes in the movie, Varda stands next to Jules Breton's famous painting of a woman gleaner and imitates her gesture of holding ears of wheat over her shoulder. She then lays the wheat on the floor and picks up her camera instead. Varda reenacts the relationship between the gleaners and the world, but instead of using her hands to collect abandoned or discarded food, she uses her camera to capture visual residues of her surroundings and experiences. Of this gleaning with a camera, Varda says, "On this type of gleaning, of images, impressions, there is no legislation, and gleaning is defined figuratively as a mental activity. To glean facts, acts and deeds, to glean information. And for forgetful me, it's what I have gleaned that tells where I've been."

Commenting on this correspondence between gleaning food and gleaning images, Mireille Rosello explains that Varda's choice to record rather than collect does not make her an indifferent observer of the social

practice.[25] Rather, her decision to glean with a camera is a response to a different need: she collects images of the world that are left unnoticed because they are ordinary or dull.[26] It is here that Rosello sees a transformation of the act of gleaning for survival into a creative impulse: where gleaned potatoes become food for *les glaneurs*—for *la glaneuse* they become aesthetic objects through which Varda explores her own aging process. Similarly, Sarah Cooper's exploration of Levinasian ethics and otherness in French documentaries focuses on how Varda is not indifferent to the distinction between gleaning for food and gleaning for images—a difference between surviving and being interested in the visual proportions of rubbish, misshapen vegetables, or mold. On the contrary, the movie becomes a meeting point between different ways of dealing with waste, the social ills of a consumer culture, the personal histories of people living in this society, and Varda herself, who examines her own self simultaneously through a project of self-portraiture.[27]

Indeed, what draws me to Varda's project is how the movie depicts the act of capturing images with a digital camera as an activity through which the world is continually archived, through the immediate ability to glean images and to subsequently encounter the subject–world relation as a creative activity. The ability to capture with the ease and immense storage capacities of the digital transforms Varda into a visual gleaner: as she records events from the lives of communities as a personal act of connecting herself to the world, she becomes involved in what she sees and responds actively to the unfolding events. Her camera, that is, is in direct relation with the ongoing present, instantly available as a tool for easily accessing and probing an event in progress.[28] No need for staging, no need for cutting, no need for bulky equipment, it is just there, readily available to allow for her encounter with the world to become an activity in time's unraveling.

Here is where the digital act can become an ethical act of encountering the world through the creative gesture of being involved and responding to what takes place *on the spot*. Varda's use of the digital camera presents the digital transformation of the moviemaker not as a passive acceptance of exterior forces that dominate and exclude her or him from the flow of change, but as a power of change and a power to change. During one scene, she holds the camera in one hand while she records her other hand collecting heart-shaped potatoes that a man had found. It is at this point that the spectator also experiences the immense potential of an active response to reality, as Varda's camera expresses an unpredictable and

Varda's act of self-portraiture. Still image from *The Gleaners and I* (Agnès Varda, 2000).

intricate encounter between personal histories, thoughts, and responses: a history of a social structure whose consumerist uniformity results in the massive waste of food; a history of a social practice that takes advantage of this waste from the outskirts of the social establishment; a personal story of a man who is part of this practice, who leaves damaged potatoes behind, who prefers large potatoes to small ones, and who finds a heart-shaped one; and a moviemaker whose camera extends her ability to become part of this encounter and act on it by making the heart-shaped potato her own and bringing a voice to a sociohistorical phenomenon. In fact, this heart-shaped potato takes on a whole new life: reminding Varda of the French charity restaurants known as *restaus du coeur,* the moviemaker informs the owner of the existence and location of discarded potatoes. Finally, while turning from the rotting heart-shaped potatoes to her own aging hands and gray hair, she reveals an interest in her own relation to the passage of time, not in the sense of dying but of time passing, of a world changing.

In other words, in the immediacy with which one can point to the world and archive its events, the potential itself to act is renewed as a response to, or exploration of, the world and the individual's relation to it.

Indeed, it is not a matter of finding answers but finding one's own creative involvement in the events that take place. Allowing her to capture material without the restrictions related to film equipment (in large formats) or film stock (in smaller ones), Varda literally gleans her way around the world, making the visual documentation of France's landscape a point of encounter between her activity in the events of the world. In fact, the heart-shaped potato functions as the sum of the dice thrown in the dice-throwing game that Nietzsche uses to describe his notion of the "eternal return." As the potato shows up in the convergence of a number of stories without precision or intention, it expresses the entropic character inherent in change itself.

Indeed, constructed as a commentary on a social and historical event through a series of interviews conducted by, and incorporating, the moviemaker, *The Gleaners and I* seems to be repeating the same strategy maintained in *Shoah*. The difference, though, is that Lanzmann must turn to the contemporary testimonies to express the difficulty of representing the past and the problem of forgetting it for the future. But Varda turns to the present as an activity of encountering bound by the activity of capturing the experience of life. For the viewer, what becomes directly expressible is the creativity involved in encountering and, by extension, in perceiving the world. Varda's visual gleaning instantly correlates and fuses her ability to archive her encounters in France with her creative stimulation by these encounters and her own involvement in them. By so doing, her capturing of the world is a matter of accessing it as a retrieval that is not simply her own (not externally subjective), but of her encountering activity within the world. This is an ethics of believing in this world here through the simple gesture of directly responding to it and participating in what takes place. It is an ethics of overcoming the distance between the world and subject through the active response to the potential of being immersed in the immediate presence of time passing. This is what digital equipment expresses both in the immediate accessibility it offers in recording, retrieving, and sending information; and it is what the digital camera enables as it packs together a recording lens, a hard drive, and a screen.

## Stuck in Time: *The War Tapes*

To be sure, activity as a power of force is not a definite prerequisite of the digital, but a potential of its manifestations. The digital expresses a

Varda's heart-shaped potato as a figuration of life's chance occurrences. Still image from *The Gleaners and I* (Agnès Varda, 2000).

means of creatively reconnecting to the world in the sense of a potential and not an assurance for the subject as either moviemaker or viewer/user to respond to her or his implicated relation to the activity of archiving and accessing reality. In his book *New Philosophy for New Media,* Mark Hansen stresses the expression of creativity linked to the constant variability of digital forms.[29] He links the digital's disposition to change forms, with the constant volatility expressed in Bergson's theory of creative perception. Here the subject is understood as a center of indetermination actively filtering and selecting images from an acentered universe. Hansen intuitively exhibits how it is this creative involvement of the subject's response to reality that the digital inherently emphasizes—indeed, a potential that becomes one of the technology's fascinating new powers. While this potential of new media is, of course, of the utmost importance for my own approach to the ontology of digital cinema, I cannot but wonder about the digital's other power—namely, its defining mathematical structure that links the image forcefully to an expression of control, where both subject and world are deserted or left powerless. In other words, rather than definitively align the technology with an ethics of creative

involvement in reality, it is imperative to see the digital's ability to express reactive or active forces as a *potential*—not a fact.

My own anxiety about the sense of being active while remaining in fact unable to act was what drew me to the question of ethics in the first place. Indeed, such is the case with Scranton's *The War Tapes*. As I discussed in the previous chapter, the movie effectively utilizes the shock effect of the digital's *immediacy* to produce the possibilities connected with indexicality's causal structure. While its digital foundation is unable to lay claim to the existential assurance associated with celluloid's causal relation to reality, it gains a sense of witnessing the world through its capability to be readily available for recording, archiving, and making events immediately retrievable as they occur. Nevertheless, *The War Tapes* expresses this ability not as an ethics of creative involvement but as a device of seeming powerful while remaining powerless. While the soldiers gain an amazing proximity to the events of the war that they can archive immediately with a simple click of their camera's button, they do not seem to be able to respond to what is actually going on around them. Their involvement in their environment and its events is not one of a force becoming active, but of a self-mutilation. Their ability to archive the world does not extend to a potential for accessing it through an unpredictable convergence and emergence of constantly renewable encounters—a type of archiving creativity expressed in Varda's heart-shaped potato. Indeed, *The War Tapes* expresses an ethical conflict that remains a matter of time: time in the movie is limited to the present battle to survive the forces of death that surround the soldiers— time, that is, expressed as a conflict of reactive forces whose multiplicity is suspended in the now. This suppressive inability experienced by the soldiers is even evident in the second part of the documentary, which continues with interviews and events from the soldiers' lives back in the United States. As the three men seem emotionally crippled by their inability to break away from their horrific past and change what had happened into a potential of a new future, the preceding recordings seem to accentuate their powerlessness to move beyond the restrictions of the image's instantaneity. They are, in effect, stuck in one time—a matter not caused, but definitely emphasized, by the digital image.

*The War Tapes* thus expresses a dimension of the digital that is of the utmost concern. In their attempt to archive the horrific events of the Iraq War, the three soldiers use the digital to archive themselves in a state of a concretized reaction to survive. The abilities of digitization favor, in this

Sergeant Steve Pink archiving his existence in the Iraq War. Still image from *The War Tapes* (Deborah Scranton, 2006).

instance, an expression of control precisely because they provide a new and extensive format for the establishment of an archiving mania that *imitates* an ethics of a creative ability to become involved in the world's becoming. In contrast, the digital may also create a series of structures that do not lead to determined consequences, but rather make possible different responses. It is this variability of forms, effects, and consequences that celluloid film made possible, and which digital technology continues. This is not to say that there is no difference between the two technologies. Celluloid's causality indeed makes possible a view of the world through which the viewer is implicated in the force of life's continual change. Conversely, the digital's mathematical codification or generation of an image of the world confronts the individual decisively with the abysmal absence of existence when she or he does not respond to the world, when involvement in reality is not an ethical response to living as the continual creativity of change.

Structures of various relationships between image, world, and individual are precisely what any new medium of visual culture induces, and which lay the foundation for this ontological interpretation that is infused with ethical concerns. The question concerning digital cinema, that is, is necessarily an ethical one—albeit one that remains continually under revision rather than fixed by a set answer. If there is something that this broad term "digital cinema" teaches us in its multiplicity of

formations and consequences, this would be it: from *The Matrix* to *King Kong*, from *The Gleaners and I* to *The War Tapes*, it becomes apparent that digital cinema is never *one* medium, but a specific form of communicating mediations between the world and the individual. The digital is a format, in other words, of mediating powers that do not exclude the powers of celluloid, but do include the reinterpretation of the latter within the setting of an evolving visual culture.

# CONCLUSION

*Change: A Point of Constant Departure*

IN *NAQOYQATSI*, REGGIO CREATES A SENSE OF REALITY in which technology does not simply affect social structures, but defines how the world is configured in its entirety. Speaking in the bonus featurette *Life as War* that accompanies the DVD, Reggio explains, "It's not the effect of technology on society, on economics, on religion, on war, on culture, et cetera, on art; it's that everything now is existing in technology as the new host of life. It's the price we pay for the pursuit of our technological happiness— that is what warfare is. It's way beyond the battlefields, it's total war, it's war as ordinary daily living." In this declaration, Reggio makes clear that he defines contemporary life on the basis of its technological existence, from which it is inseparable. To be sure, his views here are not limited to digital technology per se, but to technology in general. Nevertheless, as the movie's images contain CGI animation intermingled with recorded images whose color, perspective, and rhythm have been transformed by computer effects, Reggio creates a view of the world that is indeed nothing but digitographic: the world as graphical renditions of computational configurations and calculations. "Life as war" in the image becomes a vanishing point for existence, as living is depicted in the form of shapes, patterns, and colors all smoothly combined in a construction of complete digitization. The digital's influence, in this view, is interpreted as a predetermination of how we can relate to our world and to ourselves, governing both the creation and understanding of visual images as much as our everyday lives.

Although I share Reggio's anxieties for the effects of technology on our relation to the world, my aim throughout this book has been to focus on the technological specificities of the digital without defining them as

technological determinisms. Rather than see the transition from celluloid to digital cinema as a contrasting or distinctive rupture in the theory of visual media, I have been examining the new technology as a different setting of formal and conceptual structures that reflect on, and constantly interact with, a celluloid environment. Indeed, the current moment of cinema's history reveals how intricately involved the two technologies are as they share an interrelated role in the processes of production, distribution, and exhibition. Moreover, aesthetic and narrative constructions that had been developed long before the arrival of new media in cinema have not vanished, but have become part of new creative explorations. My interpretation of the technological transition has thus sought to understand the change embedded in the digital's newness while turning to the effects of the technology's simultaneous interrelation with celluloid media. It is for this reason that I chose to discuss the current technological change as a transition—as a transformation where differences are generated from the continual interaction between forms. Newness here is not a matter of one form taking over another, but of two specific forms coexistent in a creative development.

The complex intersection between celluloid film and the digital becomes apparent in the problem that arises when trying to differentiate the two technologies from the point of view of the representational treatment of reality as truthfulness. Considering the strong link sustained between celluloid and reality due to the technology's analogical and indexical foundation, I examined the filmic image as a form of mediation where the world is its source of construction, as well as the place of its perception. Yet early on in my discussion it became apparent that to describe celluloid images as indexically objective due to their photographic basis was as problematic as it would be to deem digital images perceptual deceptions because of their technical abilities for direct and discrete access and manipulation. The problem that the digital presents is not related to any truth claim for the factual nature of photographic causality, but to its ontological relation to the world—that is, to the existential relationship it sets up between reality and the creating and viewing subject. As such, one needs to ask not if movies merely sustain a connection to reality, but what kind of connection this is. Here is, in my view, where the change from celluloid to digital media becomes a question of the ontology of the cinematic image. It is not that celluloid is simply of reality and the digital is not—or that the one technology is more real than the other. Rather, the ontological question conjured up by the relation

between celluloid images and digital renditions is a matter of evaluating *how* each technology makes its associations to the world possible.

On this basis, I directed my discussion toward an exploration of the structures through which celluloid creates an image that relates the spectator to the world, and how these structures are reconfigured in the digital setting of contemporary cinema. Indeed, the role of the individual as creator and viewer is inseparable from the meanings that cinematic technologies can generate. It is on these premises that I examined the implications of the subject in the theories of Peirce, Bazin, and Barthes on photographic and filmic indexicality; and it is on this basis that I chose to combine the creative thrust of thinking in Deleuze's exploration with the expressive sensualization of the body in existential phenomenology. It is in the individual's active participation in molding and encountering movies that the relation of the image to reality gains a significance that cannot be restricted to technological signification. As I argued in chapter 1, there is an inherent irregularity in the indexical sign that is based on the inherent implication of the subject with the construction of meaning in the image. This is not to say that subjective narrativization eliminates the traces of reality in the index, but that it endows the sign with a fictionalization that adds a constantly renewable complexity to the potentials of representation in general. The cinematic image (both celluloid and digital) as "medium" is thus formed from this interactive conjunction between the technical base of the technology, the subject who interacts with the technology and its products, and the associations that are triggered anew with reality. It is from this point of view that the camera cannot firmly fix a representational regime, but can only enter into dialogue with the variable fields of social, sensual and emotional, and technological relations. The message of the medium is this constantly renewable set of relations from where technological creativity is generated.

In discussing aspects of materiality, spatiality, and temporality through the prism of the interrelationship between image and subject, it has become apparent that the complex relations between movies and the world are not eliminated from the process of the digital's binary transcoding. As I explored in chapter 2, the continuous interaction between reality, technical materiality, and spectatorial corporeality in celluloid film creates a significant sense of physical bonds in the image. It is from this point of view that celluloid entails the effects of the constant transformation of physical change, making the technology a "cyborg" of differentiating forces. In contrast, where the celluloid image exhibits a guarantee of material and

corporeal interactions, the digital's numerical encoding generates a sense of immateriality: its images are intangible arrays of numbers and calculations. Rather than base the digital's connection to physical and corporeal attributes on causal effects, I have maintained that it is possible to establish the image's physical grounds on a "reality effect." In other words, instead of forcing attributes of celluloid technology onto the digital, it is possible to see how the new technology generates a reconfiguration of cinematic experience in its notational insinuation of the real. Nevertheless, the digital's need to *connote* rather than *denote* reality stresses the necessary involvement of the spectator, who must deduce a sense of physical and corporeal existence through an attentive interpretation of elements that punctuate the technology's deterministic configuration: the details that remain superfluous to the intended binary configuration in the sense of Barthes's notations and Deleuze's "gests." It is from this point of view that the space set up between screen and viewer becomes an arena of poetic stimulation, where meaning is generated from the involvement of the spectator.

In other words, the image, be it celluloid or digital, cannot reduce its meaning to one universal mode of perception because the viewer is an unpredictable creator of thought. At the same time, though, the technological basis of cinematic depictions affects the ways the relationship between movies and viewers is structured. In chapter 3, where I examined how the digital configures space in the image as a grid of fixed and calculable proportions and directions, I argued that the technology favors a regime of transcendental meaning that leaves thought detached from its creative involvement in living. It is this fixity that the digital's Euclidean arrangement and Cartesian configuration express, and which creates an image of control. However, as the variability of celluloid's Riemannian structures forges a means of accessing the image through the creativity of constant change, the digital is also encountered as an alternating field of forces. As space expresses the transformative convergence between fields and figures where the subject changes according to her or his continual development, and space (as manifold, smooth, and hodological) mutates according to the variety of the interrelated forces, the digital is equipped with the potential to overcome its determining codification. This is what is expressed in the transformative expression of the morph, the incongruous simultaneity of compositing, and the incalculable variations of interactivity. Once again, numerical determination can be overcome

through a certain implication of the subject: as creator who purposefully complicates spectatorial interpretation on the basis of aesthetic and narrative choices, and as spectator who mentally and physically interacts with the image.

It is in the temporal nature of the image, however, that the question of the digital's newness brings us back to the issue of causality as an existential matter and the consequent ethical implications of movies. In chapter 4 I maintained that, while the celluloid image attests to the constant refractions of temporal layers from past to future, the digital image replays this understanding of time in a phenomenological interpretation of its structural elements. Indeed, celluloid film brings together a sense of time past with a time passing that involves a certain move toward the future. Yet celluloid does not simply manifest duration as the continuous transformation of existence as expressed in Bergson's *durée*; rather, it elicits change in the tension between *still* images and the unpredictability of their instantaneous appearance and vanishing through the rapid motion of the technological equipment. Change is not annihilated by stasis but continues despite the seeming interruption of movement. This convergence between stillness and instantaneous renewal is also expressed by the digital but in different terms: by combining the fixed repetition of code relations with the instantaneous refreshing of the image and renewal of certain numerical associations, an image of the past and the present are brought to coalesce in one simultaneous moment. Repetition in the digital image reveals the convergence of sameness and difference, where old and new are united in their expression of change. Moreover, the potential of the future's openness is generated in the constant availability of the image's data for the intervention of the creator or the spectator/user.

Despite this figuration of time at the level of the screen, as each point in the image remains a calculable and definable symbolic function, the image in its entirety is subjected to the controlling functionality of a mathematical rationalism. As I discussed in chapter 5 through Cavell's reading of cinema, celluloid's causality creates a view of the past that implicates the viewer through the continuous refractions of time. It forges a guarantee of the world despite the subject's visible absence, thus placing the ontological configuration of the image on grounds other than an ocular detachment of the subject—in the sense, that is, of a Cartesian schematization of knowledge. At the same time, as I examined through Deleuze's

work, the celluloid image creates a potential for believing in the world because it depicts a reality that exists, albeit within constantly renewable limits of *being*—a world of a becoming expressed in the creativity of differentiation.

In contrast, the digital does not foreground an interaction between past actions of the recorded world and the present response of the viewing spectator. Instead, the digital's technological structures create a sense of existential withdrawal due to a distance that leaves creator and spectator alike unable to actively take part in life. The ability of becoming involved in reality—of being able to respond to life's constant becoming—is eclipsed by the fact that the subject is in fact reacting toward predetermined paths. Here the ethical implications are disconcerting because the creator or spectator/user is caught up in a race that leaves her or him motionless without this becoming apparent. The image of control generated by the mathematical determination of the technology is thus extended to the subject, whose power to interact with the world seems predestined in the fixed configurations of digital tools, hard drives, and Cartesian grids. Taking control of the image, the subject is also controlled: she or he is "in control" in the sense of controlling from the outside and being controlled from that outside. While the subject does not lose the ability to act, she or he only seems to be reacting toward the symbolic determination of the digital; and as the constant obsession of the future nullifies the need to pay attention to the present, the world loses all significance and the subject remains desiring a utopia.

Nevertheless, there is still hope of transforming the digital's structures and technical abilities into a means for a creative encounter with the world. While the nonindexical and nonanalogical configuration of binary code cannot be disregarded, the immediate availability the technology creates for archiving and retrieving information creates a potential for experiencing the world *in the act.* This is a matter of using the digital to interact with events as they unfold, to discover arbitrary associations that lead to new experiences, and to explore life as a field of constant and unpredictable germination. Instead of withdrawing from life, as if the digital caused a fatal blow to the existential relations of the image, the individual as creator and viewer/user can reactivate the image from her or his involvement in the meanings it elicits. It is this hope to which Varda's digital images of heart-shaped potatoes bear witness by becoming metaphors for the meeting point of people and histories that are

directly affected by their encounters. And it is in this heart-shaped metaphor of change that I, too, lay my own hope for an ethics of creativity in the potentials of digital cinema.

In trying to find a point of differentiation between celluloid and the digital, it is necessary to be attentive to the structures of each technology without dismissing the forms of the implicated elements, or the direction that their force may take from the current interaction and the virtual potential of change's chance occurrence. Although each technological form creates and sustains its own functions, it does not and cannot define the expressive intuitions, psychological desires, and perceptual complexities of the individual who creates, views, or interacts with it. In asking, therefore, what changes in the movie image with the introduction of digital technology, I have examined what is replayed as a difference of change, not elimination. The transition from the one to the other is a matter of oscillating, in other words, between the two settings and paying attention to what takes place in every new moment of their interactive reverberations. It is from this point of view that cinema will never lose its link to its celluloid past, but also from where the theoretical approach to the technological transition may remain a field of replayed and renewed explorations. Indeed, the difficulty in outlining a distinct and definite division between cinema's current technological modes of creation and perception points to a potential for treating knowledge as a force of change continually renewed by strands of thought interacting with, and transforming, one another. As I remain hopeful for the creative potential of the relationship between individual and reality through the digital, I, too, remain hopeful that this book forms a point of departure for further thought in unpredictable and creative ways.

## ACKNOWLEDGMENTS

I AM PREPARING THE FINAL MANUSCRIPT FOR THIS BOOK at a crucial moment in my life—a time that signals my own transition from my doctoral apprenticeship at King's College London to the collegial validation that accompanies my new role as assistant professor at Duke University. As this event is accompanied by a move from one continent to another, *From Light to Byte* has become for me a symbol of this new moment, but also an aide-mémoire for the immense effort that it took to get here.

Indeed, this book is the result of a process of thought that grew out of all my years of academic studies as both an undergraduate and graduate student in Greece and the United Kingdom. The path I chose to take in asking and exploring its questions was informed by the variety of thinkers to whom I was exposed over the past decade and the creative impetus that resulted from the intellectual and artistic heterogeneity of these years. Of course, my academic education by itself would have been almost futile were it not for the inspiration and support I received from a number of wonderful professors who gave me more than I could have ever expected as a twenty-year-old man taking his first steps in the Panteion University in Athens. They made this journey possible, reassuring me when I was anxious about everything and supporting me when I was ready to fall.

Most of all, I need to thank deeply the two most wonderful scholars and generous people who stuck by my side, armed and ready, from the moment we met: Sarah Cooper and David Rodowick. Both Sarah and David have played the part of my academic parents with amazing commitment, guiding me and lending me a much-needed hand at every moment of my career. Above all, they believed in the potential they saw in me and stood by their conviction with the confidence of a true mother

and father. More than this, they had a direct effect on the conceptual foundation of this book. Indeed, *From Light to Byte* was inspired initially by a series of debates on digital cinema, and film and philosophy, to which I was introduced by David in his final year at King's College in 2003–4. Moreover, I was immensely fortunate to have Sarah as my PhD supervisor at King's College, and she made sure I did not fall into any intellectual pitfalls as I made my way through the research and writing. For all their indefatigable guidance, support, encouragement, and kindness, I am forever grateful.

While I am indebted to David and Sarah, I am also extremely beholden to a number of people who affected my thinking over the years in many ways. Professors from both the Department of Communication, Media, and Culture at the Panteion and the Film Studies Department at King's College have had a prime impact on my work, directing me in my theoretical concerns and inquiries, my personal fascination with the arts and philosophy, and especially my love for cinema. I particularly want to express my warmest gratitude to Maria Paradeisi for first introducing me to film studies and Sergei Eisenstein's intellectual creativity; to Effie Fountoulaki and Patricia Kokkori for their fervent display of belief in my capabilities and for helping me seek out the poetry in academic research; to Giorgos Veltsos for throwing me in the deep end of continental philosophy before I knew how *I* could be *another*; to Mark Betz for being stern when I needed discipline and reassuring when I needed a friend, for reminding me consistently that it will be worth it in the end, and for urging me to aim high; to Michele Pierson for both her friendship and encouragement during those two years of job market hell and for pointing me in the direction of Agnès Varda's *The Gleaners and I* and Deborah Scranton's *The War Tapes*—movies that played an important role in shaping the final chapter of this book; and to Libby Saxton for engaging so sincerely with my work as my PhD examiner and for being so giving, supportive, and warm thereafter.

For both their friendship and guidance during my first attempts at teaching film studies, I express my sincere gratitude to Ginette Vincendeau, Richard Dyer, Belén Vidal, Michelle Summerfield, Tom Atterson, and especially Stephanie Green for being there truly from day one. Of course, my thanks also go out to all the students I taught at King's College, whose probing questions and insatiable doubts forced me to sharpen the conceptual edges of this book. This is also true of the two readers who were assigned the difficult task of approving its publication, both of

whom offered invaluable recommendations for the further strengthening of its content. I thank them both, as well as the editorial team at the University of Minnesota Press, especially copy editor Nicholas Taylor and my editor Danielle Kasprzak, who led me through every step of this project with understanding and professional thoroughness. I also owe my appreciation to the Arts and Humanities Research Council and the School of Humanities at King's College for invaluable financial support of this project while it was still a PhD thesis. Further, I owe my gratitude to Dean of Humanities at Duke University, Srinivas Aravamudan, for a financial subvention supporting the publication of this book.

Finally, I would like to express my gratitude and love to my friends and family for their affection, support, and interest in my well-being and for their company and patience when I just never had enough time. I especially owe a big thank-you to Christos Paphitis for introducing me to Godfrey Reggio's work with such enthused persuasion, and to Loizos Olympios for providing the wonderful image that became the cover of this book. Above all, I am eternally indebted to my parents and sister, for loving and supporting me unconditionally for all these years.

# NOTES

## Introduction

1  Although Walt Disney's *Tron* is heralded as the first mainstream movie to make extensive use of CGI, the practice was hardly new. Consider, for example, the work of John and James Whitney, Stan Vanderbeek and Kenneth C. Knowlton, Steina and Woody Vasulka, and Malcolm Le Grice dating back to the mid-1960s.

2  I have chosen to use the term "movie" rather than "film" to avoid the suggestion of celluloid technology in the latter.

3  For a fascinating exploration of the cultural significance of special effects and their novel place in new media CGI, see Michele Pierson's book *Special Effects*. Shilo McClean also turns to digital visual effects to examine their expressive use and implications for narrative. See McClean, *Digital Storytelling*.

4  For a collection of books that address the various uses of digital technology, see Hanson, *End of Celluloid*; Jäger, Knapstein, and Hüsch, *Beyond Cinema*; Tribe and Jana, *New Media Art*; Brougher et al., *Cinema Effect*.

5  Anne Friedberg, "The End of Cinema," in Gledhill and Williams, *Reinventing Film Studies*, 438–52. In her last book, Friedberg extends her examination of the screen in a fascinating exploration of frames from Alberti's optics to Microsoft Windows. See Friedberg, *Virtual Window*.

6  In a similar approach, Haidee Wasson discusses the effect of the proliferation of screens for an understanding of the "screen" in her essay "The Networked Screen: Moving Images, Materiality, and the Aesthetics of Size," in Marchessault and Lord, *Fluid Screens, Expanded Cinema*, 74–95. Also see Sally Pryor and Jill Scott's interesting discussion of their experience with virtual reality and the technology's potential effect on an understanding of reality, in "Virtual Reality: Beyond Cartesian Space," in Hayward and Wollen, *Future Visions*, 166–79.

7  Rodowick, *Virtual Life of Film*.

8  Ibid., 9.

9  For the growing theoretical debate concerning the history and theoretical effects of digital media, see, for instance, Bolter and Grusin, *Remediation*; Lunenfeld, *Digital Dialectic*; Fullerton and Widding, *Moving Images*; Roman, *Digital Babylon*; Gere,

*Digital Culture*; Rabinovitz and Geil, *Memory Bytes*; Rieser and Zapp, *New Screen Media*; McKernan, *Digital Cinema*; Willis, *New Digital Cinema*; Keane, *CineTech*; Popper, *From Technological to Virtual Art*; Lyons and Plunkett, *Multimedia Histories.*

10  Manovich, *Language of New Media.*

11  Ibid., 78–88.

12  Manovich, "Old Media as New Media: Cinema," in Harries, *New Media Book,* 209–18. For discussions that take a similar stance toward the old aspects of the new, see Patrizia Di Bello, "From the Album Page to the Computer Screen: Collecting Photographs at Home," 57–71; Michelle Henning, "The Return of Curiosity: The World Wide Web as Curiosity Museum," 72–84; and Dan North, "From Android to Synthespian: The Performance of Artificial Life," 85–97, all in Lyons and Plunkett, *Multimedia Histories.* For a series of diverse debates that address the issue of media convergences, see Fullerton and Olsson, *Allegories of Communication.*

13  Mulvey, *Death 24x a Second,* 26–32.

14  Ibid., 8.

15  Laura Marks, "Video's Body, Analog and Digital," 147–59; and "How Electrons Remember," 161–75, both in *Touch.*

16  See Marks, *Skin of the Film,* 46–47.

17  Hansen, *New Philosophy for New Media,* especially 235–71.

18  See Malcolm Le Grice's 1974 essay "Computer Film as Film Art," in *Experimental Cinema in the Digital Age,* 219–33.

19  See ibid., 221.

20  See Le Grice's 1994 piece "Implications of Digital Systems for Experimental Film Theory," in *Experimental Cinema in the Digital Age,* 234–42.

21  Babette Mangolte, "A Matter of Time: Analog versus Digital, the Perennial Question of Shifting Technology, and Its Implications for an Experimental Filmmaker's Odyssey," in Allen and Turvey, *Camera Obscura, Camera Lucida,* 261–74. Walter Murch makes similar observations in his own practical experience of the technology. See *In the Blink of an Eye.*

22  Sobchack, *Address of the Eye.*

23  Vivian Sobchack, "The Scene of the Screen: Envisioning Photographic, Cinematic, and Electronic 'Presence,'" in *Carnal Thoughts,* 135–62.

24  Mitchell, *Reconfigured Eye.*

25  See ibid., 191–225.

26  Similarly, Niels Ole Finnemann examines the digital by opposing the technology to celluloid based on the variability that its mathematical symbolization makes possible. See Finnemann, "The New Media Matrix: The Digital Revolution of Modern Media," in Bondebjerg, *Moving Images, Culture, and the Mind,* 227–39.

27  Thomas Elsaesser, "Cinema Futures: Convergence, Divergence, Difference," in Elsaesser and Hoffmann, *Cinema Futures,* 9–26.

28  Thomas Elsaesser, "Digital Cinema: Delivery, Event, Time," in Elsaesser and Hoffmann, *Cinema Futures,* 201–22; and "The New New Hollywood: Cinema Beyond Distance and Proximity," in Bondebjerg, *Moving Images, Culture, and the Mind,*

187–203. This is a position reflected in Kay Hoffmann's own essay "'I See, If I Believe It': Documentary and the Digital," in Elsaesser and Hoffmann, *Cinema Futures*, 159–66.

29  Doane, *Emergence of Cinematic Time*, especially 206–32.

30  Rosen, *Change Mummified*, especially 301–49.

31  For Yvonne Spielmann this complex relation is expressed as an intermediation that simultaneously separates and connects the two technologies in a history of aesthetics. See "Aesthetic Features in Digital Imaging," 131–48.

32  Usai, *Death of Cinema*.

33  Ibid., 13.

34  See Rodowick, *Virtual Life of Film*, 12–24, especially 19–21, where he discusses Usai's work.

35  Cubitt, *Cinema Effect*.

36  McLuhan, *Understanding Media*.

37  Ibid., 8.

38  Martin Heidegger, "The Question Concerning Technology," in *Basic Writings from "Being and Time" (1927) to "The Task of Thinking" (1964)*, 311–41.

39  Ibid., 311.

40  See Deleuze's *Cinema 1* and *Cinema 2*.

41  Walter Benjamin, "A Short History of Photography," in Trachtenberg, *Classic Essays on Photography*, 199–216.

42  Benjamin's approach is echoed in Susan Sontag's reading of photography much later, where she, too, focuses on the effects that technology has on the way society observes its environment. See Sontag, *On Photography*.

43  Walter Benjamin, "The Work of Art in the Age of Mechanical Reproduction," in Durham and Kellner, *Media and Cultural Studies*, 18–40.

44  Andrew, *Major Film Theories*.

45  Münsterberg, *Photoplay*.

46  Arnheim, *Film as Art*.

47  See, for instance, Eisenstein, *Film Form*.

48  See Balázs, *Theory of the Film*.

49  André Bazin, "The Ontology of the Photographic Image," in *What Is Cinema?* 1:9–16.

50  Ibid., 1:9.

51  Ibid., 1:10.

52  For an early discussion of the aesthetic values of photography, see Peter Henry Emerson's 1889 essay "Hints on Art," in Trachtenberg, *Classic Essays on Photography*, 99–105.

53  Bazin, "Ontology of the Photographic Image," in *What Is Cinema?* 1:13.

54  See ibid., 1:13–14.

55  Ibid., 1:13. In his own approach to stylization in film, Erwin Panofsky similarly contends that artifice does not eliminate but is part of physical reality as seen in the image. See "Style and Medium in the Motion Pictures," in *Three Essays on Style*, 91–125.

56  See Kracauer, *Nature of Film*, especially 285–311.

57  See Christian Metz's 1977 piece "The Imaginary Signifier" (excerpts), in Rosen, *Narrative, Apparatus, Ideology*, 244–78.

58  See Jean-Louis Baudry's 1970 essay "Ideological Effects of the Basic Cinematographic Apparatus," in Rosen, *Narrative, Apparatus, Ideology*, 286–98.

59  See Jean-Louis Baudry's 1975 piece "The Apparatus: Metapsychological Approaches to the Impression of Reality in the Cinema," in Rosen, *Narrative, Apparatus, Ideology*, 299–318.

60  See Jean-Louis Comolli, "Machines of the Visible," in de Lauretis and Heath, *Cinematic Apparatus*, 121–42.

61  Bazin, "Ontology of the Photographic Image," in *What Is Cinema?* 1:15. While for Bazin the image's ability to convey reality is based on its indexical structure, which its movement extends into the realm of change, for Metz the reality effect is an impression induced solely from the perception of a self-moving image. See Metz, "On the Impression of Reality in the Cinema," in *Film Language*, 3–15.

62  André Bazin, "The Evolution of the Language of Cinema," in *What Is Cinema?* 1:23–40.

63  Philip Rosen's treatment of Bazin's work similarly emphasizes the importance the French theorist places on the subject for an understanding of an ontological realism in film. See Rosen, "History of Image, Image of History: Subject and Ontology in Bazin," in Margulies, *Rites of Realism*, 42–79.

64  André Bazin, "The Virtues and Limitations of Montage," in *What Is Cinema?* 1:41–52.

65  André Bazin, "An Aesthetic of Reality: Neorealism (Cinematic Realism and the Italian School of the Liberation)," in *What Is Cinema?* 2:6–40.

66  See Barthes, *Camera Lucida*, 77.

67  Ibid., 6.

68  Cavell, *World Viewed*. I discuss the consequences of Cavell's argument in detail in chapter 5.

69  It is interesting to see how this distance is understood in Metz's terms as an absence that reduces the causal power of the image, but which self-motion overcomes. See "On the Impression of Reality in the Cinema," in *Film Language*, 8–9.

70  Barthes, *Camera Lucida*, 9.

71  Ibid., 25–40.

72  Ibid., 18.

73  See Roland Barthes's 1961 essay "The Photographic Message," in *Image Music Text*, 15–31.

74  Ibid., 30.

75  See Roland Barthes's 1970 piece "The Third Meaning: Research Notes on Some Eisenstein Stills," in *Image Music Text*, 52–68.

76  See Deleuze, *Cinema 2*, 5.

77  Ibid., 156–88.

78  See Metz, "On the Impression of Reality in the Cinema," in *Film Language*, 7.

79  Deleuze, *Cinema 2*, 156.

80 In his exploration of the association between movies and philosophy, Daniel Frampton relates Deleuze's approach to cinema within a tradition of debates that link thought to the shock of the moving image, especially in relation to Eisenstein's dialectics. See Frampton, *Filmosophy*, 49–70.

81 For Deleuze's explanation of his first and second chronosigns—"virtual sheets of past" and "de-actualized peaks of present"—see *Cinema 2*, 98–105.

82 For the third chronosign—"time as becoming"—see ibid., 147–55.

83 For a valuable summary of phenomenology's history and debates from Edmund Husserl onward, see Eagleton, *Literary Theory*, 54–90.

84 Sobchack, *Address of the Eye*, 3–4.

85 Enticknap, *Moving Image Technology*, 203. For further details on the operative functions of digital technology, see Barclay, *Motion Picture Image*; and Bizony, *Digital Domain*.

86 See Manovich, *Language of New Media*, 28.

87 See Mitchell, *Reconfigured Eye*, 4.

88 Manovich, *Language of New Media*, 30.

89 For a series of essays concerned with the effects of digital worlds on the sensorial experiences of the viewer, see Everett and Caldwell, *New Media*.

90 See Marks, "How Electrons Remember," in *Touch*, 163–68.

91 Vivian Sobchack, "Scary Women: Cinema, Surgery, and Special Effects," in *Carnal Thoughts*, 36–52.

92 See Klaus Bruhn Jensen, "Interactivities: Constituents of a Model of Computer Media and Communication," in Bondebjerg, *Moving Images, Culture, and the Mind*, 241–55.

93 See Sobchack, "Scene of the Screen," in *Carnal Thoughts*, 153.

94 Bent Fausing, "Sore Society: The Dissolution of the Image and the Assimilation of the Trauma," in Fullerton and Widding, *Moving Images*, 69–82.

95 For a wonderful discussion of spatial organization in digital media from the Internet to digital cinema, television, and console games, see Maureen Thomas, "Beyond Digitality. Cinema, Console Games, and Screen Language: The Spatial Organisation of Narrative," in Thomas and Penz, *Architectures of Illusion*, 51–134.

## 1. The Reality of the Index, or Where Does the Truth Lie?

1 Gunning, "What's the Point of an Index? or, Faking Photographs," 39–49.

2 See C. S. Peirce's 1873 MS "On the Nature of Signs," in Hoopes, *Peirce on Signs*, 141.

3 Ibid., 142.

4 See C. S. Peirce, "[A Treatise on Metaphysics]," originally projected as a book in 1861, in Hoopes, *Peirce on Signs*, 19.

5 Rosen, *Change Mummified*, 11.

6 Bazin, "The Evolution of the Language of Cinema," in *What Is Cinema?* 1:35.

7 See ibid., 1:35–36.

8 See Bazin, "An Aesthetic of Reality," in *What Is Cinema?* 2:35–38.

9 See Bazin, "The Ontology of the Photographic Image," in *What Is Cinema?* 1:9–11.

10 John Grierson, "First Principles of Documentary (1932)," in Fowler, *European Cinema Reader*, 41.

11 Sarah Cooper's enlightening discussion of documentary filmmaking clarifies this point precisely. See *Selfless Cinema?* 10–11.

12 For a detailed description of Morris's techniques in constructing a sense of artifice in relation to the Texas penal system, see Curry, "Errol Morris' Construction of Innocence in *The Thin Blue Line.*"

13 Williams, "Mirrors without Memories." Also see Terrence Rafferty's reading of the movie that approaches it as an investigative inquiry of truth and falsehood. Rafferty, "*The Thin Blue Line,*" in Macdonald and Cousins, *Imagining Reality*, 332–38.

14 See Williams, "Mirrors without Memories," 20.

15 Cited in ibid., 13.

16 It is fascinating to note that, as research in digital technology has gained increased attention in film studies, there has also been a focus on matters of photographic indexicality and objectivity. See Elsaesser and Hoffmann, *Cinema Futures*; Black, *Reality Effect*; Margulies, *Rites of Realism*.

17 Vaughan, *For Documentary.*

18 See ibid., xiii–xiv.

19 See Nichols, *Representing Reality*, 112.

20 Michael Renov, "Introduction: The Truth about Non-Fiction," in *Theorizing Documentary*, 3.

21 Barthes's 1961 essay "The Photographic Message," in *Image Music Text*, 15–31.

22 Nichols, *Representing Reality*, 115.

23 Andrew Hebard's wonderful interpretation of *Night and Fog* explores how the film collapses the distinction between past and present, creating what he calls a "politics of remembrance." See Hebard, "Disruptive Histories." Similarly, Libby Saxton's masterful discussion of cinema's representation of the Holocaust draws attention to Resnais's purposeful misguidance in his depiction of both the archival footage and the contemporary physical evidence as it appears in the abandoned camp. See Saxton, *Haunted Images*, 88–90.

24 As I will discuss in the final chapter, Claude Lanzmann's *Shoah* employs a different strategy for connecting the past with the present by completely denying access to archival footage, instead resurrecting the past in the trauma of the people themselves.

25 For a detailed account of the events at the Abu Ghraib prison, see Hersh, "Torture at Abu Ghraib."

26 For an extraordinary exploration of the theoretical discourse surrounding the effects of Western ocularcentric culture, see Jay, *Downcast Eyes.*

27 See Silverman, *Threshold of the Visible World*, 125–61.

28 Crary, *Techniques of the Observer*. For Silverman's discussion of Crary's positions, see *Threshold of the Visible World*, 128–31.

29 Lacan, *Four Fundamental Concepts of Psycho-Analysis*. For Silverman's discussion of Lacan's positions, see *Threshold of the Visible World*, 131–37.

30 See Silverman, *Threshold of the Visible World*, 137–61.

31 Virilio, *War and Cinema.*

32  On the matter of the constructive nature of the camera for visual perception, one can also consult Teresa de Lauretis's book *Alice Doesn't,* in which she examines the binding effects cinematic representations have for the female subject and her relation to reality.

33  Bruzzi, *New Documentary,* 17.

34  For Bruzzi's discussion of the Zapruder recording, see ibid., 15–26.

35  For a similar fictionalization of a documented event, see Renov's discussion of George Holliday's video recording of the beating of Rodney G. King by members of the Los Angeles Police Department, in the introduction to *Theorizing Documentary,* 8–10.

36  The moviemakers' techniques in creating the hype leading up to the film's opening at cinemas are illustrated in the mock documentary *The Curse of the Blair Witch* (Myrick and Sanchez, 1999). On this topic, see also Telotte, "*Blair Witch Project* Project"; Schreier, "'Please Help Me; All I Want to Know Is."

37  The Web site can still be found at http://www.blairwitch.com/.

38  Also see Sobchack's brief discussion of the movie in "The Charge of the Real: Embodied Knowledge and Cinematic Consciousness," in *Carnal Thoughts,* 258–85.

39  For Mitchell's reference to these examples see *Reconfigured Eye,* 212–13.

40  Sobchack, "Charge of the Real," in *Carnal Thoughts,* 258–59.

41  Prince, "True Lies."

42  See David Green and Joanna Lowry, "From Presence to the Performative: Rethinking Photographic Indexicality," in Green, *Where Is the Photograph?* 47–60.

43  See Marks, "Video's Body, Analog and Digital," in *Touch,* 149.

44  Gibson, *Neuromancer.*

## 2. Physical Presences

1  Timothy Binkley, "Refiguring Culture," in Hayward and Wollen, *Future Visions,* 94.

2  Ibid., 95.

3  See Usai, *Death of Cinema,* 13.

4  See Joanna Sassoon's discussion of the cultural effects of the digital's immateriality in "Photographic Materiality in the Age of Digital Reproduction," in Edwards and Hart, *Photographs Objects Histories,* 186–202.

5  Kracauer, *Nature of Film,* 300.

6  Noël Carroll discusses the film's formal construction in relation to its Dadaist ideology in "*Entr'acte,* Paris, and Dada."

7  For a short historical introduction to the film and the techniques Man Ray uses, see Rudolf E. Kuenzli's "Introduction" in *Dada and Surrealist Film,* 1–12, especially p. 3.

8  See Enticknap, *Moving Image Technology,* 6.

9  See Shaviro, *Cinematic Body,* 32–33.

10  For a series of essays that discuss the historical background of the film concerning its techniques, aesthetics, and social and political reflections, see Prince, *Sam Peckinpah's "The Wild Bunch."*

11  David A. Cook discusses these associations in his essay "Ballistic Balletics: Styles of Violent Representation in *The Wild Bunch* and After," in ibid., 130–54.

12  It is important to note that Shaviro's opposition especially toward psychoanalysis as a mode of exploration in film has changed in recent years. See "Cinematic Body Redux."

13  Shaviro, *Cinematic Body*, 51.

14  See Deleuze, *Cinema 2*, 6.

15  See Linda Williams, "Film Bodies: Gender, Genre, and Excess," in Grant, *Film Genre Reader II*, 140–58.

16  Ibid., 143.

17  For an exploration of the relations that Oshima's work makes with Japan's history and the sociopolitical background of the filmmaker's era, see Turim, *Films of Oshima Nagisa*.

18  Marks, *Skin of the Film*, 47.

19  Ibid., 138.

20  Also see Laura Marks, "Video Haptics and Erotics," in *Touch*, 12–13, where she reiterates this discussion.

21  See Merleau-Ponty, *Phenomenology of Perception*, 240–82.

22  See Sobchack, *Address of the Eye*, 57–69.

23  Ibid., 61.

24  For a close analysis of the film, its contextual position in Vertov's theoretical work, and Vertov's own relation to the Soviet film industry of the time, see Roberts, *Man with the Movie Camera*.

25  See Mangolte, "A Matter of Time," in Allen and Turvey, *Camera Obscura, Camera Lucida*, 262–66.

26  See Enticknap, *Moving Image Technology*, 18–19.

27  Haraway, "Cyborg Manifesto."

28  For a discussion of the relation between medical technology, surveillance, and the supremacy of the male gender, see Sarah Kember, "Medicine's New Vision?" in Lister, *Photographic Image in Digital Culture*, 95–114.

29  See Haraway, *How Like a Leaf*.

30  For a similar discussion of the mastering dominance inherent in cultural structures of biological/sexual difference, see Butler, *Bodies That Matter*; Grosz, *Volatile Bodies*. For a further discussion of Haraway's "cyborg" and its complications for feminist studies, see Kirkup et al., *Gendered Cyborg*. Also see Haraway's recent work where she continues to examine the historical background of techno-scientific narratives, cultural manipulation, and the potential of new versions of transgressive structures in current fields of biotechnology, communication, and computer sciences, *Modest_Witness@Second_Millennium.FemaleMan_Meets_OncoMouse*.

31  See Rodowick, *Virtual Life of Film*, 121–22.

32  On the matter of the "human hurdle" in digital animation, see Prince, "True Lies," 33.

33  See, for instance, *Toy Story*; *Monsters, Inc.* (Pete Docter, 2001); *Ice Age* (Chris Wedge, 2002); *Finding Nemo* (Andrew Stanton, 2003); *Cars* (John Lasseter, 2006).

34  For a series of essays addressing the morphing image in digital movies, see Sobchack, *Meta-Morphing*.

35  See Hanson, *End of Celluloid*, 106–11.

36  Enticknap, *Moving Image Technology*, 4.

37  Marks, "Video's Body, Analog and Digital," in *Touch*, 157–58.

38  Roland Barthes, "The Reality Effect," in Todorov, *French Literary Theory Today*, 11–17.

39  See ibid., 11.

40  Ibid., 15.

41  Barthes's 1964 essay "Rhetoric of the Image," in *Image Music Text*, 32–51, especially 37–41.

42  Barthes, "Reality Effect," in Todorov, *French Literary Theory Today*, 16.

43  Deleuze, *Cinema 2*, 192.

## 3. Spatial Coordinates

1  See Manovich, *Language of New Media*, 27–30.

2  Ibid., 78.

3  For a detailed description of the procedure, see Enticknap, *Moving Image Technology*, 7–9.

4  For the technical details on the making of the film, see McLaren, "Technical Notes on *Blinkity Blank* (1955)."

5  Ibid., 1.

6  The whole undertaking is described in detail in the documentary *Within a Minute: The Making of Episode III* (Tippy Bushkin, 2005).

7  See Gray, *Ideas of Space*, 26–40.

8  Ibid., 28.

9  Cited in Henderson, *Fourth Dimension and Non-Euclidean Geometry in Modern Art*, 3.

10  In the final chapter, I will return to the ethical consequences of incompatible truths and falsities in Deleuze's work.

11  See Henderson, *Fourth Dimension and Non-Euclidean Geometry in Modern Art*, 11–17.

12  Grosz, *Space, Time, and Perversion*.

13  See ibid., 88–93.

14  Ibid., 85–87.

15  Sigmund Freud, "The Ego and the Id (1923)," in *Standard Edition of the Complete Psychological Works of Sigmund Freud*, 19:12–66.

16  Grosz, *Space, Time, and Perversion*, 86.

17  See Jacques Lacan's 1949 essay "Mirror Stage as Formative of the *I* Function as Revealed in Psychoanalytic Experience," in *Écrits*, 75–81.

18  See Grosz, *Space, Time, and Perversion*, 91–93.

19  My characterization of space as felt or patchwork is a reference to Deleuze and Félix Guattari's examination of "striated" and "smooth" spaces, which I discuss below.

20  Deleuze and Guattari, "1440: The Smooth and the Striated," in *Thousand Plateaus*, 523–51.

21  See ibid., 524–26.

22  This process is described in the documentary *In One Breath: Alexandr Sokurov's "Russian Ark"* (Knut Elstermann, 2003).

23  Rodowick, *Virtual Life of Film*, 166.

24  For a further illustration of the methods and consequences of abstract thought in Descartes's combination of arithmetic and geometry, see Stephen Gaukroger, "The Nature of Abstract Reasoning: Philosophical Aspects of Descartes' Work in Algebra," in Cottingham, *Cambridge Companion to Descartes*, 91–114.

25  Brian Massumi, "Translator's Foreword: Pleasure's of Philosophy," in Deleuze and Guattari, *Thousand Plateaus*, xiii.

26  See Deleuze and Guattari, "1440," in *Thousand Plateaus*, 529.

27  Hornsey, "Listening to the London *A* to *Z*."

28  Scott Bukatman presents a wonderful discussion of the theoretical complexities and concerns that arise from digital morphing in his essay "Taking Shape: Morphing and the Performance of Self," in Sobchack, *Meta-Morphing*, 225–49.

29  Norman M. Klein, "Animation and Animorphs: A Brief Disappearing Act," in Sobchack, *Meta-Morphing*, 21–39.

30  Ibid., 25.

31  See http://www.tulselupernetwork.com/basis.html.

32  Peeters, "Tulse Luper Suitcases."

33  Laine, "Lars von Trier, *Dogville*, and the Hodological Space of Cinema."

34  See ibid., 131.

35  *Waxweb* is still available online at http://www2.iath.virginia.edu/wax/.

36  For a discussion of the multiple linkages that interactivity can make possible and the relation this multiplicity of choice has with memory, see Tafler, "When Analog Cinema Becomes Digital Memory."

37  See Peter Lunenfeld, "The Myths of Interactive Cinema," in Harries, *New Media Book*, 144–54, where he explores the idea of interactivity as a deception of new media's "newness."

38  Bachelard, *Poetics of Space*.

39  Ibid., 184.

## 4. Rediscovering Cinematic Time

1  See Rodowick, *Virtual Life of Film*, 163.

2  Mangolte, "Matter of Time," in Allen and Turvey, *Camera Obscura, Camera Lucida*, 264.

3  Binkley, "Camera Fantasia," 10.

4  See Rosen, *Change Mummified*, 309–14.

5  See Manovich, *Language of New Media*, 155–60.

6  Ibid., 317.

7  Deleuze, *Cinema 2*, 13.

8  Ibid., 14.

9  Ibid., 17.

10  See Bergson, *Time and Free Will*, 90–99.

11 Ibid., 98.

12 See ibid., 100.

13 Ibid., 100–101.

14 See also Bergson, *Creative Evolution*, 1–7, where he returns to these conclusions.

15 The scene described here is available to watch online, as an accompaniment to my article that discusses Gröning's movie and the idea of digital temporality. See Hadjioannou, "Into Great Stillness, Again and Again."

16 See Bergson, *Time and Free Will*, 98–99.

17 Bergson, *Creative Evolution*, 306.

18 Stewart, *Between Film and Screen*.

19 See ibid., 9–18.

20 Ibid., 11.

21 See Sobchack, "The Scene of the Screen," in *Carnal Thoughts*, 142–43, 145–46, and 153.

22 Sobchack, *Address of the Eye*, 208.

23 From this point of view, Stewart's examination is close to Mulvey's own reading of the psychoanalytic implications related to the digital's revelation of the image's static basis. See Mulvey, *Death 24x a Second*, 8.

24 For more on Sobchack's views on this matter, see *Address of the Eye*, 206–8, where she talks about cinema as a perceiving and experiencing body instead of a mechanized illusion of motion, precisely because the latter view does not coincide with the spectator's own experience of what cinematic movement is and what it means.

25 See Stewart, *Between Film and Screen*, 125–27. I will return to Cavell's work in detail in the following chapter.

26 Ibid., 143. I will return to this matter below to show how repetition does in fact involve change.

27 Ibid., 134.

28 See ibid., 139.

29 Ibid., 140.

30 Ibid., 187.

31 Moore, *Hollis Frampton*, 14.

32 See ibid.

33 See Doane, *Emergence of Cinematic Time*, 172–205.

34 See Bergson's analysis of the cinematographic illusion in *Creative Evolution*, 304–8.

35 For more on Zeno's paradox, see Doane, *Emergence of Cinematic Time*, 172–74.

36 See ibid., 179–80. Regarding the long exposure times of daguerreotype photography and the implications for an understanding of time in the still image, see Mary Anne Doane, "Real Time: Instantaneity and the Photographic Imaginary," in Green and Lowry, *Stillness and Time*, 22–38.

37 See Doane, *Emergence of Cinematic Time*, 180.

38 Barthes, "Third Meaning," in *Image Music Text*, 52–68.

39 See Wollen, "Fire and Ice," in Wells, *Photography Reader*, 76–80.

40 Cited in Lupton, *Chris Marker*, 91.

41  See ibid., 90–94.

42  See Rodowick, *Virtual Life of Film*, 137–38.

43  Ibid., 138.

44  Consider, for example, the mobile phone video recordings of events like the sui-
cide attacks on the United States (2001) and London (2005), the tsunami disasters
of the Indian Ocean (2004), or the assassination of Prime Minister Benazir Bhutto
in Pakistan (2007).

45  Doane, *Emergence of Cinematic Time*, 208.

46  See ibid., 209–19.

47  Ibid., 222.

48  See Barbara Filser, "Gilles Deleuze and a Future Cinema: Cinema 1, Cinema 2—
and Cinema 3?" in Shaw and Weibel, *Future Cinema*, 214–17.

49  See Peter Weibel, "The Intelligent Image: Neurocinema or Quantum Cinema?" in
Shaw and Weibel, *Future Cinema*, 594–601.

50  See Siegfried Zielinski, "Backwards to the Future: Outline for an Investigation of
the Cinema as a Time Machine," in Shaw and Weibel, *Future Cinema*, 566–69.

## 5. Tracing an Ethics of the Movie Image

1  See Bazin, "Ontology of the Photographic Image," in *What Is Cinema?* 1:13–14.

2  Cavell, *World Viewed*, 16.

3  Rodowick, *Virtual Life of Film*, 66.

4  See Cavell, *World Viewed*, 23.

5  Ibid., 40–41.

6  Rodowick, *Virtual Life of Film*, 61.

7  See Felman, "In an Era of Testimony."

8  See Rodowick, *Gilles Deleuze's Time Machine*, 145–50.

9  Saxton, "Fragile Faces."

10  See LaCapra, "Lanzmann's *Shoah*."

11  Koch, "Aesthetic Transformation of the Image of the Unimaginable."

12  Indeed, this understanding resonates with Marks's understanding of spectato-
rial mimesis as a corporeal reenactment of the visual experience in order to make
sense out of it. See chapter 2, 82–83.

13  Deleuze, *Cinema 2*, 167.

14  Ibid., 170.

15  See Deleuze's *Expressionism in Philosophy* and *Spinoza*.

16  Deleuze, *Nietzsche and Philosophy*, 37.

17  See ibid., 57.

18  Ibid., 38.

19  Ibid, 61–63.

20  Ibid., 61.

21  Vivian Sobchack, "Beating the Meat/Surviving the Text, or How to Get out of the
Century Alive," in *Carnal Thoughts*, 173.

22  See, for instance, Sobchack, "Scary Women," in *Carnal Thoughts*, especially 45–48,
where she links digital immateriality to plastic surgery.

23 See Rodowick's discussion of the multiplicity of output forms that create a sense of the image not being "one," in *Virtual Life of Film*, 131–41.

24 See, as an interesting case, Rodowick's discussion of the utopian undertones of AT&T's advertising campaign in *Reading the Figural*, 203–5.

25 Rosello, "Agnès Varda's *Les Glaneurs et la glaneuse.*"

26 See ibid., 32.

27 See Cooper, *Selfless Cinema?* 84–90.

28 Needless to say, the potential of easy access to recording events was similarly important for earlier generations of avant-garde filmmakers due to the precise, lightweight, robust, and functional form of 16mm cameras. See, for example, Carlos Bustamente, "The Bolex Motion Picture Camera," in Fullerton and Widding, *Moving Images*, 59–65.

29 See Hansen, *New Philosophy for New Media*, 6–11.

# BIBLIOGRAPHY

Allen, Richard, and Malcolm Turvey, eds. *Camera Obscura, Camera Lucida: Essays in Honor of Annette Michelson*. Amsterdam: Amsterdam University Press, 2003.

Andrew, Dudley. *The Major Film Theories: An Introduction*. London: Oxford University Press, 1976.

Arnheim, Rudolph. *Film as Art*. Berkeley: University of California Press, 1957. Originally published as *Film als Kunst* (Berlin: E. Rowohlt, 1932).

Bachelard, Gaston. *The Poetics of Space: The Classic Look at How We Experience Intimate Places*. Translated by Maria Jolas. Boston: Beacon Press, 1994. Originally published as *La Poétique de l'espace* (Paris: Presses Universitaires de France, 1957).

Balázs, Béla. *Theory of the Film: Character and Growth of a New Art*. London: Dennis Dobson, 1952. Originally published as *Filmkultúra: A Film Müvészetfilozófiája* (Budapest: Szikra Kiadó, 1948).

Barclay, Steven. *The Motion Picture Image: From Film to Digital*. Boston: Focal Press, 2000.

Barthes, Roland. *Camera Lucida: Reflections on Photography*. Translated by Richard Howard. London: Vintage, 2000. Originally published as *La Chambre claire: Note sur la photographie* (Paris: Gallimard, 1980).

———. *Image Music Text*. Edited and translated by Stephen Heath. London: Fontana Press, 1977.

Bazin, André. *What Is Cinema?* Edited and translated by Hugh Gray. 2 vols. Berkeley: University of California Press, 1967–72. Originally published as *Qu'est-ce que le cinéma?* (Paris: Éditions du Cerf, 1958–62).

Bergson, Henri. *Creative Evolution*. Translated by Arthur Mitchell. New York: Henry Holt, 1911. Reprint, Mineola, N.Y.: Dover Publications, 1998. Originally published as *L'Évolution creatrice* (Paris: Félix Alcan, 1907).

———. *Time and Free Will: An Essay on the Immediate Data of Consciousness*. Translated by F. L. Pogson. London: George Allen, 1913. Reprint, Mineola, N.Y.: Dover Publications, 2001. Originally published as *Essai sur les données immédiates de la conscience* (Paris: Félix Alcan, 1889).

Binkley, Timothy. "Camera Fantasia: Computed Visions of Virtual Realities." *Millennium Film Journal* 20/21 (Fall/Winter 1988–89): 6–45.

Bizony, Piers. *Digital Domain: The Leading Edge of Visual Effects.* London: Aurum, 2001.

Black, Joel. *The Reality Effect: Film Culture and the Graphic Imperative.* New York: Routledge, 2002.

Bolter, Jay David, and Richard Grusin. *Remediation: Understanding New Media.* Cambridge: MIT Press, 1999.

Bondebjerg, Ib, ed. *Moving Images, Culture, and the Mind.* Luton: University of Luton Press, 2000.

Brougher, Kerry, Kelly Gordon, Anne Ellegood, Kristen Hileman, and Tony Oursler, eds. *The Cinema Effect: Illusion, Reality, and the Moving Image.* London: Giles, 2008.

Bruzzi, Stella. *New Documentary.* 2nd ed. London: Routledge, 2006. Originally published in 2000.

Butler, Judith. *Bodies That Matter: On the Discursive Limits of "Sex."* New York: Routledge, 1993.

Carroll, Noël. "*Entr'acte,* Paris and Dada." *Millennium Film Journal* 1 (Winter 1977–78): 5–11.

Cavell, Stanley. *The World Viewed: Reflections on the Ontology of Film.* Enl. ed. Cambridge: Harvard University Press, 1979.

Cooper, Sarah. *Selfless Cinema? Ethics and French Documentary.* Research Monographs in French Studies 20. London: Legenda, 2006.

Cottingham, John, ed. *The Cambridge Companion to Descartes.* Cambridge: Cambridge University Press, 1992. Reprint, 2005.

Crary, Jonathan. *Techniques of the Observer: On Vision and Modernity in the Nineteenth Century.* Cambridge: MIT Press, 1992.

Cubitt, Sean. *The Cinema Effect.* Cambridge: MIT Press, 2004.

Curry, Renée R. "Errol Morris' Construction of Innocence in *The Thin Blue Line.*" *Rocky Mountain Review of Language and Literature* 49, no. 2 (1995): 153–67.

De Lauretis, Teresa. *Alice Doesn't: Feminism, Semiotics, Cinema.* London: Macmillan, 1984.

De Lauretis, Teresa, and Stephen Heath, eds. *The Cinematic Apparatus.* Hampshire: Macmillan, 1980.

Deleuze, Gilles. *Cinema 1: The Movement-Image.* Translated by Hugh Tomlinson and Barbara Habberjam. London: Athlone Press, 1986. Reprint, 2002. Originally published as *Cinéma 1: L'Image-mouvement* (Paris: Les Éditions de Minuit, 1983).

———. *Cinema 2: The Time-Image.* Translated by Hugh Tomlinson and Robert Galeta. London: Athlone Press, 1989. Reprint, 2000. Originally published as *Cinéma 2: L'Image-temps* (Paris: Les Éditions de Minuit, 1985).

———. *Expressionism in Philosophy: Spinoza.* Translated by Martin Joughin. 1st pbk. ed. New York: Zone Books, 1992. Reprint, 2005. Originally published as *Spinoza et la problème de l'expression* (Paris: Les Éditions de Minuit, 1968).

———. *Nietzsche and Philosophy.* Translated by Hugh Tomlinson. London: Athlone Press, 1983. Reprint, London: Continuum, 2006. Originally published as *Nietzsche et la philosophie* (Paris: Presses Universitaires de France, 1962).

———. *Spinoza: Practical Philosophy.* Translated by Robert Hurley. San Francisco: City

Lights Books, 1988. Originally published as *Spinoza: Philosophie pratique* (Paris: Presses Universitaires de France, 1970).

Deleuze, Gilles, and Félix Guattari. *A Thousand Plateaus: Capitalism and Schizophrenia*. Translated by Brian Massumi. London: Athlone Press, 1988. Reprint, London: Continuum, 2004. Originally published as *Mille Plateaux*, vol. 2 of *Capitalisme et Schizophrénie* (Paris: Les Éditions de Minuit, 1980).

Doane, Mary Ann. *The Emergence of Cinematic Time: Modernity, Contingency, the Archive*. Cambridge: Harvard University Press, 2002.

Durham, Meenakshi Gigi, and Douglas M. Kellner, eds. *Media and Cultural Studies: KeyWorks*. Rev. ed. Malden, Mass.: Blackwell, 2006.

Eagleton, Terry. *Literary Theory: An Introduction*. Oxford: Blackwell, 1983. Reprint, 1995.

Edwards, Elizabeth, and Janice Hart, eds. *Photographs Objects Histories: On the Materiality of Images*. London: Routledge, 2004. Reprint, 2005.

Eisenstein, Sergei. *Film Form: Essays in Film Theory*. Edited and translated by Jay Leyda. San Diego: Harcourt Brace & Company, 1949.

Elsaesser, Thomas, and Kay Hoffmann, eds. *Cinema Futures: Cain, Abel, or Cable? The Screen Arts in the Digital Age*. Amsterdam: Amsterdam University Press, 1998.

Enticknap, Leo. *Moving Image Technology: From Zoetrope to Digital*. London: Wallflower Press, 2005.

Everett, Anna, and John T. Caldwell, eds. *New Media: Theories and Practices of Digitextuality*. New York: Routledge, 2003.

Felman, Shoshana. "In an Era of Testimony: Claude Lanzmann's *Shoah*." *Yale French Studies* 79 (February 1991): 39–81.

Fowler, Catherine, ed. *The European Cinema Reader*. London: Routledge, 2002.

Frampton, Daniel. *Filmosophy: A Manifesto for a Radically New Way of Understanding Cinema*. London: Wallflower Press, 2006.

Freud, Sigmund. *The Standard Edition of the Complete Psychological Works of Sigmund Freud*. Translated by James Strachey and Anna Freud (assisted by Alix Strachey and Alan Tyson). 24 vols. London: Hogarth Press, 1961.

Friedberg, Anne. *The Virtual Window: From Alberti to Microsoft*. Cambridge: MIT Press, 2006.

Fullerton, John, and Astrid Söderbergh Widding, eds. *Moving Images: From Edison to the Webcam*. London: John Libbey, 2000.

Fullerton, John, and Jan Olsson, eds. *Allegories of Communication: Intermedial Concerns from Cinema to the Digital*. Rome: John Libbey, 2004.

Gere, Charlie. *Digital Culture*. London: Reaktion Books, 2002.

Gibson, William. *Neuromancer*. London: Gollancz, 1984.

Gledhill, Christine, and Linda Williams, eds. *Reinventing Film Studies*. London: Arnold, 2000.

Grant, Barry Keith. *Film Genre Reader II*. Austin: University of Texas Press, 1995. Reprint, 1999.

Gray, Jeremy. *Ideas of Space: Euclidean, Non-Euclidean, and Relativistic*. 2nd ed. Oxford: Clarendon Press, 1989.

Green, David, ed. *Where Is the Photograph?* Brighton: Photoforum/Photoworks, 2003.

Green, David, and Joanna Lowry, eds. *Stillness and Time: Photography and the Moving Image.* Brighton: Photoforum/Photoworks, 2006.

Grosz, Elizabeth. *Space, Time, and Perversion: Essays on the Politics of Bodies.* New York: Routledge, 1995.

———. *Volatile Bodies: Towards a Corporeal Feminism.* Bloomington: Indiana University Press, 1994.

Gunning, Tom. "What's the Point of an Index? or, Faking Photographs." *Nordicom Information* 25, nos. 1–2 (2004): 39–49.

Hadjioannou, Markos. "Into Great Stillness, Again and Again: Gilles Deleuze's Time and the Constructions of Digital Cinema." *Rhizomes: Deleuze and Film* 16 (2008). http://www.rhizomes.net/issue16/hadji/index.html.

Hansen, Mark B. N. *New Philosophy for New Media.* Cambridge: MIT Press, 2004.

Hanson, Matt. *The End of Celluloid: Film Futures in the Digital Age.* Mies, Switzerland: RotoVision, 2004.

Haraway, Donna J. "A Cyborg Manifesto: Science, Technology, and Socialist-Feminism in the Late Twentieth Century." In *Simians, Cyborgs, and Women: The Reinvention of Nature,* 149–81. London: Free Association Books, 1991.

———. *How Like a Leaf: An Interview with Thyrza Nichols Goodeve.* New York: Routledge, 2000.

———. *Modest_Witness@Second_Millennium.FemaleMan_Meets_OncoMouse: Feminism and Technoscience.* New York: Routledge, 1997.

Harries, Dan, ed. *The New Media Book.* London: BFI Publishing, 2002.

Hayward, Philip, and Tana Wollen, eds. *Future Visions: New Technologies of the Screen.* London: BFI Publishing, 1993.

Hebard, Andrew. "Disruptive Histories: Towards a Radical Politics of Remembrance in Alain Resnais's *Night and Fog.*" *New German Critique* 71 (Spring/Summer 1997): 87–113.

Heidegger, Martin. *Basic Writings from "Being and Time" (1927) to "The Task of Thinking" (1964).* Edited by David Farrell Krell. Translated by William Lovitt. Revised by David Farrell Krell. Rev. and exp. ed. London: Routledge, 1993. Reprint, 2007.

Henderson, Linda Dalrymple. *The Fourth Dimension and Non-Euclidean Geometry in Modern Art.* Princeton: Princeton University Press, 1983.

Hersh, Seymour M. "Torture at Abu Ghraib. American Soldiers Brutalized Iraqis: How Far up Does the Responsibility Go?" *New Yorker,* May 10, 2004, 42–47.

Hoopes, James, ed. *Peirce on Signs: Writings on Semiotic by Charles Sanders Peirce.* Chapel Hill: The University of North Carolina Press, 1991.

Hornsey, Richard. "Listening to the London *A* to *Z.*" Paper presented at the conference *Real Things: Matter, Materiality, Representation, 1880 to the Present,* University of York, UK, July 5–8, 2007.

Jäger, Joachim, Gabriele Knapstein, and Anette Hüsch, eds. *Beyond Cinema: The Art of Projection.* Ostfildern, Germany: Hatje Cantz Verlag, 2006.

Jay, Martin. *Downcast Eyes: The Denigration of Vision in Twentieth-Century French Thought.* Berkeley: University of California Press, 1994.

Keane, Stephen. *CineTech: Film, Convergence, and New Media.* New York: Palgrave Macmillan, 2007.

Kirkup, Gill, Linda Janes, Kath Woodward, and Fiona Hovenden, eds. *The Gendered Cyborg: A Reader.* London: Routledge, 2000.

Koch, Gertrud. "The Aesthetic Transformation of the Image of the Unimaginable: Notes on Claude Lanzmann's *Shoah*." Translated by Jamie Owen Daniel and Miriam Hansen. *October* 48 (Spring 1989): 15–24.

Kracauer, Siegfried. *Nature of Film: The Redemption of Physical Reality.* London: Dennis Dobson, 1961.

Kuenzli, Rudolf E., ed. *Dada and Surrealist Film.* New York: Willis Locker & Owens, 1987.

Lacan, Jacques. *Écrits: The First Complete Edition in English.* Translated by Bruce Fink, with Héloïse Fink and Russell Grigg. New York: Norton, 2002. Reprint, 2006.

———. *The Four Fundamental Concepts of Psycho-Analysis.* Edited by Jacques-Alain Miller. Translated by Alan Sheridan. London: Hogarth Press, 1977. Originally published as *Les quatre concepts fondamentaux de la psychanalyse,* vol. 11 of *Le Séminaire de Jacques Lacan* (Paris: Éditions du Seuil, 1973).

LaCapra, Dominick. "Lanzmann's *Shoah:* 'Here There Is No Why.' " *Critical Inquiry* 23, no. 2 (1997): 231–69.

Laine, Tarja. "Lars von Trier, *Dogville,* and the Hodological Space of Cinema." *Studies in European Cinema* 3, no. 2 (2006): 129–41.

Le Grice, Malcolm. *Experimental Cinema in the Digital Age.* London: BFI Publishing, 2001.

Lister, Martin, ed. *The Photographic Image in Digital Culture.* London: Routledge, 1995. Reprint, 2005.

Lunenfeld, Peter, ed. *The Digital Dialectic: New Essays on New Media.* Cambridge: MIT Press, 2000.

Lupton, Catherine. *Chris Marker: Memories of the Future.* London: Reaktion Books, 2005. Reprint, 2006.

Lyons, James, and John Plunkett, eds. *Multimedia Histories: From the Magic Lantern to the Internet.* Exeter: University of Exeter Press, 2007.

Macdonald, Kevin, and Mark Cousins, eds. *Imagining Reality: The Faber Book of the Documentary.* London: Faber and Faber, 1996.

Manovich, Lev. *The Language of New Media.* Cambridge: MIT Press, 2001.

Marchessault, Janine, and Susan Lord, eds. *Fluid Screens, Expanded Cinema.* Toronto: University of Toronto Press, 2007.

Margulies, Ivone, ed. *Rites of Realism: Essays on Corporeal Cinema.* Durham: Duke University Press, 2003.

Marks, Laura U. *The Skin of the Film: Intercultural Cinema, Embodiment, and the Senses.* Durham: Duke University Press, 2000.

———. *Touch: Sensuous Theory and Multisensory Media.* Minneapolis: University of Minnesota Press, 2002.

McClean, Shilo T. *Digital Storytelling: The Narrative Power of Visual Effects in Film.* Cambridge: MIT Press, 2007.

McKernan, Brian. *Digital Cinema: The Revolution in Cinematography, Postproduction, and Distribution.* New York: McGraw-Hill, 2005.

McLaren, Norman. "Technical Notes on *Blinkity Blank* (1955)." *National Film Board of Canada: Focus on Animation.* http://www3.nfb.ca/archives_mclaren/notech/NT04EN.pdf.

McLuhan, Marshall. *Understanding Media: The Extensions of Man.* London: Routledge and Kegan Paul, 1964. Reprint, London: Routledge, 2007.

Merleau-Ponty, Maurice. *Phenomenology of Perception.* Translated by Colin Smith. London: Routledge and Kegan Paul, 1962. Reprint, London: Routledge, 2007. Originally published as *Phénomènologie de la perception* (Paris: Gallimard, 1945).

Metz, Christian. *Film Language: A Semiotics of the Cinema.* Translated by Michael Taylor. New York: Oxford University Press, 1974. Originally published as *Essais sur la signification au cinéma,* vol. 1 (Paris: Éditions Klincksieck, 1968).

Mitchell, William J. *The Reconfigured Eye: Visual Truth in the Post-photographic Era.* Cambridge: MIT Press, 1994. Reprint, 2001.

Moore, Rachel. *Hollis Frampton: "(nostalgia)."* London: Afterall Books, 2006.

Mulvey, Laura. *Death 24x a Second: Stillness and the Moving Image.* London: Reaktion Books, 2006.

Münsterberg, Hugo. *The Photoplay: A Psychological Study.* New York: D. Appleton, 1916.

Murch, Walter. *In the Blink of an Eye: A Perspective on Film Editing.* 2nd ed. Los Angeles: Silman-James Press, 2001.

Nichols, Bill. *Representing Reality: Issues and Concepts in Documentary.* Bloomington: Indiana University Press, 1991.

Panofsky, Erwin. *Three Essays on Style.* Edited by Irving Lavin. Cambridge: MIT Press, 1995.

Peeters, Heidi. "The Tulse Luper Suitcases: Peter Greenaway's Mediatic Journey through History." *Image [&] Narrative* 12 (2005). http://www.imageandnarrative.be/inarchive/tulseluper/peeters_art.htm.

Pierson, Michele. *Special Effects: Still in Search of Wonder.* New York: Columbia University Press, 2002.

Popper, Frank. *From Technological to Virtual Art.* Cambridge: MIT Press, 2007.

Prince, Stephen, ed. *Sam Peckinpah's "The Wild Bunch."* Cambridge: Cambridge University Press, 1999.

———. "True Lies: Perceptual Realism, Digital Images and Film Theory." *Film Quarterly* 49, no. 3 (1996): 27–33.

Rabinovitz, Lauren, and Abraham Geil, eds. *Memory Bytes: History, Technology, and Digital Culture.* Durham: Duke University Press, 2004.

Renov, Michael, ed. *Theorizing Documentary.* New York: Routledge, 1993.

Rieser, Martin, and Andrea Zapp, eds. *New Screen Media: Cinema/Art/Narrative.* London: BFI Publishing, 2002. Reprint, 2004.

Roberts, Graham. *The Man with the Movie Camera.* KINOfiles Film Companion 2. London: I. B. Tauris, 2000.

Rodowick, D. N. *Gilles Deleuze's Time Machine.* Durham: Duke University Press, 1997.

————. *Reading the Figural, or, Philosophy after the New Media*. Durham: Duke University Press, 2001.

————. *The Virtual Life of Film*. Cambridge: Harvard University Press, 2007.

Roman, Shari. *Digital Babylon: Hollywood, Indiewood, and Dogme 95*. Hollywood: IFILM Publishing, 2001.

Rosello, Mireille. "Agnès Varda's *Les Glaneurs et la glaneuse:* Portrait of the Artist as an Old Lady." *Studies in French Cinema* 1, no. 1 (2001): 29–36.

Rosen, Philip. *Change Mummified: Cinema, Historicity, Theory*. Minneapolis: University of Minnesota Press, 2001.

————, ed. *Narrative, Apparatus, Ideology: A Film Theory Reader*. New York: Columbia University Press, 1986.

Saxton, Libby. "Fragile Faces: Levinas and Lanzmann." *Film–Philosophy* 11, no. 2 (2007): 1–14.

————. *Haunted Images: Film, Ethics, Testimony, and the Holocaust*. London: Wallflower Press, 2008.

Schreier, Margrit. "'Please Help Me; All I Want to Know Is: Is It Real or Not?': How Recipients View the Reality Status of *The Blair Witch Project*." *Poetics Today* 25, no. 2 (2004): 305–34.

Shaviro, Steven. *The Cinematic Body*. Theory out of Bounds 2. Minneapolis: University of Minnesota Press, 1993. Reprint, 2004.

————. "The Cinematic Body *Redux*." *Parallax* 14, no. 1 (2008): 48–54.

Shaw, Jeffrey, and Peter Weibel, eds. *Future Cinema: The Cinematic Imaginary after Film*. Cambridge: MIT Press, 2003.

Silverman, Kaja. *The Threshold of the Visible World*. New York: Routledge, 1996.

Sobchack, Vivian. *The Address of the Eye: A Phenomenology of Film Experience*. Princeton: Princeton University Press, 1992.

————. *Carnal Thoughts: Embodiment and Moving Image Culture*. Berkeley: University of California Press, 2004.

————, ed. *Meta-Morphing: Visual Transformation and the Culture of Quick-Change*. Minneapolis: University of Minnesota Press, 2000.

Sontag, Susan. *On Photography*. London: Allen Lane, 1978.

Spielmann, Yvonne. "Aesthetic Features in Digital Imaging: Collage and Morph." *Wide Angle* 21, no. 1 (1999): 131–48.

Stewart, Garrett. *Between Film and Screen: Modernism's Photo Synthesis*. Chicago: University of Chicago Press, 1999.

Tafler, David I. "When Analog Cinema Becomes Digital Memory. . . ." *Wide Angle* 21, no. 1 (1999): 177–200.

Telotte, J. P. "*The Blair Witch Project* Project: Film and the Internet." *Film Quarterly* 54, no. 3 (2001): 32–39.

Thomas, Maureen, and François Penz, eds. *Architectures of Illusion: From Motion Pictures to Navigable Interactive Environments*. Bristol: Intellect, 2003.

Todorov, Tzvetan, ed. *French Literary Theory Today: A Reader*. Translated by R. Carter. Cambridge: Cambridge University Press, 1982.

Trachtenberg, Alan, ed. *Classic Essays on Photography.* New Haven, Conn.: Leete's Island Books, 1980.

Tribe, Mark, and Reena Jana. *New Media Art.* Edited by Uta Grosenick. Hong Kong: Taschen, 2007.

Turim, Maureen. *The Films of Oshima Nagisa: Image of a Japanese Iconoclast.* Berkeley: University of California Press, 1998.

Usai, Paolo Cherchi. *The Death of Cinema: History, Cultural Memory, and the Digital Dark Age.* London: BFI Publishing, 2001.

Vaughan, Dai. *For Documentary: Twelve Essays.* Berkeley: University of California Press, 1999.

Virilio, Paul. *War and Cinema: The Logistics of Perception.* Translated by Patrick Camiller. London: Verso, 1989. Originally published as *Guerre et cinéma 1: Logistique de la perception* (Paris: Cahiers du Cinéma/Éditions de l'Étoile, 1984).

Wells, Liz, ed. *The Photography Reader.* London: Routledge, 2003.

Williams, Linda. "Mirrors without Memories: Truth, History, and the New Documentary." *Film Quarterly* 46, no 3 (1993): 9–21.

Willis, Holly. *New Digital Cinema: Reinventing the Moving Image.* London: Wallflower Press, 2005.

# FILMOGRAPHY

*300.* Directed by Zack Snyder. 2007. USA and Canada.

*Ai No Corrida/Empire of the Senses.* Directed by Nagisa Oshima. 1976. Japan and France.

*Allegretto.* Directed by Oskar Fischinger. 1941. USA.

*Ararat.* Directed by Atom Egoyan. 2002. Canada and France.

*Avatar.* Directed by James Cameron. 2009. USA and UK.

*Banshun/Late Spring.* Directed by Yasujiro Ozu. 1949. Japan.

*Batman Begins.* Directed by Christopher Nolan. 2005. UK and USA.

*Bilder der Welt und Inschrift des Krieges/Images of the World and the Inscription of War.* Directed by Harun Farocki. 1988. West Germany.

*Blade Runner.* Directed by Ridley Scott. 1982. USA.

*The Blair Witch Project.* Directed by Daniel Myrick and Eduardo Sanchez. 1999. USA.

*Blinkity Blank.* Directed by Norman McLaren. 1955. Canada.

*Blow-Up.* Directed by Michelangelo Antonioni. 1966. USA, UK, and Italy.

*Cars.* Directed by John Lasseter. 2006. USA.

*Chelovek s Kinoapparatom/Man with a Movie Camera.* Directed by Dziga Vertov. 1929. USSR.

*The Cremaster Cycle.* Directed by Matthew Barney. 1994–2002. USA, UK, and France.

*The Curse of the Blair Witch.* Directed by Daniel Myrick and Eduardo Sanchez. 1999. USA.

*The Dark Knight.* Directed by Christopher Nolan. 2008. USA and UK.

*Dogville.* Directed by Lars von Trier. 2003. Denmark, Sweden, France, UK, and Germany.

*Entr'acte/Interval.* Directed by René Clair. 1924. France.

*Fantastic 4.* Directed by Tim Story. 2005. Germany and USA.

*Fantastic 4: Rise of the Silver Surfer.* Directed by Tim Story. 2007. USA, Germany, and UK.

*Finding Nemo.* Directed by Andrew Stanton. 2003. USA.

*Forgotten Silver.* Directed by Costa Botes and Peter Jackson. 1996. New Zealand.

*Forrest Gump.* Directed by Robert Zemeckis. 1994. USA.

*Les Glaneurs et la glaneuse/The Gleaners and I.* Directed by Agnès Varda. 2000. France.

*Die Große Stille/Into Great Silence.* Directed by Philip Gröning. 2005. Germany and Switzerland.

*Heavenly Creatures.* Directed by Peter Jackson. 1994. New Zealand and Germany.

*Heliu/The River.* Directed by Tsai Ming-liang. 1997. Taiwan.

*Hulk.* Directed by Ang Lee. 2003. USA.

*Ice Age.* Directed by Chris Wedge. 2002. USA.

*The Incredibles.* Directed by Brad Bird. 2004. USA.

*In One Breath: Alexandr Sokurov's "Russian Ark."* Directed by Knut Elstermann. 2003. Germany and Russia.

*Iron Man.* Directed by Jon Favreau. 2008. USA.

*Iron Man 2.* Directed by Jon Favreau. 2010. USA.

*La Jetée/The Pier.* Directed by Chris Marker. 1962. France.

*Jurassic Park.* Directed by Steven Spielberg. 1993. USA.

*King Kong.* Directed by Merian C. Cooper and Ernest B. Schoedsack. 1933. USA.

*King Kong.* Directed by Peter Jackson. 2005. USA, Germany, and New Zealand.

*Koyaanisqatsi: Life out of Balance.* Directed by Godfrey Reggio. 1983. USA.

*The Matrix.* Directed by Andy Wachowski and Larry Wachowski. 1999. USA and Australia.

*The Matrix Reloaded.* Directed by Andy Wachowski and Larry Wachowski. 2003. USA and Australia.

*The Matrix Revolutions.* Directed by Andy Wachowski and Larry Wachowski. 2003. USA and Australia.

*Monsters, Inc.* Directed by Pete Docter. 2001. USA.

*Naqoyqatsi: Life as War.* Directed by Godfrey Reggio. 2002. USA.

*No Maps for These Territories.* Directed by Mark Neale. 2000. UK.

*(nostalgia).* Directed by Hollis Frampton. 1971. USA.

*Nuit et brouillard/Night and Fog.* Directed by Alain Resnais. 1955. France.

*The Order.* Directed by Matthew Barney. 2002. USA.

*Radio Dynamics.* Directed by Oskar Fischinger. 1942. USA.

*Renaissance.* Directed by Christian Volckman. 2006. France, Luxembourg, and UK.

*Le Retour à la raison/Return to Reason.* Directed by Man Ray. 1923. France.

*Ringu/The Ring.* Directed by Hideo Nakata. 1998. Japan.

*Russki Kovcheg/Russian Ark.* Directed by Alexandr Sokurov. 2002. Russia, Germany, Japan, Canada, and Finland.

*Shoah.* Directed by Claude Lanzmann. 1985. France.

*Spider-Man.* Directed by Sam Raimi. 2002. USA.

*Spider-Man 2.* Directed by Sam Raimi. 2004. USA.

*Spider-Man 3.* Directed by Sam Raimi. 2007. USA.

*Starship Troopers.* Directed by Paul Verhoeven. 1997. USA.

*Star Wars Episode II: Attack of the Clones.* Directed by George Lucas. 2002. USA.

*Star Wars Episode III: Revenge of the Sith.* Directed by George Lucas. 2005. USA.

*Superman Returns.* Directed by Bryan Singer. 2006. USA.

*Ta'Ame-Gilas/Taste of Cherry.* Directed by Abbas Kiarostami. 1997. Iran.

*Terminator 2: Judgment Day.* Directed by James Cameron. 1991. USA.

*The Thin Blue Line.* Directed by Errol Morris. 1988. USA and UK.

*Toy Story.* Directed by John Lasseter. 1995. USA.

*Transformers.* Directed by Michael Bay. 2007. USA.

*Tron.* Directed by Steven Lisberger. 1982. USA.

*The Tulse Luper Suitcases: The Moab Story.* Directed by Peter Greenaway. 2003. UK, Luxembourg, Spain, Hungary, and Germany.

*Waking Life.* Directed by Richard Linklater. 2001. USA.

*The War Tapes.* Directed by Deborah Scranton. 2006. USA.

*Wax, or The Discovery of Television among the Bees.* Directed by David Blair. 1992. USA.

*The Wild Bunch.* Directed by Sam Peckinpah. 1969. USA.

*Within a Minute: The Making of Episode III.* Directed by Tippy Bushkin. 2005. USA.

*X-Men.* Directed by Bryan Singer. 2000. USA.

*X2: X-Men United.* Directed by Bryan Singer. 2003. USA.

*X-Men: The Last Stand.* Directed by Brett Ratner. 2006. USA and UK.

*Zelig.* Directed by Woody Allen. 1983. USA.

# INDEX

archiving: in celluloid film, 50–51, 59, 61, 185, 228n23; cinematic, 9; digital, 109, 122, 130, 133, 171, 173–74, 201–8, 216. *See also* accessibility; Cartesianism; control; determinism; digital; digitization; entropy; force; immateriality; instantaneity; interactivity; manipulability; navigability; new media; newness; power; quantization; seamlessness; spectatorship; teleology; user

Arnheim, Rudolf, 14

aura, 13. *See also* Benjamin, Walter

authenticity. *See* objectivity

automaticity, 16, 25, 40, 58, 61, 71, 171, 190. *See also* analog; aura; celluloid film; indexicality; isomorphism; mechanization; photography

Bachelard, Gaston, 140. *See also* immense space; space

Balázs, Béla, 14

Barthes, Roland, 20–23, 49, 52, 66, 98–99, 127, 154–55, 158, 160, 167, 213–14. *See also* Bazin, André; causality; connoted message; contingency; denoted message; determinism; entropy; indexicality; notations; photography; punctum; realism; reality; reality effect; stillness; studium; teleology; that-has-been; time

Baudry, Jean-Louis, 17

Bazin, André, 14–20, 22–23, 42–44, 52, 61–62, 66, 83, 154–55, 159, 213, 226n61, 226n63. *See also* actuality; automaticity; Barthes, Roland; causality; celluloid film; change mummified; contingency; entropy; image fact; indexicality; mechanization; motion; objectivity; ontology; photography; realism; self-motion; semiotics; spectatorship; subjectivity; time

becoming: and celluloid film, 84, 117, 127, 153–54, 159, 162, 166, 172, 182, 188, 216; change as, 27, 89, 127, 147, 153, 194; and the digital, 133, 197, 200, 208, 216; and the gest, 100; instant as, 166, 172; and space, 135; and thought, 188, 190; and time, 148, 182, 200, 227n82. *See also* change; Deleuze, Gilles; duration; durée; entropy; eternal return; ethics; force; interval; manifold; motion; smooth space; subjectivity; thought; time; time-image; truth; virtuality

Beltrami, Eugenio, 112. *See also* geometry; space

Benjamin, Walter, 13–14, 225n42. *See also* aura; painting; photography

Bergson, Henri, 6, 145, 147–49, 152–54, 159, 164–66, 170, 175, 180, 206, 215, 233n14, 233n34. *See also* change; Deleuze, Gilles; determinism; duration; durée; teleology; time; Zeno's paradox

Binkley, Timothy, 72, 144

*Blade Runner* (Scott), 156

*Blair Witch Project, The* (Myrick and Sanchez), 63–64, 229n36, 229n37

*Blinkity Blank* (McLaren), 106–8, 127, 231n4

*Blow-Up* (Antonioni), 59–60

body: and animation, 90; and the animorph, 127; and celluloid film, 75, 78, 89, 157, 166; cyborg as, 88–89; in the digital, 94, 97, 192, 197–99; and the freeze-frame, 166; and geometry, 111, 114; and the gest, 100; in haptic visuality, 82–83; in *The Incredibles*, 91; and interactivity, 136; in *Interval*, 75; in *Man with a Movie Camera*, 85; and Marey, 172; in *The Matrix*, 197–98; and the medium, 6; and morphing, 32–33, 35, 91–92; and motion, 24; and motion capture, 94–95; and the mummy complex, 15; in *Naqoyqatsi*, 100; in *No Maps for These Territories*, 68; in *The Order*, 99–101; and phenomenology,

change: in *Allegretto*, 128; analog technologies and, 29, 212, 217; becoming of, 27; and celluloid film, 86–87, 103, 129, 173, 178, 180, 187–88, 208, 212–14; of the digital, 1–8, 12, 29–30, 32, 35, 73, 90, 97, 103, 130, 143, 145, 153, 170, 175–76, 178, 194, 197, 199, 201–3, 205–6, 212, 214; entropy as, 9, 97, 205; ethics of, 13; as force, 24, 37, 74, 89, 154, 178, 189–90, 195–97, 199, 208, 217; and the freeze-frame, 156, 158–60, 166–67; as function,199; in *The Gleaners and I*, 202–3, 205; and indexicality, 62, 172, 226n61; and interactivity, 175–76; in *Interval*, 74; in *Into Great Silence*, 152–53, 173; in *Late Spring*, 147; in *The Matrix*, 198; motion as, 24, 30, 169; and repetition, 233n26; in *The River*, 118; and space, 103, 111, 113–15, 117–20, 124, 127, 130; and spectatorship, 79–80, 115, 175, 180, 188; and stillness, 162, 166–70, 215; and the subject, 58; and thought, 188–90, 217; time as, 24, 26, 30–31, 145, 147–49, 152–56, 158–60, 162, 166, 169, 172, 178, 215. *See also* animation; ani-morph; becoming; Bergson, Henri; change mummified; contingency; Deleuze, Gilles; duration; durée; entropy; eternal return; force; instantaneity; interval; manifold; morphing; motion; movement-image; power; repetition; smooth space; stillness; thought; time; time-image; truth; Zeno's paradox

change mummified, 18. *See also* Bazin, André; celluloid film; change; image fact; indexicality; motion; photography

chronosigns, 61, 227n81, 227n82. *See also* any-instant-whatevers; any-space-whatever; becoming; change; contingency; Deleuze, Gilles; duration; durée; entropy; falsification;

interval; motion; movement-image; narrativization; opsigns; self-motion; sonsigns; thought; time; time-image; truth; virtuality

cinema verité, 17, 45, 49, 88. *See also* direct cinema; documentary; free cinema

Comolli, Jean-Louis, 17

compositing, 31, 109, 131, 140, 143, 214; and reality, 35, 66; and semiotics, 40. *See also* animation; CGI; computer effects; digital; digital rotoscoping; digitization; digitographic; morphing; motion capture; realism; reality; space

computer effects, 3, 9, 31, 64, 90, 92–94, 103, 108, 127, 191–92, 200, 211, 223n3. *See also* animation; CGI; compositing; digital; digital rotoscoping; digitization; digitographic; morphing; motion capture; realism; reality; reality effect; special effects

connoted message, 22, 48–49, 62, 93, 99, 101, 214. *See also* Barthes, Roland; denoted message; determinism; photography; studium; teleology; thought; truth

contingency, 20, 22, 66, 68, 75, 166, 172–73. *See also* actuality; becoming; Cartesianism; change; control; duration; durée; entropy; eternal return; gest; indexicality; instantaneity; notations; objectivity; punctum; reality; thought; time-image; truth

control: and celluloid film, 19; and the cyborg, 88–89; and the digital, 32–33, 37, 66–67, 70, 122, 145, 191, 195–99, 201–2, 206, 214–16; and ethics, 195–99; and forces, 194; in *Forrest Gump*, 66; in *Images of the World and the Inscription of War*, 54; and indexicality, 53; in *The Matrix*, 196–98; in *No Maps for These Territories*, 68; in *Russian Ark*, 121, 123; in *Shoah*, 186; and space, 120, 122–23, 125; and

falsification *(continued)*: and reality, 62; in *The Tulse Luper Suitcases*, 132. *See also* becoming; change; chronosigns; eternal return; narrativization; thought; time; time-image; truth

film. *See* celluloid film

force: active, 193–98, 203, 205, 207; creative, 141, 190; and hodological space, 134–35, 139; and *The Matrix*, 196, 198; reactive, 193–98, 203, 207; and *Shoah*, 182, 187; thought as, 189–90; time as, 145, 149, 169, 173, 178, 182, 187, 189, 200; and *The War Tapes*, 173. *See also* Cartesianism; change; control; Deleuze, Gilles; determinism; eternal return; ethics; Nietzsche, Friedrich; power; powerlessness; skepticism; subjectivity; teleology; thought; truth; virtuality; will to power

*Forrest Gump* (Zemeckis), 64–67

Frampton, Daniel, 227n80

free cinema, 88. *See also* cinema verité; direct cinema; documentary

freeze-frame, 155–60, 166–67, 169–70, 173. *See also* Barthes, Roland; celluloid film; motion; photogram; photopan; Stewart, Garret; stillness; that-has-been; time

gaze, 54–55, 57–58, 79, 145, 167, 169, 180. *See also* objectivity; psychoanalysis; spectatorship; subjectivity

geometry: Cartesian, 110, 121, 123, 125, 232n24; Euclidean, 110–13, 125; Riemannian, 113–14, 126. *See also* Beltrami, Eugenio; Bolyai, Janos; Cartesianism; Euclid; Lobachevsky, Nikolai Ivanovich; manifold; parallel postulate; Riemann, Georg Friedrich Bernhard; smooth space; space; striated space; von Helmholtz, Hermann Ludwig Ferdinand

gest, 100–101, 127, 214. *See also* connoted message; contingency; denoted

message; entropy; image fact; indexicality; notations; opsigns; punctum; reality; reality effect; sonsigns; that-has-been

Gibson, William, 68

*Gleaners and I, The* (Varda), 202–6, 209, 220

Green, David, 65–66. *See also* indexicality; realism

Grosz, Elizabeth, 115–16, 118. *See also* body; gaze; psychoanalysis; space

Guattari, Félix, 118–20, 122–25, 129, 231n19

Hansen, Mark B. N., 6, 206. *See also* Bergson, Henri; new media; phenomenology

haptic visuality, 6, 81–83. *See also* body; corporeality; interval; Marks, Laura; phenomenology; spectatorship; subjectivity; time-image

Haraway, Donna, 88, 89, 230n30. *See also* cyborg

*Heavenly Creatures* (Jackson), 126

Heidegger, Martin, 11. *See also* McLuhan, Marshall; mediation; medium; ontology; phenomenology

hodological space, 134–35, 139, 214. *See also* Lewin, Kurt; space

icon, 15, 40–41, 44, 62–63, 76, 83, 91. *See also* digital; indexicality; painting; Peirce, Charles Sanders; semiotics; symbol

image fact, 19, 23, 43, 62, 154. *See also* any-instant-whatevers; any-spacewhatever; Bazin, André; change; mummified; contingency; entropy; gest; interval; opsigns; punctum; sonsigns; spectatorship; that-has-been; thought; time-image

*Images of the World and the Inscription of War* (Farocki), 53–58, 182

space: in *Allegretto,* 128; in analog video, 29; ani-morph, 127; body as, 118; and change, 152, 154; in the digital, 30, 33, 106, 108, 110, 122–23, 125, 130–31, 133, 143–45, 170, 214, 227n95; in *Dogville,* 134–36; in film, 18–19, 21, 29, 43, 73, 75, 85, 106–7, 116–17, 127–29, 159, 166, 214; geometrical, 110–14, 121, 125; and the gest, 100; in *Heavenly Creatures,* 126; hodological, 134–36, 139; immense, 139–41; and the index, 44, 58, 62, 178; and interactivity, 34, 136; in *King Kong,* 103–5; in *Koyaanisqatsi,* 69; in *Man with a Movie Camera,* 85; medium as, 9–10, 12, 36; in morphing, 35, 91, 93, 126, 130; and motion, 159, 164–65; in motion capture, 97; in *Night and Fog,* 51; in *No Maps for These Territories,* 68–69; as opsign, 80; in *The Order,* 99; in photography, 16–17, 44; poetic, 139–41, 214; in *Radio Dynamics,* 128–29; in *The Ring,* 85; in *The River,* 117–18; in rotoscoping, 97; in *Russian Ark,* 121–23; in *Shoah,* 184–85, 187; of spectatorship, 76, 81, 101, 114–15, 178; in *Star Wars,* 108–9; and the subject, 114–16, 178; in *Taste of Cherry,* 119–20, 123; and thought, 124; and time, 147–48, 159, 165; in *The Tulse Luper Suitcases,* 133; in *Waxweb,* 139. *See also* accessibility; any-space-whatever; arborescent thought; Cartesianism; CGI; compositing; cyberspace; Euclid; geometry; interactivity; interval; manifold; manipulability; morphing; motion; navigability; nomad thought; pixel; quantization; Riemann, Georg Friedrich Bernhard; seamlessness; smooth space; striated space; subjectivity; time

special effects (celluloid film), 3, 9, 45, 64, 92, 103–4, 107–8, 115, 126, 169, 223n3. *See also* animation; ani-morph;

celluloid film; computer effects; interval; motion; reality effect; self-motion

spectatorship: and Barthes, 21; and Baudry, 17; and Bazin, 15, 19, 43; in celluloid film, 15, 17, 19–20, 22–23, 43, 75–76, 85–86, 115, 156–57, 159, 178–81; and Comolli, 17; and corporeality, 77–81, 213, 83–84; and Deleuze, 24; in the digital, 3, 5, 32–35, 68, 73, 93, 103, 173, 214–16; and documentary, 48; in *Dogville,* 134–36; embodied, 27; in *Empire of the Senses,* 81; and ethics, 177–78, 180–81, 188, 194, 216; and the freeze-frame, 159, 166–67; in *the Gleaners and I,* 203; and haptic visuality, 83; and indexicality, 50, 53, 56, 58, 65, 172; and interactivity, 98, 103, 139, 174; in *Into Great Silence,* 149–50; and Kracauer, 75; and materiality, 36, 88; in *The Matrix,* 198; and the medium, 2; and motion, 127; in *Night and Fog,* 51–52; in *(nostalgia),* 160–64; in *The Order,* 98; persistence of vision and, 77; and phenomenology, 7, 27, 85, 233n24; in photography, 22; in *The Ring,* 81; in *Shoah,* 182, 187; and space, 115, 135, 139, 214; and thought, 188, 194; and time, 155, 178–79, 181. *See also* body; corporeality; ethics; gaze; interactivity; materiality; objectivity; persistence of vision; phenomenology; screen; skepticism; space; subjectivity; thought; user

*Starship Troopers* (Verhoeven), 191, 197

*Star Wars Episode III: Revenge of the Sith* (Lucas), 1, 108–10, 200, 231n6

stasis. *See* stillness

static. *See* stillness

Stewart, Garret, 155–61, 167. *See also* freeze-frame; photopan

stillness: in animation, 127; in celluloid film, 5, 84–85, 153–55, 159, 173; and change, 159–60, 167–68, 215; in the digital, 150, 170, 173, 233n23; and

motion, 155–59, 164–66, 169; in *(nostalgia)*, 160–64; in photography, 7, 18, 30, 167; in *The Pier*, 168–69; and thought, 188; and time, 36, 147, 150, 154, 158, 167, 169, 233n36. *See also* becoming; change; change mummified; daguerreotype; duration; eternal return; freeze-frame; instantaneity; loop; motion; photogram; photography; photopan; repetition; time

striated space, 118, 120–22, 124–25, 231n19; and *Allegretto*, 128; and compositing, 131; and *Dogville*, 134; and interactivity, 136; and morphing, 125, 130; and *Radio Dynamics*, 129; and *Russian Ark*, 121; and *Waxweb*, 139. *See also* arborescent thought; becoming; Cartesianism; change; contingency; control; Deleuze, Gilles; determinism; entropy; Euclid; geometry; Guattari, Félix; nomad thought; smooth space; space; teleology; thought

studium, 21–22, 25, 52, 136. *See also* Barthes, Roland; connoted message; determinism; photography; punctum; teleology; that-has-been

subjectivity: in *Ararat*, 61; and Barthes, 21; and Bazin, 15–18, 42–44, 62, 226n63; in *Blow-Up*, 60–61; and celluloid film, 17–18, 25, 36, 41, 43–44, 48–50, 63, 73, 75, 158, 179–81, 190; and Deleuze, 25, 80; and the digital, 32, 63, 66, 69–70, 101, 123, 175, 190, 193, 195, 197–203, 206, 215–16; and documentary, 48–49; in *Empire of the Senses*, 81; and ethics, 189, 195, 200, 216; in *The Gleaners and I*, 202–3, 205; and identification, 115–16; in *Images of the World and the Inscription of War*, 54, 57–58; and immensity, 140; and the index, 41–42, 44, 50, 53, 58, 61–62, 178, 213; and Kracauer, 73, 75; and Lacan, 57; in *The Matrix*, 196; and the medium, 12, 213; in *Night*

and Fog*, 52–53; and objectivity, 50, 53–55, 62–63, 79, 84, 89, 125, 179; in phenomenology, 27–28, 42, 84–85, 116; and photography, 15–17, 21, 44; in *The River*, 118; in semiotics, 41–42, 44, 62; and skepticism, 179, 188; and space, 115–16, 118, 120, 214; and spectatorship, 27, 36, 50, 56–57, 79, 84, 101, 157–58, 178, 180–81, 188–90, 199, 201, 206, 214–15, 229n32; in *The Thin Blue Line*, 47; and thought, 25, 124, 189–90; and time, 154, 215; and vision, 55, 57–59, 79, 85, 190; in the Zapruder recording, 59. *See also* actuality; body; Cartesianism; corporeality; cyborg; determinism; ethics; gaze; objectivity; screen; skepticism; spectatorship; teleology; thought; truth; user; virtuality

superhero. *See* digital

symbol: digital as, 19, 22, 29, 40, 63, 65, 70, 72, 95, 98, 100, 106, 110, 170, 192, 215–16, 224n26; and documentary, 48–49; language as, 22, 41, 77, 98; as semiotic sign, 41, 44, 62. *See also* digital; icon; indexicality; Peirce, Charles Sanders; semiotics

*Taste of Cherry* (Kiarostami), 119–20

teleology: in the digital, 35; in the movement-image, 24; and Ozu, 146; and space, 117; in the studium, 21; and the time-image, 155, 159. *See also* actuality; becoming; Cartesianism; change; contingency; determinism; entropy; ethics; movement-image; objectivity; thought; truth

*Terminator 2: Judgment Day* (Cameron), 91–93

that-has-been, 20, 22, 23, 49, 52, 158, 182. *See also* Barthes, Roland; contingency; entropy; gest; image fact; indexicality; interval; notations; punctum; time

**Markos Hadjioannou** is assistant professor of literature and arts of the moving image at Duke University.